THE GREENGRASS PAPERS

THE GREENGRASS PAPERS

A Film-Maker's Journey:
to Bourne and Back

TOM SHONE

faber

First published in the UK in 2025
by Faber & Faber Ltd
The Bindery, 51 Hatton Garden,
London ECIN 8HN
First published in the USA in 2025

Printed in the UK by CPI Group (UK) Ltd, Croydon

A CIP record for this book
is available from the British Library

ISBN 978-0-571-37322-2

MIX
Paper | Supporting
responsible forestry
FSC
www.fsc.org FSC® C013604

Printed and bound in the UK on FSC® certified paper in line with our continuing
commitment to ethical business practices, sustainability and the environment.
For further information see faber.co.uk/environmental-policy

Our authorised representative in the EU for product safety is
Easy Access System Europe, Mustamäe tee 50, 10621 Tallinn, Estonia
gpsr.requests@easproject.com

10 9 8 7 6 5 4 3 2 1

For KATE

'I am the camera's eye. I am the machine that shows you the world as I alone see it. Starting from today I am forever free of human immobility. I am in perpetual movement. I approach and draw away from things – I crawl under them – I climb on them – I am on the head of a galloping horse – I burst at full speed into a crowd.'

Dziga Vertov, *Kino-Eye Manifesto* (1923)

CONTENTS

INTRODUCTION

In December of 2020, Ken McCallum, the director general of MI5, Britain's domestic intelligence service, invited film-maker Paul Greengrass to the organisation's headquarters at Thames House in Millbank, London. An imposing, seven-floor, 1930s office building in the imperial neoclassical style on the north bank of the River Thames, the Grade II-listed edifice has been MI5's permanent base since 1995, when, after extensive refurbishment, it was reopened by then Prime Minister John Major to house MI5's 2,500 or so staff. The new entrance featured a central flight of steps, beside which was a pair of wheelchair-friendly ramps; a Union flag flew from a flagpole flanked by statues of Britannica and St George; to the rear was the vehicle entrance and underground car park, with a sign that read: 'Alert Status: Black Special'. Cameras, some with infrared lights, covered all sides and approaches.

Greengrass took one of the building's eighteen elevators up to the executive floor near the top. This had something of the feel of an inner sanctum, with, as he came out, pictures of previous heads of MI5 in a row by the lifts, including a head-and-shoulders shot of Roger Hollis, the organisation's head from 1956 to 1965. That stopped Greengrass in his tracks. 'It was surreal, because that picture of Hollis is the one that appears in so many books about post-war British intelligence, including *Spycatcher*, and always in reference to the fact that he had fallen under

suspicion.' While working for Granada's *World in Action* in the early 1980s, Greengrass had ghostwritten *Spycatcher*, the autobiography of an MI5 intelligence officer, Peter Wright, who had alleged all kinds of covert and illegal activity at the agency: the bugging and burgling of many foreign countries' embassies in London and Canada; a plot to smear British Prime Minister Harold Wilson as an agent of the Russians; and an exhausting, multi-pronged hunt for a super-mole within the British secret services – the so-called 'Fifth Man' – that at one point had brought Hollis himself under suspicion. As a result of what became known as the *Spycatcher* affair, both agencies, MI5 and MI6, were put on a statutory legal basis – they were 'avowed' – for the first time in their seventy-year history. If Greengrass was now standing in the inner sanctum of Britain's spy service, it was in part because of events he set in motion. The new director general was 'very big on being public-facing', says Greengrass, 'but I would imagine they must've thought carefully before inviting me. But my memories of the day are oddly quite emotional. It landed with me. It had significance as an act of coming in from the cold. It felt like a closing of the circle.'

He was met by a senior intelligence officer in charge of the outreach programme and shown into a meeting room, where he was met by the deputy director general, who explained that her boss had been detained in Downing Street and would meet Greengrass at a later date.

'It's so nice to have you here,' she said.

Greengrass told her he felt somewhat nervous. 'My wife said to me this morning, "If you'd said to me thirty years ago you were going to visit MI5, I would have thought you were delusional."'

The deputy director general laughed and told him that she had just joined MI5 when the *Spycatcher* affair started. 'If you'd said to *me* then you were coming in, I'd have thought you were more than delusional.'

He was given a tour of MI5's offices: light, airy, modern, open plan, about as far away from the grubby telephones, creaking elevators and endless files immortalised by John le Carré in *Tinker Tailor Soldier Spy* as you could possibly imagine. There were signs that read 'This is a no-phone zone', green ones indicating when it was safe to use your phone

and anti-blast blinds on the windows, so although the offices were light and airy, you never got a sense of the outside world. There were lots of cheery management signs and painted murals, alongside press reports about MI5, including some concerning a recent stabbing near London Bridge that had brought the agency criticism. It reminded Greengrass of other public-service buildings, like the BBC's or the NHS headquarters. 'They're obviously trying to make themselves more open, more account-able,' he says, 'but what struck me most was how youthful and diverse the staff were. Then you realise these young people are dealing every day with very bad people doing very bad things, and that must take a toll. That's what the director general, Ken McCallum, told me when I met him a few months later. He said, "It's easy for people to get haunted by what they're having to do here. Particularly counter-terrorism work. We have to work hard to make sure they don't."'

Greengrass was introduced to a stream of people: an officer involved in helping formalise MI5's thinking on the balance between civil liber-ties and security, and others who ran agents out in the field, who spoke of the difficulties in recruiting people, how dangerous it can be when agents finally reveal themselves, particularly if they are dealing with ter-rorist organisations, and the pride they took in ensuring that the often vulnerable people they dealt with were left in 'a better place than [where] we found them'. In a windowless situation room, he met a senior officer involved in counter-espionage, an older man in his fifties who talked about proliferating threats, resource allocation and the difficulties of identifying when a threat becomes critical. Greengrass asked a lot of questions about right-wing extremism, having documented the murder of eighty-six young people by the Norwegian Anders Breivik in his film *22 July*. 'I don't know what it is about right-wing extremists, but they love sheds,' he was told. 'These guys come to our attention, and they'll be in their sheds. And we have to work out what they're doing in there. Is he doing something truly dangerous or is it just pretence? It's a rising threat, no question about it.'

He also had a long conversation with an officer who was heavily involved in counter-terrorism in Northern Ireland, a career-long interest

of the director's since his early days on *World in Action*, when he secured an interview with hunger striker Raymond McCartney, and his subsequent docudrama *Bloody Sunday*, which was instrumental in exposing the cover-up of the events in Derry in 1972, when British paratroopers shot dead thirteen unarmed Irish civilians and wounded fourteen more. 'I remember telling him the last time I had gone to Derry, for a screening of *Captain Phillips*, I had been amazed to see spray-painted slogans in support of Continuity IRA and the Real IRA, splinter groups opposed to the peace process. They'd even defaced Raymond McCartney's famous mural at Derry Corner.'

They broke for lunch, and afterwards Greengrass was led to a small room with a camera, where he was hooked up via an internal network to several hundred intelligence officers who peppered him with questions – about his Oscar-nominated films *Captain Phillips* and *United 93* and his three Bourne movies, *The Bourne Supremacy*, *The Bourne Ultimatum* and *Jason Bourne*. It was a very film-literate audience, with a lot of good-natured badinage about Bourne's lethal prowess and intelligence capabilities. 'I talked about the two traditions,' Greengrass says. 'There's the tradition of Bulldog Drummond and John Buchan, all the way up to James Bond – the order-reinforcing characters, who are told, "Those damn Germans/Russians are playing up again, go and sort them out, will you?" And then there is the more questioning – the subversive, if you want to call it that – tradition, which is Graham Greene, Eric Ambler, le Carré obviously, and counter-cultural American cinema in the late sixties/early seventies, and on to Bourne. I was saying that in the noughties, the spy-movie universe was defined by Bourne and Bond and the struggle between them, if you're going to call it that. Bond was moribund, and Bourne came along and showed what a modern spy hero would feel like in the new millennium and how he would look, dress, what his issues were, his interior life and so on. Then Bond began to look very like Jason Bourne and absolutely cleaned up commercially.'

One officer asked about the car chase at the end of *The Bourne Supremacy*. Greengrass told them they had closed down a large part of central Moscow, causing an enormous traffic jam that the director himself

had got caught up in while on his way to the set. 'I leaned out of my window to ask another driver, "What's the problem?" "Some fucking idiot is shooting a film down there and snarling up all the traffic!"' Greengrass had sunk back in his seat. '"Oh really? That's terrible . . ."'

Finally, the conversation at MI5 turned to *Spycatcher*. Greengrass tried to sum up how he felt thirty years after the book's publication and the subsequent trial in Australia. He told the assembled staff he was obviously aware the book had caused an enormous stink and that for them Wright was a pariah figure. 'I don't regret it exactly,' he recalls telling them. 'I tried to tell them that when you're young, that's your job, and it was a great adventure, but obviously as you grow older you reflect more, and I'd hate to think I'd done real damage. In the end, for all its farce and nonsense, and accepting that it must have been a terrible thing for them as an organisation to have one of your people turn against you and so comprehensively tell all, I do believe in the end they got to a better place where both organisations were avowed. I didn't expect them to agree with that, but that was what I said.'

The deputy director general said she understood his argument without agreeing with it. She said something like, 'All I would say is that it was a difficult time for the service and a lot of changes were made around that time.' After some good-natured jousting, Greengrass remembers trying to find some common ground. 'Look, I imagine the default for a lot of you is that journalism and film-making are done by people who don't think much about consequences,' he told them, 'or rarely do. But we're as much a part of what makes a democracy work as you are, even if we're fated to be in conflict. But even those of us, like me, whose role is throwing bread rolls from the back of the class, we do think about what we do. We're asking questions, we're trying to distil what it feels like to be alive today. And you have to start with a deep conversation with yourself about what it is you want to say. You have to start with a question, to which the film itself can be the answer.'

On 19 June 1972, the *Washington Post* published a story by Bob Woodward and Carl Bernstein revealing that one of the five men arrested after breaking into the Democratic National Committee headquarters at the Watergate Hotel complex in the pre-dawn hours of 17 June with bugging devices and pen-sized tear-gas guns was James McCord, a security contractor with President Nixon's Committee to Re-Elect the President (CREEP) who had once worked for the CIA. 'What the hell do you think it means?' asked Woodward, a twenty-nine-year-old rookie crime reporter who had been sent to cover the arraignment of the burglars. Bernstein, a twenty-eight-year-old who sometimes wrote for the paper about rock music and had volunteered to make some phone calls to learn more about the burglary, said he had no idea, but the article, 'White House Consultant Linked to Bugging Suspects', the first to feature the two reporters' joint byline, was the first in a series that would eventually force Nixon from office.

The next day, Nixon met with his chief of staff, H. R. Haldeman, in the White House at just before 11.30 a.m. They talked about the weather, the president's schedule, magazine coverage, a woman from Michigan who was running for Congress, the possibility of sending Mrs Nixon to visit Rapid City, South Dakota, where there had been recent flooding, and Nixon's in-laws. We know this because Nixon secretly taped all his meetings in the White House on a Sony TC-800B reel-to-reel voice recorder. Using 0.5mm tape set to run at the irregular speed of 15/16 IPS – or half that of a standard tape recorder – and with tiny lavalier microphones poorly distributed throughout the space, the sound quality of the recordings was terrible, with a ticking clock in the background, the voices faint and an odd burping noise as a result of the voice-activated recorder starting and stopping.

Then, at 7:12 minutes into this particular tape, a penetrating, persistent buzz begins: the sound of a 60 Hz hum leaking from the power grid, as interpreted by a high-gain microphone input circuit. The tape had been wiped. This lasts for eighteen and a half minutes, before the two men are heard again, discussing the upcoming Democratic Party convention and Haldeman's opinion of the Robert Redford heist movie *The Hot*

Rock (1972), which the president had just seen with his wife. Later in the conversation, the two men discuss wire-tapping in a way that suggests it has been spoken of before:

NIXON: Back in connection with wire-tapping, I think it's very, very serious.
HALDEMAN: Right.
NIXON: There's no question there's a double standard here.
HALDEMAN: No.
NIXON: With regard to [unclear] do it –
HALDEMAN: Yes.
NIXON: – [unclear] prior authorisations to have it done. They're all doing it! That's a standard thing. Why the Christ do we have to hire people to sweep our rooms?
HALDEMAN: We know they're –
NIXON: Yeah.
HALDEMAN: – bugged.
NIXON: We have been bugged in the past.

When the public learned in 1973 that the tape had been tampered with, Nixon's personal secretary, Rose Mary Woods, stepped forward with a convoluted story about how she was transcribing the tape on a Uher 5000 reel-to-reel when the phone rang and she reached back over her shoulder to take the call, all the while leaving her foot on the pedal that erased the tape. A widely circulated photo of Woods recreating her improbable lean across her desk led many to believe that she was stretching more than just her body. When Tape 342, as it's known by archivists, was last tested in 1974 by a panel of audio experts, they concluded that the erasures were done in nine separate segments. Whoever erased the tape pressed 'record', stopped the tape and hit 'record' again between five and nine times – hardly an accidental erasure. The mystery remains: did Nixon and Haldeman talk about the break-in, reported for the first time by the *Washington Post*, or did they just talk about Haldeman's opinion of *The Hot Rock*?

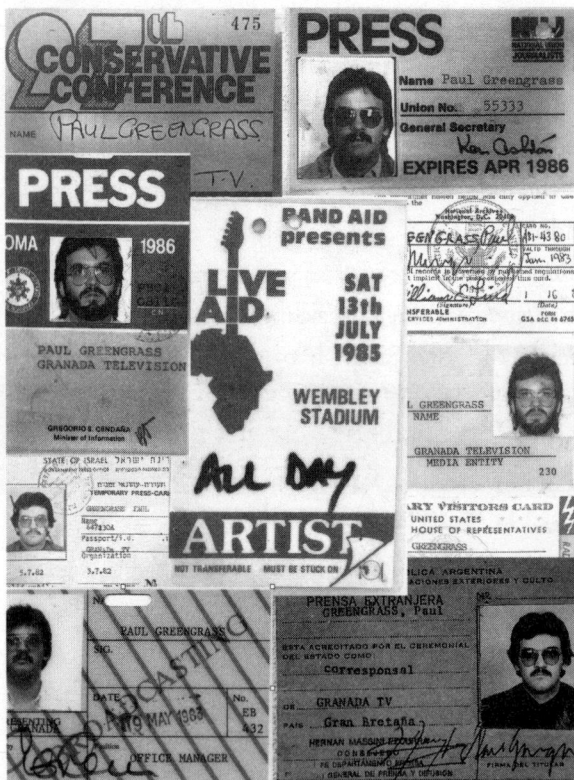

A collection of Greengrass's press passes from 1978 to 1985, obtained while he was working for Granada's *World in Action*, first as a researcher and later as a producer.

Our history is track-marked with erasure. The missing segment of the Nixon tapes. The 6.9 seconds between Lee Harvey Oswald's first and second shots. The twelve-to-fifteen-minute gap in the news coverage of Bloody Sunday, between the soldiers moving into the Bogside and the last of the thirteen civilians being shot. The final twenty minutes that elapsed on board doomed flight United 93, between the beginning of the passenger assault and the moment the plane ploughed into a field in Pennsylvania. The five days Captain Richard Phillips spent with his kidnappers on board a lifeboat after his cargo ship was hijacked in 2009 by Somali pirates. More than just gaps in the official record, these mysteries compound, ramify and metastasise, attracting conjecture, interpretation, explanation, commentary, conspiracy theory and counter-theory. 'Secrets are an exalted state, almost a dream state,' writes Don DeLillo in his novel about the Kennedy assassination, *Libra*. 'They're a way of arresting

motion, stopping the world so we can see ourselves in it.' The book is a favourite of Greengrass's, whose own films do much the same.

More than any film director working in the mainstream of Hollywood today, Greengrass has sought to make sense of the contemporary world as it unfolds around us – the daily news ticker and chyron feeds of hijackings, assassinations, kidnaps, leaks, hacks and political scandals – and show us the forces *behind* these events. He first came to Hollywood's attention in 2002 with *Bloody Sunday*, a scalding dramatic recreation of the massacre of thirteen civilians by British troops in Londonderry in 1972, shot with rolling handheld cameras, with real veterans in the roles of the paratroopers and some of the victims played by their own relatives. 'It's like a Brechtian newsreel,' wrote film critic Elvis Mitchell in the *New York Times*. 'The level of accomplishment in the filmmaking is overwhelming . . . For all the characters on screen, we can glimpse their hearts in their eyes.' As well as picking up the Audience Award at the 2002 Sundance Film Festival, *Bloody Sunday* won the Golden Bear at the Berlin Film Festival, along with Hayao Miyazaki's *Spirited Away*, and seemingly overnight made Greengrass the hottest director in world cinema.

He was far from an overnight success story, though. By the time Hollywood discovered him, he was a forty-six-year-old film and TV veteran, with four features under his belt and dozens of documentaries. He had witnessed riots and revolution and hunted for Yasser Arafat in the bombed ruins of Beirut, while using new lightweight cameras, like the 16mm Éclair. 'It was like suddenly you could fly,' recalled *World in Action* producer Leslie Woodhead on the Granadaland website. 'The technology was becoming totally liberated. It really was a time when new things were happening all over the place, and the equipment was revving up at a speed that could deal with all of that.' Many journalists have made their career in Hollywood, particularly the screenwriters of its Golden Age, when Herman J. Mankiewicz, Ben Hecht and Billy Wilder brought the hard-boiled style they had perfected as newspaper reporters – 'cynical of all things on Earth including the tyrannical journal that underpaid and overworked us', as Hecht put it – to the vernacular rhythms of film noir, historical epics and the screwball comedies of the thirties and forties. The number of journalists

who have become directors is much smaller – in the modern era, Cameron Crowe and Nora Ephron come to mind – and even fewer have come from the investigative news background that forged Greengrass.

Working at the porous boundary between fact and fiction, he makes feature films that have the urgency and immediacy of good journalism. Mixing movie stars with real people, rehearsing intensively for several weeks before the cameras roll but rarely storyboarding his action, Greengrass prefers to shoot long takes, with the camera hovering at the fringes of the action, looking for the vantage point from which to push in and capture events on the fly with custom-made lightweight zoom lenses. He is after that sense of discovery, immediacy and improvisation that suggests events happening once, and once only. He calls it the 'unknowing camera' – a rough, syncopated layering of zooms, reframings and racked focus that jolts the camera out of its traditional pose of omniscience and forces it to become a player in what it witnesses. The audience feel like they have been plunged into the middle of events, down at eye level with Jason Bourne as he barrels through the Moscow underpasses in a stolen taxicab or scrambles across the rooftops in Tangiers.

Greengrass's three films about the hunted American spy-in-exile have taken over $1 billion at the box office, winning Oscars for film editing, sound mixing and sound editing and establishing a new visual grammar for action movies that has been aped by every franchise, from *John Wick* to *Batman* to *Fast and Furious* to James Bond himself. Google 'Bourne' and 'shakycam', and you will find literally hundreds of articles arguing over the influence, deleterious or otherwise, of Greengrass's run-and-gun aesthetic, which has 'redefined the genre for nearly two decades and become a visual vocabulary unto itself', in the words of the *Hollywood Reporter*, although few have achieved the psychological and political resonance of the Bourne films. His memory wiped by a gunshot concussion, Bourne must live in a perpetual present tense of threat and counter-threat, relying only on himself and the speed of his own synapses, against a looming backdrop of shadowy geopolitics. 'The question driving the action isn't existential (who am I?) but moral (what did I do?), a surprisingly weighty mystery for a movie intent on blasting our synapses into submission,'

wrote Manohla Dargis of *The Bourne Supremacy* in the *Los Angeles Times*. 'There are all sorts of pleasures to be had in this summer bauble, but the most unexpectedly resonant is the sight of this boyish face frozen in a mirror as he finally grasps what he did once upon a time. Rarely does pop come with such sizzle.'

Greengrass's run-and-gun style was never as newfangled as critics made out. Rather, it had its roots in the documentaries of Robert Drew and the Maysles brothers, as well as the work of John Frankenheimer and Haskell Wexler, who sought to catch the convulsions of the sixties and seventies in such films as *Seven Days in May* (1964) and *Medium Cool* (1969). Arguably, the Rosetta Stone of 'shakycam' – or the 'unknowing camera', as Greengrass calls it – is the Zapruder film, the 486 frames shot in 1963 by Ukrainian dressmaker Abraham Zapruder on a Bell & Howell Zoomatic Director Series home-movie camera of President Kennedy as he rounded the corner of Dealey Plaza and was taken down by three rifle shots. Incredibly, there was no government coverage and no local-TV film of the Dallas parade, which meant the assassination of the president wasn't covered by the networks; the Zapruder film itself wasn't shown until Geraldo Rivera broadcast it in 1975 on *Good Night America*. In DeLillo's novel *Underworld*, the painter Klara Sax sees a bootleg version of the film:

> The movie in fact was powerfully open, it was glary and artless and completely steeped in being what it was, in being film. It carried a kind of inner life, something unconnected to the things we call phenomena. The footage seemed to advance some argument about the nature of film itself. The progress of the car down Elm Street, the movement of the film through the camera body, some sharable darkness – this was a death that seemed to rise from the streamy debris of the deep mind, it came from some night of the mind, there was some trick of film emulsion that showed the ghost of consciousness.

Nobody has wielded the style to such powerful effect as Greengrass. Much copied, his *vérité* style of film-making is not just a means of juicing

his action sequences, but an entire way of looking at the world – wired, jittery, fragmented, kinetic, endlessly vigilant – that strikes a very modern chord. Nothing feels staged, yet there's a hidden design to the disorder. Only once the adrenaline has subsided do you notice the moral shadow cast by events. 'In Greengrass's films, every action has its consequence, and every action must be grounded in a punctilious understanding of how events happen, and how they fit together,' wrote Jonathan Romney in *Film Comment* of *Captain Phillips*, Greengrass's nail-biting 2013 thriller about a Somali hijack that somehow managed to address the inequalities of global capitalism. Through the film, noted *The New Yorker*'s film critic Anthony Lane, 'the Greengrass paradox is on display: how can so confusing a situation seem so clear? Only Spielberg can match him in his ability to lay out conditions and terms.'

A constitutionally cheerful, youthful-looking sixty-five-year-old, with John Lennon-style glasses, whitish–silver hair that he sometimes keeps back in a ponytail and an occasional beard, Greengrass often strikes people who meet him as far too decent a bloke to have ever made it in Hollywood. British film producer Eric Fellner once told him, 'If you'd drawn up a list in the late nineties of the people who would turn out to have significant Hollywood careers, you would have been about number 99 on the list.' Bearish and broad-humoured, swearing prodigiously in the effing-and-blinding manner of a London cabbie, Greengrass's greatest claim to fame before he started making movies was having been taken to court by Margaret Thatcher for ghostwriting *Spycatcher*, making him the only British film-maker to have run afoul of the Official Secrets Act. 'The simplest way to get him involved in a conversation is to say you have a secret you can't tell him,' says his wife of thirty years, Joanna Kaye, who runs her own talent agency. 'He will not rest until he has found out what it is.'

This is the side of the director that made him such a good investigative journalist: dogged and bloody-minded, driven to divine the forces

behind the headlines and to hell with the official version of events. Matt Damon, to whom the director once gifted a copy of the first volume of Robert Caro's biography of American president Lyndon Johnson, once called him 'a conversational prize-fighter'. An aficionado of scrums, Crystal Palace football club and 'good trouble', the director relishes a good ruckus, both on screen and off, but he also knows which fights to pick and which to let go in order to retain control of his films. He's a strategic mediator whose most practised move, intellectually, is to find unforeseen middle ground between two raging opposites. This balance is perfectly expressed in his films, with their forces of chaos and order, and heroes caught between irresistible force and immovable object, attempting to keep their balance and ride out events: Ivan Cooper, caught between the protestors and combustible British paras in *Bloody Sunday*; or Jason Bourne himself, caught between 'good cop' Pamela Landy (Joan Allen) and 'bad cop' Ward Abbott (Brian Cox) in *The Bourne Supremacy*, or between Landy and Noah Vosen (David Strathairn) in *The Bourne Ultimatum*. There is a lot of Greengrass himself in his heroes.

I first met the film-maker in 2020, via Zoom, just as COVID-19 closed down cities all over the world. His film *News of the World* had just been finished, remotely, and distributed by Universal and Netflix in partnership – a sign of the world that was changing beneath our feet, as the streaming revolution changed for ever the way in which films are financed, made and distributed. Once quarantine was lifted, I visited him at his home near Henley-upon-Thames, a pretty, sprawling, multi-acre property he shares with his wife and teenage children. His office is situated in a disused barn, whose shelves are stacked from floor to ceiling with research materials – scripts, transcripts, printouts, declassified files and FOIA-requested government reports, going back decades to his first work for *World in Action* in the late 1970s. He was getting ready to donate much of his archive to the British Film Institute and seemed to be at something of an inflection point in his career, hungry for 'a new adventure', as he put it. As he tried out various ideas for size and fit, I got to see both his writing and his decision-making processes up close and was struck by how similar his approach was to various seemingly

disparate projects. 'There's one thing that I default to again and again, going back forty years. I just sit and I try and figure out what's important to me that's going on,' he told me. 'That doesn't mean, "What's in the headlines today?" because that's not the same thing. It's "What's driving things?" That's the question I always ask myself.'

Often taking as their starting point an act of political violence, our knowledge of which is somehow incomplete, like the Nixon tapes, his films fill in the gaps, using a mixture of painstaking investigative work and imaginative infiltration. Greengrass is looking not so much for secrets as for resonance: the detail that is more than just a detail; the part that stands in for the whole; the act that defines the fight; the tipping point that turns the battlefield. 'If you look clearly and unflinchingly at a single event, you can find in its shape something precious, something much larger than the event itself,' he wrote in his treatment for *United 93*, his account of the one flight on 9/11 where the passengers fought back, which was drawn from Congressional records, recordings from air traffic control that day and the plane's black box, and witness accounts. 'Making a film with Paul is like doing an MA,' said researcher Kate Solomon, who worked with him on the film. While poring through eyewitness statements as he researched *Bloody Sunday*, producer Mark Redhead noticed that he was taking 'four times longer than Paul to read them. He has this phenomenal ability to chew through information.'

Eventually, after a few false starts, in the autumn of 2023, Greengrass found the project that would be his next film: a script from *Mare of Easttown* writer Brad Ingelsby about the historic fire that razed the Californian town of Paradise in 2018. While he wrote a new draft and came up with a production plan, I peppered him with questions. Have any actors ever baulked at his shooting methods? Has a studio? What's the difference between a news story and a film plot? Why is he so interested in political violence? Has he ever been shot at? Arrested? Has he ever, to his knowledge, been put under surveillance? Why did he write *Spycatcher*? What has been the effect on his films of rhythm and blues? What was the cause of his falling-out with Bourne writer Tony Gilroy? Did Nixon and Haldeman talk about the Watergate break-in or *The Hot*

Rock? Did Oswald act alone? All books are an act of sleuthing. Perhaps appropriately for a book about a film-maker who has made such extensive use of the Freedom of Information Act, this one was the result of long hours spent combing through files, both physical and electronic, looking for clues that would lead me to a greater understanding of him and his film-making.

The resulting portrait is in its nature partial, fragmentary, incomplete – like the Nixon tapes or any of the other pieces of jigsaw that first hook him into making a film. Almost pathologically averse to secrets, of either governments or people, he was, by comparison with many of the subjects of his films – the CIA, al-Qaeda, His Majesty's Government – a model of transparency, although as we talked I got the impression that retrospection did not come naturally to him. He is by nature forward-facing, something of a workaholic who is at a slight loss during the holidays, eager to get behind a camera again, to strip down a scene to see what makes it tick, to put it back together, only this time with a little room for improv thrown into the mix and so-and-so coming in a little sooner to give the whole thing a little more crackle and pop, so that the room is alive rather than a 'fish on a slab' – his favourite phrase for a scene that simply sits there doing nothing. While shooting *The Bourne Ultimatum* in London's Waterloo Station, they could do each scene only once, because the moment Matt Damon started running, every kid in the station whipped out their phone, but Greengrass secretly loved the images the kids were shooting: they had exactly the spontaneity *he* was after – 'hurried, informal and fluid', he later noted in a BAFTA lecture.

We all live in the explosion of experiences and perspectives that constitute our everyday life, where imperfect, intimate, hastily made images are grabbed, self-made and shimmer and multiply in endless dizzying self-replicating patterns of light and sound. Where reality, fact and fiction as well as identity, nationality, gender and ethnicity are constantly mixing and merging and in flux . . . All of this is an inevitable consequence of a fast-globalizing world, and a reaction to what we can dimly see is an emerging global consciousness . . . It

will bring us closer together as it drives us further apart. We will see the world simultaneously through the long and the short end of the telescope. We will record everything, have access to everything and remember very little.

The killing of George Floyd was played around the world via a teenage girl's smartphone. Today, Kennedy's assassination would be filmed from every conceivable angle and broadcast around the world within seconds. We are all the grandchildren of Abraham Zapruder, living in Jason Bourne's world.

1: CONFLICT

In 1964, the documentary-film-making brothers Albert and David Maysles were commissioned to make a film about the arrival of the Beatles in New York by Tim Hewat, the boisterous Australian maverick at the head of a new current-affairs programme in the UK called *World in Action*. Albert didn't even know who the Beatles were at that point, but within a few hours the two brothers rushed out to Idlewild airport and started shooting. Using a modified 45lb Arriflex camera that could be carried on their shoulders, they shot a fast, raw, direct, behind-the-scenes film of the band as they ducked their fans, twitted the press or fooled around in hotel rooms over a period of four days. 'We just tagged along with the Beatles; they didn't have to position themselves for us because the camera was no longer on a tripod as it always had been up to then,' said Albert. 'That meant the Beatles could just feel free to move around and be themselves. That new technology gave us the flexibility to catch life as it was – without imposing on people. You didn't have to interview them, heighten the film with music, just real, straight, direct life experiences – a nonfiction film-maker's dream.' In one scene, Paul McCartney darts back and forth and around in circles, as if trying to elude the camera, but it is too fast, panning around to keep him in shot. Later, entering a lift, he pulls a coat over his head and makes a conjuring

gesture with his hands: the only way for McCartney to disappear, he seems to admit, would be by using magic.

The Maysles brothers were at the vanguard of a revolution in documentary film-making that was set in motion a few years before by their work on Robert Drew's film about the 1960 presidential primary fight in Milwaukee, Wisconsin, between John F. Kennedy and Hubert Humphrey. Entitled simply *Primary*, the film had been the first to take advantage of the newer, lighter, handheld 16mm Auricon cameras that could shoot for longer takes, using more sensitive film stock to capture scenes in natural light and magnetic tape that could sync sound to image, allowing for unprecedented up-close-and-personal access to the young, charismatic Kennedy as he pressed his way through the crowds to an auditorium. Albert Maysles had no choice but to squeeze in behind him and hoist his camera up high, shooting 'blind' as Kennedy battled through a sea of smiling faces and outstretched hands, which he shook, working his way up a tight stairwell before finally reaching a stage, where he and his wife Jackie delivered speeches, Jackie fiddling nervously with her white glove as she did so. 'I stayed right with them,' said Maysles later. 'I kept the camera over the back of Jack Kennedy's head as I followed him. I couldn't see what I was shooting but I knew that the camera was seeing what Kennedy was experiencing.'

The camera was seeing what Kennedy was experiencing.

It was the shot seen and heard around the world. When most people think of the word 'documentary', they think of the observational film-making that Drew and the Maysles brothers pioneered in the early 1960s – 'theatre without actors', to use Drew's phrase, 'plays without playwrights . . . reporting without summary and opinion'. In France, it was known as *cinéma vérité*, in Canada it was called Free Cinema, in America it was Direct Cinema, but they all meant the same thing. In England, after the Maysles film about the Beatles for *World in Action*, 'Yeah Yeah, Yeah, New York Meets the Beatles', was shown on British TV in its entirety in 1964, the British press hailed it as a revolution: *televérité*. 'It was like suddenly you could fly,' *World in Action* producer Leslie Woodhead told Granadaland, referring to the first 16mm Éclair

cameras, which allowed Granada's film-makers to ditch the studio and head out into the real world to document the Vietnam War, the Troubles in Northern Ireland, apartheid and Watergate. 'The technology was becoming totally liberated. It really was a time when new things were happening all over the place, and the equipment was revving up at a speed that could deal with all of that.'

Produced by Manchester's Granada TV, *World in Action* was at the centre of the *vérité* revolution in the UK. Founded in 1954 by the great champagne socialist Sidney Bernstein and located in a vast neo-brutalist building on a sprawling lot in Salford, Granada was one of the new independent broadcasters challenging the BBC's monopoly and saw itself as a pugnacious corrective to the southern metropolitan bias of the British media. Bernstein hired Denis Forman, a radical Scottish nonconformist masquerading as the television industry's permanent secretary, to shape the company for him. One of Forman's first acts was to buy the title *World in Action* from John Grierson, the godfather of British documentary realism. Up until then, current-affairs programmes meant *Panorama* – deferential encounters between BBC presenters and politicians. 'You never saw the real world at all,' said Forman. Shot on celluloid film, with no reporters, *World in Action* left the studio behind to deliver forty minutes of unmediated documentary footage every Monday evening. Politicians and the Independent Television Authority hated it, but audiences loved it.

'No-one sleeps at the back when *World in Action* is on the air,' wrote one critic. There were no suits, and films were sometimes pulled together in a haze of marijuana smoke and an attitude of bolshy lese-majesty. Margaret Thatcher called the show's producers 'Trotskyites'. If Watergate had dented everyone's morale – 'What was the future of investigative journalism once you had brought down a president?' as David Boulton, one of the programme's producers, put it – the election of Thatcher in 1979 ushered in a kind of Indian summer, with programmes on the Birmingham Six and the Rossminster tax scandal and a string of courageous films on Northern Ireland. 'There was just this sense of incredible power,' recalled editor Gus Macdonald. 'You would come down on the

train from Manchester on a Monday night as the programme was going out and know that most of the lights in the houses you could see were watching what you had to say.'

Paul Greengrass joined the programme in 1978, when he was twenty-three, a young Cambridge graduate who worshipped Bob Woodward and Carl Bernstein and dreamed of one day stepping into their shoes – the obsessive investigative reporter, his collar upturned, the soles of his shoes worn thin, who doggedly pursues a single thread and brings down an entire government. He had already served an eighteen-month apprentice-ship in Granada's sports department under Paul Doherty, where he had uncovered a story about the business practices of Louis Edwards, the then chairman of Manchester United – 'Champagne Louis', as he was known, due to his taste for bubbly – who was up to his neck in illegal share deals, bribes to council and company staff and secret payments for new player signings. This particular programme caused a sensation, drawing Greengrass his first death threats from outraged Manchester United fans and providing him with his entrée to the *World in Action* team, up on the third floor of an annexe at the end of the street.

One day, not long after starting, he found himself sharing an elevator with David Plowright, the pugnacious Yorkshireman who was then pro-gramme controller and on his way to becoming managing director.

'You're the new researcher, aren't you?'

'Yes,' said Greengrass, the 'sir' on the tip of his tongue.

'Well, don't forget your job is to make trouble,' said Plowright.

Greengrass didn't think it particularly unusual at the time. 'But now I look back on it and think, "Whoever goes into work and hears that from their boss?" But he meant it. That was your job.'

World in Action in those days was very much a closed world, with its own space, its own rules. Greengrass is always careful, when reminisc-ing about the good old days, to point out that the culture at Granada was 'very macho, very male', but to someone who had spent large por-tions of his childhood missing his father, as Greengrass had done, the environment and mythology of *World in Action* was intoxicating: an office of gruff, difficult-to-impress older males who rode newcomers

hard and let you know when you had made a mistake. 'It was a tough, sink-or-swim environment,' he says. 'To my eyes, *World in Action* was the big boys' table. They always seemed to be in the papers for some big row with the government or exposing someone somewhere or winning awards. It felt a bit like being called up to the Premier League. It was tough guys and guilty men and the eternal struggle between them in faraway places.'

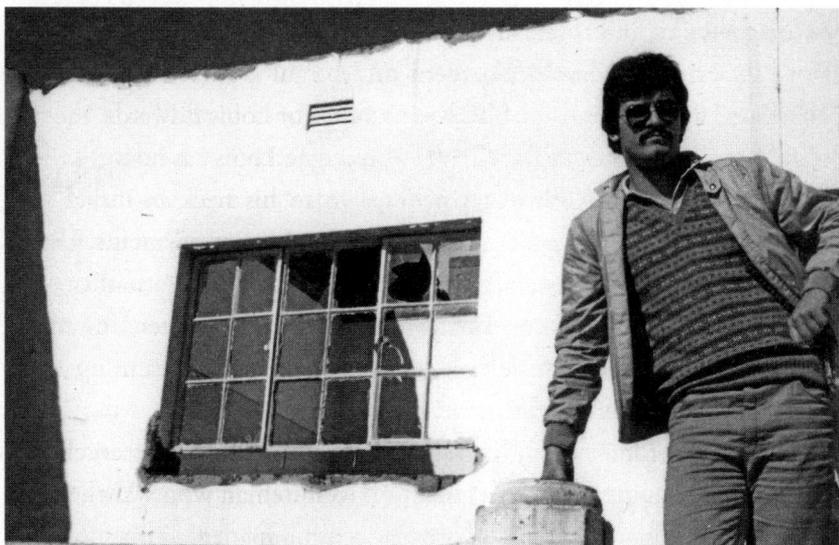

Greengrass on assignment in South Africa in 1981.

You didn't want to be seen in the office too much – nobody ever got a story by sitting behind their desk – but when you did go in, a long spur corridor, running down the side of the building, led to the offices of Tom Gill, the production manager who juggled resources and booked crews, and Ray Fitzwalter, the programme's editor since 1976, a genial but inscrutable Lancashireman who had risen up from the Bradford *Telegraph & Argus* to become the longest-serving editor in current affairs, beneath whose conventional, owlish exterior beat the nonconformist soul of a journalist cut from the old crusading cloth, driven by steely moral clarity and uncompromising, radical conviction. Greengrass would later describe him as 'the vicar in the ITV whorehouse'. At the

end of the corridor, between the two offices, stood a large, white plastic board that stretched from floor to ceiling, on which was written every single episode of *World in Action* since 1961, followed by its date and the name of the producer and researcher who had worked on it: John Birt's interview with Mick Jagger on the lawn of the singer's stately home following his arrest on drugs charges in 1967; John Shepherd and Mike Beckham's Vietnam films; Brian Moser's photographic record of Che Guevara's body; David Boulton's coverage of the early days of the Troubles in Northern Ireland; Leslie Woodhead's 'Stones in the Park', shot by the Maysles brothers, and his film about South Africa, 'The Dumping Grounds'; Mike Ryan's film about Steve Biko's funeral; John Shepherd's 'Dust at Acre Mill', about a factory in Derbyshire that had covered up the death of its workers from asbestos poisoning, one after the other after the other. 'It looked to me like a wall of fame,' says Greengrass, who would walk past it every day. 'You'd look at them and see all those names – Moser, Birt, Woodhead – and you wanted to get your name up on that board.'

The technical apprenticeship he served at Granada was astonishing. *World in Action* films were often assembled under the most intense deadline pressure, in order to make it to air on Monday evenings. They would frequently get their rushes back only on a Friday or Saturday morning; the transcripts would be typed up, and then they'd have to cut, paste and assemble the film and get it off to the neg cutter by Sunday night. 'It's one thing to cut a movie,' says Greengrass, 'but can you cut one in eighteen hours against the clock? That's when you know you can cut. See it, try and distil it, shoot it, come back, cut it, on to the next one. Get it done, get it done, get it done, move it forward. It's all about telling a story, laying a theme down. You then explore it, then you develop it further, and then you ultimately bring it back to where you started, but in a way that changes it. It was my equivalent to an actor doing rep. It was the making of me, it really was. Because I learned so many vital lessons then. Just the idea of how to write, how to shoot, what kind of stories to tell, how to tell them directly and with economy – what I always call "being eye level with the audience". No reporters, no mediation; it was direct, bang, here

we go, this is the story, twenty-six minutes, fifty-two if you're lucky. Film, film, film, film, film.'

Greengrass loved the sense of adventure that came with waking up in the morning and being sent off to some trouble spot – 'Pack your bags, you're going to Argentina' – and the camaraderie fostered by knowing your producer or cameraman had your back in a tight spot. 'Even the danger seemed comical, or surreal, or glamorous or all three,' he later wrote. He sneaked into South Africa in 1981 to make a film about its brutal government policy of forced removals, despite assurances by the minister of cooperation and development, Dr Piet Koornhof, that 'Apartheid as the world knew it is dead.' Filmed clandestinely in the internationally unrecognised Ciskei 'homeland', 'The Discarded People' showed black and Cape Coloured neighbourhoods being bulldozed, families being separated and transported out to remote so-called 'tribal homelands' that were the dumping grounds for black surplus labour – overpopulated, disease-ridden and barren. While filming, Greengrass, cameraman Humphrey Trevelyan and producer Simon Berthon were stopped, apprehended and held at a police station overnight. Interrogated by the notoriously violent and corrupt Brigadier Charles Sebe, the brother of Ciskei's president Lennox Sebe, they all kept to their flimsy cover story that they were making a film for the Church of England. They were eventually released, upon which Greengrass jumped into a car and drove non-stop for twenty-four hours, picking up the cans of film they'd lodged with black trade unionists and other allies across South Africa. 'I didn't sleep for two nights,' he says. 'I eventually got out through Botswana.'

World in Action in those days used freelance crews working out of Allan King Associates, whose office in Soho had, in the sixties, seen the likes of Allen Ginsberg, John Lennon and Yoko Ono pass through. Unashamedly part of the counter-culture, they wore combat fatigues and their cameras bore stickers that read 'This machine kills fascists', an adaptation of the message Woody Guthrie placed on his guitar in the early 1940s. 'Certainly, we were part of a wave that was going on, which included rock 'n' roll and included fashion, and included new theatre and cinema,' recalled Leslie Woodhead, who produced a film about the Rolling Stones'

free concert in Hyde Park in 1969, after Mick Jagger gave them a call. 'It was made up as we went along. When Jagger picked up the mic to start the first number, he picked up the wrong mic – or at least one that didn't contain our feed – so if you look at the first number, about half-way through it a frantic man runs from behind and sticks another mic in his hand. So half of the first number is semi-audible. And the band were so wrecked, out of their heads stoned by the time they started the concert . . . So one way or another it was very primitive technically, but it had the energy of the concert – so it delivered the goods. I remember the *Daily Telegraph* said, "This is the loudest thing since World War One."'

A still from Greengrass's 'Discarded People' for *World in Action* (1981).

Initially, *World in Action* was shot with the Auricon, the same camera used on *Primary*, but it was heavy and hard to handle over long periods of time, and in 1964, Hewat switched everyone over to the newer, handheld 16mm Arriflex with which the Maysles had shot their Beatles film. Over the course of their subsequent films for *World in Action*, the Maysles shared the modifications they had made to it – essentially taking

the magazine off the side and putting it on the back, thereby distributing the weight evenly so it could be carried on the cameraman's shoulder for long periods at a time. By the time Greengrass arrived at Granada in 1979, the cameras were lighter still: the Éclair NPR, the same camera Martin Scorsese had used to shoot *Woodstock* (1970); the Arriflex BL, which was used on *Apocalypse Now* (1979) and *The Shining* (1980); and the Aaton Super 16mm with which Barry Ackroyd would shoot *The Hurt Locker* (2008) and *Captain Phillips*. 'The mobility of those cameras and the rapidity with which you could change frame and focus are extraordinary,' says Greengrass. 'They enable you to hold back and withdraw and observe, but also, on the end of a long lens, to be highly intrusive and interrogative and enquiring. Compassion and dispassion, that's what they gave you.'

A year after his apartheid film, he was sent to Beirut to cover the Israeli siege of the city following an assassination attempt by a Palestinian splinter group on Israel's ambassador in London. He was joined by cameraman George Jesse Turner, whose footage as he crossed the River Jordan with a group of Palestinian commandos in the late sixties was company legend. His *World in Action* report started with the night sky suddenly lit up with tracer fire. The camera went haywire. Then came Turner's voice: 'Christ, I've been hit!' Next his producer's 'Where?' The reply: '*Up the fucking arse!*' – a bullet had grazed Turner's butt cheeks. Greengrass had by this point spent some time in Northern Ireland, but Beirut was his first proper war zone. The Israeli army had encircled West Beirut, Yasser Arafat's PLO stronghold, and was periodically bombing it, for hours at a time, by land, sea and air. As Greengrass and his crew approached the port of Jounieh, on a fishing boat from Cyprus overcrowded with refugees that they had paid a lot of money to get on, anxiously listening to shortwave radio to make sure Israeli gunboats weren't going to intercept them, they filmed people water-skiing while Israeli airstrikes dropped cluster and phosphorus bombs on West Beirut, all in the same frame.

They crept into West Beirut at night, led by a Middle East Airlines 747 captain who was trying to get back to his home in the city. It was a terrifying journey that involved walking for five or six hours, stopping

whenever they heard gunfire and at checkpoints manned by jittery young men, armed to the teeth, from the competing militias that oversaw West Beirut. At one of them, a kid offered to lead them to some dead bodies in exchange for a sum of money. They declined. The next day, they were on their way to get their press passes at a PLO building in West Beirut when another Israeli air raid began. They were in a stairwell. Turner was rummaging in his 'daylight' bag, the black bag with sealed armholes that they used to change magazines of film in the middle of the day. Suddenly, they heard a roar and felt 'this unbelievable pressure' as Israeli jets dived down. The anti-aircraft guns started up, returning fire from the street.

Greengrass's vision seemed to take on a compressed, staccato quality – as if he were viewing things at an accelerated frame rate, the edges almost darkened, like an iris shot, so that the centre alone seemed to glow. He did what seemed to him to be the most obvious thing: he jumped down into the stairwell to find lower ground. For five minutes or so, the jets repeatedly strafed the streets a short distance away. When the attack stopped, Greengrass resurfaced and went to find his colleagues. Climbing the stairs, his jeans felt wet: he had pissed himself. He found George Turner exactly as he had left him, with his hand in the daylight bag. Alan Bale, the sound guy, was next to him, changing reels of tape. They both looked at Greengrass and started laughing like drains.

'Where the fuck did you go?'

'Down the fucking stairs, where do you think?'

That made Turner and Bale laugh even more, until eventually Bale, who had served in the British army, looked at Greengrass's piss-stained jeans and said, deadpan, 'Just stick with us. Do what we do, and you'll be fine. And if we ever start running, that's when you need to be worried.'

The next day, they left their hotel, the Bristol on Madame Curie Street, in the heart of Beirut, to find burned-out cars and endless rubble, the Palestinian stronghold halfway to becoming a hot, dusty building site. For weeks, the Israeli army had been targeting the PLO guerrillas holed up in and around the Palestinian refugee camps, but as it laid siege to the city, life's necessities – food, water and medicine among them – were becoming scarce. Electricity supplies and telephone coverage were intermittent.

Rubbish went uncollected. Hospitals were overwhelmed. Buildings were shot up, bombed, falling down. Broken glass was everywhere. Guerrillas and civilians alike toted automatic weapons and brandished pistols. And holed up in a basement of one of the endless high rises and apartment blocks of West Beirut was the PLO leader, Yasser Arafat.

'Everyone knew he was there,' recalls Greengrass, 'but he wasn't going to give any interviews. There was no way his movements could ever be predicted. Anyway, one day we were out in the street. Suddenly, he came out of one of the underground car parks. Arafat. Literally just standing there. First there was a commotion. "What the fuck's going on? It's Arafat." So George straps on the camera, and we went into the cluster of people all around him. He was there for probably a minute. He never liked to speak English, although he actually spoke perfectly serviceable English, but he liked to pretend that he didn't. We were shooting away, and then when we finished, Arafat recognised George. He said, "Oh, Mr Turner . . . how's your arse?" It was really a matter of timing, because the minute he showed himself, be assured the Israelis would clock him. But we got the shot. That's what those cameras gave you.'

Greengrass grew up watching the news – flickering, grainy, grey–blue images of assassinations and elections in far-off places that played on the TV in the corner of the family sitting room in Gravesend. The TV was a nine-inch in an angular, wooden housing that stood on four legs. He read newspapers, precociously, and when his father was home from his long spells abroad with the merchant navy, he would let Greengrass stay up late with him to watch *World in Action* or the BBC's *Panorama* – adult news programmes about adult subjects that travelled to some of the same parts of the world his father visited. Next to being read Charles Kingsley's book of Greek fairy tales before he went to bed – the stories of Perseus, Theseus and the Argonauts – his favourite thing was to sit with his father and watch reports of distant wars, the space race, the live cast of the Moon walk. Greengrass remembers being taken to see a film about Yuri

Gagarin at the cinema, staying up late to watch footage of the Vietnam War on TV, and his mother and grandmother crying when they heard on the news that JFK had been assassinated. He was emotionally affected himself when MLK and RFK followed. 'They had a big effect on me,' he recalls. 'I can remember being very interested in the "How did this happen?" type of thinking. You'd get those *Sunday Times* Insight-type pieces in the papers – the shooter was here, MLK was here – and fantastically arresting graphic designs. That kind of stuff spoke to me, instinctively. My childhood was framed by the drama of America.'

Along with the blue glow of the TV came the sense of connection it gave him to his father. Phillip Greengrass worked as a merchant seaman, a solitary, tough life that took him away from his family for long stretches of time, aboard cargo ships with strange names like the *Auricula* and the *Ericbank*. At first, the trips lasted only six to eight weeks, down the west coast of Africa, but later there were longer ones of four, six and even twelve months to South America, Australia, New Zealand, Panama, Fiji and California. A solitary man, cautious and introverted (who used to mow the lawn when they had visitors), Phillip was a ferocious autodidact, having escaped his strict Baptist upbringing at fourteen and educated

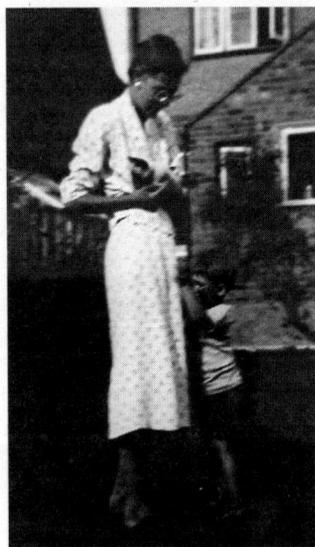

Greengrass and his
mother Joyce (1959).

himself at sea, reading Shakespeare and the classics in his bunk. His letters home to his wife were filled with loneliness and lectures on geography, politics and the philosophy of Spinoza. In preparation for Phillip's departures, Greengrass's mother Joyce would get everything ready – his uniform, badges, sextant, his canvas sailor's bag, knotted at the top and slung over his shoulder – and the next morning, Paul, his brother and sisters would get up to find their father gone. Upon his return, there'd be a similar bustle of preparation, Joyce putting on her Sunday best, with smart coat and scarf, and everyone piling into the Morris Isis to go and collect him from Portsmouth, Southampton, Tilbury.

THE GREENGRASS PAPERS

One time, Phillip returned from Africa with a beard and a parrot. His mother screamed over the beard. The kids loved the parrot, but it died not long after joining them, unable to adjust to chilly Gravesend, and Greengrass remembers his father crying. 'One of the only times I ever saw him cry. My father was a very solitary man. All those years travelling the world on his own made him a remote figure – he found it hard to talk to children as children – but there were compensations, because he talked to me like I was an adult. So politics came alive to me through him. Looking back, I think he lacked male company, but what it meant was, as a child I was exposed to a lot of adult things.'

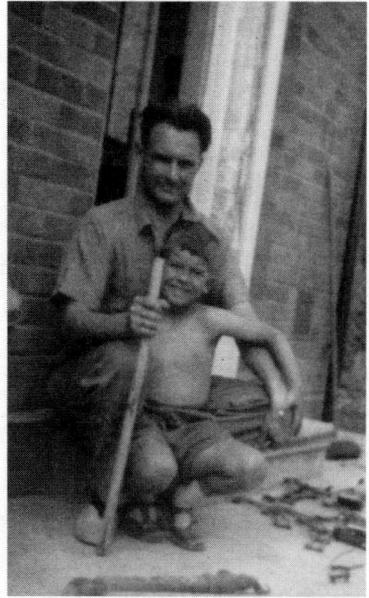

Greengrass and his father Phillip (c.1963).

Thanks to his father's restlessness, Greengrass saw 'great wonders' as an impressionable youngster: Peter Hall's production of *Hamlet* for the Royal Shakespeare Company, with David Warner in the lead; Gilbert and Sullivan; Handel's *Messiah*. His bedroom was plastered with pictures of Marilyn Monroe by the pool, the Kennedys, stills from the Zapruder film, the Apollo astronauts cut out from *Life* magazine. It looked like a Magnum photographer's contact sheet. After some years in Cheam, the Greengrasses had settled in Gravesend, in a suburban, semi-detached home hard by the grey marshes immortalised by David Lean in *Great Expectations* (1946) and *Oliver Twist* (1948) – a slightly desolate landscape, but atmospheric, right on the very edge of things. Turn a corner and you'd see a flat wasteland of green–yellow grass and weeds, intersected by the mazy tendrils of the Thames that brought heavy fog in winter. If you went east or south, you got deep into Kent countryside; north, and you got the Thames waterway, busy with boats linking you to the rest of the world. The streets on their estate were named after ships or their captains: Leander Drive, Volante Way, Vigilant Way. 'The Thames

was a gateway to the world. You could feel it,' Greengrass says. More importantly, 'It was where my father went.'

Then, in 1962, when Greengrass was seven, Phillip left the merchant navy to work as a river pilot, ferrying overseas cargo from the mouth of the River Thames up to the London docks, which meant that he was suddenly home a lot more. Always uncomfortable on the Riverview estate, he hated life in a small suburban box in a land-locked sea of other identical boxes and sought escape in theatre, music and long bike rides. A teacher from a long line of them, Joyce was Phillip's temperamental opposite – gregarious, abrasive, impulsive and extroverted. He liked books about mathematics, she liked Harold Robbins; he liked classical music, she liked the popular crooner Matt Monro. And then there was the simple truth that Phillip, from Surrey working-class stock, had married up, while Joyce had lower-middle-class aspirations. 'They had to learn to live together, which they'd never done,' says Greengrass. 'That provoked an epic struggle that lasted all their lives, really. We had to learn to grow up under the shadow of the constant threat of confrontation.'

The worst thing about his parents' rows, he says, was the 'awful predictability' of it all. 'You'd be upstairs, and you'd feel the row coming. It would have been brewing across the day. You would hear it downstairs, and you'd feel my mother goading him, and he had a terrible temper, my father. She would goad him and goad him, and then he would snap. And then it would explode in violence and rage. They would throw things at each other – saucepans through the window. Terrible, really, and it was never really about anything, although eventually it would be about him going and her pleading with him not to, having goaded him, and her hanging onto the door – "Don't go, don't go" – and clinging onto him, and then you'd hear the wrestling and come to the top of the stairs. He would hit her to get her to let him go, and then he would get in the car, and she would cling onto the door and lie down in front of the car, in front of everyone. We'd all be crying. I can remember my sisters crying and me crying. You just wanted it to go away.'

Not every argument ended in violence, but they had a cupboard at the back of the house that was full of doors that his father had put his

foot through, and more than once the police were called. As he got older, Greengrass would sometimes try to intervene, but learned only that he could do nothing besides wait for the storm to rage and eventually blow itself out. The next morning, the kids would come downstairs to find that peace had again broken out. Nothing was ever said. Their parents would go to work, and that would be that. 'Whatever sense we all made of it, I doubt any of us blamed one rather than the other,' he later wrote. 'Theirs was a marriage of two strong-willed, incompatible characters, trapped in an endless, violent, circular struggle. They were bound to one another. It was a very physical relationship. You've only got to look at their letters. But I think they both, at core, had a deep belief no one else other than the other would put up with them. So, for all their conflict, we never thought for a moment that they might divorce.'

When he was ten, his father took him to a matinee showing of David Lean's *Doctor Zhivago* (1965), at the old Empire in Leicester Square, during its first week of release. The screen, with its velvet drapes, seemed absolutely immense. There's a scene in the film where Tom Courtenay's Bolshevik activist Strelnikov leads the factory workers to petition the tsar, marching through the snowy streets of St Petersburg at night with women and children, and a band playing. Around the corner, unbeknownst to them, the Cossack cavalry awaits. 'It's the irresistible force meets the immovable object, with Zhivago up on the palace balcony watching it all and powerless, of course, to intervene when the violence begins. You just know that that's his life right there. We know that this scene will be avenged, that the revolution will soon come, and that Zhivago's destiny is to be tossed by these forces that are so much larger than him. I guess I would have understood that from childhood – that when storms rage, they're going to rage. And that dreadful scene when Strelnikov is taken from the train, much later: he gets off and he's out in the woods, and they take him and suddenly he's utterly powerless. I understood the relationship – Zhivago, Lara and the wife, the emotional complexity of it. I understood without knowing why,' he says. 'I also related, no doubt, to the great yearning that Zhivago has. It had a huge effect on me. I think I'm right there with David Lean on the pious boy and the light through

the cathedral. I think my early experience of the moving image in a movie theatre, when you are a lonely boy and very insecure and maybe home isn't as much of a home as perhaps a home should be or could be, I think that's a foundational experience from which everything else flows. Because all that follows is, you are trying to find a way of replicating the intensity and purity of the experience that you had as a small boy in a movie theatre.'

The echo in his films is clear. Violence – its causes and its effects, from trembling prelude to ashen aftermath – is Greengrass's great subject, and not just any kind of violence. His films dramatise the asymmetric, violent, circular contest between an ostensibly weaker force and a more powerful one: Irish republicans and the British military; Jason Bourne and the CIA; jihadists and the US. His heroes are peacemakers navigating their way through a minefield, antennae twitching, as Greengrass had to as a boy. Few directors are as twitchily attuned to the atmospheric pressure changes that precede a storm, nor as at home in the middle of it once it has broken. Many years later, after his mother's death, Greengrass would unravel more of his parents' turbulent history – affairs on both sides, a forced adoption – but at the time, he knew these things only by their absence. His was a family of 'secrets and strangers', in the words of Greengrass's younger sister, Emma: hidden shapes, strange absences, volcanic explosions of rage for reasons only half known, guessed at but never openly discussed. 'The family is the cradle of the world's misinformation,' wrote Don DeLillo in *White Noise*. 'The family process works towards sealing off the world. Small errors grow heads, fictions proliferate.' Outwardly at least, Greengrass was a gregarious, extroverted boy, mad for football and movies and not much else, but as he entered his teenage years, a streak of solitariness marked him as he struggled to make sense of the tumult at home. He was a carrier of secrets. A lingering sense of shame over what went on between his parents meant he held people at a distance; he had friends, but not close ones, and he didn't make them easily.

At weekends, his world revolved around football. Every Saturday, he and his best friend, Paul Beard, would pack into the London Underground to join the mass migration of children and teenagers heading to watch football at London's great football palaces: Stamford Bridge, White Hart

Lane, Upton Park in the East End or Highbury, home of the loathed Arsenal. They would meet at one of the mainline stations – Victoria, King's Cross, Euston – kids of all ages, from nine to nineteen, mixing and mingling on the platform and facing off against gangs of the opposing team's fans. 'It felt dangerous and forbidden and utterly alluring,' Greengrass remembers. In those days, the grounds were unsegregated and highly territorial, with home fans congregating in their own area – Chelsea had the Shed, Arsenal had the North Bank – in a way that invited aggressive territorial forays from the opposing team's supporters, who would run at them in waves when the cry went up – 'We're going to take the Shed' or 'We're going to take the North Bank' – led by older teenagers, with younger kids tagging along for the ride. These were also the days before numbered seating, with standing room only on the terraces, the crush barriers randomly placed, which meant that you stood shoulder to shoulder with the crowd, groaning when they groaned, cheering when they cheered, and when they surged in one direction, you had to roll with them, sometimes reaching out to balance yourself, clinging to the person on your left or right to stay upright – a sudden intimacy with complete strangers you had barely exchanged a word with – and when the crowd surged back, you surged with them and they reached out to you. 'It was like surfing: horrendously dangerous, as Hillsborough later showed us, but exhilarating, because you were being swept along by this irresistible force of mass humanity. It was like a wave, it would part and then suck back up, and when you had any kind of trouble – or a goal – you'd get surges, waves taking you away.'

After the match, hordes of teenagers would head back on the Tube, before feeding back into the suburbs via the mainline stations, often engaged in running battles as they wandered aimlessly in packs. 'Paul and I would get as close to the fighting as we could but make sure we were away from any real trouble,' Greengrass says – an instinct that would come in handy filming in trouble spots like Belfast or Beirut, and later prove invaluable when staging the violent riots of *Bloody Sunday* and *Jason Bourne*. 'Afterwards you could invent ridiculous fantasies about acts of involvement. It was intoxicating, as if you were in a movie like *The*

Warriors on the streets of London. I mean, teenage culture at that time was open gang warfare, really. And to go to football was to confront violence, to tell stories about it and love it and be excited by it and run away from it. Paul and I went to a 1966 Chelsea–Everton game, and there was a massive fight and bottles got thrown. We were eleven years old and had never seen anything like it. But, of course, then it became a contagion.'

The shock troops of this new, unrestrained, rebellious youth culture were the skinheads: urban, blue-collar teenagers with shaved heads, braces, Doc Marten boots, Ben Sherman shirts and Sta-Prest trousers, their cigarettes cupped in their hands – essentially a pastiche of what the dockers in London's East End wore and flourishing much like the American cowboy, just as that culture, best represented by trade union leader Jack Dash, was dying out. 'They were unbelievably distinctive, dangerous and glamorous-looking,' says Greengrass. 'It was like looking at a gunslinger in the 1860s, a highway man in the 1780s or a Hells Angel. Boys who were tough and renegades appealed to me, but I had two major problems when it came to skinheadism: one, I didn't fancy the fighting; and two, I didn't fancy the haircut.'

Milling around after a Chelsea–Arsenal night game in 1969, when he was fourteen, he and Beard suddenly saw, at twenty yards or so distance, a large gang of Arsenal skinheads racing towards them, grown men coming right at them. They ducked down a side street and sprinted hard to escape the fight that was about to erupt. 'Fucking 'ell, did you see them?' they asked each other breathlessly afterwards, halfway between exhilaration and fear. Another time, they were on their way to a match at Highbury when they saw a gang of skinheads break into a jeweller's and start snatching necklaces – just grabbing the jewellery and jamming it into their pockets like it was candy. Later, at the game, both sets of fans were hurling coins at each other over the line of police that divided them. 'Like an idiot I threw one too, and next thing I know a copper has collared me and thrown me out of the ground.' Beard came too, to be a loyal mate, and afterwards Greengrass complained, bitterly, 'Everyone else was kicking ten shades of shit out of one another, and all I'd done was chuck a coin.'

The glamour and excitement of Saturdays over, he found Gravesend Grammar School to be dead-end, suburban, dull – woodwork, metalwork, more woodwork – and he would play up. He disrupted the class and played truant, roaming the streets with his friends. They smoked cigarettes, dabbled in shoplifting and trashed the odd bus shelter, as he behaved like what he calls 'an early teenage jerk'. In his spare moments, he devoured Richard Allen's pulp novel *Skinhead*, later followed by *Suedehead*, *Skinhead Escapes*, *Demo*, *Boot Boys* and *Skinhead Girls*, which featured his skinhead hero, sixteen-year-old Joe Hawkins, a cockney super-thug whose life is ruled by clothes, beer, football and, above all, violence – against hippies, authority, racial minorities and anyone else unfortunate enough to get in his way. 'First, they'd find a few hippies and kick the shit out of them,' reads a typical passage. 'Secondly, they'd run riot in whatever amusement arcades were open. Thirdly, they'd come back here and bust the caf's windows and, if they could, break every stick of furniture in the rotten place.' The books brought vividly to life the gang warfare that Greengrass saw at first hand during his weekends on the streets of London, illuminating all its ennui and alienation, its excitement, its sensuality, its verve and glamour. He found something of the same rude energy in the TV dramas of Alan Clarke and, later, in his films, which marry a very particular strain of British male violence – aggro, bovva, a bit of grievous – to the gritty, social-realist sympathies of Ken Loach, with a more visceral, bare-bones, minimalist style. 'I need the buzz!' yells Gary Oldman's Bex Bissell in *The Firm* (1989), an estate agent who takes home a decent wage to provide for his wife and child, and who is also top boy in an inner-city firm of football hooligans: Allen's Suedehead reborn in the 1980s with a proper job.

'Clarke led with immersion and impact,' says Greengrass. 'There's energy about *The Firm*, right from that first scene, where you meet Oldman, and the bad guy comes to the car and cuts them all up on the football pitch. There's a lot of *The Warriors* in there. What those films did was, they took their energy from the world. The onset of Thatcherism released a lot of energy, and that created immense conflict, of course, and that's why I think *The Firm* is one of his absolute masterpieces, because

you see it. It's Jekyll and Hyde. By day, he's a loadsamoney estate agent selling houses down in . . . Canary Wharf is what we'd now call it – that diaspora of new builds in the early eighties. Soulless boxes, springing up left, right and centre. But by night, his roots were in the old Richard Allen Skinhead novels. Which was always going to win. And that's why the end is so fantastic, because he wins, but he loses. It's just a genius end. Bex gets his revenge but dies in the process. This is where that struggle ends, where it goes to. The release of energy leads to violence and conflict. It was so truthful, but so profound. Just a brilliant film. There's energy in *The Firm*, *Scum* . . . There's energy in all those films, there really is.'

His own films would barrel along, fuelled by a similar tank of propane – combustible, propulsive, explosive.

The slow-motion car crash of Greengrass's school career was not lost on his mother, who, as a teacher herself, knew all the signs of a kid in trouble. He had aced his eleven-plus, his IQ was in the top one percentile, but by the time he was thirteen, the gulf between his evident intelligence and his record at school was unavoidable. 'Paul has borne the brunt of it,' Joyce wrote in a letter to a friend of their difficulties at home. 'His behaviour deteriorated; he was taking drugs; he became acutely depressed and he wouldn't/couldn't work.' Things came to a head in the summer of 1969, when the headmaster at Gravesend Grammar wrote to Joyce, explaining that her son had failed to get through a single week without a serious complaint about his behaviour. 'I have spoken to Paul at some length this afternoon and I am bound to say he seems not to know whether he wishes to remain in this school or not . . . If he remains here, and there is no appreciable, sustained change in his general approach to his work, he is just as likely to leave here empty-handed.'

In desperation, Joyce sent him to an adolescent psychiatric clinic in Maidstone, where Greengrass confided to the psychiatrist that he hated his school and didn't want to go there. 'I was looking to escape. I think that's pretty clear, although I don't think I knew it – I'm talking about Gravesend,

family life, school life, all of it. It was a painful and difficult time for my poor parents, but also for me. Being lost and troubled isn't much fun.'

Antidepressants were prescribed for him, which he refused, and a few weeks later, after the umpteenth provocation, Greengrass was expelled. For six months, he didn't even attend school, while his mother worked hard to find him a new one, calling on her teacher contacts to organise interviews. One was at a school near Ipswich for maladjusted kids, where there were no rules and you were encouraged to smear pain on the walls – '*No way*,' he said – before she finally managed to secure an interview for him at Sevenoaks School in Kent, an experimental private establishment run by a man named Michael Hinton, a former parish priest who was deeply involved in campaigns for social justice. Upon becoming head-master of the school in 1968, Hinton had reformed and modernised it, creating a parents' association and a school council, as well as making room for a small quota of disadvantaged pupils from families who other-wise couldn't afford the fees. Hence, late one autumn afternoon in 1969, Greengrass was led into Hinton's book-lined study, held forth for five minutes on why he hated school and why it would never be right for him, was asked if he smoked, then told it would not be tolerated at Sevenoaks, and finally offered a place. 'You should probably come here,' said Hinton gently. 'I think this place will suit you.'

Something about the calm way Hinton said this – after all the turbu-lence, isolation, angst and anger of the years that had led Greengrass to this point – quieted the teenager. Maybe it wouldn't be so bad. A sense of resignation settled over him. The condition of Greengrass's free place at the school was that he had to board. His elder brother and sister had already left home: Sarah to go to university in Newcastle, and Mark to Sheffield to begin work as a teacher. 'I hadn't been as bad as all that, but it was a bit convenient for Joyce to have me out the way,' he says, not with-out a certain self-protective hardness in his tone. 'I was a teenager and acting up, and they didn't like it, so I think it solved the problem neatly.'

He arrived at Sevenoaks in the fourth year, and at first hated the experi-ence of boarding, counting down the days until he could return home. 'Being from outside the local area he was at a disadvantage joining already

established circles of friends amongst local boys,' his school friend Pete Cannon later wrote. 'Maybe he was a fish out of water to start with. That didn't last too long and didn't seem to bother him too much. He was an in-your-face sort of lad. Boisterous, extrovert and rough around the edges.' He would test the school's patience just as he had at Gravesend Grammar: he was suspended for smoking dope, and even ran away at one point, though this time the head of the English department sat and listened as he tearfully articulated the reasons why he had absconded. 'But even though I provoked them sorely, somehow they believed in me, understood me and tolerated me. I owe that school and those wonderful teachers an incalculable debt. They saved my life, really. I was the personal recipient of all that was wonderful about the liberal post-war settlement: the idea that troubled kids were worth persevering with, that their lives could be changed.'

The school had a film club – who had ever heard of such a thing? – where, every Thursday, they would watch European and British classics, like *Closely Observed Trains* (1966), *The Loneliness of the Long Distance Runner* (1962), *À bout de souffle* (1960), *Battleship Potemkin* (1925), *The Battle of Algiers* (1966) and *Bicycle Thieves* (1948), as well as D. A. Pennebaker's ground-breaking documentary about Bob Dylan's 1967 England tour, *Don't Look Back* (1967), featuring a young Dylan dancing rings around his press entourage. Just as importantly, there was the art department: a light, industrial-looking space with large windows that looked out across the car park towards Knole Park. Tucked away at one side of the school, and with its silk screens, pottery wheels, dark room, welding gear, plaster room, record player and kettle, it was a place where the normal rules didn't seem to apply. It was run by an exacting, brilliant painter and art teacher named Bob White, who gave Greengrass and his friends their own set of keys so they could come and go as they pleased: after school, during lunch breaks, in free periods or late into the evening, putting Bob Dylan's *Blonde on Blonde* or *Highway 61* on the record player, sneaking in the odd joint out the back. Greengrass made all of his important teenage friendships there, one of a gang of suburban beatniks that included Adam Curtis, who went on to make acclaimed documentary series such as *The Power of Nightmares* (2004); Pete Cannon, who became a documentary

film-maker and editor; and Andy Gill and Jon King, who later formed the post-punk band Gang of Four.

'It was more than just a key to a room,' says Greengrass, who made his first film there on an old spring-wound 16mm Bolex camera, which he found somewhere in the back of the space. *Straw Dolls* (named after Sam Peckinpah's 1971 movie *Straw Dogs*) was a horror film featuring art-room still-life dummies, dolls, scissors and black ink, and was full of angst, hands peeling oranges and barely suppressed lust. The art room was where he first came across the work of the abstract expressionists – Rothko, de Kooning, Pollock – and, above all, British pop artist Richard Hamilton, whose 1956 painting *Just What Is It That Makes Today's Homes So Different, So Appealing?* launched pop art in Britain. In 1970, Hamilton made a famous silkscreen print of the student massacre at Kent State, on 4 May 1970, after Ohio governor James Rhodes had called in the National Guard

A still from Italian film-maker Gillo Pontecorvo's *The Battle of Algiers* (1966). Regarded as a virtual textbook on urban guerrilla warfare, it has been studied by everyone from the Black Panthers, the PLO, the IRA, South African militants and the Viet Cong to the George W. Bush administration in Iraq.

to squash violent anti-Vietnam War demonstrations. About twenty-five minutes after noon, the guardsmen thought they heard a single shot. Almost instantly, there was a salvo from troopers on the knoll – nearly seventy shots in thirteen seconds – that left four dead and ten wounded, including a youth, Dean Kahler, who was paralysed from the waist down by a bullet in the spine. Quite by chance, Hamilton had set up his camera in front of his television, hoping for some interesting images, and captured an image of the wounded Kahler, spectral and blurry, his legs truncated by the rectangular TV screen. It 'was not just an image captured on TV,

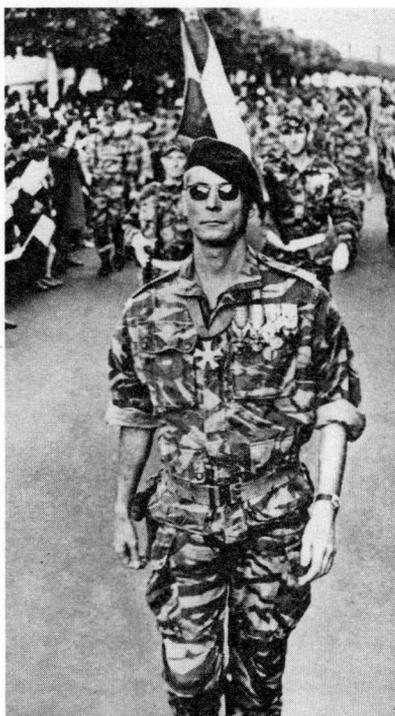

but a work about the mediation of this image by television', said the artist.

'Hamilton was such a legend for all of us,' says Greengrass. 'His paintings and prints had a massive effect on me. They made me grasp the drama of what was going on in Vietnam and in America. He connected up so many things for me – popular culture, political thinking, wit, attack – and he was such an exquisite and beautiful painter. Hamilton was like a portal. He entirely transformed the way I looked at the world. My world in Gravesend was much more blue-collar, but at Sevenoaks it became much broader and influenced by Woodstock and Hendrix, more hippie, if you like.' The other Hamilton print that had a big impact on Greengrass was his print *Swingeing London 67*, of Mick Jagger and art-gallery owner Robert Fraser snapped through the window of a police van as they arrived at Chichester courthouse following their infamous 1967 drugs bust. Reproduced from a photograph for the now-defunct British newspaper the *Daily Sketch*, the print is blurred, the colours lurid yet blanched by the camera flash, the two men lifting their manacled hands together as if to deflect attention, although Jagger seems to smirk under his palm and the handcuffs double almost as bracelets – a gesture caught somewhere between deflection and defiance. 'The idea of the Stones being busted for drugs was a big deal for a teenager. I can remember there was a drugs bust in the boarding house at Sevenoaks, not long after I first arrived. The housemaster and the police came in and searched everybody. Some of the older boys were caught and expelled. The Stones' bust in 1967 felt almost classical in a way. That's how Hamilton treated it. You could see the flashbulbs going off in Jagger's face.'

Greengrass grew up in the Stones' backyard. When he was younger, he used to lie on the floor and listen to the singer Kathleen Ferrier on his father's Mallard radiogram, a bulky cabinet radio that sat in the living room. Once he was older, he got his own portable radio, and at night tuned in to all the pirate radio stations playing American blues – Howlin' Wolf, Muddy Waters, B. B. King – that peppered the Medway corridor, just as Jagger and Keith Richards had done a few years before, just a few miles up the road in Dartford. The kid who lived opposite and his friends were blues fiends, and they'd let Greengrass come over and listen

to their records, even though he was too young to hang out – eight or nine to their thirteen or fourteen. Blues lyrics were the first time he'd heard people talking about sex. Later, in his second year at Sevenoaks, he went to the old Electric cinema on the Portobello Road and saw *Gimme Shelter*, the Maysles brothers' 1970 documentary about the Stones concert at Altamont, which descended into violent chaos after an audience member was fatally stabbed by a member of the Hells Angels.

'*Gimme Shelter* had a massive impact on me,' he says. 'First of all, it was just unbelievably cool to see Keith Richards with his snakeskin boots when he's listening to "Wild Horses". The Stones never really rehearsed. They were utterly shambolic. They would just turn up and see what happened. So the film had all this documentary observation, but it also had a powerful narrative drive. You're right in where the concert is being arranged, with the lawyer on the phone, and you're thinking, "This is insane." And then driving all the way to the concert and the way order breaks down and the killing of Meredith Hunter in the audience, the way it has an entire dramatic arc, that film. And then it ends with Jagger watching the scene on the Steenbeck editing machine. I thought it was just a brilliant film. The narrative drive of it wasn't just like a documentary. What you were seeing was generational change, an unshackling of the conventions that had held society together, all the dark forces of the sixties and the violence underlying youth culture. What the Stones created was this alternative universe, this hippie idyll, in which the Angels played the police and the police beat everybody up – a kind of bastard version of what had happened in 1968 in Chicago. All that hubris, and then they're the last plane out of Saigon when they all get in that helicopter to get the fuck out. It was terrifying really, what they authored. The whole thing was collapsing, a tear in the fabric of civilisation. That was what I really got out of it. It thrilled me.'

By 1969, the Rolling Stones were just about broke, thanks to the embezzlement of their manager, Allen Klein. Bassist Bill Wyman was writing bouncing cheques. Keith Richards was struggling to come up with the

down payment for a house in Chelsea. Embarking on an American tour for the first time in three years, they found a country transformed by the peace and free-love movements. When journalists grilled them about the hefty price of their tickets, Jagger decided, with just a few weeks to go before the end of their tour, to pursue an idea first thrown up during a late-night hashish session involving Richards and Grateful Dead manager Rock Scully: a free concert along the lines of Woodstock, which had happened four months earlier. The date of 6 December was decided upon. Unable to secure a venue, Jagger nonetheless announced the concert to the press on 27 November, with less than two weeks to go, intent on providing a 'microcosmic society which sets an example to the rest of America', where everyone could 'get together and talk to each other and sleep with each other'.

Jagger met with Oscar-winning cinematographer Haskell Wexler, whose *vérité* movie, *Medium Cool* (1969), had just opened, but Wexler

Mick Jagger performing at Altamont in 1969. 'Who's fighting and what for? Why are we fighting? Why are we fighting? We don't want to fight. Come on!'

found Jagger's plans alarmingly nebulous and suggested instead docu-
mentary film-makers Albert and David Maysles, who had followed
the *vérité* revolution of *Primary* with the first non-fiction feature film
released into cinemas, *Salesman* (1969), about travelling Bible sales-
men. Their film for the Stones begins in the cluttered, Victorian-style
office of lawyer Melvin Belli – the self-styled 'king of torts', who had
represented Lee Harvey Oswald's killer, Jack Ruby – as he attempts to
finagle a venue for the band with just thirty-six hours to go. Wearing
horn-rimmed spectacles and cowboy boots, a gold watch chain tucked
into his bulging waistcoat, he finally secures, amid a flurry of affidavits,
the Altamont Speedway, a desolate eighty-acre plot of scrubland on the
edge of southern Alameda County with an auto racetrack, littered with
wrecked cars and abandoned tyres, carved into its central plateau. An
aerial shot from the Stones' helicopter reveals a scene out of Jean-Luc
Godard's *Weekend* (1967): cars jamming the highway six to eight miles
from the site, unable to move. The hastily erected stage area, just four
foot high and easily climbed, was more like something out of Federico
Fellini's *Satyricon* (1969), with members of the audience held back by a
piece of string and the presence of the Hells Angels, whom Scully had
recommended the Stones use for security. Clearing a path through the
crowd for the band with their bikes, the Angels then park their precious
choppers at the front of the stage – a flashpoint for the coming con-
flagration. 'They put up a barrier of their Harleys and defied people to
touch them,' wrote Richards later.

The band get only a few bars into 'Sympathy for the Devil', Jagger
twirling his demonic orange and black satin cape, before the first erup-
tion of violence, the Angels storming over the lip of the stage and into
the fray, starkly visible in the unforgiving backlight. 'Hey, people,' pleads
Jagger. 'Sisters, sisters and brothers, brothers and sisters. Come on now.
That means everybody, just cool it. Will you cool out, everybody?' To
open up a little dancing room for himself, he asks the Angels to step
back a few paces – there must be a hundred people on the stage – and
the song starts up again. A speaker topples over. A dog ambles across the
stage. A naked woman tries to climb on. Then Jagger glances down to

the ground and sees another beating taking place a few yards away. An audience member just shakes his head at him, miming the words 'It's no good, man.' Jagger twirls away and tries to get lost in Richards's solo. At the front of the stage a woman nods along, her face wet with tears, and by the time the song ends, there is no applause, just the sound of commotion. Another body goes down.

'Uh, people – I mean, who's fighting? What for?' demands Jagger.

Richards angrily points out one of the Angels. 'Look, that guy there!' he says. 'If he doesn't stop it, man . . . Either those cats cool it, man, or we don't play.'

Someone in the audience calls for a doctor. A bike goes over. One of the Angels then commandeers a microphone – the Stones have completely lost control of the stage now – and after more vaguely worded entreaties from Jagger, the band launch into 'Under My Thumb'. On the far side of the stage, the Maysles' camera catches a bearded guy in a paisley shirt who is clearly in the throes of a bad acid trip, his face contorting, his fists clenching and unclenching – he looks like he's turning into a werewolf. Then Jagger halts again, his gaze drawn by another scuffle, this one involving a black guy in a green suit, apparently wielding a pistol, who is swiftly taken down by a scrum of Angels and hauled out of sight. The killing happens so fast that at first nobody – not the Stones, nor the Maysles – realises what has happened. It is only later, in the editing room, after the film's editor suggests the Maysles show the band what they have filmed, that Jagger sees it.

'There's the angle right there with the knife,' says David Maysles, freezing the film on the arm of the Hells Angel, a knife in his hand, as it swings down on Hunter.

'Where's the gun?'

The tape is rewound. 'If I roll it back, you'll see it against the girl's crocheted dress,' says Maysles.

'There, isn't it?' says Jagger, finally seeing the gun in the man's hand. 'It's so horrible,' he says, the camera staying on his face as he watches.

We could be watching the sixties coming to an end – a slow-motion cataclysm unfolding with awful predictability thanks to a toxic mixture

of hippie business practice, white-male aggression and bad LSD. Jagger's helplessness and horror as the world disintegrates around him anticipates that of Greengrass's own protagonists, caught between the forces of order and chaos, as well as echoing the contours of the director's turbulent upbringing, feeling his parents' rows brewing and helpless to do anything about them, until things exploded into violence and rage. That sense of gathering storm and ambient terror would be one he distilled in movie after movie.

'Being raised in a violent household left me with a highly developed sense of dread,' he says. 'The brewing of violence, and then its suddenness, because violence is never prolonged, it's always discharged quickly and anarchically because it's connected to loss of control. I don't think it's any coincidence that *The Magic Flute* is my favourite opera. The story speaks to me at some very deep level, because it's the story of a boy who has to find his way through the warring between Sarastro and the Queen of the Night, and he never knows who is wrong and who is right. And, of course, it turns on its axis and turns again. So, yeah, I think that's left its mark on me, unquestionably. I have an ability to live with quite a lot of subterranean stress and tension and still function. So the shock of it, and then also how do you make sense of that? An uncertain family history leaves you with a great desire to find out what *really* happened, to penetrate behind the fronds of what you're told or what you think you know into what something *really* was. And I think that is at the heart of me.'

2: CONSPIRACY

'By the time I left school. I was always going to America,' says Greengrass. 'Where did all the rock bands go? They went to America.'

In the spring of 1974, towards the end of his year off between school and university, Greengrass paid his first visit to New York. Arriving on a Freddie Laker flight, he stayed first with the father of a school friend, the theatre director Carmen Capalbo, a legendary theatre director whose revival of Bertolt Brecht's *The Threepenny Opera* in the 1950s became one of the biggest hits in off-Broadway history; Greengrass would see his Rolls-Royce from the art-room windows at Sevenoaks. Capalbo's apartment was on East 11th Street, just off Fifth Avenue: a beautiful, high-ceilinged brownstone with wall-to-wall bookcases and a hallway lined with signed photographs of actresses, including Jane Fonda ('To Carmen, love from Jane. XXX') and Lotte Lenya, with whom Capalbo had worked on a production of *Threepenny Opera*. Books and records were everywhere: Crosby, Stills, Nash & Young, Joan Baez, Santana, the Velvet Underground and Bob Dylan.

'Well, of course, that automatically said to me, "Fuck me, he's cool,"' remembers Greengrass. 'Carmen's life seemed so glamorous. He was a war hero who'd been badly wounded at the Battle of the Bulge, with a

piece of shrapnel that once came out of his arse on Park Avenue in 1958. "Stop mumbling," he'd say to me in this deep, rich, modulated American voice. "Don't just take pictures, read some books. Have a point of view. Don't just stay in New York, travel. The world's right there.'"

They soon settled into a routine. Arising before his host, Greengrass would go and get the paper from the corner store, and by the time he got back, Capalbo would be up, making coffee. They would read the paper together – Sy Hersh in the *New York Times*, Woodward and Bernstein in the *Washington Post* – and then Greengrass would walk around the Village, checking out all the bootleg albums and conspiracy-theory pamphleteers tying up the assassinations of JFK, MLK and RFK with one big military–industrial-complex ribbon. He would visit the new galleries in Soho, before heading up to the Met and the Guggenheim, all the while taking photographs, walking, dreaming. It was the summer of garbage strikes, the black bags piled over the fire hydrants, which everyone seemed to agree not to notice. There were pimp-mobiles in Times Square, and downtown they had begun construction on the World Trade Center, cranes and work elevators skirting an unfinished skeleton that reached up into the morning haze.

Returning to Capalbo's apartment in the afternoon, he'd catch the rest of the Watergate hearings before the House Judiciary Committee, which played from gavel to gavel, every day, on TV. They'd watch until six or seven o'clock, then they'd get pizza from round the corner, or maybe they'd go to Elaine's restaurant, where Capalbo had a table and everyone talked non-stop about Watergate and Nixon, followed by games of poker played long into the night. Capalbo was the first phone addict Greengrass had ever come across, talking to friends and colleagues non-stop until 3 a.m., his life a seemingly endless round of people, plays, poker, Watergate, coffee and cigarettes. Greengrass was almost lost in his absorption of the man. 'It was just intoxicating,' he says. He recalls Capalbo telling him how, after a long day at rehearsals, he used to just shovel candy into his mouth, having been working so hard he'd forgotten to eat. 'It was the idea of having a calling, I suppose, and doing something that was so overwhelming that you just got lost in it. It was the

artistic life, so far as I could see. He encouraged me to believe that I could pursue it too, that something like that might be possible for me. If you're a lost boy, that's what you're looking for.'

After staying a few weeks with Capalbo in New York, Greengrass travelled up and down the east coast – Boston, Lexington, Concord, Walden's Pond, down to Washington, Virginia, Gettysburg and the battlefields of the Civil War – then visiting the Deep South – Savannah, Georgia, the Carolinas, Florida and the Keys – before heading back to New York, where he was joined by his then girlfriend, Helen Miller, whom he had met the year before at the Woodhouse pub in Dulwich, during his final term at Sevenoaks. She was training to be a teacher in Hertford and had been offered a placement at St Cloud College in Minnesota during her second year. The idea was they would cross the US together and then Greyhound bus it back to Minnesota for the start of term. After heading west, they rented an apartment in San Francisco with a beautiful view of the Berkeley Hills, just a few hundred yards from where Patty Hearst was kidnapped a few months before. Posters with 'We Love You Tania' over a picture of Hearst toting a machine gun decorated the bulletin boards at the University of California at Berkeley, where Greengrass would hang out during the day on lawns kept green by the sprinklers, pretending to be a student for a few weeks and digging into Kennedy assassination tomes in the library or the Shakespeare and Co. book shop. Even during the summer break, the university plaza teemed with corduroy, denim, bare legs, blonde hair, hornrims, bicycle spokes in the sun, book bags, swaying card tables, posters and students in nose-to-nose dialogue. He became a complete 'Watergate nerd', absorbing all the details that spilled from the hearings on TV almost as if they were a drug. 'It's crucial to try and grasp how little was known about how power truly worked, about our secret history in the US and UK prior to Watergate. Watergate was like a lightning storm that flashed repeatedly for nearly two years, illuminating that hidden landscape with startling clarity, followed by the Church Committee hearings after that, and the Rockefeller Commission after that. All this information came tumbling out. It was all just intoxicating to me.'

Greengrass in Washington, DC, in 1974.

Greengrass was driving up Highway One, the Californian coastal road, when Nixon finally resigned. A friend from Dulwich, Andrew Wileman, had joined them in San Francisco, and together with an American friend of his, a witty ex-serviceman who was working in a bar while preparing for law school at Berkeley, the four of them had headed down to Los Angeles in his friend's car. They were on the way back to San Francisco, smoking joints and trying to perfect Smith's numerical system for working out who was higher, on a scale of one to ten – 'I think I'm about 7.2'; 'Definitely I'm an 8.5' – when the news came on the radio. The cars in front and behind them suddenly swerved to the roadside. People sat out in the late-afternoon, stunned, sharing beers. 'Everybody celebrating that Nixon had gone, because he was the sort of anti-Christ. He was the Trump figure of the day, because he led the anti-communist crusade in the '50s. He was Tricky Dicky, the liar.'

They got back to San Francisco that night and watched the coverage until six in the morning, hearing Nixon's resignation speech, in which he

tried to grab at one last fig leaf of rectitude ('I have never been a quitter. To leave office before my term is completed is abhorrent to every instinct in my body'), and watching his final wave as he made his way to the helicopter on the White House lawn, his fingers shaping a sad pair of 'V's.

Greengrass's trip had been paid for by Leica, after he wrote letters to all the big camera companies, asking for sponsorship for his photographic project about the relationship between the abstract expressionists and the American landscape – 'to draw out the links between physical landscape and the paintings', as he put it in his proposal. Leica had coughed up a new Leica CL camera, with which he continued to take photographs that summer, as he and Miller hitch-hiked their way back east through the Dakotas towards Minnesota, where Miller was due to start college. By the end of the trip, Greengrass had amassed hundreds of photographs of the American landscape, from Robert Rauschenberg's New York and Jasper Johns's South Carolina to Mark Rothko's Portland and Jackson Pollock's Southern California. He was fascinated by the way Rauschenberg and Johns, both children of Eisenhower, incorporated the flags, targets, maps, numbers and cyphers of the Cold War into their work. Even Pollock's paintings, with their thick tangles and dense, looping arabesques of paint, struck him as resembling 'giant, encrypted messages', not unlike the documents, spidery with redactions, that were beginning to trickle out in the wake of the Watergate crisis through the Freedom of Information Act – American signal and noise, all mixed up, waiting to be disentangled and decrypted. He returned to England on 8 September, the day a news ticker in Times Square announced that President Ford had issued Nixon a pardon, and in the same week that screenwriter William Goldman sent Robert Redford his first draft of the screenplay for *All the President's Men*.

Written at the glamorous intersection of Washington and Hollywood, with Redford's input helping shape its characters and plot, Woodward and Bernstein's book *All the President's Men* was not, strictly speaking,

turned into a movie idea – it already *was* one. The Watergate investigation was still ongoing when Redford first called Woodward and Bernstein in November 1972. The story was about to burst wide open with the news that the plans and budget for the Watergate burglary had been approved by Nixon's attorney general John Mitchell, and the two reporters were certain they were under surveillance. They did not return Redford's call, so he tried again in April 1973, telling Woodward, 'I'd like to talk to you about the work you've done.' A meeting was convened in Jack Valenti's office at the Motion Picture Association of America, where a Democratic fundraiser was being held, with a buffet dinner and a screening of Redford's film, *The Candidate* (1972). The release of *The Way We Were*, *The Sting* and *The Great Gatsby* within just six months over the winter and spring of 1973–4 had made Redford the world's biggest box-office star, and he had recently campaigned for Democratic Congressional candidate Wayne Owens in Utah. He turned up for the meeting looking 'something like a cowboy', recalled Woodward, who felt stiff and uncomfortable.

'Look, I'm interested in doing a film about your partner and yourself,' said Redford, according to Jack Hirschberg's *A Portrait of* All the President's Men. 'The contrasts are intriguing. Looks like a couple of good characters, a fascinating relationship. And I'm very concerned with the canvas, the newspaper business. I don't know much about it. If done correctly, I think it could be engrossing for an audience.'

'Look, we're writing a book,' replied Woodward, who told him they already had a book deal with Simon & Schuster, but he seemed secretive to Redford, hugging the corners of the room as if trying not to be seen, parcelling out little morsels of information, but no more than was strictly necessary. 'Maybe you should see the book when we're done. It's about Gordon Liddy, Howard Hunt and John Mitchell – what these three and some others did in connection with Watergate and the concealment.'

Redford disagreed and said he wasn't interested in the book. He thought it should be the story of the two reporters. He saw it as an odd-couple buddy movie, like *The Sting* and *Butch Cassidy and the Sundance Kid* (1969). He wanted William Goldman to write it. When Carl Bernstein heard of Redford's proposal, he was flabbergasted. 'When we sat down to

write a book, the book that we started to write was not about us; it was about Watergate,' he said. 'Woodward came up to me one day and said he'd gotten a call from Redford, and I said, "What the hell about?" And he said, "Well, he thinks the story is really *us*."' Bernstein was vehemently opposed. 'I thought nobody was interested. And did not see how we could keep it from looking like an ego trip.'

The two journalists were still unpersuaded, but as they began writing their book, trading drafts back and forth, they found that Redford had been right: that the only way through the morass of material – the burglary, the cover-up, the use of the FBI, IRS and CIA to harass Nixon's list of enemies – was to anchor it through the tick-tock storyline of two reporters. 'The material was so totally complicated and bizarre it needed a storyline, and the reporters could give it that storyline,' recalled Woodward in a 2006 documentary. 'Carl and I were pursuing the book our way, but we'd been influenced by Redford in the way we compiled it. It was he who suggested we make it about the investigation, and not about the dirty tricks campaign. He had his movie ideas. We had our book to be getting on with, but the two ran side by side.' Note that Woodward said 'the reporters', referring to himself and Bernstein in the third person, already beginning the process of fictionalising fact, casting themselves as characters in their own book so that it would read like a thriller ('Woodward walked the final stretch and arrived at the garage at 1.30 a.m. Deep Throat was already there, smoking a cigarette . . .'). Redford kept close tabs on the investigation, but Woodward and Bernstein kept equally close tabs on the fate of Redford's movie. 'Bernstein drove me nuts with almost daily calls to find out how the deal was coming along,' said Redford.

During his final year at Cambridge, Greengrass was part of an audience of student journalists invited by Redford to a BAFTA screening of *All the President's Men*. Afterwards, the actor took questions for several hours. 'I'm sure it was a very mundane encounter for him, but it was very important to me. Redford was about the biggest movie star in the world at that point. I remember him saying, "Go out and hold power to account. This is about the abuse of power and a free press, and you guys have got to go out there and make a difference." He didn't come across

like a movie star. He came across more like an actor crossed with an activist like Tom Hayden. He wasn't saying, "Go out and make movies." He was saying, "Go and be Woodward and Bernsteins." But it was the same thing to me. It was a call to arms. "Play your part, be active." And that absolutely spoke to me, profoundly. I was already heading that way – it was the same call to arms I'd heard from Carmen, "Go and do" – but it was one of those moments when you felt the world was moving your way, and that where you were instinctively looking was the right way to go. There was a big world out there, and I wanted to be part of it. Later, of course, *Bloody Sunday* won the award at Sundance, and that really changed things for me in a big way and opened the door for me to do larger movies. So I have a lot to thank Redford for.'

A few years after he had graduated from Cambridge and started work on *World in Action*, Greengrass met Woodward in Washington, while shooting a film about the confirmation hearings for Alexander Haig, Ronald Reagan's proposed secretary of state, the one-time chief of staff for Nixon who had been the one to convince him to resign. 'Haig was thought to be the keeper of the secrets,' he says. 'He knew everything about Watergate, everything about Allende, the assassinations, the coups.' Greengrass called up Woodward and met him at his office at the *Washington Post*, at the paper's old address at 15th and L Streets, with its mammoth underground presses and linotype machines, and its famous newsroom with its overhead fluorescents, 250 desks, 300 phones, teletype machines and perimeter of glass-walled offices for the senior staff. Greengrass was impressed by the speed with which Woodward had his phone calls returned by senators leaving the hearings.

'It seemed like [it was] the first thing they did,' he says. 'That was the first time I'd ever worked in Washington, and my first professional exposure to the reality of investigative journalism in America. Suddenly, I wasn't pressing my face against the glass. I was actually working there, actually meeting some of the principals in a drama I had been thrilled by as a student. It was a moment of great discovery for me going there, because you could simply phone up people – ex-CIA, whatever – they'd all answer their phone and they'd all see you, and you could talk about

Pages from the CIA's 'Family Jewels' file, the 693 pages of memos outlining the agency's biggest skeletons, drawn up in 1973 by its then director, James Schlesinger, to launder the agency's conscience after Watergate, complete with White House memcons on damage control. When the file was declassified in 2007, Greengrass distributed it to Matt Damon, David Strathairn and other members of the *Bourne Ultimatum* cast.

TOP SECRET

MR 00-29, # 125

ROCKEFELLER COMMISSION:
David Belin Assassination Study

SUMMARY OF FACTS
INVESTIGATION OF CIA INVOLVEMENT IN PLANS TO
ASSASSINATE FOREIGN LEADERS

June 5, 1975

Table of Contents

anything. Nothing was off limits. It was just unfathomably exciting to me. I think the key, for me, is that what Woodward and Bernstein gave us, my generation, was the idea of conspiracy. They created a conspiratorial mindset. They showed us granularly that they truly existed and gave us a language and a way to talk about them and a character: the modern muckraker. They became icons of their profession. They gave us a cult, really. Thousands of young journalists rushed to follow in their footsteps, including me. That book was like a thunderclap. I thought that it was one of the most exciting books I'd ever read, and I still think it's the single best piece of journalism since Ida Tarbell's *History of the Standard Oil Company*, and the best book of all time about what doing journalism feels like – a stunning book of immense consequence to me.'

Woodward introduced Greengrass to Scott Armstrong, a staff member on the Senate Watergate committee who later set up the National Security

Attachment A

"FAMILY JEWELS"

1.

2. Johnny Roselli -- The use
 Mafia in an attempt to

3. Project MOCKINGBIRD -- Dur
 March 1963 to 15 June
 installed telephone ta
 based newsmen who were
 classified information
 of governmental and co

I suggest we let the whole thing drop

Archive, a library of declassified US documents based at George Washington University, which soon became a haven for journalists and scholars eager to devour files on subjects related to national security and foreign policy – a kind of WikiLeaks before there was WikiLeaks. It soon grew into a global secrecy watchdog, filing over 32,000 FOIA and declassification requests and obtaining the release of seven million pages of once-secret documents, including the first official CIA confirmation of Area 51; US plans for a 'full nuclear response' in the event of the president ever being attacked or abducted; FBI transcripts of twenty-five interviews with Saddam Hussein after his capture by US troops in December 2003; and the so-called 'Family Jewels', the 693 pages of memos containing the CIA's biggest skeletons, drawn up in 1973 to launder the agency's conscience during Watergate. The Family Jewels would eventually be declassified, after many decades of secrecy, on 25 June 2007. At the time, Greengrass was shooting *The Bourne Ultimatum* in London. He had printed out a five-inch-thick document that he kept in his trailer and showed to his cast, including Matt Damon and David Strathairn, so they could read about the 1960 plan to poison Congolese leader Patrice Lumumba, the model for the exiled African dictator Wombosi in *The Bourne Identity*; the operation, known as the ZR/RIFLE project, to take 'executive action' and assassinate Fidel Castro using mobsters recruited by gun-toting CIA operations officer Bill Harvey, the model for Brian Cox's Abbott Ward in *The Bourne Supremacy*; and the

training of foreign police in the making of bombs, as ordered in 1973 by James Angleton, the CIA counter-intelligence chief who was the model for Strathairn's Noah Vosen in *The Bourne Ultimatum*.

'It was a journey I was on to understand that world very early on, from that first trip to Washington, really,' says Greengrass. 'The full story of the CIA assassination plots was mostly known by then, but it was extraordinary – still is now – to see the actual documents. The National Security Archive had the genius idea of using the Freedom of Information Act to tell, essentially, the secret history of America through its declassified documents. That made absolute sense to me. I completely got it. The contours of the secret history of America, essentially, but the West, really, were starting to be sketched.'

<hr>

Greengrass can remember returning to London from that first Washington trip and thinking, 'The *ancien régime* has got to change.' Two stories of his, in particular, were to achieve a resonance way beyond his time at *World in Action*. In both cases they grew from Greengrass's attachment to a source that went beyond the transactional nature of television journalism, developed into a kind of friendship and closely resembled the deep dive of a dramatist encircling his subject. The first involved an assignment to cover the hunger strikes at the Maze, the British government's high-security prison at Long Kesh, near Belfast. In 1981, ten IRA members in a section of the jail known as the H-Blocks demanded to be classified as political rather than criminal offenders, and thus be accorded a number of rights and living conditions that were being denied them. The British government refused to grant such status, so the prisoners intensified their protests, refusing to obey any prison regulations or wear prison clothes, wrapping themselves only in the blankets they were provided with as bedding, later escalating to smearing the walls with their own excrement, and finally began to starve themselves to death. After travelling to Derry to investigate the story, Greengrass established communication with one of the leading prisoners on hunger strike, Raymond McCartney, who

was serving twenty years for the murder of a local British industrialist, Jeffrey Agate, and a senior member of Derry's then (among Catholics) widely hated RUC Special Branch (though his charges were eventually quashed on the grounds that he had been coerced during his interrogation). Greengrass spent several weeks investigating the story, exploring Derry, interviewing those who knew McCartney best – his family, his friends, his victims, his enemies – and trying to understand what had led him to join the Provos, all the while communicating with McCartney surreptitiously via messages written on cigarette papers and smuggled out of the prison.

'They had to be careful, of course, because they were searched,' remembers Greengrass. 'He used to write them on cigarette papers and then wrap them in plastic, conceal them, and then pass them to an intermediary, who would bring them out to me. I would give questions to the intermediary for him to answer: "Tell me about when you joined the Provos"; "What attracted you to this?" So we were having this exchange through an intermediary, as he was on hunger strike. It was a strange relationship, because it was entirely distant, but oddly intimate, because the guy was starving himself to death.'

The cigarette-paper missives were detailed, personal. Greengrass worked out that he and McCartney were roughly the same age, had seen the same football matches, listened to the same music, discovered girls at the same time, and yet McCartney's life had veered towards a deep political commitment that embraced violence and armed struggle. Why?

Approaching day forty of the protest, with McCartney very near death, the Northern Ireland Office finally agreed to allow Greengrass to film McCartney for five minutes inside his cell in H-Block 3, the hospital wing of the Maze, where the hunger strikers were being kept in isolation. This was the first time cameras had ever been allowed inside the H-Blocks, filming prisoners huddled in blankets inside cells smeared with their own shit. Greengrass had to walk through the Provo and the Loyalist wings. 'The noise was unbelievable – shouting and banging – because they knew someone was in there from the outside. And the tension, because

of course at the time what the IRA were doing was shooting the prison officers. They'd come home, and the Provos would come – *bang* – and kill them as they left for work. I mean, terrible. A lot of them, not just one or two. I remember the governor or deputy governor of the Maze was killed round about that time. It was a high-risk occupation. The Provos went out of their way to find out who the prison officers were, and you know, inside the prison it would be, '*I fucking know who you are. We'll fucking pop you . . .*' Intimate, and you felt it, the rage and the hatred and the danger and the superficial normality, intermingled with this utter surrealism.'

Finally, they emerged in the hospital waiting room, and suddenly it was absolutely quiet. 'I'll always remember that door opening, and McCartney was lying there. They used to leave bread and water at the end of the day. You're on a hunger strike, but the food is always three feet away from you. Their argument would have been, "We wanted to make sure they could get food immediately if they decided they needed it," but what it meant was, you've got to look at the food every hour and decide not to. It suggested deep reserves of rage, commitment, dedication. That's what that told me.'

Greengrass working for Granada TV's sports department (1977).

They were allowed one question. Greengrass and his producer, Simon Berthon, had sweated over it the night before and decided on: 'You and your colleagues have been convicted of murder and bombings. Why should you have any special treatment?' McCartney answered articulately and surprisingly clearly, given his physical condition, and the programme, entitled 'The H-Block Fuse', went out on 24 November 1980. Mrs Thatcher claimed it provided the IRA with the oxygen of publicity and gave succour to the enemies of democracy. Protestant paramilitaries warned Greengrass to get out of Belfast. Painted murals depicting

McCartney as he had been glimpsed in the programme, with matted hair and beard, appeared in every Catholic community.

A day or two after the film went out, Greengrass was in the office – a rarity for him – when the phone rang. It was the artist Richard Hamilton, whose painting of blurry newsreel from the Vietnam protest at Kent State had so opened his eyes at Sevenoaks.

'I wondered if I could have a piece of your film from last night?'

'A piece of it?'

'Yes, a piece of the actual film. Of the guys in the cells with the shit smeared on the walls. I want to make a painting . . .'

Greengrass went down to the cutting room, snipped twelve frames and put them in an envelope, thinking how surreal it was that Hamilton, whom he had admired all these years, whose paintings he had studied and copied, wanted some crappy snippet from a film of his. The resulting painting, *The Citizen*, depicting a republican blanketman at the Maze, inspired by the film, a crucifix around his neck and a rosary in his hand to confirm the figure's air of almost monastic austerity, formed part of a triptych that included *The Subject, 1988–90*, which showed a parading Loyalist Orangeman, and *The State, 1993*, a depiction of a British soldier on patrol in Northern Ireland. 'In my view, they are one of the greatest statements about the Troubles ever made in any medium, literary or visual,' says Greengrass. 'I can see in them everything that also inspires me about the creative process, how you can take what you see, what's happening out there in the world, and expose it to your inner influences and techniques, and render it as something else – a statement about the world that you see, but also about yourself.'

Hunger striker Raymond McCartney as he appears in 'The H-Block Fuse', *World in Action* (1980).

Greengrass's feature-length contribution to our understanding of the Troubles was to

come over a decade later, but an early fragment of its genesis was to be found in one of the first cigarette papers on which McCartney had scribbled out his answers to Greengrass's questions. Asked what had made him join the armed struggle, McCartney had replied, 'It all began for me on Bloody Sunday,' referencing the protest march in Derry in 1972 that descended into chaos when British paratroopers opened fire on marchers, killing thirteen and wounding fourteen more. An inquiry chaired by Lord Chief Justice Widgery quickly concluded that the army had been fired upon by the IRA as they entered the Bogside and that several of the dead had been involved in handling weapons. It was quickly condemned as a whitewash, but not even Lord Widgery had quite known what to do with the account of Soldier H, who claimed to have seen a gunman firing from the window of a flat on the south side of the Glenfada courtyard. The soldier said he fired one aimed shot at the man, who withdrew but bobbed up again a few seconds later. H fired again. According to his account, the gunman bobbed up another eighteen times, and he duly put eighteen shots through the window. On the nineteenth, the gunman was 'seen to fall'.

No bullet holes were found in the window through which H said he had fired, while a number of civilians had been shot trying to flee the British gunfire. Sheltering in the doorway of 7 Abbey Park was John William Porter, a quartermaster sergeant in the Irish army, who saw a man fall to the ground in the Glenfada estate after several people had come through the alley. 'He started to lift his head up off the park and as he did so I saw his jacket jump up in the air, twice, four or five inches. At the same instance I realised that this man had been hit twice in the small of the back.'

It was James Wray, McCartney's cousin. He was, like every other victim that day, unarmed. He was soaked with the purple dye from the water cannon that had been fired at him when he sat down in front of the stone-throwers at Barrier 14 in William Street. Years later, when Greengrass looked at the news footage of Bloody Sunday, there was a big hole in the coverage. The broadcasters had plenty of film of the march itself and the British paras going through Barrier 14 after the rioting

started. Then there was a gap, before the footage picked up again after the thirteen people had been shot dead and others wounded. 'What happened was that when the rioting started, they sprayed the rioters with water cannons, hitting the news crews,' he explains. 'As the paras went through the barrier, the news crews were cleaning their cameras. So there's a missing hole in the coverage of about twelve to fifteen minutes when the shootings took place. What would those cameras have seen?'

Years later, Greengrass would answer that question by making an entire film.

The second story involved spies. In March 1981, British Prime Minister Margaret Thatcher announced an inquiry into the defences of the security and intelligence departments against penetration by spies, the first independent investigation into this issue for twenty years. A book, *Their Trade Is Treachery*, by Chapman Pincher, about the penetration of MI5 after the war by Soviet double agents, had forced her to admit the deeply embarrassing fact that both the director general of MI5 and his deputy had been investigated as the so-called 'Fifth Man' – a 'super-mole' whom some believed to be buried deep within the British secret service. Pincher's book amounted to a staggering leak for a service that in 1981 wasn't even officially said to exist.

Pincher's book appeared in the middle of a journalistic feeding frenzy around Britain's not-so-secret services. In the wake of Watergate, teams of ambitious young hacks at the *Sunday Times*, *Observer*, *World in Action* and *New Statesman* had set about hunting for leads that would pull MI5 and MI6 out of the shadows, just as Woodward and Bernstein had done with the CIA. In spite of the Freedom of Information Act, the default position of Anglo-British governance remained that all official information is secret until officialdom decides otherwise. The lobby system smoothly controlled and shaped the outflow of official information to the public. Prime ministers could safely confide secret information – often related to intelligence – to senior peers, judges and members of opposition parties

on the Privy Council without fear of it going any further. If secrets are like sex, then the glimpses of the Fifth Man fed to Pincher were 'a form of journalistic porn', says Greengrass, 'big business for circulation and ratings, and reflecting the collapse of deference when it came to intelligence matters in the early 1980s. Suddenly, *bang*, Pincher comes out with the greatest scoop of all.'

After a little digging, Greengrass worked out that the most likely source for the book was a retired MI5 officer named Peter Wright, who had left the service in 1972 and emigrated to run his own stud farm, Duloe Arabians, in a remote town in Tasmania. It was a long way to go for a story that might turn out to be nothing, but Greengrass persuaded Ray Fitzwalter to send him, and in April, he caught a twenty-one-hour flight to Hobart and then drove for three hours through the Tasmanian apple groves to the tiny one-horse town of Cygnet. You couldn't have picked a spot further, geographically, from England. A telephone box stood on the corner of the dusty, narrow lane to Wright's farm. It was dusk by the time he called and introduced himself.

'Where are you?' asked Wright, warily.

'At the end of your road.'

There was a long pause.

'You'd better come along.'

The bottom had clearly dropped out of the market for Arabian horses. The farm was about 30 acres, but the fences were falling down, and the horses were fed but not broken in. Wright's house, which he shared with his wife Lois, looked like a bushman's shack: one small bedroom with barely enough room for a double bed, a living room-cum-kitchen and a tiny room where his books and papers were. There were just a few bits of furniture and a couple of threadbare old chairs. Messy didn't even begin to describe it. Though he and Lois looked like a couple of farmers, Wright turned out to be one of those characters that only England could produce. With his bald pate and its crown of wispy white hair, and a severe speech defect somewhere between a lisp and a stammer, he was tall, frail, with flashes of the ferocity that had driven his lectures on the pre-World War II Comintern apparat in the UK or his interrogation of

Anthony Blunt and his communist friends. But he was clearly carrying an immense burden, with a streak of romantic patriotism that was borne out by the sign above his desk, written in Wright's own hand, which read: 'I love my country, therefore I die in exile.'

He asked Greengrass if he wanted a sherry, and they sat down to talk – of his time at MI5, the molehunts that followed the defections of Burgess, McLean and Philby, the 'ring of five' and a so-called 'super-mole', and how his own efforts to unmask them had led to him being ostracised within the service, his pension hobbled, forcing him to up sticks and move to Australia. Greengrass could see immediately that Wright had a drink problem and a grudge a mile wide. But he had an encyclopaedic memory and a willingness to talk openly that made him compelling company. He was like a casualty, the walking wounded of the Cold War. 'A very emotional man,' Greengrass recalls. 'A functioning alcoholic, more or less, with great vulnerability. He was a certain kind of English malcontent and dissident that undoubtedly echoed my father. Not that I ever felt like Peter Wright's son, that would be ridiculous, but Peter had this deep sense of being locked out of Britain, and that there was an establishment that looked after its own. And he was an autodidact, as my father was, filled with all sorts of arcane knowledge. You'd go for a walk with him out in the fields, and he'd point at a butterfly – "Oh, that's a red lacewing . . ." My overriding sense of him was of a man carrying a massive burden which he needed to lay down.'

Greengrass spent a week trying to persuade Wright to step in front of the cameras – to be free of his burdens, get it all out into the open – but in the end, he wouldn't do it. He was too frightened that the British government would take away what remained of his pension. But Greengrass stayed in touch and two years later finally persuaded Wright to be filmed. It was the first time an MI5 officer, let alone one as high-ranking as Wright, had ever gone on camera. The film, entitled 'The Spy Who Never Was', aired in the summer of 1984 and detailed Wright's part in the molehunts, which at one point even investigating the head of MI5 himself, Roger Hollis. 'I always thought that the molehunters' case had to be brought into the open,' says Greengrass. 'That was the prize, landing one of these

strange deep-sea fish that had never been seen, because they're right down at the bottom, never see daylight. I felt I'd brought one of those up to the surface and landed it.'

When a literary agent approached him a few days after the programme to see if he'd be interested in writing a book about, or with, Wright, Greengrass was at first reluctant – 'I felt I'd done the job that I wanted to do in the programme' – but the more he thought about it, the more appealing it seemed. Wright's background was fascinating: his house full of radios as a kid; his father's work for Marconi and the British Admiralty; coming up with a radar that could detect a U-boat periscope amid rolling waves; passing the scientific civil-service exams with very little education; designing a microphone, codenamed SATYR, that enabled the British and American governments to pick up conversations via an umbrella-shaped receiver dish; his encryption breakthrough, codenamed ENGULF, that allowed British intelligence to intercept and crack Egyptian cyphers during the Suez crisis. He had clearly been a brilliant, Barnes Wallis-style boffin, all elastic bands and paper clips in a back room somewhere.

'To me, the book was going to be a little bit like the lost art of black-smithing,' says Greengrass. 'It was going to be a well-realised account of an intelligence professional and tell the story of how this ambitious, young, damaged, eccentric and highly talented Englishman had first risen to the top and then become *persona non grata*. It was a rise and fall. I used to think of him as the "Tick Tock Man", who had gathered all these secrets and who one day was going to explode. The only question was, who was he going to explode *onto*?'

Greengrass gave little thought to the idea that Wright might explode onto him.

3: SECRECY

In 1946, Meredith Gardner, a linguistics professor working for the code-breaking facility at the Signal Security Agency, the forerunner of today's NSA, found on his desk the charred remains of a Russian code book with a bullet-hole through it. It had been rescued from the burning cypher room of the Russian consulate in the harbour town in Petsamo by a Finnish intelligence officer in 1941, after a valiant last stand by the Russians ended with an emergency procedure to destroy all coding materials. Four code books were retrieved from the flames, including a partially burned copy used by the First Chief Directorate of the KGB, the intelligence group that directed overseas agents. The book contained a list of 999 five-digit code groups, each one representing a different letter, word or phrase. A large portion had been destroyed by fire, and what remained seemed of little value, since the Soviets employed a system of super-encipherment, in which random numbers, or 'additives', further enshrouded the meaning. Only someone in possession of both the code book and the additive would know to subtract 05555 from 22611 and arrive at 17056 and the word 'agent'.

A tall, shy intellectual with a fondness for tweed sportscoats and button-down Oxford shirts, Gardner had started working for the SSA

after Pearl Harbor, at Arlington Hall in Virginia, where an important breakthrough had been made. To send a message, the Russians used a code pad on which to distribute the latest additives to its embassies. As long as every sheet of numbers was used only once and then destroyed, the code was unbreakable, but in the winter of 1941, as German tanks advanced on the Kremlin, harried cypher clerks decided that with the motherland imperilled and resources dwindling, it was time to take a small risk, and instead of using a single sheet of carbon to make a single pad, they would use three sheets to make three. As a result, the output of pads was tripled, but since there were now duplicates, the seemingly random sheets of numbers rumbling out of the coding machines no longer represented an unbreakable wall. When the American cryptanalysts discovered that the same series of additives had been used more than once, they had all the leverage they needed to break the Soviet cypher system.

With the compromised pads in one hand and the partially burned Soviet code book in the other, Gardner went to work. 'My hunt for the great White Whale,' he called it. For weeks he stared at intercepted Soviet cables, and eventually he began to see entire blocks of numbers – representing long bodies of text – introduced by the same five digits. At the end of this chunk would be another five-digit group. Could it be 'to' and 'from'? 'Open quote' and 'close quote'? Since only a portion of the code book had been salvaged, many of the 999 five-digit groups used by the Soviets were missing. Whole passages were blank, and the meaning of other phrases could be only vaguely grasped. 'Only about 15% of the equivalences are identified, some only tentatively,' he wrote. 'In its present state the traffic tends to arouse curiosity more than it does to satisfy it.'

According to Howard Blum's 2019 book *In the Enemy's House*, the text looked a little like this:

TEXT OF MESSAGE
YOUR COMMUNICATION OF 74689 AND 02985 47199
67789 88005 62971 CONCERNING SPELL H I C K S
ENDSPELL 55557 81045 10835 68971 71129 EXTREME
CAUTION AT PRESENT TIME 56690 12748 92640 00471

SPELL S T A N L E Y ENDSPELL 37106 728854 MONTHLY
UNTIL FURTHER NOTICE. SIGNATURE OF MESSAGE

At first, no one in Washington paid him much attention, but in 1949, Gardner found a duplicate additive in the New York-to-Moscow channel and was able to decipher the phrase 'Defence does not win wars!' in a Washington-to-Moscow intercept. Ears pricked up: it was the text of a 1945 telegram from Winston Churchill to Harry Truman. The SSA shared the secret code with the British, and the two countries began a joint effort to decipher Soviet communications that would last forty years. The Venona code break, as it became known, was the biggest breakthrough since the cracking of the German Enigma code in World War II. The results remained fragmentary, but by autumn 1949 enough shards had been pieced together to reveal with disconcerting clarity the devastating extent of the Soviet penetration of the West. More than 1,200 cryptonyms littered the traffic, of which more than 800 were most likely Russian agents: fourteen close to the Office of Strategic Services (OSS), five with access to the White House and a chain of agents inside the Manhattan Project with access to the nuclear programme. Who were *Homer, Rest, Kalibre, Hicks, Liberal, Osa* and *Christian name Ethel*?

The British officer assigned in 1949 to work with the FBI in tracking down the Soviet spies referred to in the Venona traffic was Kim Philby. 'We had received some dozen reports referring to the source, who appeared in the documents as HOMER, but little progress had been made in identifying him,' Philby later wrote in his autobiography, *My Silent War*. He knew exactly who Homer and Hicks were: his old friends from Cambridge, Don Maclean and Guy Burgess, all three men having been spying for the Russians since the 1930s. But after someone apparently tipped off Maclean and Burgess that they were about to be uncovered, prompting them to flee to Russia, suspicions finally began to swirl around Philby. He was forced from active duty in Washington and sent to Beirut, where, under a cloud of suspicion, he worked for the *Observer* newspaper, until in 1962, an old acquaintance of his, Flora Solomon, came forward with the story of how, in 1935, Philby had tried

to enlist her help with a 'very dangerous job for peace'. Solomon was persuaded to be interviewed in London about the three-decade-old conversation, and in January 1963, the heads of MI6, Dick White, and MI5, Roger Hollis, thought it time Philby was interrogated again. The MI6 station chief called Philby and told him to come for a routine meeting in a nearby apartment, which was bugged. Philby climbed the stairs to the flat, knocked on the door, and when it was opened by his old friend Nicholas Elliott, seemed strangely unsurprised. According to Ben Macintyre's *A Spy Among Friends*, their conversation went as follows:

'I rather thought it would be you,' Philby said.

They shook hands and swapped pleasantries about their health and families.

'Wonderful tea,' Elliott said.

There was a pause.

'Don't tell me you flew all the way here to see me?' asked Philby.

Elliott took out his Mont Blanc pen, placed it on the table and began to roll it back and forth under his palm. 'Sorry for getting right on with it. Kim, I don't have time to postpone this. And we've known each other for ever, so, if you don't mind, I'll get right to the point . . . Unfortunately, it's not very pleasant.'

Another pause.

'I came to tell you that your past has caught up with you.'

Elliott returned to London in triumph: Philby had confessed to spying for the Russians since 1934. But ten days later, on 23 January, Philby disappeared from Beirut, probably on a Soviet freighter that was conveniently docked there and, it is believed, with the connivance of the Lebanese police. He, too, had defected.

'Many people in the secret world aged the night they heard Philby had confessed,' writes Peter Wright in *Spycatcher*. 'To find that a man like Philby, a man you might like, or drink with, or admire had betrayed everything; to think of the agents and operations wasted: youth and innocence passed away, and the dark ages began.' It was the beginning of that era of febrile paranoia, paralysis and spiritual exhaustion that John le Carré later documented so well in *Tinker Tailor Soldier Spy* (1974), the

book which put the word 'mole' into general usage. 'It's the oldest question of all, George,' Lacon says to Smiley. 'Who can spy on the spies?' As the Cold War wore on, a rash of high-ranking KGB defectors – Volkov, Gouzenko, Golitsyn, Penkovsky, Nosenko – brought with them rumours of a 'ring of five' double agents lurking within British Intelligence, and of a so-called 'super-mole' buried deep within MI5. Not everyone believed the story of Soviet penetration – in fact, there were many who thought it was just that, a story – but among those who did, there were few more fervent believers than MI5's principal scientific officer, Peter Wright.

Wright had been born in 1916 and was of the same generation as Philby. Hired as MI5's first-ever scientific officer in 1954, he led the agency's effort to modernise its eavesdropping and code-breaking efforts. He designed a bugging system called SATYR and a radio receiver detection technique known as RAFTER that enabled MI5's officers, aboard planes flown over London, to scoop up clandestine Russian agents' transmissions to Moscow – 'night after night up in the indigo sky, listening to the signals coming in from Moscow, insulated from the deafening sound of the plane's propellers by headphones', as Wright put it in *Spycatcher*. 'Down below, somewhere amid the endless blinking lights of London, a spy was up in an attic, or out in a car, listening too, I could hear him. But I had no way of knowing where he was, who he was, whether he worked alone or as part of a ring, and, most important of all, what Moscow was telling him. I was caught between knowledge and the unknown, in that special purgatory reserved for counter-espionage officers.'

Philby's defection struck him as immensely suspicious, starting with his first words to Elliott, 'I rather thought it would be you,' as if he had somehow known someone was coming. Embarking on a freelance investigation with a colleague at MI5, Arthur Martin, they went back to the tapes of Philby's 'confession', using binaural tape to clean up MI6's single-microphone recording. When Elliott told him there was new evidence, Philby, who had denied everything time and again for a decade, swiftly admitted to spying since 1934. He never once asked what the new evidence was. Listening to the tape, there was no doubt in Wright's mind that Philby arrived at the house well prepared for Elliott's confrontation.

Who had tipped him off? 'What until then had been a hypothesis, became an article of faith. There was a spy; the only question was – who?'

MI5 was not the only intelligence service consumed with molehunts in the aftermath of the Venona code break. Wright had a powerful ally in James Angleton, the head of counter-intelligence at the CIA, who led a similar campaign against Soviet penetration that required entering the place he called the 'wilderness of mirrors', his favourite phrase for the 'myriad of stratagems, deceptions, artifices, and all the other devices of disinformation which the Soviet bloc and its coordinated intelligence services use to confuse and split the West . . . an ever fluid landscape where fact and illusion merge'.

Angleton had known Philby personally – he was his best friend in British Intelligence, with whom he had shared many a secret over liquid

Greengrass, Peter Wright and his wife Lois in Tasmania (1985).

THE GREENGRASS PAPERS

lunches in Washington – and, stung by his defection, seemed to make up for it with a ferocious crusade against Soviet penetration, becoming consumed with the idea, planted by one of the Soviet defectors, that some of the others were fakes, sent to protect KGB moles who were already in place and to confuse US policymakers about Moscow's intentions. 'For Angleton, every CIA misadventure was by KGB design; for that matter, so was every CIA success, since it was merely setting the stage for the disaster to come,' wrote David Martin in his 1980 book *Wilderness of Mirrors*, which was recommended to Greengrass by Sir Dick White, the retired head of MI6, to help him make sense of the molehunts, after Greengrass visited him at his home in Arundel in March 1984. There, at the base of the Sussex Downs, tending a beautiful garden, he found a trim, thin-faced, silver-haired man in his seventies with the build of a long-distance runner and a beady, professorial air about him. He can remember thinking that this man was exactly the kind of person you wanted to run a secret service in a democracy; in fact, White was the model for 'M' in the Bond books. They discussed the molehunts.

'The defector situation was the real problem,' White told him. 'How could you reconcile all these different stories? It was impossible. People tried, and quickly got into the area of every success is a failure and every one of their failures is really a success. Well, it is very easy to argue this. You have to study Russian history, steep yourself in the country, as I have done. You see that Russia is not all-powerful. It's a lumbering giant, very cautious – very, very cautious.' In the end, he said, he came to believe that all the suspicions were 'merely the echoes of the Burgess–Maclean–Philby business'. The super-mole, 'Elli', was a ghost, a trick of the light, a collection of dust motes caught in the half-light of Venona decrypts and defector snippets, magnified by paranoia and fear.

When Greengrass flew out to Tasmania a few months later, Wright struck him as almost the last person on Earth who should have been conducting a witch-hunt. An emotional man possessed of a scientist's imperviousness to other people's feelings, he had alienated half of MI5 and most of MI6 with his chaotic and divisive investigations. As Wright edged towards retirement, he found his promise of a full

pension withdrawn by the new management at MI5. 'I thought that for Peter, the super-mole was a kind of psychological creation in a way,' says Greengrass. 'He could never get his head around the fact that even though Philby and Blunt were traitors, still they were part of the elites, and he was still below stairs, and he drove himself mad – literally – because he wanted to be accepted and wasn't. All he wanted was to belong, to be liked, to be accepted by Lord This and Sir Thingy That, but he came from the wrong side of the tracks. He was not one of them. He called them "the velvet-assed bastards" and saw in them a conspiracy of sorts that was locking him out. I mean, he was a drunkard and a vengeful man, but he was also human, vulnerable, talented and had done the state some service. And he had been unbelievably badly treated – just beyond belief, when you looked at it. They'd consigned him to the most appalling poverty. I thought, how could people behave like that towards someone who, whatever they thought of his role in the molehunts, had toiled all his life for the Crown?'

After six weeks debriefing Wright in Tasmania, Greengrass returned to London in early September, just in time to watch *Spycatcher* catch fire in the law courts, before he had even completed a first draft. Heinemann had not announced the book in any of their seasonal lists or catalogues, but news leaked to the *Observer* newspaper, which printed a diary item on 31 March 1985 stating that Wright was writing his memoirs. As the full plan of Wright's book came into view, on 25 June, the cabinet secretary, Robert Armstrong, wrote to Mrs Thatcher to confirm the story and, along with Sir Antony Duff, the new director general of MI5, advise the government to seek injunctions not only against Greengrass in Britain, but also Wright in the Australian courts. On 2 August, letters were fired off to both Wright and Heinemann threatening an injunction, which arrived on 10 September in the Supreme Court of New South Wales.

Greengrass wrote the book during the latter half of 1985, through Christmas and the new year, and delivered it in early 1986. Not long after, the head of accounts at his literary agency, Anthony Sheil Associates, told everyone that two HM Customs and Excise inspectors had announced

their imminent arrival. His agent, Giles Gordon, joked about 'whether they would wear bowler hats and carry rolled umbrellas' and took the precaution of removing all the *Spycatcher* files from the office, taking them home and concealing them under his bed. 'All mention of Wright and *Spycatcher* and Greengrass was expunged from our computer and other systems,' he wrote in a 1993 memoir. 'Wright and Greengrass did not exist in our lives, nor did the book.' The two inspectors duly arrived at Anthony Sheil Associates and started rifling through invoices, statements and ledgers, checking and double-checking columns of figures, every now and again gravitating back to the 'W' section of the filing cabinet. When he spotted them, Gordon would direct them back to the files they were supposed to be inspecting – 'A' for 'Ackroyd' was there, 'C' for 'Cookson' was there, 'F' for 'Fowles' was there – but kept on finding them back at 'W'. They were quite clearly Special Branch.

Finally, Greengrass received a call from Cleveland Cram, a retired CIA station chief whom he had tried to get in front of the cameras for his *World in Action* programme on Wright. A jovial, portly Minnesotan in a pork-pie hat and trench coat who had written the CIA's definitive report on the molehunts – twelve legal-sized volumes, each running to between 300 and 400 pages, a veritable encyclopaedia of US counter-intelligence – but he had declined. The two stayed in touch, Cram amused by the young journalist's keenness, Greengrass happy to have added to his collection of avuncular father figures. 'Cleve was a big, jolly chap with an impish sense of humour,' he says. 'A tough guy, but also an idealist, part of a generation of CIA officers who emerged out of the Second World War and believed in things like the Peace Corps. And genuinely wanted to spread democracy and do good things in the world. And were appalled by what people like Angleton and others did to the CIA. Cleve taught me that the history of these organisations – the CIA, British intelligence – had been a struggle between sensible, honourable people and these QAnon conspiratorial nutters.'

The message he received from Cram in early 1986 was not so jovial, however. 'I remember him saying, "I need to see you." He must have phoned me. It was, "I need to see you *now*."'

A selection of the MI5 files detailing Greengrass's involvement in the *Spycatcher* affair, obtained by *sub rosa* methods in 1987 and declassified in December 2023.

Greengrass went straight over to the mews house Cram kept in Richmond for five or six months of the year. He was an Anglophile who had served for almost a decade as the deputy head of the CIA's London station, responsible for the agency's liaison with MI5 and MI6. 'I can remember being in his kitchen, and he said, "You need to be very careful. They're definitely not amused by your book."' The deputy director general of MI5, John Deverell, had been round to see Cram and given him a warning, which Cram had decided to pass on.

'I hadn't handled secret information. I didn't have documents or any of that. The danger was conspiracy. That was the one. Deverell had referred, in this conversation, to Section 7 of the Official Secrets Act. Section 7 was conspiracy. And that was pretty serious. I mean, you could go to prison for a fair number of years. And from then on, the *Spycatcher* affair began to escalate alarmingly. *Spycatcher* did my head in, truth be told. On the one hand, it was like living through the *Oz* trial, a Mad Hatter's tea party for spies and journalism, a magnificent and exhilarating journey for a

young man. It was just non-stop. It was front page for week after week after week after week. It was absolute madness, like being in the eye of the storm. But I was always taught at Granada that what you're there to do is to make trouble. And we certainly made trouble. The best trouble, the biggest trouble I ever made, that's for sure. But there was also a serious side to it all, knowing that they wanted me in prison, if they could get me. I became pretty paranoid, looking back, which is hardly surprising. Taking on Mrs Thatcher was a business. You couldn't escape the clear knowledge that you'd stirred up a hornets' nest.'

In early October, Armstrong updated Mrs Thatcher on the book in its final form, which he had finally obtained. Should they act? 'We must,' replied Thatcher. 'I am utterly shattered by the revelations in the book. The consequences of publication would be enormous.' It accused Roger Hollis of having been a Soviet spy. It also named many MI5 personnel and described numerous MI5 operations – including Wright's subsequently most famous line that for five years, he and a colleague had 'bugged and burgled our way across London at the State's behest, while pompous bowler-hatted civil servants in Whitehall pretended to look the other way'. Armstrong advised that it was 'much worse for a former member of the Security Service to make revelations' than for a private citizen to do so and prepared to do battle over enforcing the life-long duty of confidentiality, although no mention was made of the fact that many of the revelations had already appeared in Chapman Pincher's book, *Their Trade Is Treachery*.

The case was set for 17 November 1986, in the New South Wales Supreme Court. The lawyer assigned to defend Wright was the young, ambitious Malcolm Turnbull, later to be prime minister of Australia. He was thirty-two years old at the time, educated in Australia and Oxford, intelligent and pugnacious, sharing with his client a deep distaste for the hypocrisy of the British establishment. He very quickly zeroed in on his real aim in the case, which wasn't to defend his client, but to attack the central thesis of the prosecution and aggressively dismantle the 'absolute

duty of confidence' that they said Wright owed the British government. 'It was all a matter of trust,' he later wrote. 'Sir Robert's whole philosophy involved the people trusting him, and it was blind trust he and his colleagues demanded. They would not deign to provide any information on their decisions. Their integrity was all the public needed to be satisfied of.' Audaciously, he aimed to put the secrecy of the secret services in the dock.

Greengrass arrived in Sydney for the trial in early November, looking 'anxious', according to Turnbull. Accepting that his offices were likely bugged and their telephones and faxes intercepted, Turnbull asked him for a drink at a wine bar in King's Cross, where they found a table at the back.

'Look, there's something I need to tell you which I couldn't tell you on the phone,' said Greengrass. 'It's about how Peter came to be Pincher's source for *Their Trade Is Treachery*.'

Greengrass told Turnbull the whole story – how no less a figure than Victor Rothschild, former MI5 officer and 3rd Baron Rothschild, had asked Wright to come to London, sending him an air ticket, introduced him to Chapman Pincher and encouraged him to tell the author everything so he could use it in a book. He'd even arranged for the royalties to be split fifty–fifty and Wright's share be paid to him through Rothschild's Swiss bank account. As Greengrass told him all this, he could see Turnbull's mind whirring.

'Good God, Rothschild was responsible for *Their Trade Is Treachery*?'

'Without a doubt. One hundred per cent.'

'Why would he do that? He could go to jail.'

'God knows. Maybe a deniable operation. Maybe Pincher was the safe way of getting the molehunt story out without making an official statement. A typical establishment unattributable leak.'

'That's collusion right there,' said Turnbull. 'What other explanation is there? Rothschild was a spook once, wasn't he? It's obvious. Does anybody else know?'

'The only person I've told is a friend of mine in the CIA.'

'Because?'

'Because I wanted to protect my position. They can't take me down without coming for Victor Rothschild first.'

'What did your friend in the CIA say?'

'He laughed.'

When the writ was first received by the publishers, Heinemann, the company's lawyers said the case was unwinnable, but Turnbull never accepted this. He took the case when no one else would and worked tirelessly, believing he could win against all the odds. Now, he had an ace up his sleeve. The Rothschild information enabled him to substantially escalate his argument that the UK government had acquiesced in the publication of MI5's secrets in Pincher's book and, therefore, could hardly claim those same secrets were now confidential. Turnbull set Greengrass to the task of performing a line-by-line annotation of *Spycatcher*, cross-referencing every fact that had appeared before, not just in the Pincher book, but in as many other MI5 books and memoirs as Greengrass could lay his hands on, going all the way back to 1909. 'Greengrass was a natural lawyer, in the sense that all he lacked to be a great advocate was a law degree,' Turnbull wrote later. 'I have never met a non-lawyer who better understood the nature of litigation and tactics of cross-examination. He also understood the way the British establishment thinks.'

After exhausting pre-trial proceedings, the trial itself began on 17 November. Every day, Turnbull, together with his wife Lucy, Greengrass, Wright and the Heinemann solicitor, David Hooper, all carrying bags of books and folders, hurried across Sydney's Hyde Park and past the international news crews, arriving at the courthouse hot and sticky – a situation that was improved after they swiped a supermarket trolley in which to carry everything. The news broadcasters loved this, sometimes tripping up in their efforts to catch the trolley on camera, as they did Wright's drover's hat, with which Turnbull had outfitted him. He also got him Australian citizenship, thus making sure the image transmitted to TV sets around the world was that of a persecuted bush farmer.

Once inside the building, banks of elevators ferried litigants, nervous witnesses and frantic solicitors up to the federal courts occupying the upper floors, giving the otherwise modern building a Hogarthian sense

of bustle and business. Inside the courtroom sat barristers and judges in wigs and gowns, a royal coat of arms on the wall behind the judge, law reports piled up high on the bar table: the symbolism seemed auspicious for the British government. On the right-hand side of the court, however, crammed into the jury box, were the foreign press, including a rowdy collection of London journalists, most of whom knew Greengrass, lending a distinctly carnival air to the spectacle surrounding a book that had received more legal attention than almost any other publication of its kind in history. The government's principal witness was Armstrong himself, the cabinet secretary, a man renowned for his bureaucratic skills and devotion to the doctrine of official secrecy, who was hamstrung from the get-go by what Turnbull later called 'the comedy of not being able to admit that MI5 and MI6 actually existed'.

At one point, Turnbull asked him to identify Dick White, the head of MI6, whom Greengrass had met in Arundel and who had recommended *Wilderness of Mirrors* to him.

'Who is Sir Dick Goldsmith White?'

'He was director general of the security service some years ago,' replied Armstrong.

'And also MI6, was he not?' pressed Turnbull.

'He had other jobs, yes.'

'And also MI6, was he not?'

'He was also head of that other organisation, yes.'

But when Turnbull pressed him about MI6's activities after White's term in office had ended, Armstrong demurred.

'I acknowledge the existence of MI6 at the time that Sir Dick White was head of it. I do not wish to go further than that.'

So MI6 did exist, but only up to 1969, when White retired. This kind of establishment casuistry sounded nonsensical in the cold light of an Australian courtroom.

On the second day of the trial, Turnbull and Greengrass received a godsend. When Wright and Pincher had first started corresponding, they had agreed to destroy their correspondence, but Wright had been too much of an old spy to do so. He had kept his copies of their letters, but

they had seemingly been lost in the transfer between solicitors. Then, on the 18th, they suddenly resurfaced in a large box of papers delivered to Turnbull's offices in Sydney. Excited, Turnbull and Greengrass went on a long walk to go over their find.

'The letters are complete proof of Victor's involvement,' said Turnbull.

'The problem we're going to have here is that Peter considers Victor to be his best friend in the whole world.'

'But Rothschild manipulated him.'

'He was the only member of the establishment to make him feel welcome.'

'Well, if he wants to win this case, he's going to have to tell the story.'

The two men went to meet Wright in his room at Cranbrook Private Hotel, a small place not far from Turnbull's house in Rose Bay, a harbour-side Sydney suburb. As expected, Wright was reluctant to testify against Rothschild.

'I don't want to get him involved. He was very good to me.'

'You have to choose, Peter,' said Turnbull. 'You or Victor. And if you don't, I think you'll lose the case. You have to tell the story, Peter. You've been manipulated. You've no reason to protect Victor. He's not had your best interests at heart.'

They could see it was incredibly painful for Wright, whose devotion to Rothschild was almost filial. Accepting that his friend had been a manipulator made him feel small. He had been used and discarded. Quietly, he began to wipe away tears.

'Do I have to tell the court everything?' he asked, miserably.

'Yes. You can't leave things out. If you do, they will cross-examine you the way I have been cross-examining Armstrong, and they'll destroy you.'

It went on like this for a while, before Wright finally fell silent, reached for his glass and took a deep swig of whisky, then held his empty glass up, as if for a toast. 'Oh well, poor, dear Victor,' he said, putting the glass back down on the desk. 'Okay, we'll have to throw him to the wolves.'

Turnbull was able to tear Armstrong apart, making him look like an evasive fool, arguing with great force that the UK government didn't just tacitly acquiesce in the leaking of their secrets, they actively conspired to

leak them to a 'safe' establishment figure like Pincher, in order to forestall their publication by others. He produced Greengrass's exhaustive list of publications, which proved that disclosures of confidential information had long been permitted, even encouraged, if it suited the intelligence services and boosted their image. This area was the most detrimental to the government's case. Why, if Wright's disclosures were so damaging, had no effort been made to stop Pincher's earlier book, which foreshadowed much of what Wright now wanted to say?

Greengrass and Malcolm Turnbull outside the Supreme Court of New South Wales (1986).

'You and the prime minister and the security service agreed to let Pincher write his book,' Turnbull suggested to Armstrong, 'so that this affair would come out in the open through the pen of a safely conservative writer, rather than some ugly journalist on the left.'

'It is a very ingenious conspiracy theory,' countered Armstrong, still under oath, 'and it is quite untrue.'

'Totally untrue?' asked Turnbull.

'Totally untrue,' Armstrong replied.

But later, on the simple issue of whether they had seen an advance copy of Pincher's book, Armstrong conceded that he had given the 'misleading impression' that they had not.

'What is the difference between a misleading impression and a lie?' pressed Turnbull.

'A lie is a straight untruth.'

'What is a misleading impression – a sort of bent untruth?'

'As one person said, it is perhaps being economical with the truth.'

A gasp of disbelief went up in the courtroom. The phrase was Edmund Burke's, but it was immediately taken up by the press as a classic piece of

pettifoggery by a British mandarin. That day in court, you could practically feel the case slip away from him. Armstrong no longer sat forward in the witness box but leaned back, as if to put as much distance as possible between himself and Turnbull's questions. Finally, on 8 December, Peter Wright ascended the stand to give his testimony, reading from an affidavit rather than undergoing cross-examination because of his ill health. Turnbull's tactics with the hat had worked: Australians had taken the old boy to their hearts.

'The British establishment has never accepted that it was, en masse, penetrated by the Russians,' Wright began, delivering a long peroration roasting the secret services for failing to clean house after the betrayals of the Cambridge Five and the granting of immunity to Blunt and others. 'That is the object of my book, which compromises no operations, prejudices no sources and exposes no secrets,' he said.

Then he delivered the knockout punch, telling the court how Lord Rothschild had flown him to London, where Rothschild read Wright's dossier and said he would help get it published. And that he would channel half of the royalties to Wright via his Swiss bank account. 'I concluded in my own mind that I was being used as part of a deniable operation,' with full official approval, he said, before concluding, 'My patriotism is undiminished,' and quoting Pope Gregory VII, '*Dilexi iustitiam et odivi iniquitatem, propterea morior in exilio*,' the same dictum that Greengrass had seen pinned above Wright's desk, written in spidery handwriting: *I have loved justice and hated iniquity. Therefore, I die in exile.*

Looking up from his affidavit, Wright looked tired and had tears in his eyes.

'You've done well, Peter,' Greengrass told him as he climbed down from the stand.

On 12 March 1987, the British government lost its case in the Sydney court. Mrs Thatcher immediately authorised an appeal and attempted to obtain injunctions in other jurisdictions – Canada, Belgium, Ireland, New Zealand, Hong Kong and London, where details from the as-yet-unpublished manuscript had begun to find their way into the British press, including the *Observer* on 22 June. Punitive injunctions were

obtained prohibiting any British newspapers from referring in even the briefest form to the allegations in Wright's book. Magazine and television offices across the country were raided by the police; radio and TV programmes were banned.

After millions of pounds in legal expenses, and with the book having sold more than a million copies worldwide, the Law Lords ruled that its publication overseas meant it no longer contained secrets and allowed its publication in the UK. The spy with the inadequate pension would eventually, thanks to Mrs Thatcher's battle against him, sell nearly two million copies of his book and die, in 1995, a millionaire, the money having allowed him to keep his stud farm afloat. By far the biggest effects were constitutional. Increasingly recognising that the government's position on the Official Secrets Act was 'under strain' – in particular, the notorious 'catch-all' Section 2 of the 1911 Act, which made any disclosure of any official information whatsoever unlawful – the head of MI5, Sir Antony Duff, advised Mrs Thatcher that the time had come for an overhaul, and he oversaw the introduction of the Security Service Act in December 1989, which was designed to put MI5 on a statutory footing, but not

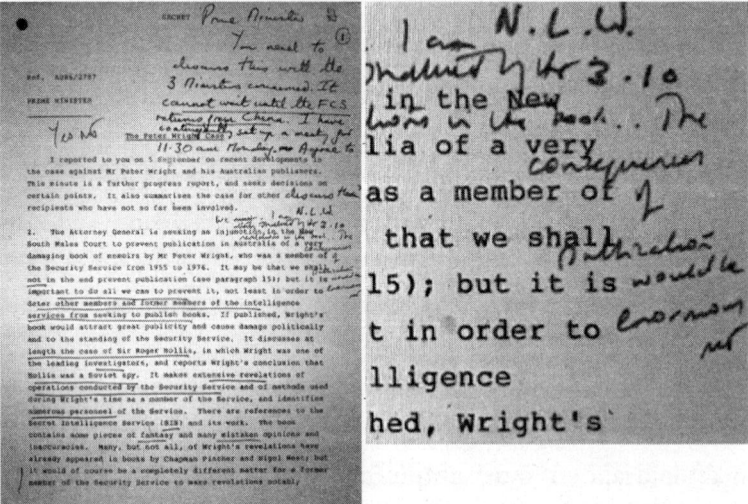

From MI5's *Spycatcher* files, a marginal note from Mrs Thatcher to her secretary Nigel Wicks, proclaiming herself 'shattered' by the revelations in the book. 'The consequences of publication would be enormous.'

to make it subject to parliamentary oversight. Both MI5 and MI6 could be said, finally, to officially exist. They were 'avowed', to use the official terminology. The secret services were no longer secret.

A coda to the *Spycatcher* story arrived in December 2023, when MI5 declassified some of its files on the case, revealing the panic inside Thatcher's government as it tried to suppress the book. 'I am utterly shattered by the revelations in the book,' wrote Thatcher in a document dated October 1986. 'The consequences of publication would be enormous.'

Only a fraction of the extant files were released, a lot of them redacted, but Greengrass read them over Christmas 2023 as he was preparing to shoot *The Lost Bus* and found them 'highly entertaining. The student conspiracy theory that Malcolm [Turnbull] and I had about the case – Robert Armstrong had pretty much perjured himself in court – turned out to be absolutely true. It's all there in black and white.'

Some of the newly released records were from a ministerial committee investigating the Peter Wright case, with the home secretary, the foreign secretary and the head of MI5 all in attendance. Point 3 of the minutes states: 'Mr Paul Greengrass should be investigated because he may have committed offences under the Official Secrets Act,' adding that Greengrass's involvement 'is known through *sub rosa* methods'.

Sub rosa is spy jargon for 'secret methods', and more particularly, 'surveillance'. Greengrass used it himself in the scene in *The Bourne Ultimatum* where David Strathairn's CIA spymaster, Noah Vosen, orders 'a *sub rosa* collection of the bodies' after they think Bourne has been killed. 'I presume if they say, "This person should be investigated," that means you get investigated,' says Greengrass. 'That must have been around the time Cleveland Cram called me up to say, "You need to be careful because they're really coming after you." What's hilarious about it is, there are literally thousands of pages . . . The amount of man- and woman-hours, the amount of senior people, from Thatcher down, obsessed with what was to all intents and purposes a stupid jape – it was really pulling the headmaster's trousers down on sports day. They obviously had a massive sense-of-humour failure.'

One of *Spycatcher*'s most profound, if unforeseen, effects was to point Greengrass towards Hollywood. The book is a prodigious feat of forensic research, driven by a pathological delight in the exposure of secrets and warmed by Greengrass's clear identification with Wright as a quixotic tilter at establishment windmills. *Spycatcher*'s first half, in particular, is enlivened by a series of brilliant Barnes Wallis-style breakthroughs, made while Wright was working for GCHQ. On the eve of the Suez crisis, Wright disguised himself as a telephone engineer and bugged the telephone in the cypher room at the Egyptian embassy in London, thus enabling GCHQ to break their diplomatic cyphers and confirm the danger of Soviet intervention on the Egyptian side. According to Wright, the intelligence from one Egyptian intercept 'did as much as anything to prompt [Prime Minister Anthony] Eden into withdrawal' and also played 'an important part in shaping American pressure on Britain to end the crisis'. Similar surveillance techniques were also used, in even more sophisticated form, in the Greek embassy to monitor the Greek assistance given to Colonel George Grivas during the 1956 Cyprus emergency, and to monitor Charles de Gaulle's determined attempts to keep Britain out of the Common Market. Wright was summoned to the Foreign Office to receive the congratulations of the permanent secretary. '"Priceless material," he said, beaming, "simply priceless."'

'*Spycatcher*, although filled with errors, exaggerations, bogus ideas, and self-inflation, is one of the outstanding works in the field of intelligence literature to appear in the last three decades,' concluded Cleveland Cram in a report for the CIA's Center for the Study of Intelligence titled 'Of Moles and Molehunters', which was declassified in 1992. *Spycatcher* is non-fiction but on some level it wants to be fiction, which is not to say that Greengrass made it up, although it does contain his first attempts at dialogue, scene-setting and so on. Crotchety, brilliant and paranoid, Wright is a figure straight out of le Carré, and his accusations would create no problems for a dramatist, who has the luxury of both empathy and distance. 'I had faith in [Hollis's] treachery, another man might have faith in God, or Mammon,' declaims Wright in full witch-finder mode, while Greengrass rushes to provide mollifying context. 'We were in the place

Angleton calls "the wilderness of mirrors", where defectors are false, lies are truth, truth lies and the reflections leave you dazzled and confused.' Was Wright really this cognisant of his own paranoia? It sounds more like Greengrass commenting on his errant, prickly collaborator, which raises the spectre of a commission taken on in bad faith, or at the very least a ghostwriter's crisis of conscience. Simply put, he did not believe a central plank of what Wright believed to be true.

Tellingly, Greengrass followed *Spycatcher* with two attempts at novels, both centred on an elderly spymaster. One is a British secret services officer named Haldane, living in seclusion on a houseboat, writing a memoir that takes him back to the very inception of the British Intelligence service. The other is an American CIA chief undergoing chemotherapy for an inoperable brain tumour who invites a wealthy Wall Street lawyer and OSS veteran to his ward at Georgetown Hospital in DC, where he passes on the baton of a black-ops unit. Based on Oliver North's enterprise, it has its own aircraft, airfields and bank accounts and is involved in Third World counter-insurgency and assassination – in effect, a private CIA, with distinct shades of Operations Treadstone and Blackbriar in the Bourne movies. *Spycatcher* marked the culmination of Greengrass's journalistic career at *World in Action*, but on a deeper level it signalled a pivot towards the freedoms afforded by fiction.

'I think there was a little of Peter Wright in me,' says Greengrass. 'I understood instinctively who he was, what drove him and what he was looking for, which was to come out of the shadows and speak for himself, which in a weird way was what I was doing at around that time. I definitely felt at the time that I was trying to liberate myself, in a way that was much bigger than the book. My heart and imagination and ambition were all in a different place.'

In 1983, he and his first wife sold their terraced back-to-back in Stockport and moved down to London, buying a semi-detached three-bedroom house in Dulwich, where they could raise their two kids, Katie and Tom – an almost unimaginable 'thought crime' inside Granada, which prided itself on taking a stand against the metropolitan elite. 'Inside, I was starting to move on. All that *World in Action* machismo,

that diet of righteous anger, that need to settle scores,' as he puts it, 'was beginning to feel very restrictive. The truth is, it was the film-making that turned me on, not the investigative reporter, Woodward and Bernstein thing. In the end, I wanted more complexity, more nuance and more the making of something, rather than just the pulling of something down. *World in Action* was honourable, absurd, responsible, infantile, enormous fun and rather repetitive. It was all the contradictions you can imagine. It was ten years of learning that the world was complex, that life was not so much a conspiracy as a struggle for control. There were those who had power, and there were those who wanted it. And that was leading me towards movies.'

And not just any movies, but movies that drilled down into the same seam opened up by the *Spycatcher* affair, between the daylight world of verifiable fact and the secret one that lies just beyond its reach – fragmentary, partial, tantalising, requiring an effort of imagination in order to truly be penetrated. In 1995, the director of Central Intelligence, John Deutch, released to the public the first batch of the NSA's Venona translations – the decrypts that had led to the unmasking of the 'Ring of Five', and which had sent Peter Wright down the rabbit hole. Some 2,900 Soviet intelligence messages were posted on the Internet and in hard copy at major archives around the country. 'It was fascinating,' says Greengrass. 'Like looking at a jigsaw puzzle, with only a certain number of pieces able to be seen, but what you could see showed there was tremendous activity by the KGB, lots of interest in recruiting people and penetrations and so on, but not enough pieces to know for certain in every case who the spies were. In that sense, Venona was a perfect metaphor for the paranoia of the Cold War, because what it was showing them was their worst fears, but without ever being able to be dispel those fears or disprove them. It was a siren's source.'

Venona was a perfect metaphor for the Cold War, but it was more. The Venona decrypts – teasing, ambiguous, inconclusive – would be the model for all of the films Greengrass would later make, all taking as their starting point some fragment of inconclusive evidence from a scene of mayhem: the missing twelve-to-fifteen-minute gap in the news coverage of Bloody

Sunday, between the soldiers moving into the Bogside and the time the last of the thirteen civilians was shot dead; the final twenty minutes that elapsed on board doomed flight United 93, between the beginning of the passenger assault and the moment when the plane ploughed into a field in Pennsylvania; the five days Captain Richard Phillips spent with his kidnappers on board a lifeboat, away from the network cameras, after his cargo ship was hijacked by Somali pirates in 2009; or Jason Bourne himself, that walking cypher, the redaction made flesh. 'It's true of all human events,' says Greengrass. 'The missing photographs at Dealey Plaza. Or Bobby Kennedy walks off stage: it's a partial view, we don't see his killing. The past is another country. We live in a world where we think it is recoverable, but it never is. All of us are desperately searching for the missing piece, or certainly I am – the missing pieces of us, and how we fit in to the world. We're all sort of Jason Bournes in a way. That's why he was such a great character. Of course, he's a secret agent. And, of course, he's a movie hero and all that, but there's something at the core, something incredibly mythic about the character. Because we all face the mystery of otherness, don't we?'

You want a Paul Greengrass film? Leave an incomplete puzzle lying around. Scatter existential clues as to the protagonist's identity. Solve with a mixture of investigative doggedness and deep imaginative infiltration. Where the redactions end, a Paul Greengrass film begins.

4: SURVIVAL

Britons didn't see much of the Falklands war. As the British naval task force departed from Portsmouth on Monday, 5 April 1982, ITV broadcast it live – two aircraft carriers towering over the waterside houses, the helicopters strapped to the decks, sailors waving from the edge of the ship – then the fleet disappeared into a misty long shot, and that was it. Thereafter, such was the control that the Ministry of Defence exercised over the media – reports were censored, delayed, lost or sent back on the slowest ship the Royal Navy could find – that presenters prefaced their bulletins with the rider that they were being censored. For fifty-four of the seventy-four days of the conflict itself not a single image got out. 'So, the war, instead of being experienced back home as a continuous narrative, was a succession of jump cuts, of sporadic sound- and vision-bites,' wrote novelist Julian Barnes, then the television critic for the *Observer*. 'The episode of war itself has remained enclosed, separate, unreal, without consequence.'

Greengrass was sent by *World in Action* to cover the war from Argentina, one of the first journalists who managed to get into Buenos Aires, where he stayed for several weeks, filing reports on the war fever whipped up in the Argentinian capital by General Galtieri, but it wasn't until after he

returned in August that a story in the *Daily Mail* caught his eye: Philip Williams, an eighteen-year-old Scots Guardsman who had been declared dead, his mother and father forced to bury an empty casket, had turned up at a farmhouse on the Falklands seven weeks after the end of hostilities. Apparently knocked unconscious by an explosion, he had awoken the next day and wandered for months, unaware the conflict had ended, at one point living in a dirty hut, eating discarded army rations. Claiming amnesia, he was reunited with his family and hailed by the tabloids as a hero who had come back from the dead. Greengrass remembers reading the story in the *Mail* and thinking, 'I don't believe it.'

'It didn't all add up to me – the extravagance of the homecoming, the way they were all with him. He had Ministry of Defence minders who were controlling all this information. You knew that it was only a thousandth of the story. So I went to find him.'

In Seaford, he found a rattled eighteen-year-old who dressed like a hippie, in denim, matched with odd items from his past – marching boots, green combat jacket. His hands trembled as he smoked obsessively. He was doing his A-levels, claiming social security when he could and he wanted to travel, but you didn't need to be an army psychologist to know that his scars had not healed. Greengrass felt certain there was a movie in the story, something punchy and provocative, in the vein of the old Ken Loach *Plays for Today* – 'Cathy Come Home', 'The Golden Vision' – he had watched with his father as a kid. British film-making at the time seemed lost in a haze of colonial period dramas and white linen. Granada's own drama department was riding high after its success with *Brideshead Revisited* (1981) and *Jewel in the Crown* (1984), but when he trotted upstairs to ask Mike Scott, then the programme controller at Granada, if he could join the drama department, Scott levelled with him. 'Here's the reality,' he said. 'You're doing a good job on *World in Action*, so why would I move you to drama, where you might not be good, plus do you really want to do a year on *Coronation Street*, which is where you would start?'

In July 1985, Greengrass persuaded Ray Fitzwalter to let him make a film about Live Aid, the concert Bob Geldof was planning for famine

relief in Ethiopia. 'Song for Africa' was a free-form observational film in the *World in Action* tradition, following Geldof in the run-up to the concert. As Greengrass cut the film with Eddie Mansell, the film became fluid, telling the story purely with the images. 'That was an important moment for me,' he says. 'You're always trying to make it fluid, and one thing moves to the next, and it's not driven by commentary. It's just got its own life, and you can tell your story that way and you enter a different time frame – the time frame of film. And I remember feeling, "Oh, this is me." Something was changing in the UK at that time. You could feel it, and I felt like a change was coming for me, personally. There was some hope in the air.'

As he shot 'Song for Africa', he was approached by a producer, Adrian Hughes, who was making the official film of the event. He asked Greengrass as a favour whether they could use any of his footage, and after Greengrass got the okay from Granada, was so impressed that he asked if Greengrass could come and shoot the back- and front-stage scenes for them. Greengrass agreed, and at dawn on the day of the concert he drove out to Wembley with Hughes and his production partner, Tara Prem. It was a beautiful day, and as they drove through north London the sun streamed in low over the rooftops. Greengrass began asking them questions. Hughes and Prem, in the front seat, were seasoned hands in TV drama.

'Can I ask you something?' he asked. 'How do you get to make movies?'

'What do you mean?'

'Well, I've always wanted to make movies, but how does that happen, exactly?'

'Have you got an idea?' said Prem. 'That's the best way.'

He said he did and told them about Williams, how he'd gone missing on the last night of the Falklands war, only to reappear forty days later, like a biblical resurrection, and be greeted as a hero, when, in fact, everyone knew the poor kid had been shit-scared and run off. He saw the film as telling us 'everything we need to know about how that war had injected madness and xenophobia into our veins, and things will never be the same'.

'Sounds interesting,' says Prem. 'Can you write something?'

'I'm flying tomorrow, but I'll do it when I get there and send it to you.'

He wrote his treatment for *Resurrected* on the flight to Australia for the *Spycatcher* trial and faxed it from his hotel when he arrived. Hughes and Prem took it to David Rose, the head of Film4, who had helped finance Neil Jordan's *Angel* (1982), Stephen Frears's *My Beautiful Launderette* (1985) and Wim Wenders's *Paris, Texas* (1984). Rose agreed to put up half the money, in effect buying two television screenings of the film. Greengrass went to see him at the Film4 office, where Rose told him, 'I think you should let someone else write it, and you stick to the directing. That's a big enough step for you.'

They hired playwright Martin Allen, who, after visiting Private Williams in the winter of 1986, wrote several drafts based on Greengrass's treatment. Returning from the *Spycatcher* trial in December, Greengrass started work prepping and casting the film at the offices of St Pancras Films in King's Cross. He thought, 'I'm living the dream and I've never worn a necktie to work.' Then, in February, after six weeks of toil, came a bombshell: Channel 4 had decided to delay the film. He was screwed. A few weeks earlier, when he'd informed Granada he was leaving to embark on a career in the movies, Ray Fitzwalter had told him, 'You can always come back,' but the thought of that humiliation was too much; telling everyone he was leaving to become a fancy-pants film director had been embarrassing enough. He'd had his leaving party, drinks in the pub around the corner, everything; the idea of slinking back was too much. He had a sleepless night as he wrestled with what to do. 'Helen went to sleep, and there I was on my own, wrestling with myself, until finally I remember thinking, "I'm fucked if I'm going back. I've got to go forward."'

But moving forward meant coming to terms with the fact that his marriage was over. They had married young, in his first year at university, and were ill-matched from the start, a truth hidden from them by Greengrass's long absences on assignment for *World in Action*. 'Helen was and is a lovely person, but we were wildly unsuited, with different dreams, different temperaments. I basically married and left for sea, like my father. We had two gorgeous kids, Katie and Tom, whom we both

Greengrass and David Thewlis on the set of *Resurrected* (1989).

doted on, but most of our marriage was spent living apart, and by the mid-1980s – as we finally started to grow up – we had to face the painful fact that we were not meant to be together. Helen couldn't bear my restlessness. She wanted her own life. And, to be fair, she was braver than I was. She had the courage to say, "This isn't working." I resolutely refused to hear it. It was a messy, painful period before I accepted that it was over. And that I had to be honest with myself. I had to see that I had been hiding away. And admit that deep down another life was calling me. Looking back now, I can see so clearly that I was being driven by two radically different impulses: hiding away from the world and roaring to get into it, both at the same time.'

That spring, he made a documentary as a freelance for Granada about U2, 'Anthem for the Eighties', shooting footage from the final night of their gargantuan *Joshua Tree* tour at Croke Park stadium in Dublin. After the programme was broadcast in June, he flew to New York to publicise the American publication of *Spycatcher*, which had become a surprise best-seller in the US, thanks in part to travellers picking it up in airports

THE GREENGRASS PAPERS

and bringing it to Britain, where the book was still banned. Newspapers still couldn't even report on *Spycatcher* without facing an injunction, but samizdat copies were in circulation. There were copies being sold on the side of the M4 motorway. A bold vendor even delivered a postcard to 10 Downing Street, offering the book for £20, payable to 'Robert', whose telephone number was attached. 'I've never seen a book by an unknown author take off with such a roaring start,' said Marvin Brown, the publisher at Viking Penguin. 'In some places, it's even outselling the major fiction titles.'

Life for Greengrass seemed to be speeding up, change coming all at once, in the way it does after being held back for a long time. Finally accepting that his marriage was over, he moved into his friend Andy Harries's place in Hammersmith and started writing a spy novel in the back bedroom, while Hughes and Prem worked to revive *Resurrected*. One evening, a few months after moving in with Harries, he went out to dinner with a group of friends, including a pal of Harries's, a television reporter at London Weekend Television's *Six O'Clock Show* named Joanna Kaye. The daughter of Solly Kaye, a lifelong communist and political agitator who in 1936 had been one of the principal organisers of the movement to stop Oswald Mosley's Blackshirts from marching through the East End, she had spent much of her childhood 'either in party meetings or on demonstrations every weekend', says Greengrass, so Kaye was fascinated by *Spycatcher* and the streak of troublemaking it demonstrated in him. He told her he hoped to be directing a movie soon. '*You?*' she teased him. 'Yes, me.' By the end of the night, he knew he'd met someone who was going to be very important to him. 'I had that feeling where you feel like you already know someone,' he says. 'I just had an overwhelming sense that she knew who I was and that I didn't have to pretend to be anyone. I could just be me, and that was something I'd never been able to do before.'

A few weeks later, out of the blue, Hughes and Prem announced that they had obtained a green light for *Resurrected* from Channel 4. Greengrass shot the film in Yorkshire in the summer of 1988, with a twenty-five-year-old David Thewlis in the lead, after Greengrass had seen

him in Beeban Kidron's *Vroom* (1990), and with cinematographer Ivan Strasburg, who had shot Alan Clarke's *Rita, Sue and Bob Too* (1987). 'It was a slightly out-of-body experience to be making a film at all,' he says. 'The whole idea. But I had an unbelievably clear sense that I belonged there. I can remember being on a dolly, setting a shot up in the hospital and choreographing the movement, which was pretty crude on that film. And I remember thinking, "I understand this." A bit like I felt when I first went to Granada. A distinct feeling: "This is who I'm meant to be. This is who I am deep down inside." I felt as free and easy as I did when I was seventeen. You know, "I can do this. I know what I'm doing." Shooting a movie and, most of all, meeting Joanna. It was just a great, great summer.'

<hr>

Staggering out of a thick fog that blankets the Falkland Islands, Private Kevin Deakin (David Thewlis) knocks on the door of a grumbling sheep farmer, who phones the British army to come and collect the soldier. Where has he been? Does he know the war is over? Did he not see the helicopters and foot patrols searching for him? An inquiry clears him of any suspicion of desertion, but upon returning to England, he is escorted away from the flags and tearful reunions that greet the other soldiers on the tarmac for a private reunion with his family in a deserted arrivals lounge. On the drive home, his mother (Rita Tushingham) and dubious father (Tom Bell) are silent, unsure what to say to their son. On returning to his rural home town in Yorkshire, he is greeted as a hero by the welcoming party in his local pub, where everyone sings 'Rule Britannia' in Union Jack hats, beneath bunting and streamers – 'We haven't had a night like this since the World Cup,' someone says – but after an initial spell proclaiming Kevin to be a 'hero back from the dead' and a 'latter-day Lazarus', the tabloid press turn on him, printing rumours of his desertion and souring the atmosphere in the pub. When Kevin wins big on the slot machine, he looks around anxiously as the coins rain down into the tray like ill-gotten gains, each one seeming to shout out his shame to the world.

Thewlis is unimprovable in the scene – a picture of mortification – which provides one of the film's few flashes of humour. Cracking jokes with his on-screen girlfriend Julie (Rudi Davies), Thewlis displays some of the cheek he would later show in his work with Mike Leigh, but his performance in *Resurrected* is otherwise one of his most internalised: traumatised, guilty, gingerly intimate. Is it the shock of returning home, PTSD or something worse that he finds difficult to voice? Shaken by flashbacks to the Battle of Mount Tumbledown, which saw some of the bloodiest fighting in the war, Kevin angrily tells of seeing his mates with their 'arms and legs and bollocks hanging off', and when his father asks him if he ran, he denies it. 'It's all in the past now anyway,' says his father, as if to say, 'I don't quite believe you, and I'd rather not hear any more about it.' That's what the film is about, essentially: our collective unease at the reality behind the headlines jollying up the war. Greengrass's ire is directed at the media – every other scene features a rah-rah newspaper headline or clip of heavily sanitised TV coverage – while the artful smudge of Martin Allen's screenplay renders moot the question of whether Kevin deserted or not. 'Whether or not he's a hero doesn't really concern us,' his parents are told at the end by one of his commanding officers. 'Whatever he did or didn't do that night on the mountain will always be something of a grey area.'

The smudge is a little *too* artfully grey: an opaque mirror of other people's attitudes, Kevin remains hidden to us for much of the film's middle section, which drags through a lack of development. *Resurrected* would have made a highly creditable *Play for Today*, in the social-realist manner of Ken Loach, but for a film about PTSD its visual language feels too soothingly televisual – distant figures crossing Yorkshire hills in long shot – and shakes off Loach's influence only for one electrifying scene towards the end. Returning to his unit, Kevin is shunned and becomes the victim of a bullying campaign led by a Guardsman named Slaven (Christopher Fulford). He, too, is suffering from PTSD, waking up from nightmares with a scream, only to catch Deakin's eye, embarrassed. Briefly, the two men recognise themselves in each other, and in Slaven, the result is further disgust. An inquiry clearing Deakin builds cynicism

in the ranks, and finally something snaps. Emboldened by booze, the men subject Deakin to a mock court martial in their moonlit barracks, pinning him against the lockers. 'Where were you on the night of June 13th, 1982?' screams Slaven, his face shadowed in the moonlight. 'Admit you did a runner!' The camerawork is rough, handheld and electrifying. 'I can't remember!' cries Deakin, and for a moment it matters little. Two traumatised men are locked in a fight that almost resembles an embrace, one chosen to torment the other, the other chosen to be tormented. Two things are immediately clear to anyone watching the sequence: pretty scenery bores its director silly, but trigger his fight-or-flight response, and his film-making comes fully alive.

The film was good enough to garner a handful of respectful reviews – in *The Spectator* Hilary Mantel found it 'well-intentioned and thought-provoking' – but not so good that it led automatically to more offers of film work, and the months that followed its release were easily the darkest of Greengrass's career. 'I couldn't get arrested,' he says. He returned to his novel but soon ground to a halt with that, too, and then everything crowded in on him at once. His marriage had ended. There were children to support. He was broke. During the shoot of *Resurrected*, he'd been served with an injunction by government lawyers seeking to reclaim all the profits he'd made from *Spycatcher* – half the initial advance plus the royalties that had flowed in from having a number-one international best-seller, which amounted to around a million pounds. 'I didn't see any of it,' he says. 'It was a bit like handing over the keys to the car back to the hire-purchase company. "Here you go with this." It never really felt very real to me, all that, to be honest with you.' His biggest fear, in those days, was that '*Spycatcher* was going to define me. I was trying to escape from it. So when *Resurrected* ended and *Spycatcher* crowded in again, it was like everything collapsed. All the cards came tumbling down. I kind of seized up at that point. It was a dark few years, for sure.'

He gave up on the novel and wrote a couple of screenplays, which were an important education. A BBC TV executive belittled a script of his – *The Fix* – before then announcing he was going to send it to the celebrated writer Alan Bleasdale in case he could use it. Bleasdale wrote

back a letter saying, 'It's fine as it is, you should make it.' The BBC didn't, but Bleasdale spent an afternoon turning the pages with Greengrass and 'talking' the characters. 'My voice in the draft was imperfect, too cerebral,' Greengrass later wrote to Bleasdale. 'I could feel it as you talked the script. It needed to live and breathe. I'd written something that was like a new suit. Whereas what I needed was something that was lived in, creased and wrinkled and filled with edges and imperfections – real.'

A stint on the Channel Islands detective show *Bergerac* ended after a single morning. He liked the show well enough, and the producer was a nice man. Everyone in the BBC's office at Shepherd's Bush was incredibly kind, offering him cups of tea. 'I just felt that horrible feeling when people are being so nice to you but you know you're in the wrong place. And I was so broke. I went out for a sandwich at lunchtime and I didn't come back. I just walked across Shepherd's Bush Green, going, "I can't do it, I just can't do it, it's not me." I phoned the guy and said, "I'm sorry, I can't do it." "What?" It was one of those moments where I knew I needed to go back to the only thing I really knew how to do, which was to make films about what I was interested in.'

Retracing his steps, he went back to documentaries, teaming up with an old *World in Action* buddy, Clive Maltby, who had cut a few of his films at Granada and now wanted to direct himself. Together they made a string of documentaries – about the Hackney police, the singer Kathleen Ferrier, Woodward and Bernstein – and a series of films about Boris Yeltsin-era post-Soviet Russia for BBC2's *The Late Show*. Greengrass caught Moscow at an interesting time, just as post-glasnost capitalism was flourishing under Yeltsin's presidency. There was much talk of Russia's 'silver age' – that magical creative period between the Revolution of 1905, which ushered in the experiment with democracy, and the onset of war in 1914, which lead to a second Revolution – and its resurgence seemed to catch something of Greengrass's own mood at the time. One film in particular, 'Looking for Irena', about the search by author Victor Erofeyev for the fictional heroine of his glasnost novel *Russian Beauty*, demonstrated the director's growing interest in mixing documentary and fictional forms, tracking Erofeyev's heroine as if she were a real person

through the smog-haze, golden minarets and concrete-panelled Stalin-era *khrushchyovka* tower blocks that ring Moscow's suburbs.

'I'm looking for Irena, who lives in flat number 20,' he asks the elderly doorwoman, who is sitting in a cubbyhole at the base of the stairwell. 'No. She doesn't live here,' she replies. 'We haven't any kind of Irena.' Within a few years, Greengrass would be back at a very similar set of Moscow tower blocks, on behalf of an $85-million dollar Hollywood film production, looking for another young girl, also called Irena, who haunts the memory of Jason Bourne: Irena Neski, the daughter of Bourne's first kill. 'I'm looking for the girl who lives at number 48,' says Bourne. 'The Neski girl?' he is told. 'She doesn't live here any more.'

More than just providing Bourne with a name and a setting for its final scene, Greengrass's 'Looking for Irena' evolved a haunting visual grammar, too, for the shuffle of memory, as Erofeyev sifts through his memories of Irena – in a snowy street, waking through woods, at the train station – all shot on Super 8, in super-saturated colours, using a flickering frame rate that lends them a haunting, mnemic blur that foretells the similar blur of Bourne's memories.

A still from 'Looking for Irena', one of the documentaries Greengrass shot in Moscow for the BBC in 1993 and which later informed the Bourne films.

'Making those little documentaries in Russia with Clive eventually got me comfortable with not making movies,' he says. 'I did miss it, but I got to a good place with it, which was my life's moving forward, I know what's important. It's about making a new life with Joanna and making that work. She had immense patience. Those first couple of years were hard, as I dealt with the aftermath of a collapsed marriage and all the guilt and remorse you have to wade through, but thanks to her, I recovered my balance. I remember I used to say, "You

know what? Most people don't even get to make a movie. At least I can say I've made one." Slowly, I got over the feeling of being rejected. That Moscow trip was a key part of it. We had some fantastic adventures, Clive and I – went loads of places and did loads of things and worked like demons. We were there for months and months. It was a rejuvenation.'

'Be tough on your heroes, love your villains.' That was the advice legendary TV writer Alan Bleasdale gave Greengrass after reading his script, *The Fix*. The first of his TV dramas to be written, *The Fix* (1997) was the last to get made. Greengrass's most adroit expression of his ambivalence towards journalism, *The Fix* stars a thirty-two-year-old Steve Coogan, in his first dramatic role, as Mike Gabbert, the foot-in-the door reporter who, in 1963, brought down a football-match-fixing scheme that resulted in jail sentences and life bans for four players, notably England's then most expensive signing, Tony Kay (Jason Isaacs). For the first forty minutes, we are at Gabbert's elbow as he follows the money trail to its source, urging him on, but there is a note of facetiousness to Coogan's performance, alongside his shabby raincoat, shiny black suit and winklepickers, that keeps our sympathy at bay. Gabbert doesn't even like football and is not above a little entrapment to catch his prey. 'Yeah, I am bent, the whole stinking game is, but at least I love it,' says Kay, when confronted with his crimes on a hillside, in a scene which neatly pivots our sympathies: suddenly, it is the exposed footballer, along with his wife and daughter, playing the only game he knows, who commands our sympathies.

A similar eye for the story behind the news story animates Greengrass's other forays into TV drama: *When the Lies Ran Out: The Ian Spiro Story* (1993), with Alfred Molina as a Jewish boy from Golders Green who got mixed up in selling arms to Iran for Oliver North; *Open Fire* (1994), about Stephen Waldorf, the unlucky twenty-six-year-old film editor mistakenly shot by trigger-happy police on the lookout for a notorious armed robber; and *The One That Got Away* (1996), with Paul McGann as a corporal in the SAS patrol unit Bravo Two Zero, who had been dropped behind

enemy lines to destroy Iraqi Scud missile launchers and had to make
their own way back through 180 miles of desert to the Syrian border. But
the films always fell short of the one he had in his head. Filming a night
scene of the SAS patrol unit marching through the Iraqi desert – eight
of them, with multiple eyelines and dialogue, a darkly lit group at night,
trying to make sure the scene didn't look artificially lit, while hopefully
catching something of the ragged reality of stressed, exhausted human
beings, rather than actors waiting to deliver their lines – Greengrass found
himself furious, banging his head against a jeep in frustration with the
sequence as he had filmed it. 'I remember this particular night becoming
unbearably frustrated with myself,' he says. 'This sort of bubbling sense
that I was failing to make the film that I saw in my head, and I couldn't
understand why. I felt almost violent with myself, because I wanted to
have a breakthrough, to find a new way, but I couldn't seem to find it.
That was a feeling that stuck with me in those years.' Later, at about
5 a.m., when they had finished shooting, he went for a walk in the desert,
thinking, 'This is not right. I need some new way.'

At the root of his frustration was a couple of questions that grew louder
with each film: how could he marry the rough-and-ready documentary
tradition he came from with the practice of making polished fictional
dramas? How could he break free of the traditional film grammar –
the formal language of the tracking shot, crane shot, establishing shot,
close-up, reverse – designed to guide the viewer safely and clearly through
a scene, but whose precise carpentry gave the lie to the idea that what you
were witnessing had happened spontaneously? He called it 'the knowing
camera'. 'It kills me every time if I know what the camera is going to do.
That sort of grammar is not me. It's God-like, like a nineteenth-century
novel. The actors become pieces on the chessboard, being moved by the
authorial hand of God. It's all about camera movements that are dextrous
and elegant. But what's it in service of? The vicar comes into the dining
room, and the camera tracks back as he opens the door and he sits in
his seat, and it rotates 180°, and you're into a nice profile; there's a two-
shot there. Then he reaches down to the teacup, and you come to a nice
close-up, and then you take the reverse – it's all beautifully elegant, but

it's not me, because it's a knowing camera. It can only make those moves because everybody knows that that's what the moves are going to be. There is no discovery in it. And I wanted to break that, because that's not where I come from. I come from describing something that only happens once. I wanted to create an *un*knowing camera. And how do you marry that with a piece that you've written, where you do know? It's a paradox, it's a contradiction, and I was trapped in it.'

His frustrations finally spilled over while making *The Theory of Flight* (1998), which had been fished out of the slush pile of unproduced scripts at the BBC, and which had acquired a reputation as some kind of diamond-in-the-rough. Starring Kenneth Branagh as an artist-cum-amateur-aeronaut who shakes off a midlife crisis by building a flying machine, and Helena Bonham Carter as the paraplegic woman, speaking through a voice synthesiser, who helps him get airborne, physically and emotionally, the film was a queasy blend of off-duty Merchant–Ivory players, pretty hillsides and disability schmaltz. 'I think that all of us are probably capable of committing an act completely out of character,' says Branagh, his first line of dialogue in a film that must surely stand as Greengrass's least characteristic creative effort. On the first day of shooting, he found himself out on a rainy hillside in Merthyr Tydfil, and when Bonham Carter first started doing her Stephen Hawking voice, he and his director of photography, Ivan Strasburg, looked at each other. Everything Greengrass had been secretly afraid of in prep jolted into vivid life. Strasburg was famous for chattering to himself or his focus puller during takes, and as the scene progressed, he muttered, 'Oh, for fuck's sake. We're totally fucked here . . .'

That night, he and Greengrass went back to their hotel, got hammered and laughed at their predicament until they cried. Greengrass thought about quitting, but just as the shoot had begun, Joanna had found out she was pregnant with their second child and was going to have to give up her job, so he couldn't afford to walk. '*Theory of Flight* was an absolutely essential lesson for me,' he says. 'I was confronted with an inadequate screenplay. And a whole bunch of producers who were convinced that it was a great screenplay, and that my job was just to shoot it. But the truth was, because I could only see its inadequacies, I had no vision for the

piece. I was lost in film-making hell. You just sit there thinking, "This is just ghastly. Who am I? Who are all these people?" I went through that film in a state of intense loathing for them and self-loathing in equal measure. The writer thought his script was brilliant and thought he should be directing it. The producers and executives made it obvious they thought so too. The actors didn't fancy me either, and to be fair, I don't blame them, because I was offering them nothing. So you sort of go, "Oh, my God. I've stumbled into one of *these* directing nightmares."'

In the end, he had to suck it up and shoot it. One night, filming one of the movie's interminable speeches on another Welsh hillside at night, his producer, Ruth Caleb, said, 'We're never going to finish in time.'

'Of *course* we're never going to finish,' replied Greengrass. 'We've got three hours left and twelve pages of nonsense to shoot!'

'You're going to have to do something.'

'Okay,' he said, and ripped the script for that scene in half.

'But it's such marvellous writing . . .' she protested.

'It's not marvellous, it's nonsense.'

Caleb was unimpressed. 'You'll never be a director,' she told him, with that iron-clad certainty that only BBC drama lifers possess. 'You just don't have reverence for the text.'

Only his delight at Tony Blair's recent election victory kept him from returning fire. 'I was in a rage inside. Rage. As much against myself as anyone. It took me a long time to process the failure of *Theory of Flight*. All the mistakes I made and the position that I allowed myself to be put in. I seriously contemplated leaving the business. When eventually the rage subsided and I got my head straight, I found a determination that if I ever made a film again, I was going to be true to me and take no prisoners. Sir Alex Ferguson famously said that leadership rests on control. You have to have control; you must never concede it. And that was something I didn't understand until *Theory of Flight*. Control is everything. But control rests on vision. And if you don't have vision – and I didn't on *Theory of Flight* – you can't earn control.'

In October 1997, a close friend of Greengrass's, a TV producer named Mark Redhead, whom he'd known since the late 1970s, drew his attention to a long-form article in *Granta* magazine about the killing, four years earlier, of Stephen Lawrence, an eighteen-year-old black man. Walking home on the night of 22 April 1993, he and his friend Duwayne Brooks were waiting to catch a bus near the Well Hall roundabout in Eltham, south London, when a group of white youths ran across the road without warning – Duwayne Brooks heard the remark 'What? What? Nigger!' as the youths approached – and stabbed Lawrence twice. Remarkably, Lawrence, a trained athlete, ran a distance of about 150 yards before collapsing. As Brian Cathcart later described it in his 1999 book, *The Case of Stephen Lawrence*:

> The whole encounter took no more than a few seconds – seven seconds, it was later estimated . . . In that brief moment, Stephen was stabbed twice. One blow, to the chest, cut through two major

Stephen Lawrence (Leon Black) prepares to flee in *The Murder of Stephen Lawrence* (1999).

nerves, a large vein and an artery before penetrating a lung. The other, gashing the left shoulder, also cut through an artery and a vein. As a result, Stephen lost all feeling in his right arm and his breathing was constricted, while he was losing blood from four major blood vessels. The shock of the attack has sent his heart rate sharply up, so the blood was pouring out onto his clothing and onto the ground. At such moments, however, the body plays tricks. The nervous system reacts to mask the damage and natural painkillers flood the system, while fear and shock produce a rush of adrenalin. Stephen had no idea how terrible his injuries were; he knew he had been hit very hard, but that was all. He picked himself up and he ran.

Around those few vital seconds, ambiguity spread like ink on a blotter. The prosecution case was withdrawn for lack of evidence, and the jury entered formal verdicts of not guilty. The Lawrence team would allege an establishment conspiracy involving racism and corruption, while the police took refuge in the claim of incompetence. On 14 February 1997, after the suspects, acting within their rights, declined to give evidence at the reconvened inquest, the *Daily Mail* brought out its famous front page: photographs of the five youths, under the headline 'MURDERERS . . . If we are wrong, let them sue us.' The positioning of the *Mail* – of all the newspapers, the one least likely to align itself with a black family against the police – told Greengrass that something interesting was happening, a loosening of the social fabric that suggested change was afoot when it came to the subject of race in Britain.

He also knew that part of the world, which was just a spit away from Gravesend, and felt he knew the killers – not them, exactly, but boys like them. 'I knew those kinds of kids and their attitudes. I knew those issues. One of the things that I wanted to do in the Stephen Lawrence film was explore the complexities of racism as I understood it and as were revealed through that case.' He and Redhead also both knew Michael Mansfield, the Lawrences' barrister, and just before Christmas 1997 they met with Stephen's parents, Neville and Doreen, in a restaurant full of jolly people wearing party hats and pulling crackers. For a while, they talked about

Freud and Jung – Doreen was doing an MA in counselling – then, finally, over coffee Greengrass said, 'Look, this is your life. We don't want you to do something you don't want to do, but if you'd like to tell your story as a drama, well, we're volunteering to do it.'

He explained to them exactly how he saw the film and how he saw it proceeding; that he would come back to them in six months with a script and read it to them, acting it out, so they knew what they were getting. He offered them no money, a rule he'd brought with him from *World in Action*, one that he would bring to all his docudramas. He was trying to encourage what he calls 'stakeholders': people directly affected by the events depicted in the film who had an inherent interest in how it turned out. 'Political violence engenders great questions and quests amongst people who are touched by it directly,' he says. 'What does it mean? Why did it happen? Why isn't more notice taken? These are the questions that people ask, and of course, what they face is a culture where lots of meanings are imposed on it. And what people really want is to explore it in a way so that its meanings emerge. If you believe in the power of films to operate in that space, what they can do is show you, in that instance, something about the nature of racism. And that ranges from young kids with knives, saying, "What? Nigger!" and stabbing somebody. That's naked, violent, teenage racism. But then there's all those grey areas that radiate out from that act, including many by people who think themselves extremely well intentioned, and that's the nature of institutional racism – it's shades of grey, collectively depriving this family of justice. So if you select the right story, you can catch those meanings.'

After listening to Greengrass, the Lawrences agreed to the project and embarked on the first of many hours of interviews that would feed into the script. When the film was first commissioned by Nick Elliott, the head of drama at ITV, the public inquiry into the case had not yet been established, but as the extraordinary story of the murder and the disastrous police investigation spilled out, Redhead and Greengrass wondered if they should incorporate these details into the film. When they tried this, however, it became more like an eight-part series rather than a two-hour film, so they decided to keep the focus on the Lawrences and their

experience, which was that for most of the past five years they had been told virtually nothing of the case against their son's killers. 'I was talking a lot about the knowing camera and the unknowing camera,' recalls Greengrass. 'Mark and I talked about it many times, and I remember saying, "I've got to go for it this time. I've got to . . ."' Attractive locations were discounted for being 'too drama'. They abandoned tracks, dollies, even tripods – everything that smooths out the world – and decided that the entire film would be shot handheld on very fast 400 ASA film stock. Even night scenes on roadsides would be done using only available light. Greengrass told Ivan Strasburg, 'I don't want to shoot this conventionally. I want this to be like what I see. I want this to unfold urgently in front of me, and I'm not going to set shots for you in that way. I'm going to tell you broadly what I'm going to do, and then I'm going to follow this with you, with me on your shoulder, and I'm going to direct you as we go.'

Even so, on the first day, Greengrass almost choked. The first scene they were due to shoot was the one where the parents come and lay flowers at the spot where Stephen died, and as preparations got under way, Greengrass could feel his fear tightening. By about eleven o'clock, he thought to himself, 'I cannot afford to make a mistake.' And by about two o'clock, he was going, 'I'll just get the reverse.' He started shooting 'reverses' – the conventional building block of characters engaged in dialogue, shot at a standard angle and distance.

Redhead was distraught. They'd spent weeks talking about how Greengrass was going to do it. 'The fuck are you doing? What's the point of making this film unless you go for it? You can't find the film that you're trying to find with them unless you go for it first. You can't get them not to be safe if you're playing it safe, you know what I mean?'

When they came to the scene of Lawrence's Olympian, adrenalised run, Greengrass realised that Redhead was right. They had very little time in which to shoot it – only a couple of hours. 'Okay, here's how we are going to do it. It's going to be one shot,' he told Ivan Strasburg, his director of photography. 'We're just going to go with one.'

'But . . . what? You want me to sprint after him?'

'Yes, I want you to run after him. Do your best to keep it in frame, but I don't care if you don't.'

From there everything seemed to fall into place. Greengrass even started standing in a different position, not behind the camera, but up front, as close to the centre as he could be without being in shot. 'I saw how my pieces should be shot and I was able to stand in a way that mediated everything through me. You feel in command of it all, the entire 360-degree-ness of it. But suddenly there's a freedom to it. I don't want to play the scene so neatly that it's just these moments. I want to open them up. Let's just look at them on the page, open them up. It's like, I'm playing my script, but I'm opening it up and allowing other windows onto it. It's not improvising because it is the script, but I'm opening it up so that there's all this looseness and feathering and repetition and strangeness. Footballers talk about getting a side that starts to win matches and to roll. It just starts to roll. Suddenly, it's like, "We're cooking here, we're cooking." But not cooking in little bits. I've had little bits of cooking for films, but I've never had that sense of, I'm conducting this and I'm conducting it in the moment as it unfolds, which, of course, is what you're always doing. But suddenly it's free and loose, and you're making giant strides and mining a rich seam. I was standing in a different place and directing in a different way, finally. It's not like suddenly I started being a different person, but I found a way to liberate and express the energy that I felt inside in my films. It was exciting. It worked. I could *feel* it was working. It's like, "Yeah, fuck it. You're right. Let's go for it. Off we go."'

He was not the first to try the idea. Feature film-makers have been essaying something close to a handheld documentary style for decades, all the way back to Abel Gance's *Napoleon* (1927), whose snowball fight Gance filmed with one camera strapped to a toboggan, another that spun in a circle and a third that recorded what it saw through an angled mirror. 'The camera becomes a snowball,' said Gance, 'it is in the fortress and fights back.' Inspired by the newsreels of World War II, cinematographer James

Wong Howe shot the boxing matches in Robert Rossen's *Body and Soul* (1947) with a lightweight, handheld Bell & Howell 70D Eyemo camera as he roller-skated around the ring. In *The Miracle Worker* (1962), director Arthur Penn mimicked the disorientation of the blind and deaf Helen Keller, who, in *The Story of My Life*, wrote about her apprehension of a house: 'My fingers cannot, of course, get the impression of a large whole at a glance; but I feel the parts, and my mind puts them together . . . The process reminds me of the building of Solomon's temple, where was neither saw, nor hammer, nor any tool heard while the stones were being laid one upon another. The silent worker is imagination which decrees reality out of chaos.' This is not very close to how you or I see a house, but it is very close to how Jason Bourne sees a house, particularly one in which an assassin lurks. What do a boxer, a blind–deaf girl and a CIA assassin have in common? They are all, in their different ways, trying to avoid being prey.

When William Blake wrote 'Tyger, Tyger, burning bright / In the forests of the night,' he wasn't just indulging in poetic fancy, he was describing a physiological fact. Like most predators, a cat's eyes face forwards, but they also have a reflective layer behind the retina known as the tapetum lucidum, which reflects light outwards and thereby allows the visual pigments a second chance to absorb very low-intensity light – the equivalent of very fast film, preternaturally attuned to catching movement. That's why a lion's night vision is six times better than a human being's, a leopard's seven, and why nyalas, mountain reedbucks and grey duikers will all use the freeze technique to avoid predators. 'Detection of movement is essential to survival,' writes R. L. Gregory in *Eye and Brain*, a book Greengrass was given by his art teacher at Sevenoaks, Bob White, the central thesis of which is that perception is not a passive process, but a dynamic one, born of the need to predict the immediate future a fraction more accurately than the next mammal and, therefore, survive. 'We do not perceive the world merely from the sensory information available at any given time, but rather we use this information to test hypotheses of what lies before us,' writes Gregory. 'Perception becomes a matter of suggesting and testing hypotheses.'

THE GREENGRASS PAPERS

Simply put, the brain is a probability computer, making a series of high-speed predictions geared to our survival. When you get into a situation in which you perceive the need for fight or flight, one where things are about to get a lot worse, the adrenal medulla starts blasting adrenaline and cortisol into your system as fast as you can take it. Your heart rate goes up. Most of your blood vessels expand to accommodate the raging storm of blood roaring through your tissues. Your blood pressure and breathing rate rise. 'It is this adrenal medulla response that truly prepares you for the fight-or-flight response, the overriding physiological response that is about to change your body into another thing entirely,' writes Matthew J. Sharps in *Under Pressure: Stress, Memory and Decision-Making in Law Enforcement*. 'You are about to become faster, stronger, and more durable than is normally possible. You are literally about to become a superhero.' One of the more immediate side effects of this enhanced metabolic rate is 'tunnel vision' – a sense that your field of vision has narrowed to a single intense focus, such as might be needed to hunt prey – along with diminished sound sensitivity, heightened visual clarity and a feeling of a slowing of time, giving the perception of more opportunity in which to take the necessary actions.

It was this tunnel vision that Greengrass experienced for the first time in Beirut and reproduces exactly at the start of *The Murder of Stephen Lawrence*. On a dark stretch of one of London's B-roads, scarcely lit by the street lights, two boys are waiting for a bus – one just a few yards ahead of the other – when suddenly a gang of white youths run over from the other side of the road, raining down blows and kicking one of the boys to the ground, before running off into the night. The boy gets up and runs, urged on by his friend – '*C'mon, Stephen, c'mon! I think they're coming back*' – and the camera swings behind them, the street lights tracing a pendulous arc as the cameraman legs it to keep up with the boys' desperate, headlong sprint. They seem to have got away, the danger over, when the attacked boy, who has started to limp, suddenly collapses by the side of the road. '*No, Stephen, c'mon, man, c'mon!*' implores his friend, who crouches down to see what is the matter with him and comes away with his hands dripping with blood. We have seen no close-ups of knives

and no faces. If the film were not titled *The Murder of Stephen Lawrence*, you wouldn't be sure that what you have just seen *is* a murder. And in a sense, what Greengrass films is not the act of murder at all. What he commits to film is the experience of being murdered, in all its numbness, bewilderment and shock.

Chief Superintendent Isley (Michael Feast) disposes of Doreen Lawrence's list of suspects.

If *Resurrected* felt like television given a theatrical release, *The Murder of Stephen Lawrence*, made for TV, is unmistakably cinema. The film records the series of injustices visited upon the Lawrences, starting with Stephen's murder, followed by the botched police investigation into it, with an emphasis on the racial animus underpinning both – the material of a traditional, socially conscious 'issue movie', except Greengrass completely jettisons the speeches, exposition and point-scoring that usually turn the socially conscious drama into such a dutiful scold. He doesn't tell us what injustice looks like; he shows us. We feel outrage, anger, but all on the fly, so we don't feel manipulated. We don't have time. The quick, crowded, frantic actions of the emergency room where Stephen slips away are soon replaced by the Lawrences' living room in the days after his death, which is crowded with friends and relatives, the representatives of various political action groups from the black community

THE GREENGRASS PAPERS

and a pair of insensitive police liaison officers, who question the presence of everyone else ('Um, sorry, but who are all these people?'). Everybody seems to have a slightly different agenda to the Lawrences – how can it be otherwise when all the parents need to do is grieve? – but the movie doesn't give the couple a moment to themselves. Denied breathing space, they must instead fight for justice while still newly traumatised, and the film-making seems to share their raw, sensitised state. If *Resurrected* only came alive when Greengrass's fight-or-flight instincts were triggered, in *The Murder of Stephen Lawrence* those same instincts are rarely *not* triggered. It's a film made in the same super-adrenalised state that invigorated Stephen's Olympian run for his life.

The film is no whodunnit. Everyone knows who did it. After the murder, the neighbourhood buzzes with the killers' names, one helpful neighbour writing them on a scrap of paper and posting it through the Lawrences' letter box. Doreen (Marianne Jean-Baptiste) later takes the list and hands it to Chief Superintendent Isley (Michael Feast), during a meeting convened by the Lawrences' lawyer, Imran Khan (Shaun Chawdhary), to find out about the police's progress on the case, and then watches in dismay as he folds the list, once, twice, three times, until it is the size of a matchbox. She could almost be watching her hopes for

Neil Acourt (Ricci Harnett) goads the protestors at his court hearing.

clarity and justice disappear. A detail snatched on the fly by a mother desperate for an answer, it lands with exactly the right weight. Greengrass hasn't quite mastered his technique yet – there are a few pans to characters that betray advance knowledge of what they are about to do – but the film begins with a bravura sequence of long, handheld shots showing the killers as they emerge from a courtroom and are heckled and jostled by a large, angry, jeering mob, who are held back by a thin line of police. Exiting an elevator, they hear the crowd and pump their shoulders in readiness. Flashbulbs go off as they leave the building, and as the boys push their way through, one of the accused Acourt brothers makes a small gesture with his hands that is familiar from the football terraces or the pub after closing time: *You want some?*

It's a stunning sequence. Camera movements learned on the streets of Belfast and Beirut turn London briefly into a war zone. Bottles and punches are thrown, shirts grabbed, the camera bobbing and weaving as the boys punch back and duck, finally wrenching themselves through the sea of arms and bodies, before Neil Acourt, cocking a fist, seems almost to collide with the camera itself. What most impresses you about the style is its versatility, expressing equally the raucous tribalism of the killers as well as compassion for the community they terrorised. For all the rawness of its emotions, the film has an almost surgically light touch.

With *The Murder of Stephen Lawrence*, the director had found not just a style of shooting, but a whole new way of looking at the world, comprising equal parts chaos and compassion: the compassion softens the chaos, and the chaos sharpens our compassion. There's a lovely shot near the end, showing Neville Lawrence (Hugh Quarshie) talking to his son's grave. The speech is painstakingly plain. 'I should have protected you, you know?' he says in his soft Jamaican lilt, seemingly caught in a moment of private heartbreak by the camera. A technique that can convey both the privacy of a father's grief and the raucous energy of those who killed his son is a formidable thing indeed.

Before showing the film to the Lawrences, in a scruffy editing room behind Oxford Street in late 1999, Greengrass was nervous. He'd shown them the script at every stage in its development, there was nothing about

Doreen Lawrence (Marianne Jean-Baptiste) prosecutes her son's case.

what he'd done that was a surprise, but there was a world of difference between reading someone a script and talking through what you're going to do and them actually seeing it. 'Look, before we start,' he said, 'I just want to remind you, as we discussed, that we do depict Stephen's murder and the immediate aftermath in the hospital, and it's quite a distressing scene.' Doreen looked him in the eye and said, 'I just want you to know there is absolutely nothing, nothing that you could ever put on screen that will be the faintest shadow of the reality of what I've lived through.'

In that moment, all his secret fears about the film came to the surface. 'When it's all done, there's more than a bit of you that feels inadequate in the face of these events. A little bit, I suppose, like a cameraman visiting a hospital in a war zone. And somewhere inside you, if you don't feel that sense of . . . shame, really, inside, it would be wrong. These films are not tourism. Nobody asks you to make them. You go and ask these people if you can depict their lives, their tragedy. And you feel like you're charting a path where your constant fear is that what you're doing is illegitimate somehow. Because it's just a film, and these things are real. And you've got them in direct conversation. I mean, can you imagine making a film, any of those films, and have the families denounce them? That's your deepest fear, your deepest nightmare.'

At the end of the screening, Doreen said very little, thanked the film-makers and left. 'But there was an intense emotion in the room,' says Greengrass. 'You felt something had happened, something intangible but real. I felt it again after we screened *United 93* for the families. Something happens, and it's wordless, and then you feel there is something about the power of film that is extraordinary.'

A film-maker had found his voice.

'I felt like I was comfortable in my own skin at that point, which was unusual for me,' says Greengrass, of the months following *The Murder of Stephen Lawrence*, which was first broadcast on ITV on 18 February 1999. Later that year, the film won the BAFTA award for Best Single Drama. After it was shown in the US as part of *Masterpiece Theatre*, David Simon called up Greengrass's cinematographer, Ivan Strasburg, and offered him a job on *The Wire*, later screening *Bloody Sunday* for his cast and crew. 'I was certainly getting a lot of attention,' remembers Greengrass. 'You become *du jour*, you know? I'd gone through my slough of despond. I'd learned the lesson on *Theory of Flight* that you shouldn't make a film that you don't feel passionate about. Those are sort of fundamental final lessons that launched me forward into finding my voice. It's less finding my voice, more getting that steel in your soul that you need to make films. It is a contact sport; you've got to know your boundaries. And that was something I didn't understand until *Theory of Flight* and learned to my cost. It's everything. That film was all about getting that steel in your soul that you need to make films. I'd gotten to a good place.'

That April, Greengrass was sitting in an Irish cafe in Kilburn drinking an espresso. The sun was shining. Britney was soaring up the charts. Blair had just got the National Minimum Wage Act through parliament, upping the minimum wage to £3.60 per hour. Greengrass picked up a book Mark Redhead had been asking him to look at for weeks called *Eyewitness Bloody Sunday*, by Don Mullan, and started to read. It was a collection of first-hand accounts by those caught up in the events of January 1972, when at

the height of the Troubles civil-rights marchers in Derry found themselves under fire from British guns. Mullan had been fifteen when he went on what he thought was going to be a peaceful demonstration. He was at the corner of Glenfada Park and the rubble barricade on Rossville Street when the 1st Battalion Parachute Regiment advanced, fanning out across the waste ground to the north of the Rossville flats complex. He recalled the thump of rubber bullets, then the unmistakable cracks of high-velocity self-loading rifles (SLRs), and a youth clutching his stomach and falling to the ground with a cry of disbelief a short distance away. It was seventeen-year-old Michael Kelly. People ran to his aid, as others, including Mullan, sheltered behind the barricade. Suddenly, the air was filled with what seemed like a thunderstorm of bullets. The barricade spit dust and the wall above him just exploded, fragments of brick and mortar raining down on them. Mullan turned and ran through Glenfada Park, until three-quarters of a mile later a woman enquired, 'What's happening, son?'

'Missus, there must be at least six people dead,' he told her.

As midnight approached, the death toll crept up: not six, but thirteen dead and another fourteen wounded, including Peggy Deery, a mother of thirteen children, and fifty-nine-year-old John Johnston. Greengrass read Mullan's book in a single sitting. He could see it all: the families, in their Sunday best, gathering after lunch in a playing field at the heart of the barricaded Catholic ghetto they call 'Free Derry', singing 'We Shall Overcome' as thousands of them walk down the hill through the Bogside towards Protestant Londonderry's city walls, where the British army stand waiting – an irresistible force is about to meet an immovable object; the civil-rights leaders losing control of the march, and a section of the crowd, mainly youngsters intent on trouble, breaking away towards an army barrier; stones, bricks and bottles raining down on the soldiers, who crouch behind cars as an army water cannon hoses the crowd; the armoured vehicles revving and accelerating into the Bogside, and the paras debussing into a fleeing crowd. And then the awesome, percussive sound of British army SLRs firing live rounds. And firing. And firing again. And still firing. By the time Greengrass had finished the book, 'I knew I wanted to make a film about Bloody Sunday.'

5: RIOT

From the beginning, the problem was simple: how to recreate a violent riot without triggering a second? The dream for Greengrass and Redhead was a film that would be broadcast simultaneously on television in the UK and Ireland, and that everyone, whether liberal or conservative, republican, nationalist, Loyalist or moderate Unionist, would watch it and think, 'It must have been something like that.' While in Derry in September, the two men also optioned *Eyewitness Bloody Sunday* and brought Don Mullan in as a co-producer, less because the book had material they needed, more because Mullan came from the Creggan housing estate and had been there on the day, among the marchers, just two feet away from Michael Kelly when he was shot.

With Mullan at its head, they began an outreach programme, visiting schools, youth clubs, community centres and churches to spread the word and ask for the people's support. 'Initially there was a trust issue,' Mullan told *Irish America* magazine in 2003. 'Very honestly, many of the families told them that because they were English and because of their experience with Lord Chief Justice Widgery in 1972, they had fears and reservations. They would, however, feel more secure if I was involved.' He brought Greengrass and Redhead over and introduced them to the sister

of one of the men who was killed, Betty McDaid, so she could hear their pitch. 'Lads, I don't trust yis,' she told the two men. ''Cos you're English. But I trust Don. And if Don's involved, then it's okay.'

Greengrass delivered the same pitch to both families and financiers. He wanted to compress the whole story into a single twenty-four-hour period and stage it as a 'live' event, with cameras catching the action on the fly – 'hand held, hyper-real', as he wrote in a one-page proposal for the film, citing as a model *The Battle of Algiers*, Gillo Pontecorvo's stunning 1966 re-enactment of the guerrilla war between the French military force occupying Algiers in the 1950s and the rebel army led by Ali La Pointe (Brahim Hadjadj). Shot on stark, grainy, black-and-white film, giving it the immediacy of newsreel, and using non-professional actors, the movie records, with stunning neutrality, the asymmetric pitched battle between the French and the National Liberation Front (FLN). 'People practically never experience the great events of history with their own eyes,' said Pontecorvo, 'so not only did I want to shoot in black and white, I also wanted to use the same lenses which would reproduce images like those of the mass media.' Pontecorvo was hailed as a 'Marxist poet' by critic Pauline Kael, and the film was later shown by the Pentagon to its military leaders in the wake of the 9/11 attacks, in order to illustrate the principles and dynamics of a counter-insurgency battle. To them, it wasn't a movie about the past, it was a movie about their future.

Greengrass first saw it in the film club at Sevenoaks. 'It was an enormously influential film on me,' he says. 'A little bit like the Maysles brothers' *Gimme Shelter*, the same shock of the new. In my mind, it's incredibly clear and vivid that that film, along with *Don't Look Back* and *Z*, it was like, fucking hell, I loved it. They really spoke to me, those films. That's the world. Collision. Conflict. Character. Violence begets more violence. The way that violence really is so sudden and almost random. The tremendous narrative drive of *Battle of Algiers*, the way that you could make reality unfold like a thriller, with that great Morricone score. So you could be looking at an ordinary street and a cafe, and people are going about. They've been sitting in the cafe, chatting. What they don't understand is that somebody's put a bomb under the table. Of

course, Pontecorvo's world view was a classic sixties, post-imperial, rad-
ical world view: that in the conflict between the colonial oppressor and
the oppressed, history will judge the oppressed the winner, because they
will rise up in the end, and the oppressor will be forced to go home.

'And that's what you see in *Battle of Algiers*. He charts that process. The
guerrilla war that radicalises, leading to the counter-insurgency that the
colonel leads. He smashes the guerrilla movement, but at the end of the
film the people come out of the Casbah and the French go home. But it
didn't seem to speak to the world that I knew. In Northern Ireland, every-
body knew you couldn't say to the Protestants, "You've got to go home."
They already *were* home. They weren't like the French colonists in Algeria.
The conflicts I'd grown up with and experienced were those in which two
tribes lay claim to the same land – Palestine, obviously, but also South
Africa and Northern Ireland. That was why Derry occupied such a very
important place in my imagination, because in Derry you had the emer-
gence of the civil-rights movement that said, "We've got to live in the same
space." It was about shared rights, not contested nationalism. That was one
of the reasons that made me want to make that film in that way. *Bloody
Sunday* was my homage to Pontecorvo, but also my dialogue with him.'

After attending day one of the Saville hearings, convened by Tony Blair
to reinvestigate the events of that day, Greengrass decided that there was
little need to do their own research; they could just dig into the thousands
of eyewitness statements gathered by Eversheds' solicitors for the inquiry
and use those to create a 'baseline' for the script. He also rescreened Leslie
Woodhead's documentary for *World in Action*, 'The Demonstration'
(1968), about the anti-Vietnam protest in Grosvenor Square that was
met with a cavalry charge by mounted police. The first wave of vérité
documentaries in the sixties – the Maysles brothers' *Salesman* and *Gimme
Shelter*, Robert Drew's *Crisis: Behind a Presidential Commitment* (1963) –
had shown that without presenters or narrators to give shape to a story,
it was more straightforward to film a situation in which the narrative
was fully formed, like an election or a sporting event. The critics called
this the 'crisis structure', which sees subjects facing an imminent crisis
in their lives that comes to a dramatic climax, with a winner-or-loser

PROVIDED BY
MINISTRY OF DEFENCE
FOR BLOODY SUNDAY
INQUIRY 1998

The Ministry of Defence report on the events
of Bloody Sunday, declassified by the Saville
Inquiry in 1998.

outcome. Greengrass's docudramas – *Bloody Sunday*, *United 93*, *22 July* and, to some extent, *Captain Phillips* – all follow it.

'The "tipping point" is a phrase I use a lot when I'm making a film,' says Greengrass. 'If you can identify a tipping point and look at it in enough detail, you can see broader truths. You don't have to put them there; they are there. If you select the right event and tell it with dispassion and compassion, and with rigour, and you listen to the event, and you get the right actors and the right crew, and you get your head in the right place, then it is possible to unlock the truth about it. It's like looking at something through a microscope. You see much broader truths. In Iraq, the tipping point was the de-Ba'athification and disbanding of the Iraqi army – that pushed the whole country off a cliff. That's what I was trying to get to in *The Bourne Supremacy*: the tipping point at which the desire for revenge becomes instead a desire for atonement. At what point does Bourne stop running? Of course, you can often get multiple tipping points, as was the case on *Bloody Sunday*. [The journalist] Eamonn McCann said that Bloody Sunday marked the point at which war became unavoidable. That was my thinking behind the film. I wanted to show that point.'

Among the many 'stakeholders' Greengrass consulted before making *Bloody Sunday* – the families of those killed and wounded, politicians like Ivan Cooper and John Hume, religious leaders, community leaders, historians, journalists such as Eamonn McCann – was Raymond McCartney, one of the hunger-strikers, whom he'd interviewed in his cell at the Maze almost two decades before. McCartney had been near death when Greengrass saw him, emaciated and filthy, but not long after had come off his hunger strike. Towards the end of his twenty-five-year sentence, he became the IRA's commanding officer within the Maze, playing a critical role in persuading the large numbers of Provos inside the H-Blocks to accept the negotiations that ultimately led to the Good Friday Agreement. He'd corresponded with Greengrass a little since his *World in Action* film, and after he was released in 1994, they spoke a couple of times on the phone, enough for 'a friendship of sorts' to grow between the two men.

When Greengrass went to see him in Derry in the autumn of 1999, McCartney had married his girlfriend, Rose, who had waited for him throughout his sentence. They now had two kids and lived in a small house in the Shantallow area of Derry. Meeting him at his door, Greengrass noticed how time had left its mark on McCartney's face, now without its long beard, and registered the passage of time in his own life. They had a coffee with Rose and talked families and football ('One of the oddities of my roam around the Troubles was the way the Brits were seen as the problem by all political actors, yet they all madly followed English football teams'), before taking a long walk in the hills behind Shantallow, with their views towards the River Foyle and Donegal. Greengrass got to ask McCartney all the questions he had not been able to put to him in 1980. *Was the violence worth it? Did we get to a better place? When he thought back to the killings, did he have regrets?* 'All the obvious questions that a liberal would ask, you know. Ray McCartney was a dedicated Provo. And though later his convictions were quashed because of the beatings he was given during the interrogations after his arrest, I had little doubt he had been involved in the armed struggle.

'"I was a soldier," I remember Raymond saying. "I have no regrets. I had to do what I had to do. But those days are gone now." And so whilst

I understood his loyalty to the Provos, I totally believe he wanted to make peace, and he had played his part and he'd given a lot – twenty years of his life. The conversation was a very intense, intimate encounter, oddly, because when I'd last met him, he was six stone and about to die, and I was a young kid, and now here we were, meeting again in a different world.'

Greengrass told him he wanted to make a film about Bloody Sunday, but before he did, he was trying to take everyone's temperature and work out whether it was going to help or hinder the peace process. 'It will mean finding British soldiers pre-pared to be involved,' he told McCartney. 'We want to recreate the march, start-ing at Creggan fields and down through the Bogside, and then the confrontation with the RUC and the sol-diers, all the way through to the rioting, the killings and out the other side. But I want to do it in a spirit of reconciliation. What do you think? Is that even pos-sible, given that I'm a Brit? And how will the community feel about that?'

The Maze prison, in Northern Ireland, where Greengrass interviewed hunger striker Raymond McCartney.

He was acutely aware that on some level, in talking to McCartney he was talking to the Provisional IRA in Derry – or, at least, leading ele-ments within that world. McCartney was a close friend and colleague of Martin McGuinness, the dominant figure in republican circles in Derry. And despite the peace process, the Creggan and the Bogside were still republican strongholds. 'I wasn't asking for his permission, but I genu-inely wanted his opinion. I told him, "I don't want to do it if it stirs people up in a bad way."'

McCartney said, 'You should do it. Make whatever film you want.'

Greengrass's first big creative decision was to centre the film around the character of Derry MP Ivan Cooper, a Protestant who nonetheless was at the forefront of the largely Catholic civil-rights movement, and one of the organisers of the march who had struggled to keep events from sliding over the precipice. To play him, Greengrass wanted Jimmy Nesbitt, one of the most popular actors in Northern Ireland, himself a Protestant who had grown up just a few miles from Derry, so his history echoed Cooper's. Greengrass and Mark Redhead went to see the actor in Manchester, where he was shooting the TV series *Cold Feet*, and they talked into the early morning about what they were trying to do and why they wanted him. 'A lot of people of my Ulster Protestant background would have been very suspicious of the notion of a film about Bloody Sunday,' Nesbitt told the *Independent*. 'Our fear would have been that it would be terribly anti-Britain and anti-soldiers, a piece of nationalist propaganda.' But he read the script and was persuaded by its tightness and balance. Nesbitt's father read it and told him, 'You have to do this.'

While Nesbitt began his research, casting directors Dan Hubbard and Chris Villiers began the search for former British soldiers who had served in Northern Ireland and were willing to return to use their own experiences in re-enacting the day. One of the things Greengrass had learned from his SAS TV drama, *The One That Got Away*, was that it was 'better to get your soldiers to act than it is to get your actors to soldier'. Moreover, the British army were stakeholders in the events being portrayed, too. 'It was quite easy to find soldiers who'd served in Northern Ireland, not so easy to find ones who would come back.' Greengrass had long conversations with Cooper and other local politicians about the safety issues around bringing British soldiers back into the area and asking them to mix with the people of the Bogside and the Creggan. Special Branch and the British army were at that time pursuing a 'non-visible' policy in Northern Ireland. 'Anyone who's ever spent time in Northern Ireland knows how volatile the place is. You could create great difficulties if you acted stupidly, and this one needed a lot of thought.'

Before filming began, Nesbitt went to Derry and met with Cooper, who still carried a great burden of guilt about his part in the events of

that day. He tried to persuade the politician to walk the march route with him. 'Oh, Jimmy, I just can't, I can't. I haven't done it in thirty years,' replied Cooper, but Nesbitt prevailed upon him, and they began the walk, starting at the Creggan playing fields. 'As we were walking, I could see the album of his memory opening up to him,' said Nesbitt. 'He almost aged in front of me. You could see the colour draining from his face. I said to him a couple of times, "Are you okay?" I knew I was putting him in a situation. Then he started to talk about the water cannons and the rubber bullets and then the sound of the real bullets. We finished it and he was not broken, but I think it was unquestionably an exorcism for him. We were standing there, and he put his arm out and steadied himself. It was an incredible thing . . . Just the sense of silence that he had and the memory of an abject and unnecessary loss.'

That night, Nesbitt returned to the Strand Hotel, where he was staying in Derry. He ordered a pint of Guinness at the bar and was about to drink it when he felt a tap on the shoulder. He looked round and this guy said, 'Who am I?' Nesbitt looked at him and said, 'You're Bubbles Donaghey. You were the first man shot on Bloody Sunday; you were fifteen and shot in the thigh.' All the research Greengrass had asked him to do had paid off. Donaghey held out his hand to shake Nesbitt's. 'Okay, you'll do for us,' he said.

After months of patient work, pitches and pleas to the communities of the Bogside and Creggan to take part in recreating the march, Greengrass stood on the Creggan playing fields in the early afternoon of 28 April 2000, alongside Jimmy Nesbitt, Ivan Cooper, Don Mullan and the camera crew, which was headed up by Ivan Strasburg, next to a version of the famous blue van that Cooper had used, and waited anxiously to see if anyone would turn up. They had asked people to arrive on time to start shooting at two o'clock. Since they didn't have many costumiers, they had to rely on people coming as they were, although they begged them not to wear trainers or any bright pieces of clothing. But as the clocked ticked down to two, the concern was less what everyone might be wearing than whether anyone would turn up at all. 'This was the bet of the film,' says Greengrass. 'If nobody shows, there's no film. It's all over. We're done.'

Quarter to two, there was still no one.

'It'll be all right. It'll be all right,' Mullan reassured an anxious Greengrass.

'What do you mean, it'll be all right?' he responded. 'Where are they?'

'They'll be here.'

Ten to two, still no one.

Nesbitt looked at Cooper and Greengrass, wondering what was going to happen next. It certainly wasn't *his* fault. The joke was that Nesbitt had, by that point, had a drink with everyone in Derry.

Then suddenly, at around five to two, the field started to fill with people – hundreds, then thousands of Derry locals, a vast throng all wearing brown and green and grey, no bright colours, no trainers, some bearing umbrellas, flags or home-made signs reading 'Go home!', 'We shall overcome!' and 'Free all internees now!' The general air was curious, expectant, as if they didn't know whether they were there to celebrate a wedding or a funeral. Strasburg and the rest of the camera crew got into position, fanning out, some on the blue van, others at the edges of the crowd. From Pontecorvo Greengrass had learned to direct small pockets

Ivan Cooper (Jimmy Nesbitt) steels himself for the march through Derry.

THE GREENGRASS PAPERS

of activity, working in concentric circles, shooting tight on Nesbitt, playing Ivan Cooper, and his gang, including Bernadette Devlin and Eamonn McCann. He had one cameraman on top of the van, another walking alongside and a third out wide so he could keep track of the moment when half the crowd would peel off for a confrontation with the British forces at the so-called 'Aggro corner'. 'So, you worked out a fundamental plan, but essentially it's a live event, which you control by having concentric circles. The innermost ring you can control, and you let the rest go.'

Greengrass turned to Nesbitt and said, 'Okay, Jimmy, off you go. We'll follow you,' recalls Greengrass. 'And this is where, in the fog of it all, all our planning came to bear. It was absolute fucking chaos, but it's thrilling because you've planned it in the knowledge that you can't control it. You're reacting to something that has a life of its own; it's this free-form thing. You catch a glimpse of it, and then it's off and running, and in truth, that's the only way you can do it, because otherwise it's bogus. So you're looking to pit the elements of control against the forces of disorder, because they're built into the structure of what is, in the end, a low-budget film, and you've got to trust that in the middle of it, with your fleet-footedness and ingenuity, you can capture your moment. There is no controlling a crowd at a certain point. The crowd has an inner logic of its own. You've got to be prepared to follow it. As long as you're ready for it and you know how crowds operate – as Ivan and I did, having been in a million crowds by that point; we knew what they were like, and he knew how to operate in them, which is, don't try and control things. You just have to surf and find your point of attack, your way in.'

At around 5.50 p.m. on the evening of Sunday, 30 May 1927, a large crowd gathered at Croydon Airport spotted a small aeroplane on the horizon, accompanied by six British army aircraft. Captain Charles A. Lindbergh had arrived in his single-engine monoplane, *The Spirit of St. Louis*, having just completed the world's first solo non-stop transatlantic flight from Long Island, New York. When they saw the plane, the

crowd erupted in cheers, broke through the police lines and surged across the tarmac of the runway, forcing Lindbergh to abandon his descent, fly upwards again and circle the airfield while police forced the crowd back. It was not until ten minutes later that they managed to clear a space large enough to permit him to land. The jubilant crowd, waving American flags, smashed fences and knocked down police as the plane came to a halt, and the young American pilot emerged from his cockpit, grinning and serene, as English notables fought to get near his plane. Scores of people fainted in the crush, while others suffered minor injuries. One man's leg was broken; another fell from the top of the hangar, injuring himself internally. Lindbergh's first words, as he reached the reception room where Sir Samuel Hoare, the British air minister, United States ambassador Alanson B. Houghton and others were waiting to greet him, were, 'Save my plane!'

Among the crowd that evening was a young David Lean. 'It was in the papers that he was flying the Atlantic, then he was seen over Ireland and he landed in Paris,' he wrote in the unpublished *Notes for a Film*, cited in Kevin Brownlow's biography of the film-maker. 'We knew that he was coming to Croydon and the crowds were enormous. I can see him now, a tall, blond, slim figure as he climbed out of his tiny plane.' Next to the cinema and radio, Lean's principal source of excitement as a boy was Croydon Airport, a mere bicycle ride away, where vast crowds would gather to watch the planes take off and land. Many famous aviators launched or completed their epic flights there – Charles Kingford Smith, Alan Cobham, Jim Mollison, Amy Johnson – but what fascinated the young Lean, as much as the planes and pilots, were the crowds. The memory of the vast throng gathered around Lindbergh, a visible embodiment of the great man's aura, stayed with him. In *Lawrence of Arabia* (1962), he framed Peter O'Toole the same way, another tall, blond, slim figure, this time in white robes, commanding cheering crowds from atop a train, silhouetted by the sun. 'Yes, sir, that's my baby,' says the press photographer who takes his picture. Lean's crowds are centripetal. They are an expression of greatness, a dream of glory, obediently marshalled and radiating out from the great man at their centre like spokes on a

wheel. In *Doctor Zhivago* (1965), Omar Sharif watches powerless as the Cossack cavalry rides into the St Petersburg factory workers, women and children petitioning the Tsar. Everything is seen in his close-up. 'I decided that as they clash, as the dragoons hit the crowd, I cut to Zhivago and just stay on his face for about a minute, just with the sound on it,' said Lean. 'And then, at the end of it, cut, and there are bodies in the street and the dragoons are gone. Now I've taken myself out on a limb because I haven't shot anything beyond the actual charging down the street, so if it doesn't work on his close-up, I'm cooked.' It was this scene, in particular, that drew Greengrass's eye when he saw it, aged ten, with his father in Leicester Square.

'Lean is reaching back here to Eisenstein, as he shows the charging cavalry, the slashing swords, women and children screaming and running, bodies falling. Lean and Eisenstein were all about letting the frame dictate the crowd, essentially as decoration, a graphic element. In my films, I want the crowd to dictate the frame. I am most comfortable in the middle of a live event, responding to it unfolding around me, both from my upbringing and my *World in Action* days – extremely comfortable, I would say. I want to be in the middle of it. You have to start with structure, you have to start with a screenplay, you have to start with a deep understanding of what it is you want to say, you have to start with a question that needs answering, to which the film itself can only be the answer. And it will only be the answer once, so in that sense it's a theatrical act, really. It's only going to be the once; you're not going to come back and do it again. It's not like you're shooting scene 64B, exactly like a storyboard; you're shooting something that's got a life of its own. And you've got to plan for that in the most meticulous way, understanding what forces are going to be in play in the physical rendering of the scene. It's going to be a crowd, and where's the crowd walking, what's the intensity of the crowd? What's the crowd made up of? Is it made up of middle-aged men and women walking to church? No, it's going to be made up of lots of boisterous kids. How's it all going to look and feel? It's going to have a mass to it, and it's going to have inside it a mass of detail, of individuality.'

Greengrass may be one of the few modern film directors who are genuinely unafraid of the mob. He is moved and excited by the spectacle of human rioting as perhaps no film-maker has been since Costa-Gavras and Pontecorvo. 'The future belongs to crowds,' wrote Don DeLillo in *Mao II*, and in Greengrass's films all the dread and magic of modern collectivity is caught and transposed into thrilling patterns and fractious spectacle. When Lean directed Omar Sharif observing the crowds on the street below, he told him to think about sex: the passions loosed were the same. 'By the mere fact that he forms part of an organised crowd a man descends several rungs in the ladder of civilisation,' warned Gustave Le Bon in his wildly influential 1895 treatise *The Psychology of Crowds*. 'Isolated, he may be a cultivated individual; in a crowd, he is a barbarian – that is, a creature acting by instinct.' Beneath the exquisite crowd control of Lean and Steven Spielberg beats a similar fear: what would happen if one ever slipped out of their control?

In Greengrass's films, we find out. If Lean's crowds are centripetal, Greengrass's are centrifugal. His crowd scenes have the crackle and electricity of genuine chaos; you never have the impression of extra no. 17 marching on to perform their appointed bit of business and then exiting stage left. People congregate and clash, the audience part of the scrum, carried along by the momentum of events, moving like an ocean or a murmuration of starlings, swelling and buckling in fantastic shapes. His crowds are a natural phenomenon, a force of nature fortified by the blood of numbers, with a life of their own, their own will, strength and morality. In a Greengrass film, they are never the enemy – mindless, seditious, wantonly violent. There is a hidden order to the chaos. The crowds in *The Murder of Stephen Lawrence* and *Bloody Sunday* bay for justice. A riot is the 'language of the unheard', said Dr King. People do not 'lose themselves' in the mob. They find themselves, like Jason Bourne disappearing into the sea of student demonstrators on Alexanderplatz in *The Bourne Supremacy* or the masses in Waterloo Station in *The Bourne Ultimatum*, shoulder to shoulder with their fellows, safe, anonymous.

'Attending football matches as a kid teaches you to read a crowd, to know where to go and when,' says Greengrass. 'I've always understood

that the camera is an extension of you when you went out as a kid, wherever it was, looking for trouble but not wanting any. That was what you did. You'd be looking for those moments. Crowd psychology is fascinating because it's primal and has an identity beyond an individual, so there's a theatricality to the movements of crowds and how they respond. But, at root, crowds are all about identity. That's really what's going on. It's to do with tribes and identity and blood. That's true of football crowds just as much as crowds in Northern Ireland or the Philippines. It's about identity, and you surrender to the identity. You belong. It's about deeply belonging. Or that footage we got in Zagorsk, when I went to Russia. It was just the intensity of emotion. Some thousands of people. You're absolutely packed in like sardines, and it's closed and the incense . . . I mean, you're all off your faces because it's slightly hallucinatory. You come out from there, head throbbing. I mean, it is transformative in that way because the incense is intense, and that music – God, it makes the hairs stand on end. People weeping because it was their identity found. Mother Russia. It's the first scene in *Zhivago*, isn't it, with the funeral. The very reverse of that, because it's in the middle of nowhere, but it's the same idea – somewhere, deeply belonging. It was a religious festival, but you could feel Russian nationalism stirring, and like English nationalism, it's got a dark side, and I felt then that the democratic experiment was not going to end well. The rage, of course, comes when people feel their belonging's denied to them.'

'In every riot in Northern Ireland there is a man with a megaphone waiting for the meeting to start,' wrote Eamonn McCann in his 1974 history of Derry, *War and an Irish Town*. In *Bloody Sunday*, that man is Ivan Cooper, as played by Jimmy Nesbitt a cheery and indefatigable man of the people, with a dash of cheek but also a hint of exhaustion as he threads his way through the streets, greeting each of his constituents by name ('Mrs Hagerty, I hope you'll be joining us today') and handing out fliers for the civil-rights march. To modern eyes, we're in an unfamiliar

patch of Northern Irish history, before the start of the Troubles, when it was still possible that a Protestant like Cooper, who is dating a Catholic girl, might organise a march on behalf of Irish Catholics protesting against internment by the British security forces. If a single person could bring peace to Northern Ireland, then it is Cooper, who seems to be on a mission to personally charm the area into comity, pleading with teenagers not to hurl rocks at the British troops and engaging in a tense head-to-head with an implacable IRA man, Martin McGuinness. 'Marching isn't going to solve this,' says McGuinness, scanning the piles of rubble, the angry youths, the line of British soldiers. 'You watch us,' says Cooper, showing a rare flash of anger.

Bloody Sunday cleaves to the same parallelism as *Doctor Zhivago*, fading in and out of multiple storylines in the lead-up to the day's events, but without any of Lean's lofty, bird's-eye omniscience. Greengrass's natural home is in the thick of it. In the background of Cooper's peace-keeping efforts, we observe the remorseless build-up of armoured personnel carriers and troops, who are led by the iron-fisted commander of the British forces, Major General Ford (Tim Pigott-Smith), newly arrived from Westminster with news of the prime minister's impatience with what he calls 'this Londonderry Rebellion'. Further down the chain of command, we have the leader of the 1st Parachute Regiment, Colonel Wilford (Simon Mann), an impatient bulldog tasked with 'teaching these hooligans a lesson', and his squad of paratroopers, who are tired of being shot and spat at. The fade-outs in between scenes act like a countdown, although to what, we do not know yet. The rhythm of the film builds with an implacable sense of dread, mixed with anticipation and even sick excitement, of the kind reported by war correspondents at the onset of battle. As with *The Murder of Stephen Lawrence*, the docudrama form allows for an extraordinary freedom from the didacticism to which a traditional feature about Northern Ireland might be prey. In a typical film, we would have to choose sides for better dramatic effect. But here we understand the soldiers' impatience and anger, just as much as we do the Derry youth, who are sick of having snipers in their high street, and the result is not a wan even-handedness, a mouthing of empty assent to both sides,

but an electric sense of contest that the audience feels in its stomach as a small pit of dread as it watches events slide inexorably into chaos.

When a splinter group, younger and rowdier, peels away from the march and heads down to Barrier 14 to shout at the British troops ('*Get you the fuck out, you British bastards*'), we are there with Gerald Donaghey (Declan Duddy) and his friends. We know that Donaghey is flirting with a second arrest, but the excitement he feels is a close cousin to what Greengrass felt as a teenager when he was on the edges of trouble at football matches, and as Cooper heads down to see for himself what is happening and turn the crowd around – 'Boys, get back, get back!' – he is one man against a tide of people. The film-making catches the crackle of chaos, the camera right there with Cooper as he elbows his way to the front of the crowd, where the British soldiers stand guard. 'Excuse me,' he says, and smooths down the front of his jacket, a beautifully comic gesture,

Derry residents run from the paras in *Bloody Sunday* (2002).

as if to demarcate himself from his more boisterous friends in the pub as the bricks and stones begin to rain down overhead. 'I'm Ivan Cooper, I'm a Member of Parliament, if you can just give me some time . . .' As the Area Superintendent declares through a megaphone, 'Under Section 6 of the Civil Authorities (Special Powers) Act of Northern Ireland, processions and parades are banned until further notice . . .' both men's actions seem equally futile. You might as well declare an ocean illegal. They are standing in the middle of a riot.

———

After shooting the first half of the march in Derry, the production moved south to the Ballymun area of Dublin, where researcher Lucy Dyke had located the best facsimile of Derry's Rossville flats; built in the late 1960s to a particular design, with open land to the front, the flats – the scene of the worst of the killing – had been demolished about ten years before. Greengrass had written the screenplay so that at crucial moments he could cut back to the army control room, where the radio messages coming in and out knitted together the various theatres of action. Finally, nearly 1,500 Derry locals were bussed in to Dublin for their angry confrontation with the British paras in their maroon berets – about as inflammatory a symbol as you could imagine – on the production's version of Rossville Street in Ballymun, facing off at a distance of about 300 yards. Greengrass got up and made a speech about 'the shared narrative of Bloody Sunday' and the importance of making something that everyone, 'whatever tradition we come from, could feel was a version of the truth', all the while thinking quietly to himself, 'Well, that's not going to work.' He looked at the maroon berets of the British soldiers on the one side and the banners and flags on the other, and began to wonder: had he just made the biggest mistake of his life?

'You walk out onto the street, and you see it all taking form, all that you've envisaged in your mind up to this point as something in the abstract. Then it takes physical shape, and you can feel the vibrations of history and animosity and fear. I began to get the bad feeling of

not having got it right. Suddenly, it's not just a film set. There's something real going on – a whole bunch of former British soldiers back in Ireland, wearing those – to Irish eyes – notorious crimson berets, and on the other side, 1,500 people from Derry, many of whom had family members on the march. There's an electricity, a tension, real tension. And Don I remember walking across no-man's-land and going up to the soldiers and holding out his hand and saying, "My name's Don Mullan. Welcome, really glad you came." That was a big thing for him to do, of all people. A *big* thing for him to do. That broke the ice, and then all of a sudden it melted away, or even became a different thing. It became a film.'

He cut the film with Clare Douglas, who had worked on *Stephen Lawrence*, and together they tried many different ideas, including a split-screen version. 'We had such an abundance of material, we wondered: what would happen if we actually played this as a split-screen film? So you were following all these threads, not in real time, but you'd go from single screen to double, maybe to triple, to quadruple, and follow it that way. And I actually put that together. In the end, I didn't like it as much, but it was a useful way of clarifying our thinking, because it was essentially about pitting the elements of control against powerful forces that are uncontrollable and trying to bring those two things together. I just remember endless days and nights as we wrestled both those films into shape, and Clare had the perfect temperament because she was not over-assertive, but not under-assertive. She was a woman of great convictions, political and otherwise, but in a gentle, understated way. She had a great belief that a film should speak for itself, so she was not as assertive as I would naturally be, but somewhere in those two films that yin and yang between us helped enormously.'

While editing, one scene in particular caught his eye: a sequence shot by Ivan Strasburg of a soldier who had run off set when his gun jammed (it happened a lot with the blank ammunition) in order to fix it. 'So, it was entirely unusable as a piece of film, because I even think there was a sign that said, "Set this way." But Ivan had followed him because he'd come in and was clearing his weapon. And I remember doing the cutting

and looking at this guy, and there was an intensity about what he was doing. He was entirely oblivious to anything. He was oblivious to being filmed. He was oblivious to the fact that he was standing next to a piece of old plywood. It was like, you could tell at some level that he'd entered the zone of his own memories. Not Bloody Sunday itself, because he was too young. But he'd been on those streets and felt the boredom, the tension. He was emotionally reliving that. He was in a zone of intensity, a bit like when you're a kid and you play a chasing game, and it just becomes so real, even though it's a game. That's what it was like. You just felt these waves of intense, unmediated emotion. It was all the way around that set, in a million interesting ways.'

Admitting defeat, Ivan Cooper returns to his blue van and the remaining peaceful marchers, entertaining them with his jokey patter – 'Mrs Hamill, I haven't seen you march like that since '68' – even as we can clearly see tear gas and a hail of bricks at the end of the street. 'We have to show them that non-violence works,' he says, 'because civil rights isn't the soft option . . .' Cooper now seems like a man hanging on to peace by a very slender thread. At his end of Rossville Street, civil rights are still within reach; at the other, it's the Normandy landings. The dissonance is extraordinary and awful at the same time. It's the last point at which Cooper seems ahead of, or in control of, events. From here on, he will be a man trying to outrun an avalanche. As Aggro corner disintegrates into chaos, something finally tears. 'We've got to teach these people a lesson,' says Colonel Wilford, whom we have seen champing at the bit to let his men off the leash. 'We've got to go,' he radioes to base. 'On whose authority?' stammers Brigadier MacLellan (Nicholas Farrell), but it is too late: an armoured battalion of British soldiers is heading for the car park of the Rossville flats, armed with high-velocity 7.62mm SLRs, looking for targets amid the fleeing protestors. Of all the afternoon's possible outcomes, we have now arrived – incredibly, imperceptibly – at the worst.

As chaotic as events now become, we are always oriented with regard to what is happening and where by the cutaways to the army comms room, with its maps and radio intelligence – a trick Greengrass would later repeat with the Bourne movies. The ex-journalist in him thrills to information hubs of all sorts, as a means of both delivering crucial exposition and orienting the viewer within the film, but it's more than just a matter of orientation. Beneath the propulsive momentum of *Bloody Sunday* and its visceral impact lies an extremely keen diagnosis of systems failure on the part of the British authorities, with Brigadier MacLellan, a more experienced hand when it came to Derry, trying to dial down the harshness of his superior's orders ('Tell Wilford it's just one unit to pick up the yobbos, and no running battle up Rossville Street'). MacLellan, though, is sandwiched between two more bellicose men, and when Wilford and his men head out in the direction of the Rossville flats, the film's mixture of excitement and dread comes to a peak. It's crunch time. What follows is probably as close as a modern audience will get to knowing what it was like for audiences to see the Odessa Steps sequence in *Battleship Potemkin* for the first time.

Greengrass puts us right there on the ground, propelling the audience with a series of rolling, vertiginous, handheld camera movements as Support Company pile out of their armoured carrier, take up positions and fire first rubber bullets and then live rounds into the fleeing crowd, the unmistakable crack of rifle fire – 'They're firing live rounds,' says Bernadette Devlin – echoing off the Rossville flats. As Gerald Donaghey and his mates make for the cinder-block barricades, the camera nips at their heels, making no attempt to frame a subject, as Strasburg did with the fleeing Stephen Lawrence, but simply recording the flat-out blur of a cameraman's sprint as the bodies start to go down around them. The deaths are caught only in passing, accidentally. Some of the paras realise they've turned the Rossville flats into a shooting gallery – 'What are we firing at?'; 'Only aimed shots'; 'I can't see any fucking targets' – but the gunfire has its own dreadful momentum now. Cooper sees one of his own stewards go down and another man leave the shelter of the flats to help the fallen man, only to be shot, too, except we don't see it: the moment

of impact is blocked by Cooper's bobbing head as he takes refuge behind a car. An almost unimaginable editing choice in a normal feature, here it only adds to the desperate cascade of events.

'It was probably the point at which I should have said to myself, are you wise to be doing this?' writes photojournalist Don McCullin of heading once more into Aleppo in north-western Syria, whose civil war had been escalated by the Arab Spring in 2012. 'But, in reality, I was just excited; elated to have made it into what was obviously a real war zone.' McCullin's reactions – a 'combination of awe, fear and a kind of excitement' that leaves him 'too exhausted to be scared' – is pretty much what Greengrass reproduces for his audience here, as Cooper goes from one dead body bleeding out on the tarmac to the next, his dreams of peaceful protest in tatters, his movements slow, like those of a man in shock. And yet this is no *Zhivago*, where the Cossack massacre is funnelled through one man's reactions to it. Cooper seems almost beside the point now. He is not the protagonist of *Bloody Sunday*, we now realise; the violence itself is. Greengrass has essentially made a biopic of an act of political violence, as if it were a living organism in its own right, following it all the way through, from first tremors to ashen aftermath. 'You will reap a whirlwind,' Cooper says, after the action has shifted from the streets of the Bogside to a local hospital, where relatives look for their loved ones while still under the guns of the war-painted British soldiers. The martyred dead will benefit not the civil-rights movement but the IRA. Indeed, in one of the film's last shots, shell-shocked young men are seen lining up to enlist. We have not seen the end of this story, only its beginning – and not just of the Troubles in Northern Ireland. If a riot is the 'language of the unheard', then *Bloody Sunday* raises a shout whose echoes can be heard today, everywhere from Ferguson, Missouri, to Minneapolis–Saint Paul to Lafayette Square.

By the time the film wrapped, twenty-five days later, Greengrass felt like he had seen things he'd never expected to see in his lifetime. He saw Simon Mann, a former SAS officer who had served in Northern Ireland

undercover and whose best friend was killed by the IRA, share a drink with Martin McGuinness's brother, two men who would undoubtedly have tried to kill each other ten years before. 'It's pretty surreal this, isn't it?' said Mann, and McGuinness agreed. 'All feels like a long time ago, don't you think?' McGuinness looked at him and replied, 'Aye,' paused and said, 'Then again, not so much.' Greengrass saw Ivan Cooper laughing about middle-aged spread with Eamonn McCann, thirty years after their intense arguments within the civil-rights movement. He saw Ken Williams, sixteen years a Para and hard as they come, talk politics with Carmel McCafferty, a Republican legend in the Bogside, with Carmel crying and saying she had never knowingly talked to a British soldier. He saw Don Mullan sing 'The Town I Loved So Well' to a room full of former British soldiers, and them toasting him after it was over. He saw Jimmy Nesbitt sing 'The Sash' in a Derry pub, and people from the Bogside laughing and joining in.

'When I think about that film now, that's what I remember,' says Greengrass. 'All the conversations that went on, on the set, around the set, during and after filming, between people who for thirty years or more would never have been able to have a conversation, let alone agree. And so slowly you felt it becoming not dangerous, starting to become a conversation. Starting to become people having drinks after work. Starting to be a million conversations that people are having about their lives. An exercise in building something. It was interesting, but within it there were the demands of film-making, and then those moments where you realise something quite intense was happening that was not dangerous, but necessary.'

In early 2002, they held their first screenings of the film at Derry's brand-new Millennium Hall, which seated more than a thousand. In attendance were the survivors, plus their friends and relations, alongside everyone from Gerry Adams and Martin McGuinness to Ivan Cooper, all three sitting happily next to Bishop Daley of Derry and the leaders of the Apprentice Boys of Derry, the loyalist of loyal Protestants. After the film was over, Bishop Daley shook Greengrass's hand, then Mark Redhead's and Don Mullan's, telling them the film had made a contribution to the

peace process. One of the Apprentice Boys shook Jimmy Nesbitt's hand and told him, 'Well done.' 'This film changed my life,' a tearful Nesbitt told the audience. A nervous Greengrass made a speech in which he said, 'As an Englishman, I'm sorry that this city had to live through this' – a comment that was immediately taken up by the British press as a sign of his treachery. 'All trainers and Islington casual-chic,' sneered Ruth Dudley Edwards in the *Daily Mail*. 'George Orwell, who wrote with wonder of the way in which English intellectuals loathed their own country, would have recognised Greengrass instantly. Sinn Fein/IRA will use this film to back their lie that the British government wanted civilians murdered on Bloody Sunday.'

In fact, the film shows the exact opposite, going out of its way to puncture the republican conspiracy theory that Bloody Sunday was planned in advance to teach Derry a lesson and that there was firing from the city walls down onto the march below. Instead, as a result of the pressure to impress the British prime minister, we see a cascade of bad decision-making, from Major General Ford at the top, trickling all the way down to the trigger-happy Colonel Wilford. Everything in the film was backed up by the Saville Inquiry, when it was published on 15 June 2010, save for one key detail: it concluded that Gerald Donaghey, shot down as he tried to escape from Glenfada Park, in all likelihood did not have nail bombs planted on him by British troops to justify their actions, as the film depicts. There were many witnesses, including a medical officer in the Royal Anglian Regiment, who swore under oath that the body they examined did not have nail bombs on it, but in the end, on balance, Saville edged towards the view that 'The nail bombs were probably on Gerald Donaghey when he was shot. However, we are sure that Gerald Donaghey was not preparing or attempting to throw a nail bomb when he was shot; and we are equally sure that he was not shot because of his possession of nail bombs. He was shot while trying to escape from the soldiers.' There are reasonable arguments made in good faith on both sides; the worst that can be said is that this one is not uncontested.

The film premiered at the Sundance Film Festival on 16 January 2002, where it picked up the Audience Award for World Cinema. 'It's like a

Brechtian newsreel,' wrote Elvis Mitchell in the *New York Times*. 'It's impossible to see *Bloody Sunday* and not be reminded of the American civil-rights struggle, if only because the picture has subtly infused Cooper's behavior with gestures and nuances from his chief influence, the Rev. Dr. Martin Luther King Jr.' A fortnight later, the film shared the Golden Bear at the Berlin Film Festival with Hayao Miyazaki's *Spirited Away* and won the Ecumenical Jury Prize. Released simultaneously in theatres across the UK, Ireland and overseas and broadcast on TV – a fact that, sadly, rendered it ineligible for the Academy Awards – the film eventually took £482,117, an astonishing amount for a film about the Troubles. The TV viewing figures when it was shown a day or two later north and south of the Irish border were also extraordinary. 'When Sundance happened, that was a big deal,' remembers Greengrass. 'I came back, and the phone was ringing off the hook. You know what it's like in America: if anything happens that's good, they certainly let you know.'

A few days later, he was in the car, driving to a drinks party at ITV, when the phone rang: 'This is Dustin Hoffman.' Greengrass was certain it was Mark Redhead, who had a gift for catching him out by pretending to be Martin McGuinness or some obscure Japanese film director. 'Oh, yeah, whatever. How are you, Mark?' 'No, it's Dustin Hoffman.' That evening, he and Hoffman had dinner, together with Simon Mann, who had played Colonel Wilford. Another time, he got a call from Ridley Scott: 'I really like your film. Come and see me.' Greengrass went down to the offices of Ridley Scott Associates on Beak Street, where Scott had a huge, beautiful penthouse office. 'He was smoking his cigars, wreathed in cigar smoke. He said, "I liked your film. It's quite a good film, not bad. What are you going to do next?" "Well, I don't know." "I wanted to give you a bit of advice: don't fuck around. Go and make a proper movie." And he went off on this whole rant about how he'd made *Z-Cars* for the BBC in about 1965, and they'd only paid him £20 or whatever it was. "They're fuckers. They never pay you. Don't waste your life. Go and do it. Go and make proper movies." He was fantastic. And I'm like, "Yes, but how?" "Don't worry. It'll happen. It's just that's the choice you've got to make. Proper movies. *Proper* movies."'

By this point, Greengrass had already committed to making a film about the car bomb detonated by a dissident IRA group that killed twenty-nine civilians in Omagh, after having been approached by Michael Gallagher, who lost his son in the blast, while he was editing *Bloody Sunday*. 'I was very aware that if Bloody Sunday was the moment that made the Troubles inevitable, the Omagh bombing was the moment when the peace process became inevitable. They were the two great, violent events that book-ended the Troubles that I and everyone else had lived with since I was a teenager.' Teaming up with producers Greg Brenman from Tiger Aspect Productions, Don Mullan and Ed Guiney from Element Pictures, they approached Channel 4's head of drama and hired playwright Guy Hibbert to write the screenplay. 'I wanted to stay out of it, but I wanted it to be made. It became a difficult situation. The point is, by then, everybody wanted me to do it. The more that I wanted to support these people, the more everybody wanted me to do it. Michael wanted me. The families wanted me. Channel 4 wanted me. It was very hard.'

As Greengrass stepped away from directing *Omagh* and into a role as one of the film's producers, the other forces that Ridley Scott had predicted would turn up had turned up, pulling him in a different direction. An agent at CAA, Beth Swofford, had called and asked to meet him in Soho, where she enquired whether he had ever thought of making films in Hollywood.

'Well, not really, to be honest,' he said. 'Given the kinds of films I make.'

'Well, you should do,' she said. 'You can make a commercial film, definitely. It's just a question of choosing what you want to do and doing something interesting. Do you want to do it?'

He thought, 'I'd love to,' though looking back he realised, 'Well, of course I've always wanted to do that'; he had just never thought that it was a credible proposition. After their second child, Kit, was born, joining Millie, his wife Joanna had given up presenting and set up a talent agency, KBJ Management, to represent other TV presenters, but by the early 2000s, Greengrass was beginning to feel the financial strain of a divorce and become aware of the precarious position of film directors in Britain. 'When you get divorced with young children, you effectively

start again,' he says. 'But you're always at a financial disadvantage. And the reality was that directing and writing the kinds of small films that I did, mainly for television, was not paying the bills, and you're always trying to balance making unfettered creative choices with the need to earn a living. That's what I always say when I go to talk to young directors: "You've got to find your way of being true to yourself, while at the same time paying the bills."'

Hollywood was clearly where the money was. But how would that work? Would he enjoy it? 'Those are the questions that go through your mind,' he says. 'And it happened at a time when I felt I'd got to an end of a chapter, felt I needed to do something different. Didn't know what it was going to be, but I felt I needed a new adventure.'

Greengrass had seen *The Bourne Identity* upon its release in the summer of 2002, while he was editing *Bloody Sunday*. It had been a beautiful summer's evening. Getting off the Tube at Notting Hill Gate, he had called Joanna.

'Why don't we go out? Let's go and see a movie. Is Rosie free?' Rosie was their babysitter.

'Yeah.'

'Can she stay?'

'I'll ask her.'

'Great. What shall we go and see?'

Normally, dates with your spouse founder at this point. This time, however, he was standing outside the Coronet in Notting Hill, where *The Bourne Identity* was playing.

'It's that thing with Matt Damon, isn't it?' he said.

'Oh, yeah. I think it's supposed to be quite good,' said Joanna.

'Okay, fine. Let's go and see that.'

Afterwards, as they filed out into the early evening, Greengrass said, 'Well, if I'm going to go and make a film in Hollywood, I want to make a film like *that*.'

———

By the early 2000s, Hollywood film-making had reached such a nadir of silvery falsity that in *Die Another Day* (2002), Pierce Brosnan's Bond, aided by computer-generated effects, even *surfed* down the slope of a mountainous tsunami. As David Denby wrote in his review of *X-Men 2* (2003) in *The New Yorker*, 'Gravity has given up its remorseless pull; one person's flesh can turn into another's, or melt, or become waxy, claylike, or metallic; the ground is not so much *terra firma* as a launching pad for the true cinematic space, the air, where bodies zoom like projectiles and actual projectiles (bullets say) sometimes move slowly enough to be inspected by the naked eye.'

Planting a well-aimed fist through the Styrofoam falsity of most Hollywood thrillers, *The Bourne Identity* left its characters with bruises and broken ribs, while its car chases bent fenders. Its characters seemed to be made of flesh and blood, not spies at all, but ordinary people thrown into the world of espionage against their own inclination. 'Look at what they make you give,' says Clive Owen's professor, a line that perfectly captured the pathos of Jason Bourne, the spy who can never come in from the cold: when he rolls up at the farmhouse of Nicky's friend at the end of the first film, with its clutter of wellington boots and children's toys, he is looking at an ordinary life he can only dream of.

Swofford sent Greengrass a number of scripts to look at – an adaptation of Sebastian Faulks's *Birdsong*, for which he did a draft; the plane-abduction thriller *Flight Plan* – before phoning him in the spring of 2003 with the news that Universal were interested in meeting with him to talk about his directing the follow-up to *The Bourne Identity*. 'When *Bourne* came along, I was very responsive to that character, the oppositional aspect, the anti-establishment aspect, going back to find the truth, the search for identity, and "They're lying to us" and all of that stuff – it was like a melange of all those things that I'd gone through and been interested in all my entire adult life really,' says Greengrass. 'I felt I knew the spy world. I knew that world in reality and cinematically. I think that was one of the big differences from *The Bourne Identity*. I think *Identity* was great, but it didn't really sit in our world quite. I very much wanted Bourne to sit in the world as I saw it at that time, which

was the post-9/11 world of the Iraq invasion and all the paranoia that those events unleashed.'

On the other hand, he had never made an action film before – he'd never shot a fight, a car chase or a pursuit on foot – let alone a franchise movie. The budget for *The Bourne Supremacy* was $89 million, almost twenty times that of any film he'd ever worked on. Would it be possible to work in Hollywood and still be true to himself? Would he recognise the film he made as his? In June 2003, he flew out to meet producer Frank Marshall, his line producer, Pat Crowley, and Ally Brecker, the Universal executive overseeing the Bourne films, none of whom he knew. From Shutters hotel, where he was staying in Santa Monica, he ordered a cab to Universal Studios, only to find himself deposited at the Universal theme park, which he took twenty minutes to distinguish from the studio. By the time he realised his mistake and turned up at the office, huffing and puffing from a fifteen-minute run, he was over half an hour late.

'I've only got five minutes,' said Marshall. 'I have another meeting.'

Greengrass thought to himself, 'Well, this is a long way to come to fuck up a job interview.' However, sitting in a room on the lot at Universal, reading Tony Gilroy's treatment for the film, Greengrass realised what it was they wanted. 'They don't tell you what to do, but they want you to be made comfortable. They want you to have a strong point of view but be a team player. The treatment had issues, but it was like, "Oh, I know what they want. They want to take on Bond." It was never said, but that's what they were hoping for. That played to my competitive nature. I've never been crazy about James Bond as a character, whether literary or cine-matic. I admire the franchise, of course, but revelling in the cruelty, the amorality, the frankly xenophobic nature of Bond would never have been to my taste. But Bourne isn't about the technology, the Aston Martin and the gadgets and so on. He's on his own, living by his wits, and when he does have to kill someone, he is full of remorse. He's actually a very moral character. I felt I knew what to do with Bourne, which was to strip him back and make him more iconic. There's much less dialogue in *Supremacy* than there was in *Identity*, but that was part of what I wanted – to strip him down, make him speak less, make him dress only one way, make

him enigmatic and engineer a turn from revenge to atonement. And that pretty much stayed all the way through to *Ultimatum*, because that was a clear way you could make him iconic. And, of course, Bond then copied all that and he started dressing exactly the same – bless him.'

Universal called him later that day. They wanted him to do it, pending a meeting with Matt Damon, so after returning to London, he got ready to fly to Prague to meet Damon, who was shooting Terry Gilliam's movie *The Brothers Grimm*. On arriving at Heathrow, he put his card in the wall to get out some cash for the trip, and it was declined – he was that broke. He spent the entire dinner with Damon thinking, 'What the fuck? I've only got twenty quid in my pocket. How am I going to pay the bill?' The two of them got pissed and had a good laugh, talking movies and Bourne until 3 a.m. It was very clear they saw eye to eye. Damon paid.

Stopping off briefly in LA again, Greengrass started prepping Gilroy's treatment. 'At the heart we'll develop Bourne's identity – a pilgrimage to find who killed Marie and where it all began,' he wrote. 'Style – European, unconsidered, lots of handheld, emotional realism at the heart.'

Two weeks later, he was in Studio Babelsberg, the oldest large-scale film studio in the world, just outside Berlin, prepping *The Bourne Supremacy*.

6: ASSASSINATION

Not long after his first book, *The Scarlatti Inheritance*, was published in 1971, the thriller writer Robert Ludlum clean forgot about a meeting with his accountant – not forgot to meet him but forgot that he *had* met him. He was doing research into the terrorist Carlos the Jackal at the time, after it was reported in a radio broadcast by the White House's press secretary, Pierre Salinger, that the Venezuelan, who was wanted for a number of assassinations and bombings, had eluded capture again, this time after a sighting in Vienna. Ludlum knew about the Jackal, although not that much, but had an inkling that he might be a good subject for a new novel. Three days after he had begun his research, he was sitting at home in Connecticut having coffee, when he got a call from his accountant, Jeffrey Weiner, in New York. The conversation was just coming to an end when Weiner casually referred to an upcoming meeting the two had recently arranged.

'. . . All right, I'll expect you at eleven o'clock.'

There was a pause, before Ludlum replied, 'What do you mean, you expect me at eleven o'clock? Where?'

'In New York.'

'You never told me that.'

'Well, I was up at your house yesterday, and we were talking about it.'

Ludlum could not remember having met his accountant at his house, nor their conversation, nor the plan they had apparently made to meet

in New York. He had lost a full twelve hours of his life. What had happened to him? He had not been drinking. Was it the stress of having just finished a book? 'There is a medical term for it,' he told Don Swaim of CBS News in 1984. 'It's a temporary amnesia . . . I had promised [my wife] Mary that I would not sit down and start another book for at least a couple of weeks. But the idea of one, that kind of incredible news that Pierre Salinger related about Carlos the Jackal having been seen in Vienna, and having done some reading about that, and then the fact that I had lost twelve hours of my life when I was supposed to be in New York, and I didn't remember the guy even went up to my house, I put the two germs of thought together and thought, "Suppose a man was after Carlos the Jackal and lost his memory by going into deep cover?" That was the genesis of *The Bourne Identity*.'

The book was written amid public shock over the breadth of the CIA's covert operations, as revealed in the US Senate's 1975 Church Committee report on 'Alleged Assassination Plots Involving Foreign Leaders', which contained a heavily redacted outline of what came to be known colloquially as the 'Family Jewels' – the 693 pages of memos outlining the CIA's biggest skeletons, drawn up in 1973 by the agency's then director, James Schlesinger, to launder its conscience after Watergate. At a luncheon with editors from the *New York Times* in January 1975, President Ford was pressed on why he did not want to declassify the documents. Because they contained explosive material that would 'blacken the eye of every president since Truman', replied Ford. 'Like what?' asked the reporter. 'Like assassination.'

As the Church Committee moved to release its findings, after sixty days of closed hearings and seventy-five witnesses, Ford met with his chief of staff, forty-three-year-old Donald Rumsfeld, and Rumsfeld's deputy, thirty-four-year-old Dick Cheney, to discuss what to do. Rumsfeld and Cheney convinced him to suppress the report on the grounds of national security. 'It was the biggest political mistake of my life,' said Ford later. 'And it was one of the few cowardly things I did in my life.'

President Ford's caving in to Rumsfeld and Cheney was, arguably, a bad day for democracy but a great one for the country's thriller writers.

If you went looking for Jason Bourne in the Church Committee report, you would not find him. What you would discover were a lot of assassination attempts, outsourced to third parties such as Cuban exiles, French paramilitaries or the Corsican Mafia, which were either bungled, abortive or entirely counter-productive. To uncover anything like Bourne, you had to go back to Operation Phoenix, during the Vietnam War, or the Jedburghs, the clandestine special ops team run out of the OSS during World War II. 'A hammer, axe, wrench, screwdriver, fire poker, kitchen knife, lamp stand, or anything hard, heavy and handy will suffice,' counselled a 1953 CIA manual called *A Study of Assassination*.

The idea of a paramilitary elite whose existence the government will neither confirm nor deny, who can stay awake for days on end, hike a hundred miles, seize a small town, raid a building, kill *mano a mano* and vanish was to have a viral life in the years after Watergate in the cycle of thrillers begun by Rodney Whitaker's *The Eiger Sanction* (1972), James Grady's *Six Days of the Condor* (1974) and William F. Buckley's *Saving the Queen* (1976), all of which feature CIA assassins of varying degrees of amorality, and their cinematic counterparts – John Huston's *The Kremlin Letter* (1970), Michael Winner's *Scorpio* (1973), Sam Peckinpah's *The Killer Elite* (1975) and Sydney Pollack's *Three Days of the Condor* (1975), with Robert Redford, Faye Dunaway and Max von Sydow as an international assassin who relishes the freedom afforded by the freelance-assassin lifestyle: 'It's almost peaceful. No need to believe in either side, or any side. There is no cause. There's only yourself. The belief is in your own precision.'

This is very close to Bourne. The first movie, written by Tony Gilroy and directed by Doug Liman, junked Ludlum's Carlos the Jackal plotline to focus entirely on the premise established in the book's opening chapters. In the middle of a storm, a man is found clinging to the debris of a boat by some French fishermen, just off the coast of Marseilles. He is riddled with bullets, including one in his head, which has left him with amnesia. The man recovers on shore with the help of an English doctor, who finds surgical scars suggesting a completely revamped face, American dental work and a small microfiche of film implanted beneath the skin

of his right hip that contains the numbers for an account at a bank vault in Zurich. After a fight with the boat's crew leaves three of them unconscious, the patient wonders, 'Where had he learned to maim and cripple with lunging feet, and fingers entwined into hammers?' writes Ludlum. 'How did he know precisely how to deliver the blows?' He eventually makes his way to Zurich, where a bank clerk recognises him. His name is 'Jason Charles Bourne', and he is associated with a phantom American corporation, Treadstone Seventy-One; his account holds 7.5 million Swiss francs.

Thereafter, the novel spins the globe, as Bourne finds himself the target of the notorious Carlos the Jackal, the world's most notorious assassin. Why? Bourne was once part of a special op called MEDUSA in the Mekong Delta, where he was programmed by a top-secret US intelligence group to start taking credit for Carlos's kills around the world, in the hope of drawing the assassin out into the open. Speaking to *The New Yorker*, Gilroy said that when he first met Liman to discuss the project, he told him that 'Those works were never meant to be filmed. They weren't about human behavior. They were about running to airports.' Gilroy was not enthusiastic initially, and when Liman asked him for his ideas, he gave him some: throw the novel out and just take the idea of an assassin with amnesia. Fill him with doubt and an amazing set of lethal skills. Then what was interesting was how he was both like and also different from the rest of us. 'Your movie should be about a guy who finds the only thing he knows how to do is kill people,' he said, and characterised Bourne's thoughts in an email to Damon: 'Who am I? If I'm a bad person, do I have to stay that way? Can I stay alive long enough to work it out?'

Although it was never spoken about with Greengrass, it was clear there had been problems with the first film, which had left relations between director Doug Liman, producer Frank Marshall and the studio in tatters. Fresh from his indie hits *Swingers* (1996) and *Go* (1999), Liman had shot *The Bourne Identity* in Paris, rather than choosing a cheaper city like Montreal as a substitute, and clashed repeatedly with Gilroy, at one point hiring his own screenwriter, William Blake Herron, which

prompted Damon to threaten to quit. By the time Marshall set about bringing the production to heel, it had gone $8 million over budget, slipped past its original release date by five months and required extensive reshoots. Shot in October 2000, the film was scheduled for release in the summer of 2001, then pushed back to 2002 for reshoots, by which time tongues were beginning to wag that it was in trouble. 'When the movie was testing at a 75 and was a year delayed in coming out, I'm sure the studio just wanted to release the thing,' Damon told *Variety*. 'Frank laid out this surgical plan for what he wanted to do and got us $3 million for a reshoot, telling Stacey Snider [chairwoman of Universal], "I can't say this is going to make you more money, but I guarantee you it will make the movie better." Had it not been for Frank, we never would have had

Pages from the CIA's manual *A Study of Assassination* (1953). The nineteen-page typewritten document, undated and unsigned, was released as part of a collection of CIA files declassified in 1997.

a franchise. It would have been just one and done. Instead, it became a 15-year project for all of us.'

The film was the sleeper hit of 2002, taking $214 million and resurrecting Damon's career, but Liman fell very much out of favour with Universal. 'I never got involved in why they'd all fallen out,' says Greengrass. 'I grasped very, very early on that there'd obviously been bad blood. It was clear that relationships had broken down between them, as a group, and Doug felt very angry about what had gone on, very bitter towards them all. It was obviously a mess, a political mess, and yet out of it came a good film. I remember saying, "Look, it seems to me like what this film needs is a smooth ride." Because it was obvious, really, that everybody had fallen out in a horrible way, and that what the film needed most of all was to be made in a harmonious way. And that's what I, in my mind and in my heart, set out to do.'

First, he had to meet the challenge of Tony Gilroy.

The irony, when everyone later looked back on their falling-out, is that it had been Gilroy who had first suggested Greengrass as director of *The Bourne Supremacy*. At a meeting convened among the producers in 2003, 'Tony Gilroy said, "Watch *Bloody Sunday*,"' recounted Damon later. 'I left the meeting, bought the DVD and went straight home and watched it. And within two hours I was completely on board.' For a screenwriter, Gilroy had an unusual amount of power with the studio, having helped steer *Identity* to becoming a global box-office smash, while a string of hits including *Dolores Claiborne* (1995), *The Devil's Advocate* (1997) and *Proof of Life* (2000) had established him as a writer of sharp movie thrillers, albeit one with a reputation for combustibility. 'The thing is a lot of Tony's anecdotes end with "And then I quit,"' the screenwriter David Koepp told *The New Yorker*. 'We call him Tony (Fuck You) Gilroy,' said the director of *Dolores Claiborne*, Taylor Hackford. 'He wants to do it his own way.'

But producer Marshall had the highest confidence in Gilroy, as did Ally Brecker, the Universal executive tasked with shepherding *The Bourne*

Supremacy through production, who had paid him $3 million for his script. Greengrass was in Berlin prepping the film for a start date in November 2003, when Gilroy's first draft arrived in September. It started in Goa, India, with Bourne waking up in a sweat from inchoate nightmares about what he has done. His relationship with Marie has unravelled. 'I don't want to be Belgian or paranoid or blonde,' she says. 'I want to be myself again.' She storms off and is killed when a bus driver, going too fast at an intersection, jumps the kerb. Bourne attacks the driver and is thrown into prison in Mumbai: a vast criminal ghetto of sentry towers, cracked concrete and broken glass, seemingly based on the prison in *Midnight Express* (1978). A second Bourne, impersonating him ('close in size, weight. Blond – the brushcut – the jaw . . . mock Bourne'), is also at large, conducting kills in his name for a Russian handler, while a CIA officer named Helen Landy begins to follow the trail of destruction left by Operation Treadstone. ID'd in prison, Bourne is met by Treadstone's architect, Ward Abbott, who shocks him with the news that 'Nobody's been after you . . . We gave up after Paris. We shut down Treadstone. We stopped looking.' Bourne's persecution, his flight, Marie's death – they are nothing but paranoid delusions, persecution mania.

'That's bullshit!' screams Bourne, who escapes, sprinting across rooftops and down drainpipes. 'He looks terrible,' reads the script. 'There's a painful bruise where the rib's been broken. He's filthy. Raw. Haunted.' He returns to the Hotel Brecker in Berlin, where he pieces together his killing of Neski, a KGB accountant who was looking to defect, years before. A mole lurks within the CIA who used Bourne as a cleaning service to cover his tracks. At first, we think it is Conklin, from the first film, but it turns out to be Abbott, working hand in glove with his KGB counterpart, an old Russian general named Gretkov. 'It was a helluva lot more fun when the Wall was up, don't you think?' says Abbott, before killing himself. In Moscow, Bourne battles his doppelgänger, before tracking down the daughter of Neski to apologise for orphaning her. Exhausted, he collapses in the snow and wakes up in a hospital bed at an air force base in Germany, where Landy hands him his file. 'You called me, David,' she tells him.

Greengrass and Matt Damon on location in Moscow while shooting *The Bourne Supremacy* (2004).

There were three things Greengrass liked about the script: first, Marie's death; second, Bourne's recovered memory of killing Neski and his wife; and finally, his journey to visit their daughter at the end. Those three 'pillars' would provide the rough architecture of the movie they eventually made, but Greengrass hated Marie being killed by some random bus driver rather than the bad guys; he didn't like it that Bourne spent most of the movie locked up rather than on the run, nor the new emphasis on him being a master of disguise, nor the drugs supplied by Nicky; and he thought the Cold War-era molehunt plot dated the film terribly – he knew as much from his *Spycatcher* days – and wanted something modern, with Bourne on the move through a recognisably contemporary landscape. 'There are two key problems: Bourne is static,' he wrote in his

notes, and 'the CIA story is incredibly complicated and old-fashioned. Our first priority is to give Bourne a motive.'

He had already met with Gilroy once, for a couple of hours, at the screenwriter's apartment on Manhattan's Upper West Side, when Gilroy was midway through his first draft. In July, he met with him again at the London house of Oscar-winning screenwriter William Goldman, a family friend of Gilroy's, in Kensington.

'It's not right,' said Greengrass, draft in hand. 'The girl's got to be killed by the bad guys. He's then got to come for them. He has to be impelled into action by a need for revenge.'

'No, no, I don't see it that way,' said Gilroy, horrified. 'You can't just make changes like that. You can't fuck with a script. It's a fucking house of cards – you take one card out and the whole thing falls down.'

Very quickly, the two men found themselves in a stand-off. Gilroy wouldn't alter the script, but Greengrass was adamant it had to be changed. 'We were stuck, basically, as weeks of vital importance slipped away,' recalls Greengrass. 'We were due to shoot in a short time. Tony is one of those guys with a titanium certainty that everything he does is brilliant, which isn't how I'm built and which strikes me as a pretty strange place to be, plus he was viewed by Frank [Marshall] and Pat [Crowley] and Ally [Brecker] as if he were the oracle. And, of course, I was the outsider, the newcomer. It became obvious that their expectations of me were as someone malleable who was simply going to shoot what was there and not ask too many questions.' After the meeting with Gilroy, he had conversation after conversation with Marshall and Brecker, in which he explained what he thought needed to be done. They would listen, seemingly agree and then nothing would happen. 'Pat would be talking to me about going to this location or that on the far side of the world, and I'd be going, "Yes, fine, but we need to change the script." I thought they were trying to run me, behaving like I wasn't going to notice.'

Towards the end of August 2003, there was a big conference call between Brecker, Marshall, Crowley, Gilroy and Greengrass, during which the director once more pushed hard for the changes he wanted. Gilroy again resisted, but finally, on 17 September 2003, another draft

arrived, with none of the big alterations that Greengrass wanted. 'It was getting very, very close to the start of filming,' he recalls. 'I was under a lot of pressure. Two months out from shooting, and there was simply not a film there. If you'd shot that script, you'd have been in a world of pain. I was thinking, "This is not tenable. This is either going to be a bad film or no film at all." Those are the two choices. And you're driving at a hundred miles an hour, so you're either going to hit the rocks on the right or tumble off a cliff to the left. Those are your choices.'

By now, Damon had shared his doubts about the script and told Marshall he wasn't going to sign on for the film. Marshall and the studio may have thought they could bounce Greengrass into shooting Gilroy's script, but Damon pulling out was a category-A problem. They couldn't green-light the film without Damon signing his contract, so the producers went back to Greengrass and asked him, 'Can you speak to Matt and get him to commit?'

'I can't get him to commit, but I can tell him what sort of film *I'm* going to make,' the director replied.

He hadn't spoken with his star since the two men had got drunk in Prague, just a few months before, so he called Damon from his apartment in Berlin. 'I can't make this film,' the actor told him. 'The script is simply not there. I'm not going to make it, and I've told them that.'

'I hear you, and I get it,' said Greengrass. 'All I can do is tell you what I would do. Here is the film that I see. Do you have your copy of the script there?'

'Yes.'

'Okay, turn to page one . . .'

And he ran through the film he wanted to shoot, from beginning to end. Marie is killed by the CIA. Get rid of the Indian prison. A plot powered by revenge. No molehunts. Bourne on the move through a modern-day political landscape. A transition from revenge to atonement. By the end of the conversation, Damon was back in again.

It was this phone call with Damon, however, that was the fundamental cause of the breach with Gilroy, as Greengrass found out late one night in October, when he called the screenwriter to make yet another plea

for changes. Gilroy was clearly trying to run down the clock, forcing Greengrass into production of his script. 'It was a horrendous phone call,' Greengrass remembers. 'It wasn't very long. I started in a conciliatory fashion: "Tony, we've got to make changes. We're getting short of time. And I feel very strongly about this. You've got to work with me, or it's never going to work. You've got to change the script."'

Gilroy accused Greengrass of trying to isolate him. 'You're trying to play me, man. You spoke to Matt. You hung me out to dry.'

Greengrass thought, 'Is this the playground?' By this point, he was also angry. He wasn't interested in this kind of political bullshit.

'What the *fuck* are you talking about, Tony? I just want some changes. It's nothing to do with Matt. I'm not speaking for him, I speak for me. And I want to change the script.'

At which point Gilroy unloaded. '*This is bullshit, man. You're fucking this thing up, and you don't even realise it!*'

Greengrass knew they had reached the end of the road.

'You know what, Tony, I think we should end this conversation, because really we've got nothing to say to one another.'

That night, the director called Brecker at Universal and told her that he couldn't work with Gilroy. 'Either you get me another writer or I'm going home,' he said. The next morning, he got a phone call asking him to come into the production offices at Studio Babelsberg to meet with Marshall and Crowley. 'They said they'd spoken to Ally and the studio. Their idea was that they would keep on with Tony, but I wouldn't have to deal with him. They would handle the script. And I said, "That's just not acceptable to me." I got quite heated. "I don't care who you hire, I'll work with whoever you want it to be, but it needs to be another writer, and if you don't want to change it, that's fine, I'll go home." I'd been through the *Theory of Flight* experience. I wasn't going to be dicked around by another writer. I knew how that ended. Who fucking needs it?'

He went back to his apartment to pack. 'The truth is, I was quite comfortable about going home,' says Greengrass. 'Joanna and I had a baby on the way. And I was confident I'd go back and find another film like *Bloody Sunday*.'

He was about to leave for the airport when Brecker called back to tell him that *L.A. Confidential* (1997) screenwriter Brian Helgeland could fly out that night to begin work on the script. Gilroy would maintain his relationship with the film's producers and continue to wield considerable creative power as a sort of king-across-the-water on both *The Bourne Supremacy* and its sequel, *The Bourne Ultimatum*, but he and Greengrass never met or spoke to one another again. 'The relationship between Tony and I was presented as a big feud. It really wasn't. I barely met the man. The truth is, I tried really hard to work with him, and our push-and-pull, for all its personal difficulties, gave the two films we worked on a real edge. But the situation was impossible. His view was, we sit in a room, he and I, and we don't ever allow our disagreements to come out, which effectively gave him a veto over what was to be done with the film, and to do that was to surrender my authority and hand it over to him. He saw it as him being my instrument, versus me being his. So it was never going to work between us. Frankly, I thought he was trying to get power without responsibility. Where is the band of brothers that is supposed to be at the heart of film-making? Matt and I were sailing into the line of battle, the guns were about to go blazing, and you're at your maximum point of vulnerability. He left us to face the guns alone. That's what it felt like, and that's why a degree of bitterness grew in my mind and also, I suspect, in Matt's. Because whatever script he did or didn't write, it was going to be a year of hell for us to bring home a film that was even passable. We were going to have to live on the edge of a precipice.'

Gilroy's exit was not well received by Universal. Stacey Snider tried to get him back onto the film a few months later, but Greengrass again put his foot down. Marshall also thought that letting Gilroy go was a bad idea, but he accepted that it was a fait accompli, and the day after Gilroy's exit in late October, Helgeland took Greengrass's call at his home in LA. 'I didn't know Paul,' said Helgeland later in a BAFTA lecture. 'I still to this

day don't know how he got my name, but he called me and said, "Can you come out to Berlin, we start shooting in a week?"'

Helgeland read the script on the plane to Berlin and arrived to find Greengrass 'exhausted'. The two men went for a beer.

'I wanted to redo the entire script, and now there isn't time,' said Greengrass, glumly.

'When do you start shooting?' asked Helgeland.

'Five days.'

'We have time. We can rewrite the entire script.'

'Do you think so?' asked Greengrass, perking up. 'In five days?'

The two men holed up in the director's flat in Berlin and hammered away at it. 'We stayed up basically four days and rewrote the entire movie from start to finish,' said Helgeland. Out went the KGB, the seventy-five-year-old general, the CIA mole and all the other throwbacks to the Cold War. Neski wouldn't be a KGB accountant looking to defect, he would be a reformist politician, like Mikhail Khodorkovsky or Alexei Navalny, who has angered the oligarchs. Out went Marie's tragic bus accident and in came her assassination by the CIA, drawing Bourne out of hiding and back into the game. Helgeland's draft had the beginnings of the conflict between Ward Abbott and Landy, now rechristened Pamela and a more sympathetic figure. Initially, the part had been slated for Helen Mirren, whom Gilroy knew through her husband, Taylor Hackford; in his draft, Landy's first name is Helen, and little separates her from Abbott.

'I wanted Pam Landy to be a big figure,' says Greengrass. 'I wanted her and Nicky to be ambivalent but ultimately sympathetic characters, victims of Treadstone but functionaries, and that's what Brian worked on. So she really emerged as a character, with her own relationship, slightly maternal, with Bourne, just as Abbott, Conklin and later Vosen were always father figures. I always saw in the Bourne movies some of what I see in *The Magic Flute*. Bourne is the prince who has to make sense of his warring parents – who is good and who is bad, and who is he? There was a lot of self-dramatisation in my Bourne. I don't want to say that Brian and I solved all the problems. We definitely had not. We hadn't nailed the riddle of Abbott's endgame, why he was doing what he was doing, and

also the crucial matter of how to engineer the turn from Bourne's revenge to his act of atonement. Matt still had significant anxieties, as did Frank, and so did the studio, but thanks to Brian we turned a major corner towards putting the architecture of the final film down.'

At the end of the four days, they handed in their draft and were waiting around at the hotel when Marshall showed up. It was around eight o'clock at night, and the producer had just arrived from LA. 'He walked into the room and he said, "Brian, you don't have to stay here for this meeting,"' recalled Helgeland. '"In fact, your plane to LA leaves tomorrow at five in the morning." I looked over at Paul, and he kind of looked at me and said, "It's okay." And they basically had it out for three hours, about this script we had done. He kept saying to the producers that the Soviet Union fell, you can't really have this in the movie, and they were like, "We don't want to change it." He said, "Well, they want to go back to what we had." I said, "I figured that." And he said, "But no Soviet Union." So he had kind of got what he wanted, and I think as he shot he worked back in more of what he wanted without them quite realising it. But I was in love with him, and that's what you can do as a director and a writer together. You can turn the film on its head three days before shooting starts.'

As the first day of production loomed, all agreed they would shoot the material that everyone had settled on – namely, the chase in Moscow and Pam Landy's introduction at the start of the film – and worry about the rest later. They had run out of time. On 24 November 2003, production on *The Bourne Supremacy* started in the suburbs of Moscow, with the scene where Bourne is walking under a tunnel and is shot in the shoulder by Kirill, up on the bridge. 'It was a sequence where I've just been shot,' Damon later told the *Daily Telegraph*. 'As we were setting up the shot, I turned to Klemens, the cameraman, and asked him, "What's your bottom frame?", so I would know where to hold my fingers so that he could see the blood. And Paul overheard that and just launched himself between us and said, "No, no, no – absolutely not! Hold your hand, do exactly what's natural; Klemens, go down and try to see the blood on his fingers, and if you miss it, it's okay – we'll know what it is." I remember

thinking, this is just the greatest feeling you could have as an actor: you're going to be working with someone who not only trusts you to do what feels right but doesn't mandate you to do something that feels unnatural in order to facilitate their framing.'

Later on that first day, Greengrass recalls seeing the actor run through the scenes in which Bourne ransacks a supermarket for a bottle of vodka to disinfect his wound and feeling 'the weight of the movie come off my shoulders. I just remember a tremendous excitement, seeing what he was doing, making this wordless character work, because Matt's a writer too, of course, and I could tell there was going to be a tremendous amount we could get done on the day. He was everything that I wanted Bourne to be – a little older, more harrowed, more intense. It was thrilling. The hair goes up on the back of your neck. But it was much more than that. It made me feel like I wasn't alone, like I had a brother. Matt and I – okay, we're going to make this movie together.'

After months of anxiety, argument, impasse and frantic rewrites, Jason Bourne was finally in motion.

'Six point nine seconds of heat and light,' writes Don DeLillo in *Libra*, his Joycean sift through the fact-rubble left by the Kennedy assassination. 'Let's call a meeting to analyse the blur. Let's devote our lives to understanding this moment, separating the elements of each crowded second.'

The 486 frames of silent 8mm footage shot on a Bell & Howell camera by dressmaker Abraham Zapruder on 22 November 1963 show a motorcade led by two open-top limousines proceeding at a stately pace through a street lined with people. We see the black Lincoln Continental with JFK and his wife, Jackie, in a pink skirt and jacket, both waving to onlookers as the motorcade turns the corner onto Elm Street. We see the president turn his head very rapidly from left to right as he hears the first shot, and over frames 220–6 Zapruder's footage blurs, mostly likely a startle reaction as he, too, hears the shot. At frame 256, Kennedy clutches his throat in response to the second shot passing through his upper back

and exiting via his trachea. Jackie leans over to attend to her husband, and the right front lapel on Governor John Connally's suit flips up as the bullet passes through his chest. At frame 309, there is more blur, most likely a second startle reaction as Zapruder hears the second shot, and then comes the image that would keep the dressmaker up at nights. At frame 313, we see the catastrophic effect of a supersonic 161.2-grain bullet passing through a human head at 2,100 feet per second. A powerful expulsion of blood and brain tissue is sent in all directions, with two streaks of larger ejecta going upwards and forwards of Kennedy. A cloud of blood forms and moves towards the left of the frame as the car drives through it, with Kennedy's head, or what remains of it, flying backwards and to the left, a peculiar dynamic that would keep conspiracy theorists in business for decades to come.

In Berkeley in 1969, a physicist named Luis Alvarez asked one of his students what they thought was the clearest evidence of conspiracy in the assassination. The response was, 'The head snap.' In 1976, Alvarez published *A Physicist Examines the Kennedy Assassination Film*, in which he argued that the president's head does indeed fall forwards, but so fast that it blurs, only to be then pushed back by the exiting brain matter. 'The simplest way to see where I differ from most of the critics is to note that they treat the problem as though it involved only two interacting masses: the bullet and the head. My analysis involves three interacting masses: the bullet, the jet of brain matter observed in frame 313 and the remaining part of the head. It will turn out that the jet can carry far more momentum than was brought in by the bullet, and the head recoils backward, as a rocket recoils when its fuel is ejected.' Alvarez further developed what he called the 'jiggle theory': that the blurs at frame 220 and the crucial frame 313 are the result of Zapruder hearing the gunshots. 'What that guy doesn't know is that all Abe's movies look like that,' joked Abraham Zapruder's brother Myron when he heard the idea.

'Zapruder should have been on Bourne second unit,' says Greengrass, who first saw the Zapruder film while visiting Berkeley himself, during his gap year. One evening, he attended a roadshow lecture by Mark Lane, whose 1969 book, *Rush to Judgment*, had been the first to challenge the

THE GREENGRASS PAPERS

Warren Commission's account of the Kennedy assassination. The auditorium was packed with students, who watched aghast as Lane led them frame by frame through the Zapruder film, pointing out its anomalies: the man holding an umbrella; the odd backwards motion of Kennedy's head when it was hit by the second bullet; the tramps arrested in the underpass. The crackpot theory around that time was that Howard Hunt, the White House point man for the Watergate burglars, had been in Dallas on the day and had orchestrated it all.

'It was all heavy, heavy stuff and, of course, in '74, all too believable, too, given what was coming out on TV every day during the Watergate hearings,' says Greengrass. 'Berkeley was the absolute epicentre of all that stuff. The Zapruder film was a foundational moment. The Kennedy assassination, the Oswald killing on live television, along with *Life* magazine, the growth of photojournalism, 16mm cameras – they were all part of a cultural reorientation around reality. Reality was something that was just brought to you through the medium of a lens. There he is, driving down the street, bang, and he's killed. It's unbelievable. Shocking. It changed the relationship between the viewer and reality. All those things were about capturing something that was happening, as opposed to planning something that was recorded. That was a fundamentally different relationship of the camera to reality – all those imperfections. Albert Maysles trying to keep Kennedy in frame in *Primary*: it was a once-only event, and that meant imperfections in the image, but those imperfections made it feel real. While the Zapruder film had the same imperfections that made it seem real, interestingly and paradoxically, those imperfections, that sense of reality snap, also gave rise to conspiracies. Because the essence of the Zapruder film was that it was thought to show a Bourne-style kill, essentially. That, I think, was a journey that people of my generation had to go through. Conspiracy clouded the fundamental, philosophical root of documentary realism.'

In Alan J. Pakula's *The Parallax View* (1974), about a vast, shadowy organisation that recruits assassins to engineer a seismic shift in the power structure of the US, there's a remarkable twelve-minute sequence in which a bomb detonates on a plane whose passengers, including

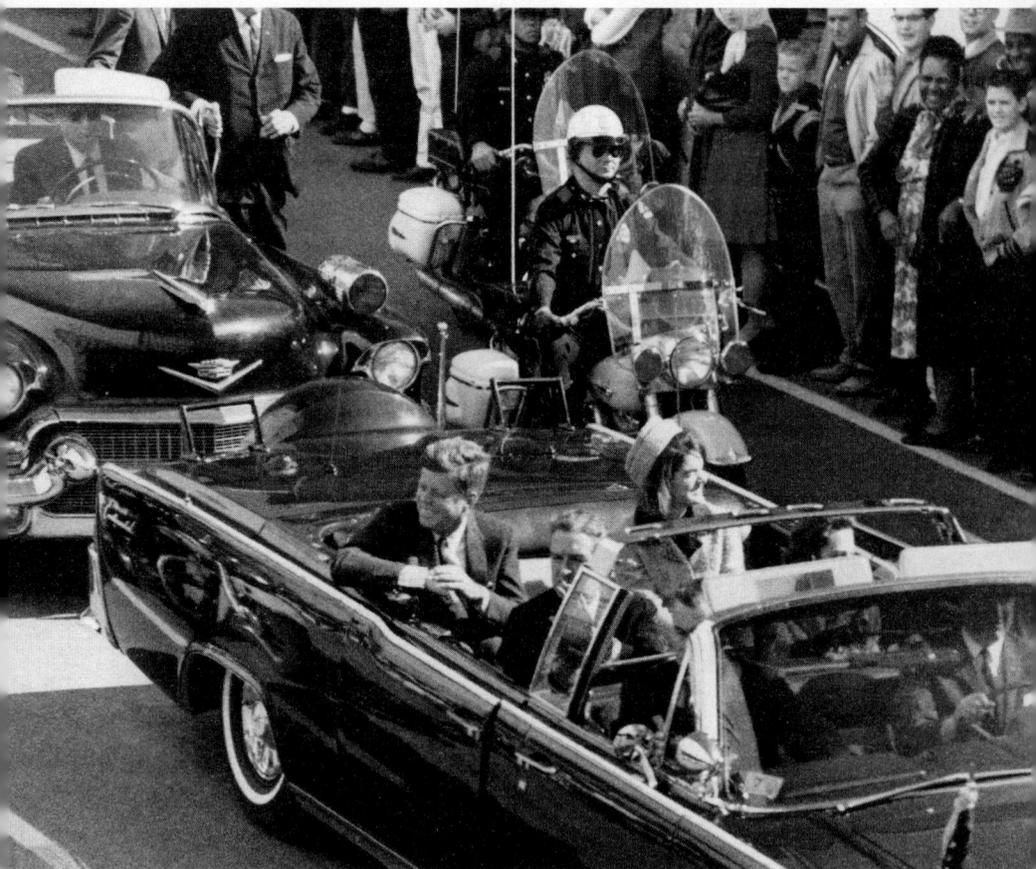

'Six point nine seconds of heat and light,' writes Don DeLillo of the Kennedy assassination in *Libra*. 'There is much here that is holy, an aberration in the heartland of the real.'

newspaper reporter Joe Frady (Warren Beatty), have safely evacuated. When it goes off, the camera is staring at a patch of empty tarmac, while airport announcements drone on the PA, the camera registering the blast with a shudder. In another scene, a man attacks Frady at the base of a dam, but the camera stays in long shot, so you almost don't notice the attack taking place, and when you do, the effect is doubly shocking for you almost having missed it. When a senator is gunned down as he rides through a convention centre in a golf cart, which then veers off course and cuts a swathe through an array of dinner tables arranged to resemble the American flag, we could almost be watching CCTV footage, so

impassive is the framing. *The Parallax View*'s cinematographer, Gordon Willis, realised that in an age of televised random political violence, the camera has a different role. His refusal to prioritise one corner of the frame over another, to tell us what we should be looking at – the violence happens in the corner of the frame or out of it altogether, while background noise, parades, political speeches and patriotic music drone on irrelevantly – all this serves to jack up the viewer's paranoia. 'If the picture works, the audience will trust the person sitting next to them a little less by the end of the film,' said Pakula.

There's a word in Italian, *dietrologia*, that means the science of what lies behind a suspicious event. Greengrass's films, like Pakula's, turn that science into an art. 'It's all predicated from the very beginning, from that first scene, where the candidate comes in with his wife from the truck, through the crowds and marching bands,' says Greengrass. 'It's all saying to you there's a surface, and there's a reality behind the surface. Film-making will allow us to grasp what goes on behind the curtain. Behind the theatre of politics lies a different story, and the camera can take you there. What it does is, it brings conspiratorial intent into play in everyday life. It's got a relationship to the world as we see it, as it was seen at that time. There is the everyday, and behind it there are the forces that are making things happen. And so it just happens and reverberates afterwards. It's exactly the same as the Zapruder film. It's exactly the same as Robert Kennedy on the podium, going, "And now we go on to Oregon – on to victory," and then he walks off – *bang*. It's the quotidian life in conflict with these forces that are behind it that burst onto the stage. No *Parallax View*, no Jason Bourne, basically.'

Besides *The Parallax View* and the Zapruder film, the other main stylistic influence on *The Bourne Supremacy* was a piece of footage Greengrass had shot in the Philippines for *World in Action*, which he showed to cinematographer Oliver Wood, A-camera operator Klemens Becker and B-camera operator Florian Emmerich as part of a clip reel that also included some footage from Leslie Woodhead's 'The Demonstration', *Bloody Sunday* and *The Murder of Stephen Lawrence* to initiate them into his way of working. Returning to Manila after making his film about the

presidential campaign of Cory Aquino, Greengrass and his cameraman had observed a sit-in protest by nuns, daring the army to either disperse them or join in. President Ferdinand Marcos and his remaining officials, refusing to concede defeat, had mobilised columns of armoured tanks and positioned barricades along Epifanio de los Santos Avenue, as thousands of unarmed Filipinos took to the streets. There were gunshots and people were killed. 'You very rarely see people shot on camera for one good reason: when guns start going off, the camera becomes very skittish,' says Greengrass. 'The first thing that happens when there are gunshots is the camera goes down low, because then you can move very, very fast. You're traversing distance in order to capture the event. One of the things that I was interested in on *Supremacy* was to incorporate those moments into the film itself – into the drama itself. So when Bourne goes racing up the road, it's like following a live event. It made you a participant.

'Other people wave the camera around, and that became very sort of voguish,' he says. 'That's not what I do. I remember having conversations with [cinematographer] Dariusz Wolski on *News of the World*, saying, "I come from a place where the obtaining of the shot was itself a physical struggle." If you've been in a place where you shouldn't be, or in a place where you can only be for ten minutes, you're under the most intense pressure. The process of getting the shot is a physical struggle. It's not like a physical struggle against time, like on a movie or a drama set, where you're constructing a shot and you've got to get it by half past five. When something's happening in front of you and it's only going to happen in that moment, you've no knowledge of it and you can't control it – it may just be as simple as Yasser Arafat walking out of a house – you've got to physically move the camera through space and time, against great physical difficulty, to get the shot. So the shot has a drama to it because of how hard it is to do. That is at the heart of the documentary tradition, really.'

The technique – using lots of handheld camera, long lenses and whip-fast editing to give the impression of a live news event erupting around the audience – would prove wildly influential. *Batman Begins* (2005), *Cloverfield* (2008), *G.I. Joe* (2009), *The Expendables* (2010), *Battle: Los Angeles* (2011), *The Hunger Games* (2012), *Elysium* (2013), *World War Z*

(2013) and *John Wick* (2014) were among the first responders who rushed to copy *Bourne*, as did the Bond series with *Casino Royale* (2006), where Eva Green's underwater death echoes Marie's at the start of *Supremacy*. But what few understood about the so-called technique – shakycam, unsteadicam, run-and-gun, the 'unknowing camera', call it what you will – was that it was not something that involved solely the camera. It was as much about changing what the camera was looking *at*. It was a matter of staging and *mise en scène*. In the script of *The Bourne Supremacy*, for example, there were half a dozen short scenes in the CIA hub, filmed in an empty office block at 32 Karl-Liebknecht Allee, where Landy or Abbott are monitoring Bourne's progress remotely, little fragments, often in isolation, not really making sense and full of movie-ish zingers – '*You're in a big puddle of shit, Pam, and you don't have the shoes for it.*' 'Trailer lines,' Greengrass called them, because they popped nicely in the promo trailer. He ran together half a dozen of these scene fragments into a single dramatic entity, a kind of fully live one-act play tracking Bourne's progress that could run for ten, twenty, thirty minutes, into which actors could be inserted, dropping a scripted line here, throwing in an improvised line there, with the crew catching what they could on the fly. Essentially, he made the communications hub fully operational. He used to call it 'cranking' – as in 'I want to crank the hub.'

It took a bit of explaining to the actors. 'Matt and Brian and Joan never worked like that,' remembers Greengrass. 'It was quite alien to them. I remember at the beginning trying to create a logic to the hub, explaining to Joan Allen and Brian Cox that I wasn't asking them to come into a cold, dry room just to give a line. If you think of it in musical terms, it's like having a lot of texture and burying your vocals in the texture. Jagger always used to say he wanted his vocals buried in the texture of the sound. [Phil] Spector was the first guy who did that. It came from the old blues guys. You wanted your solo parts buried in the collective. That gave you a crackle of reality and an urgency, and it also made it interesting. And they got it because, of course, in the end I would give them both. They would get their moments popping out nicely. I'd make sure they had a boom [microphone] for the moment when Brian says his line, but we'd also

have this luscious kind of feathered feel to the whole thing, improvising and throwing up other things, so that the room is alive, rather than fish on a slab. And they all loved it, threw themselves into it and owned the process, so you ended up with Brian, for instance, coming up with the scene where he shot himself.'

There was much muttering in the screening room at Studio Babelsberg after Greengrass got back from Moscow in December and showed his rushes to Frank Marshall, Pat Crowley and Ally Brecker. 'It did cause nervousness,' says Greengrass. 'I could feel my rushes were out there – handheld, whip pans, staccato movements – and I think it was challenging for Frank and Pat and Ally. I could feel them fidgeting behind me. "Why does he have to do that?" "Can't we have a static camera?" "Are we going to shoot the whole film like this?" And it became a fault line through the film. They communicated their anxieties, but never as, "We don't want you doing that." It would be, "Are you sure?" and "I think you need to make sure that we're covered" – that sort of stuff. Frank was very clearly the boss, as far as I was concerned. In the end, I knew if I couldn't persuade Frank to a point of view, I wasn't going to carry the studio. I remember him talking about it once. "My job," he said, "is to put you in a box. That's my job. Because if I put you in a box, I know you will fight to get out and come up with something interesting." There were frustrations and a butting of heads sometimes, but in the end, I wasn't going to be stopped, because they knew as a studio, and Frank knew too, that they had to harness the indie spirit, if I can call it that, for it to be a Bourne movie. It was a marriage between a sort of indie spirit and a studio movie. So they couldn't get there if they didn't let the indie spirit live. And in the end, for all the tension, they never said no to me.'

Greengrass hired two young assistants to help him prosecute his agenda for the film: Chris Forster, a *Sight and Sound*-reading storyboard artist he'd met on *The Theory of Flight* and used again on *Stephen Lawrence* and *Bloody Sunday*, whom he hired to do storyboards on *The Bourne Supremacy*, and Rosanne Flynn, a bright twenty-four-year-old researcher who had worked for the philosopher Amartya Sen. 'I wanted young people in my camp who were not Hollywood types – the farthest thing

from it – people who could help me articulate what I was trying to do. We were a bunch of vagabonds in the middle of this Hollywood movie, trying to drive the search for an original film.'

In November, another crucial ally arrived in the form of editor Chris Rouse, who had been brought in to help cut *The Bourne Identity* by Frank Marshall, but whom Greengrass didn't know. They were about the same age and had both come up through television. Rouse knew from *Bloody Sunday* that Greengrass embraced a *vérité* style – lots of long lenses, a continuously moving camera – and before shooting commenced, had talked about how that would translate to a larger piece, with pace and attack, seeking clarity through abstraction. 'As soon as we got together it was just one of those meetings of the minds that you really hope for,' said Rouse. 'We were off and running.'

Says Greengrass, 'Once we realised we were both intent on driving down the same road, Chris and I drove down as hard as we possibly could.'

The split between indie and studio sensibilities found its most concrete expression in the film's two scripts, one by Tony Gilroy, the other by Brian Helgeland, which Marshall worked every night to marry together. Gilroy's was still the official shooting script, but after much back-and-forth, a tacit agreement emerged that any pages that achieved 'pink' status – later green, blue, salmon – would be shot, with locked-down cameras on key pieces of dialogue, thus satisfying Marshall and the studio, while simultaneously Greengrass and Damon would be free to shoot the scene their way, and also to pursue whatever ideas or material they generated, as long as they had time. 'Sometimes there would be pages that would come in that I didn't like or knew full well weren't going to make it, but I felt duty-bound to shoot them,' says Greengrass. 'But I would make sure that I could also shoot pieces that *I* wanted shot. You've got to give everything its day. "Let's shoot this stuff. Let's keep shooting. Let's keep going." And then we'd have it out later in the cutting room, what worked and what didn't.'

One early scene that united Greengrass and Damon in their scorn was one in which Bourne was supposed to burn Marie's personal effects after she'd been killed. There was talk of Damon giving a small salute, hinting

at his military background. When it came to doing publicity for the film, the two were still cracking each other up over how many times they could get the word 'salute' into interviews. 'There was a screening, and I'd get up and say, "And I'd just like to salute our movie star, Matt Damon . . ."' says Greengrass. 'Or, "The man deserves a salute because . . ." It went on for the entire press junket as a running score between us.' Damon had been in a movie with Denzel Washington, *Courage Under Fire* (1996), where he had to salute over the grave, and he thought it an ill-fitting cliché. 'So we turn up in the cutting room and Stacey [Snider]'s in there and talking about whatever our shots are going to be. We're going, "So we're going from this bit, and then we're going to do that bit, and then this bit." And Stacey goes, "And the bonfire scene." "Yeah, yeah, yeah. Anyway, then we're going to shoot this." "No, but we're going to do the bonfire scene." "Yeah, yeah, yeah" – and sort of rolled my eyes at Matt. Anyway, this went on for about ten minutes. There was a sort of banter-ish atmosphere, and suddenly the temperature dropped by about thirty-five degrees.

'"*I have indulged you in every conceivable way, and all I've asked for is this one scene. You are both going to shoot it and you are both going to do it really, really well. Have I made myself clear?*"

'We were like two naughty boys. "Yes. Yes, ma'am." But it was true. We were indulged, and she was right, of course: it was an important scene. It was also a melodramatic load of old hogwash, but it doesn't matter. It was a necessary scene in the movie. To a certain extent, Matt and I played to the hilt our roles as the "rebel insurgency". Frankly, it was amusing and necessary for our sanity.'

For the actors, the chaos that still surrounded the script, which was being rewritten every night, was sometimes a little frightening. Brian Cox was particularly unhappy about the amount of confusion around his part. 'Brian used to get disheartened when scenes would be brought on the floor that didn't really make any sense. We all did. You'd be shooting and going, "Well, why is this scene even happening?" Or, "This doesn't make sense with what we shot three weeks ago." "No, I know it doesn't, but you know what? It might make sense. So we need to shoot it." Everybody was groping in the dark, is the truth of it.'

Damon had, of course, won a screenwriting Oscar for *Good Will Hunting* (1997). As much as Gilroy, Helgeland and Greengrass, he was the one who helped shape Jason Bourne as a master improviser, king of the riff, making things up as he goes along. Improvisation wasn't a luxury on the set of *The Bourne Supremacy*; it was a necessity. 'I'd go in and see Matt in the morning, and we'd go, "I mean, look at this fucking stuff,"' recalls Greengrass. 'Then we'd sit, and one of us would say, "What about if we do the scene this way?" And the other would say, "Well, yeah, maybe, but what about if we did this?" And we'd start riffing. We'd be doing it all day, every day. You'd sit and have supper in the evening, and you'd be fucking shitting yourself. I mean, you've no idea what it feels like when you're on the edge like that, going, "What the fuck are we going to shoot tomorrow? What the fuck are we going to shoot? Jesus fucking Christ." It's beyond stressful, when I look back on it, because it feels like there's a machine that's going to eat you. And you've got to somehow stay out of its mouth and stay alive and service it, do stuff. You can't stop and not do anything; you've got to somehow find your way, inch your way forward, trying to figure out what to do, where to take each scene, where to take the movie as a whole . . . Matt was the person I was bound closest to. He was as engaged in the scripts of those movies as I was, every step of the way, and when I think back now on some of the really radical ideas inside those movies, and the way they married up with a popcorn ride, Matt was behind them all the way, understood where I wanted to go and just drove on down that road with me.'

In the early days of the Rolling Stones, long before their 'let's-jump-in-a-Bentley-and-go-to-Morocco' phase, Keith Richards and Mick Jagger found that the only time they could write songs was after their shows. Stuck in the back of a Volkswagen camper van, wedged in with all the gear – amplifiers, microphone stands, guitars – Richards would noodle around with two lines of a riff or a chord sequence until something

took over. 'I don't want to say mystical, but you can't put your finger on it,' writes Richards in *Life*. 'The mood is made somewhere in the song. Regret, lost love . . . If you can find the trigger that kicks off the idea, the rest of it is easy. It's just hitting the first spark.'

A lot of their songs were about the emotional strain of being on the road, the jealousy they felt about what their girlfriends might be getting up to, but their sound sometimes owed its rawness to the technological poverty of their environment. The famous guitar riff on 'Satisfaction' was Richards trying to imitate an Otis Redding horn section with guitars, using fuzz tone so he could approximate what the horns would do. 'Jumpin' Jack Flash' was 'Satisfaction''s riff, inverted. Staying in crummy motels where the only thing they could record on was a Phillips cassette recorder, Richards found that even an acoustic guitar would overload the machine to the point of distortion, effectively turning the acoustic into an electric guitar, the cassette player being both pick-up and amplifier. 'Mostly I've found, playing instruments, that I actually want to play something that should be played by another instrument,' writes Richards. 'There's no "properly". There's just how you feel about it. Feel your way around it. It's a dirty world down there.'

Jason Bourne would understand. When he is picked up at Naples airport in *The Bourne Supremacy* and interrogated by CIA officer Jon Nevins (Tim Griffin), he is so unresponsive that Nevins is reduced to clicking his fingers in front of his face, to check whether he reacts to sensory stimuli. No response. Drawn away by a call on his cellphone, Nevins is warned, from CIA headquarters at Langley, 'He's an agency priority target.' 'I understand,' says Nevins calmly, but something about the tone of his response draws Bourne's attention. For the first time, he looks up. What happens next happens fast. Nevins draws his gun, but as soon as he does so, Bourne rises, grabs Nevin's wrist with his left hand and punches him with his right. He relieves Nevins of his gun, swings around to take out the security guard who has risen to his feet with a left hook, then, completing a 360-degree, returns to finish off Nevins with another left hook, bringing the gun into both hands and securing the floor.

This series of violent actions takes just under two seconds. Fast work.

Most people would be unable to sustain the momentum necessary for a right–left–left punch combination within a single 360-degree spin – they would have to pause between punches to recock each one – but Bourne has an advantage: a *jump cut*, hopping over the pause. Told that his original edit of *À bout de souffle* was too long to find a distributor, Jean-Luc Godard consulted director Jean-Pierre Melville on how to trim his film down: 'I told him to cut everything that didn't keep the action moving, and to remove all the unnecessary scenes, mine included. He didn't listen to me and instead of cutting whole scenes as was the practice then, he had the brilliant idea of cutting more or less at random *within scenes*. The result was excellent.' So instead of seeing Jean-Paul Belmondo driving all the way down the Champs-Élysées, Godard hopped to the highlights reel – Jean Seberg complaining of a headache, fixing her hair in a mirror; Belmondo admiring another car, and Seberg telling him, 'You are a kid' – catching something of the flirtatious glissade of their conversation.

In *The Bourne Supremacy*, the jump cuts aid a different sort of ballet. Bourne reaches for Nevins arm. Cut. Bourne's right connects with Nevins's jaw. Cut. Bourne swings a left at the security guard. Cut. Bourne puts down Nevins with another left. Cut. Bourne secures the floor. Cut. Using the bare minimum of footage necessary to convey each impact, the fifty-frame sequence lends Bourne's escape a Houdini-like suppleness. He escapes from captivity like a liquid.

Conceived and born in a spirit of seat-of-the-pants extemporisation, the Bourne films are an extended meditation on the possibilities of living life as one long riff. The scene was Damon's idea: confabbing with his director one morning, he thought it might be a good idea for it not to be a mere escape scene, but instead one in which he plays possum, before surprising his captors with skills the audience knows he possesses all along. The actor was something of an expert on the subject of playing possum, having written an entire movie, *Good Will Hunting*, about a talented kid who plays dumb. The fourth in a string of eponymous roles – Will Hunting, Private Ryan, Tom Ripley – which played to both the everyman in Damon as well as his self-deprecating desire to disappear, Bourne seemed to chime with Damon's ambivalence about his

own fame. The actor made no bones about the fact that the first Bourne film, coming on the heel of two outings perceived as flops – *The Legend of Bagger Vance* (2000) and *All the Pretty Horses* (2000) – had basically sprung him from movie jail. 'To take somebody who we establish as the ultimate American machine weapon who does the only thing he can with it – attempt to atone and start to redeem himself,' said Damon of the character. 'That was the idea.'

The scene in Naples airport was actually shot in Berlin. While filming it, Damon accidentally knocked out the actor playing Nevins, Tim Griffin, with a punch that also broke his nose. 'They were really throwing it at each other,' says Greengrass. 'It was a complete accident, and when he came around, Tim goes, "Did you get it?" The key to the thing you're doing, when you start to shoot it, you've got a very clear choreography. Then what you do is you'll do a pass at a piece of it. Then it will be, "Okay, that piece, it looks like you're throwing it wide," "It looks like you're pulling that one," or "That one looks a bit slow." You literally just go through it tiny piece by tiny piece, just trying to build it up. It's unbelievably tiring.'

Parallel cutting sharpens Bourne's ingenuity: plugging Nevins's phone into a thumb drive, he performs a quick SIM duplication, wedges a filing cabinet behind the door, attaches new number plates to Nevins's car, and by the time Pamela Landy and Ward Abbott at Langley hear that Bourne has 'been detained, he's being interrogated by a field officer', he is, in fact, revving an unidentifiable car, armed with an earpiece that gives him access to all their conversations. One of the chief delights of the series is the Roadrunner-like ingenuity with which Bourne consistently outsmarts the entire national security apparatus of the United States, an asymmetric struggle that is first suggested in Ludlum's original book, in which Bourne pockets the walkie-talkies of his assailants, along with their guns, at the Gemeinschaft Bank in Zurich. 'He infiltrates the armies of others,' says one of Bourne's opponents in *The Bourne Identity*. 'Refined guerrilla tactics applied to a sophisticated battlefield.'

Ludlum's novel plugged into the US's sense of its strengths and vulnerabilities, as had just been revealed to it in Vietnam during a war fought on two fronts: on the battlefield and at home, where, thanks largely to

newspaper reports, America essentially lost the will to fight. 'We fought a military war,' noted Henry Kissinger in 1969. 'In the process, we lost sight of one of the cardinal maxims of guerrilla warfare: the guerrilla wins if he does not lose. The conventional army loses if it does not win.' The director of *The Bourne Identity*, Doug Liman, the son of Arthur Liman, who served as lead counsel for the US Senate's Iran–Contra investigation, understood this aspect of American power: his Bourne, too, uses the assassin's own walkie-talkie to alert him to the whereabouts of the other killers, but he also throws away the gun he finds in a safety deposit box, tilting the battlefield against him still further. If Tony Gilroy's great gift to the franchise was to expand upon the ambivalence towards America's lethal power and turn Bourne against his own CIA masters, Greengrass's was to realise how well this would work as a submerged allegory for the asymmetric battlefield America found itself on after 9/11.

'They don't make mistakes, they don't do random,' says Nicky (Julia Stiles) to Landy and Abbott in *The Bourne Supremacy*. 'There is always an objective, always a strategy.'

'The objectives and targets always came from us,' says Landy. 'Who's giving them to him now?'

'Scary version? He is.'

What follows is Helgeland's. Arriving at the Berlin hub, Landy, the svelte intelligence professional, tells her team to look at everything: outbound flights, trains, police reports, the Treadstone material, parking tickets, satellite imaging, the Neski files. 'Turn it upside down and see what we find. Come on, guys, we ran this guy's life with total control for all those years. We should be a step ahead of him.' Intercut with her delivery of the speech is another piece of editing parallelism showing Bourne's ascent up the service stairs of the building opposite and his assembly of a rifle on the roof, crouched behind a giant sign for Bosch, ever the fan of kitchen appliances. 'What if I can't find her?' says Landy of Nicky. 'That's easy . . . she's standing right next to you,' says Bourne, a line which captures so much of what is so delightful about the series: the multiple head swivels as everyone realises they have been outwitted, all that satellite imaging outdone by a simple eyeline, the security apparatus

of the world's one remaining superpower briefly outmatched by a single man. We are enthralled by the ease with which we are undone.

It's a dirty world out there.

In March 2004, the production returned for its final month in Berlin, where it got light at nine in the morning and dark, in terms of shootable light, at around three or three-thirty. 'We didn't see the sun for quite some time, so I think that probably was a subconscious aid throughout the shoot,' said Damon. But as the gloom enveloped them, so the biggest holes in the script – Abbott's game plan and Bourne's transition from revenge to atonement – now gaped at them like rips in a jet's fuselage. 'I remember Stacey and Frank saying, "We really need to flesh out Abbott's plan. Why is he going to Berlin?"' remembers Greengrass. *Seabiscuit* (2003) screenwriter Gary Ross was hired for two weeks to solve the problem, and wrote a long scene in which Landy tried to explain Russian history, which they shot, but it didn't work. 'We were in a situation that I had never encountered in film-making,' recalls Greengrass, 'where you had a lot of film, but you didn't have the film. The hounds of hell are at your back. You're shooting every day. You're spending money, you're doing shit, but the form is still to be found. Brian [Helgeland] had gone home. But you're just driving forward, and that's when I bonded with Chris [Rouse] very strongly.'

Like a lot of editors, Rouse used large note cards tacked to the wall, each one showing a representative thumbnail image taken from a particular scene, along with a description. This gave him the 'big picture' view of how the film was constructed, so he could see how an alternative flow might affect the story and also spot and plug holes. On any film, normally there is a moment when the version being shot transitions from that of the screenplay into the one tacked up on the wall. The screenwriter's vision gives way to that of the editor. On *The Bourne Supremacy*, with the script in flux, this happened much earlier in the process. Essentially, the editing room became a writing room. Rouse's cards,

tacked up on the wall, became the primary means by which they found the way forward for the film. 'So you shoot. You put it together. You see what the holes are. And then you start to plug them,' says Greengrass. 'Chris was working ahead from early in the day, anticipating issues, firing ideas at us, and at night he and Matt and Frank and I, we'd all put our heads together. "Okay, now we need to get that scene. And now we need to do that piece."'

The pressure on Greengrass was unearthly. In addition to compiling multiple versions of a cohesive shooting draft out of what was essentially two screenplays on a daily basis, he was also overseeing the editing of Pete Travis's film *Omagh* (2004). Slowly but surely, he had been drawn into it, first to rewrite Guy Hibbert's script, which Tessa Ross, who was running Channel 4 drama at that time, was pressing him to do, and then to oversee the edit, after Travis encountered problems cutting the film. Greengrass would shoot *Bourne* during the day, then watch the rushes; after that he would receive the rushes of *Omagh* and watch those through the night, before going back to *Bourne* the following day. Universal never knew about this side project. '*Omagh* was important to me on an emotional level,' he says. 'It kept me in touch with my identity as I understood it. So I never felt I was dependent on the studio – I'm not talking about financially, just in myself. I had an identity beyond that. I wasn't just a guy who wanted a job in Hollywood. I was a film-maker who made films about things that interested me, and I was making *Supremacy*. I think, in a way, it bridged an uncertain period for me. It allowed me to deal with Bourne with more sangfroid than I otherwise might have done. I was under a lot of pressure and with a firework under my butt. It was my time. I had a lot of things inside that I needed to get out.'

Also, his and his wife's baby was coming any day now. Someone posted Joanna's due date onto the schedule in the production office, with a Post-it note that read, 'Paul's baby – done!'

They had a good laugh about that.

As the final weeks of production approached at the end of March, all of Greengrass's work began to pay off. The contrast between Landy and Abbott was beginning to sharpen, even though Abbott's plan was still murky. Nicky was coming across nicely, and finally, with Chris Rouse's help, Bourne's pivot from revenge to atonement was engineered. In Gilroy's script, Bourne returns to the Hotel Brecker, where he remembers his first mission – to kill the Russian reformist politician Neski and his wife – in a series of flashbacks. Interrupted in Neski's room by a drunken British hotel guest, Bourne was supposed to then exit through the bathroom window, scramble along a narrow ledge 60 feet up, drop to a terrace, come in through another window and, disguised as a hotel guest – in a bathrobe, with wet hair and bright-pink wash bag – steal a bike, which he later disposes of by throwing it off a bridge. To this was added the suggestion, from the studio, that Bourne write the words 'Neski Was Here' in shaving foam on the mirror so that Landy would find them.

'I was fuming,' recalls Greengrass. 'It was risible, like an ugly rivet, when what you're really looking for is an artful, seamless flow, so you don't see the hand dealing you the card. They were right. Bourne had to learn the truth about the Neski killing, as did Landy. But the crudeness of the foam didn't feel right to me at all. I wanted him to move, to explode into action. I wanted him to go balls out and run. He's going to experience that flashback, and then he's going to look in the mirror and see himself. You're going to read, in that moment, all his shame, all his guilt for what he has done. The desire for revenge is going to be entirely waylaid at that moment, because he's going to come face-to-face with his guilt. At that moment, there's going to be a knock at the door or he's going to hear the bad guys come – police, goons. So he's going to have an overwhelming desire to run away, because otherwise he's going to be caught. But, at a deeper level, he's running away from what he did. How it got solved was, trusting that Matt could sell it. The key moment was when he jumps on the tube train and we push into him, and that's what he sells in that moment.'

The sequence was shot over a couple of nights at Haus Cumberland, on Kurfürstendamm, the Friedrichstrasse S-Bahn station and the Weidendammer Bridge over the River Spree. 'We didn't have very much time,

I remember. We could only do it once, because we weren't supposed to get on the tube. It was like, "Fuck it. Let's sneak the shot." They were all going, "You can't do that on a big movie. You can't." "It's okay, we'll go about three stops and change and come back again." "Okay, you can do it, but you're only going to have one or two nights." So it was jacked up on the hoof.' In the finished sequence, as sirens and SWAT teams converge on the Hotel Brecker, Bourne stares at the mirror in room 645, his face cloaked in shadow, in full knowledge of what he has done: murdered the Neskis, whose family picture in the hotel room reveals a daughter. As the SWAT teams shuffle up the stairs, John Powell's familiar sixteenth-note ostinato is played over and over on cello and bass, telling us that Bourne is soon to be on the run again. He scales the side of the building via a drainpipe up to the roof, as the SWAT team burst in and search the empty room. Bourne then drops down onto the street and calmly exits as Landy arrives out front. At this point, Powell's ostinato is taken up by the entire string section, suggesting an almost musical link between hunter and hunted, both playing their respective parts like instruments in an orchestra, counterpoints in the same melody.

'What the hell is he doing here?' asks Landy, referring to Bourne.

'Maybe he just wants to stay the night,' replies Gallup (Tom Cronin).

Most action sequences accumulate hardware: guns, gear, ammo, cars, men. In Bourne, the sequences get tenser the more attenuated they are. The CIA cannot get rid of their gear fast enough, although only Bourne seems to know this. Missed by the SWAT teams, he is spotted by the security guard in a jewellery store. Pursued by cars and police motor-cycles, Bourne escapes on foot, as the bikes are snarled up in traffic. (If the Bourne movies have a single sound effect that sums them up, it is the Doppler effect of a European police car approaching and then passing by Bourne.) Followed on foot onto a railway platform, he makes it into one of the trains, whose door obstinately refuses to obey the rules laid down by *The French Connection* (1971) and close in time for him to make his getaway – does that only happen to bad guys? – so he drops onto the tracks in front of an incoming train that just misses him, and then, while the policemen's view is blocked by the train, hops over the railings of a

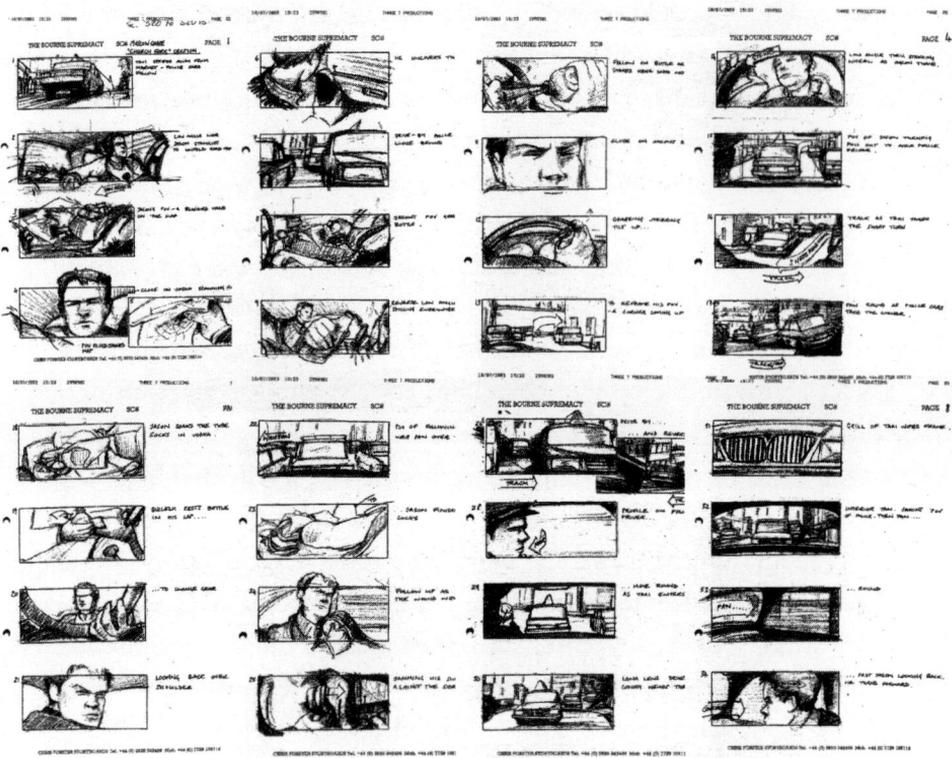

Chris Forster's storyboards for the Moscow car chase in *The Bourne Supremacy* (2004).

bridge onto a coal barge passing underneath. What follows has a wonderful circularity: pursued along the towpath of the Spree by the police, Bourne uses a boat hook to swing himself up onto the girders of the next bridge along, from where he hauls himself back to the railway station and catches a train after all.

From train to bridge to barge and back to train again. You have to return to the climax of Buster Keaton's *Spite Marriage* (1929), in which Keaton is thrown from the bow of a yacht, gets dragged under by the current and clambers back on board to rejoin the fight, to match the ingenuity of Bourne's course of action here. Steven Spielberg did something similar in *Raiders of the Lost Ark* (1981), when Indy is punched through his windscreen, disappears under the wheels of his own truck, attaches his whip to its undercarriage and hauls himself back on board to

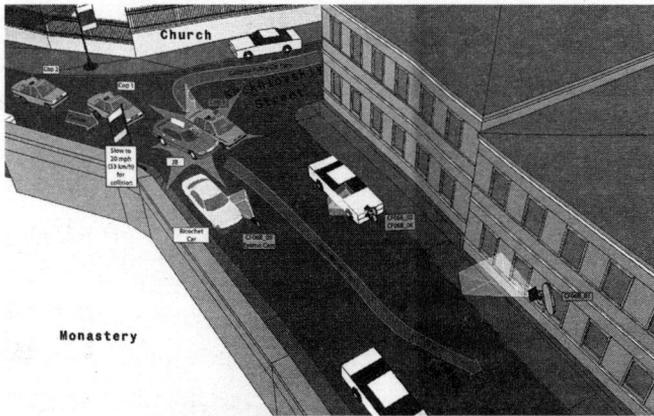

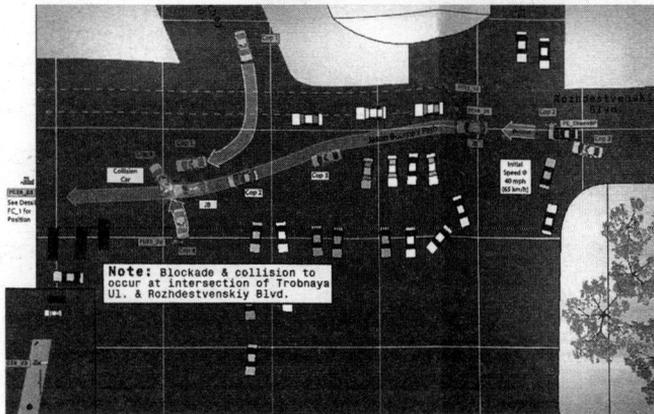

A computer-generated schematic for the Moscow car chase in *The Bourne Supremacy*.

resume his fight with a Nazi. But where Indy met his foes with a comic shrug ('Nazis, I hate those guys'), Bourne casts a deeper shadow. As the train pulls away, Powell's orchestra swaps out for an ambient wash of synths, and the camera moves in on Damon, his face again partly in shadow; he looks around, his panic taking a while to subside, as the realisation that he is no longer hunted sinks in. In the space of a few seconds, Damon conveys three things: first, that he's evaded his pursuers; second, his gnawing horror at the discovery that he's a killer; and third, a quiet resolve about what he must do next.

'If you remember, the camera goes in and we sit there with him,' says Greengrass. 'There's a shot that holds for a long time with him as you take

his temperature. You feel, although you couldn't articulate it as such, that he has run away to the place where you can't run any more. There is no more running away you can do. At that point, all you can do is atone. All you can do is move forward, and that's what he does. The next move that Bourne makes is to go to Moscow. I wanted the exhilaration of the foot chase, the balls-out long chase with layer after layer of impediment, because that's exciting, and I wanted the film to explode at that point. But, at a much deeper level, I wanted it to make the turn from revenge to atonement through action. By making it non-verbal it really worked, because it was within the chase his character changes, because he's run until he can't run any more.'

If anyone resembled a man with nowhere left to run, it was the director, as principal photography on *The Bourne Supremacy* wound down. A day or so after they wrapped, after a long night in the editing room in London, Greengrass sent Stacey Snider an email that, according to him, went something like: '"I've reviewed the film, and as I've been arguing for a long time, we have the following problems, and the film is broken in a number of places – A, B and C, and so on . . ." I was a bit ass-y, to be honest. It was a pretty provocative email, and as I walked home to Queen's Park, my phone rang. "Can I have Paul Greengrass for Stacey Snider please?" Then Stacey came on the phone, whom I had met but I couldn't say I knew. She's pretty formidable and direct. "I've just got your email. You've just spent $84 million of the studio's money. It is not acceptable to send an email saying the film is broken in many places . . ." "Okay. Fair point," I thought. It made us all look like fools. She slapped me down. Fair enough, because the stakes are rising, you're spending a lot of money and we're getting towards the business end of the timing.'

Snider told him to send over the film as it was, and in March, Greengrass flew to Los Angeles, where he and Joanna rented a bungalow in Malibu for the film's post-production, in the belief that *The Bourne Supremacy* was going to be a one-time deal, so they might as well enjoy

it while they could. Set on a big plot of land, it had a pool with a water slide that their kids absolutely loved and a balcony that overlooked the ocean; across the bay they could see the planes wheeling in and out of Los Angeles Airport. Greengrass had a new daughter, Betsy, born the previous September, whom he wanted to get to know. 'I'd been away an absolutely horrendous amount of time. By the time we got there, we both felt like, "How's this all going to work with family life?" These films were enormous and all-consuming, and we were being overwhelmed by the speed with which my working life was moving and changing. How were we going to deal with it as a family?'

In April, screenwriter Paul Attanasio, twice Oscar-nominated for his scripts for *Quiz Show* (1994) and *Donnie Brasco* (1997), was hired to fix the things on which Snider agreed with Greengrass and thought needed fixing, but with a release date of 15 July looming, they didn't have much time. Attanasio came into the editing room, saw the cards and quickly got what Greengrass and editors Chris Rouse and Rick Pearson were trying to do: define and clarify the relationship between Abbott and Landy, and in the process, find out what Abbott's plan was. Finally, it came to them: Abbott had purchased oil leases from Yuri Gretkov using CIA money. An outspoken critic of oil privatisation, Neski was in Gretkov's way, so Bourne was assigned to kill him, but files linking Bourne to Neski came to light, so Bourne had to be rubbed out as well. During the reshoots, says Greengrass, 'an executive was tasked to stand by the monitor to ensure that I shot everything with a locked-off camera, as well as with my hand-held camera'. The executive would stand next to him during the reshoots and remind him, 'Have you done our locked-off shot yet? Don't forget our version.' Greengrass would reply, 'Don't worry. You'll get your version.'

In June, they tested the film for the first time: it did okay, not great, but okay. After additional shooting, they did another test later that month, in San Diego, and the scores actually went *down*. The whole crew was there: Snider, Marshall, Crowley, Greengrass and Rouse. 'The scores went down, but it was very clear it was a better film,' Greengrass recalls. 'Well, that was bad news. I could see them all off to the right, around Stacey in a hubbub. I can see that, for them, that really is a lot of pressure. You've got

one of these franchise movies hurtling down the tracks and your scores go down. That's not where they want to be. I'm thinking, "Uh-oh," and they finish their hubbub, and then I'm called over. Stacey said something like, "Okay, guys. We've done a lot of good work on this film and tonight we've not had a reward for the good work that's been done, but I want you to know I'm right behind it. We're going to sit down tomorrow and have another conversation about what else we should do, but I don't want you to feel that this film is not going to work, because it absolutely is. We've just got to stick to our guns . . ." That was Stacey. Real courage under fire. The great joy of *The Bourne Supremacy*, actually, as I look back on it through all the hair-tearing, was that we became a sort of band of brothers. Our little group of very disparate people came together, even though we were talking to the film from different positions. Somewhere you've got to align, and the joy of the Bourne movies, and the reason I think they were so successful, is because somewhere, in the creative mix of all these people sat together at that table, out of all our creative tensions, was built this tremendous sense of personal loyalty and camaraderie that felt very blessed – but, fuck me, it was close to the wire. That last period was absolutely mental.'

The final scene between Abbott and Bourne was shot no fewer than five times. Damon and Cox even wrote a version together. 'We shot three of those endings and having done that, I dusted myself off, thinking the job was done, and scarpered off to do an adaptation of Chekhov's *Uncle Varick* at the Royal Lyceum in Edinburgh,' recalled Brian Cox in his 2022 autobiography *Putting the Rabbit in the Hat*. They did the previews for the play on the Thursday and Friday, for an opening on the Tuesday. Then a call came through from Universal. He was needed again. '"There's going to be a plane waiting to fly you to Germany. We're doing some pick-ups."'

Even after another round of reshoots, everyone agreed that the film still needed some sort of coda. As it currently stood, Bourne confronts Neski's daughter in her apartment block, confesses to killing her parents, apologises and leaves. Attanasio thought the film needed a new piece of information about Bourne, while Marshall wanted something to give it a

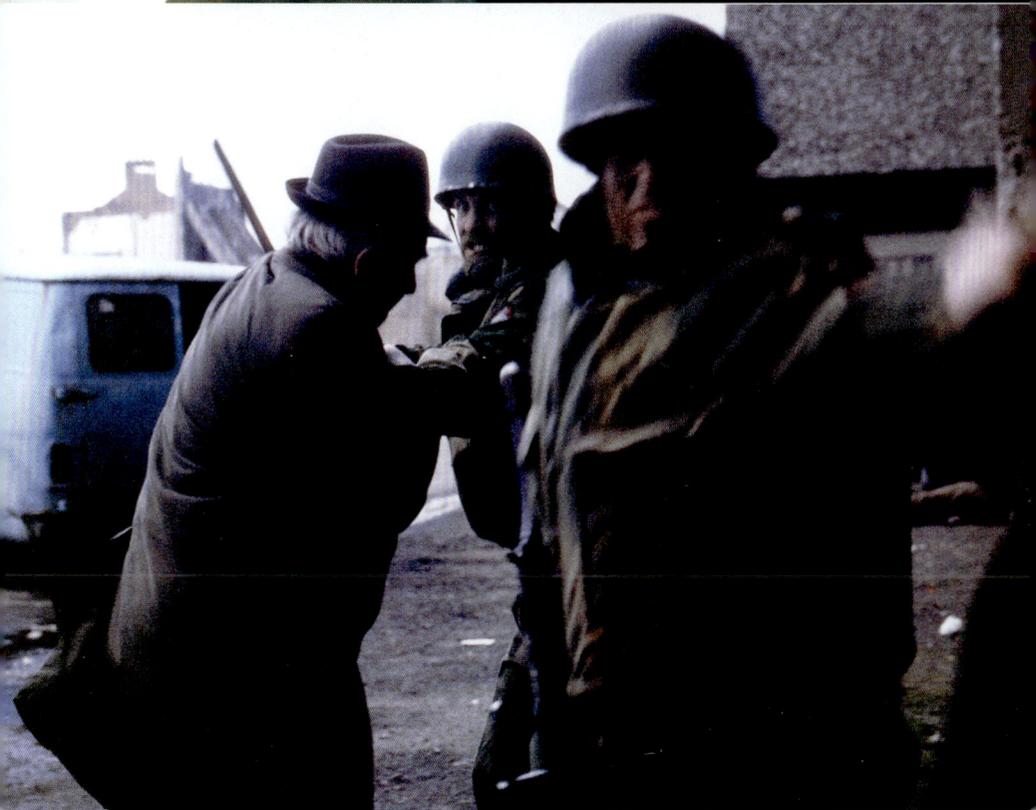

Bloody Sunday (2002): (*top*) James Nesbitt and Kathy Kiera Clarke star; (*bottom*) paras brutalise a civilian.

Greengrass and Matt Damon prepare the Naples interrogation scene for *The Bourne Supremacy* (2004).
Greengrass rehearses *United 93* (2006) at Pinewood Studios, London.

Greengrass and Damon consult while on location at Waterloo Station, London, during shooting for *The Bourne Ultimatum* (2007).

Chris Forster's storyboards for *Ultimatum*'s Waterloo sequence: 'I was going for something a bit more symphonic,' says the director.

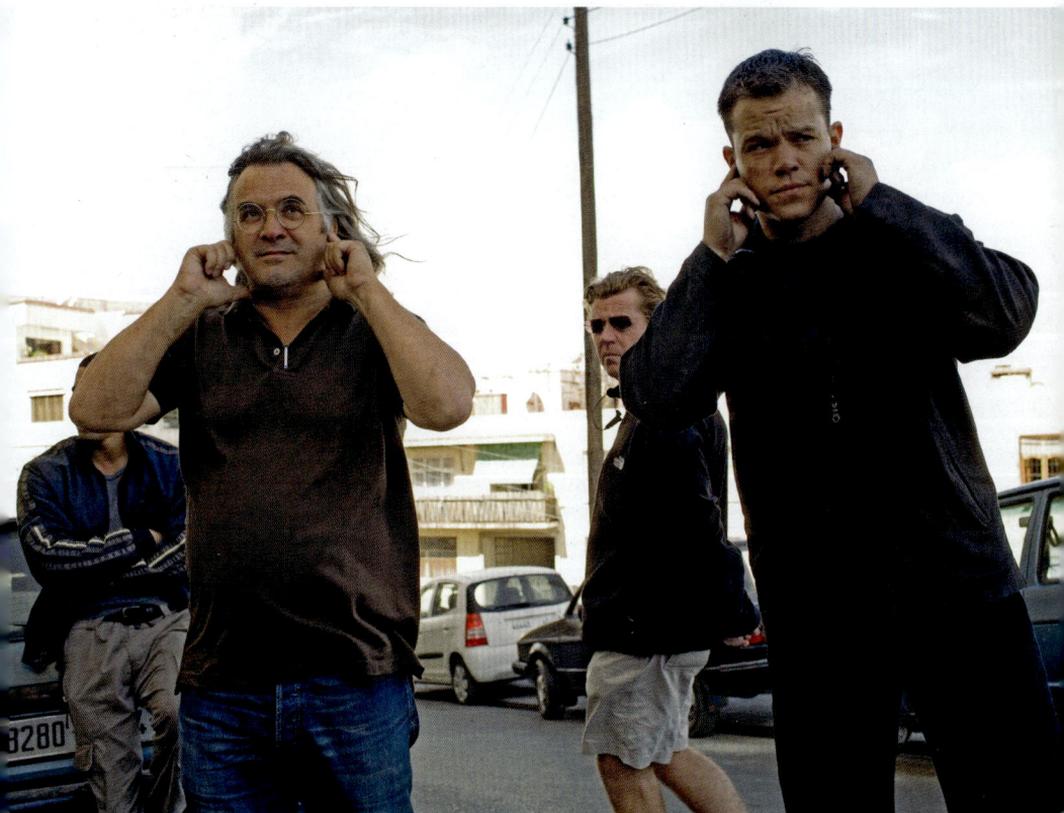

Greengrass and Damon shooting *The Bourne Ultimatum* on location in Tangiers.

Captain Phillips (2013): (*top*) Tom Hanks prepares to shoot on board the lifeboat; (bottom) the Somali pirate leader Muse (Barkhad Abdi) below decks.

Anders Danielsen Lie as Anders Breivik in *22 July* (2018) – was he mad or a political actor?

Tom Hanks, Greengrass and Helena Zengel share a joke on location for *News of the World* (2019).

The Lost Bus (2025): (*top*) Greengrass talks to cast and crew while shooting in Santa Fe, New Mexico; (*bottom*) Greengrass preps for the evening's shoot.

Greengrass works out a shooting plan for *The Lost Bus*.

lift, with less of a European note and more of an American one. Damon had by this time been pulled into shooting *Ocean's Twelve* (2004) for Steven Soderbergh. Finally, a writer–director friend of Damon's, George Nolfi, with whom he was about to shoot *The Adjustment Bureau* (2011), came up with an idea. 'I remember Matt calling me up one evening, like a day or two later,' recalls Greengrass. '"I've just been chatting with George. He's just pitched me an ending. What do you think?" I thought, "Well, that's fucking great." "Should we do it?" "Yeah, let's."' In Nolfi's ending, one bright, sunny day, Bourne shows up in New York and phones Landy at the CIA's headquarters, at 48th Street and Third Avenue. She tells him what he's actually called: 'David Webb. That's your real name. You were born in Nixa, Missouri . . .' He thanks her, then adds, 'Get some rest, Pam. You look tired,' prompting her to spin and look out of the window as she realises he must be watching her.

Greengrass and Matt Damon in India while shooting *The Bourne Supremacy* (2004).

Greengrass jumped on a plane to New York, and within three days they were shooting the scene on a closed-off section of Seventh Avenue, for a cost of $200,000. Damon had to be pulled from reshoots on *Ocean's Twelve*. Then, with literally only a couple of weeks to go until it was released, they tested the film again. It scored ten points higher. 'We were so close to the wire it was unbelievable. That's what I mean about ballsy studios and ballsy producer. It's like, "You got another ending? Okay, let's do it." We put that ending on and we tested it again, and the scores went vertical. I remember standing outside with Frank, and him saying, "That's what a hit movie looks like." Because you could feel it. It hit the audience's G-spot. And you could see it, people's faces – they loved it. Suddenly, everything that you'd done that you didn't get the credit for, all the blood, sweat and tears, suddenly, it was just like . . . That's when I knew this wasn't going to be a one-off.'

The Bourne Supremacy ended up taking $176,241,941 in North America and $290,633,422 worldwide. 'The question driving the action isn't existential (who am I?) but moral (what did I do?), a surprisingly weighty mystery for a movie intent on blasting our synapses into submission,' wrote Manohla Dargis in her glowing review in the *Los Angeles Times*, which Paul Attanasio emailed to Greengrass. 'Director Paul Greengrass, who either has very creative attention deficit disorder or the fastest reflexes of anyone over 14, keeps his movie moving and then some . . . Rarely does pop come with such sizzle.' The director had embarked on a marathon of back-to-back movie-making, going from *Bloody Sunday*, through *The Bourne Supremacy*, *United 93* and *The Bourne Ultimatum* – a startling, high-speed blur of hits, a darting zig-zag run between studio and indie projects that critics often like to characterise as 'one for them' and 'one for me', on the presumption that the studio projects draw less in the way of personal vision, focus and creativity from a film-maker. Part of the reason why Tony Gilroy underestimated Greengrass may have been that he pegged him as a hired hand from the indie world who would not have strong instincts with regard to the making of a mainstream commercial hit, his style having been prised away from subjects like Northern Ireland and applied cosmetically to a studio project for a little extra grit. If *The Bourne Supremacy* and *The Bourne*

Ultimatum were any less magnificent, one would be inclined to agree, but instead they are among the greatest action thrillers of the twenty-first century, fusing indie and studio sensibilities, spy movie and action thriller in such a way as to permanently alter Hollywood's grammar. Wrote Dargis:

> *The Bourne Supremacy* isn't just paced and cut for maximum speed, with eye-blink edits and quicksilver camerawork, it's brilliantly paced and cut. In contrast to most contemporary action films, the hopped-up rhythms don't just sex up the material or try to transpose a video-game pseudo-reality to the big screen. Rather, what Greengrass and company do is capture a distinctly modern fractured sense of time and space, locking on a jagged, near-Cubist style that vividly conveys how Bourne experiences the world.

Auteur theory explains careers better than it explains classics. While writing *Taxi Driver* (1976), screenwriter Paul Schrader hit rock bottom while drifting around LA, living and sleeping in his car, eating junk, watching porn, drinking round the clock. Heavily into guns, he considered suicide, and later admitted, 'Travis Bickle is me.' Robert De Niro was enraptured by Schrader's script, having been working on one of his own about a political assassin, which he immediately dropped. 'He *was* Travis,' said Martin Scorsese of De Niro, and he had the exact same response on reading the script. 'I thought I had dreamed it.' So that made three of them – 'a rather unusual kind of symbiosis', as Scorsese put it – all playing midwife to this spiritual misfit and self-appointed scourge, Travis Bickle. 'The three of us just came together,' said Scorsese. 'It was exactly what we wanted; it was one of the strangest things. We were like the Three Musketeers together.'

Strange, but not unprecedented, for the same three-way midwifery constitutes the backstory of a surprising number of classic films: *On the Waterfront* (1954) only happened because writer Budd Schulberg, director Elia Kazan and actor Marlon Brando saw something of themselves in Terry Malloy; and likewise, in *The Graduate* (1967), Benjamin Braddock was an act of simultaneous ventriloquism by writer Buck Henry, director

Mike Nichols and actor Dustin Hoffman. Call it Auteur Theory 3.0: the optimum conditions for a great film to result are a writer, a director and an actor all committing an act of synchronous three-way autobiography through the person of the film's hero.

So it was with *The Bourne Supremacy*. Gilroy supplied Bourne with his stricken conscience, disruptive stratagems and command of 'Bourne-speak', somewhere between a PowerPoint presentation and a drill sergeant ('This is not a drill, soldier. We clear on that? This is a live project. You are go'); Damon shaped the character's ambivalence into a dynamic force that expressed his urgent desire for anonymity and a normal life; while Greengrass invested Bourne with his restlessness, his abhorrence of cabals and his drive towards the truth, as well as doubling down on his status as an agent of chaos. It is there in Robert Ludlum's book: 'On the pavement the growing chaos was Jason's protection. Word had gone out of the bank; wailing sirens, growing louder as police cars raced up the Bahnhofstrasse.' Conceived and executed under the gun, Greengrass's instalments of the franchise are full of magnificent chaos, ruckus and hurry, like the Rolling Stones at full gallop. 'You can't believe the people in the band are keeping up with themselves,' wrote Greil Marcus of the Stones performing a Muddy Waters track. There is no better description of both the genesis and experience of watching these films – and yet keep up with themselves they do. Greengrass did not actively seek chaos on the set of *The Bourne Supremacy*, but of all the directors the studio could have found, he was the one best equipped to flourish in, and take advantage of, the chaos that enveloped its production and turn it into a style that caught the mood of the post-9/11 era.

'They probably viewed it as chaos,' he says. 'It gave me freedom. You're doing this so fast and in so many directions at once that as long as you're always getting done what needs to be done, nobody really can kind of keep tabs on it. They sort of know what you're doing, but it doesn't really matter because in the end it's all going to come out in the wash. Buying space to make the film you want to make is at the heart of directing movies, how you buy yourself that space. The great footballers have an ability to give a ballet of unbelievably intense physical exertion and speed

in many dimensions all at once. The great players have that ability to find that little pocket of time and space that no one else can. Just a tiny shrug of the shoulder, and they've got it. That's what you have to do as a film-maker: you've got to find space to be able to do what you need to do. You've got to bring these two forces that are immensely powerful – the forces of anarchy and the forces of control – and you've got to harness them together. That's my view of it. And if you can bring them right into alignment – because these two forces want to throw each other off – but if you can bring them into balance, something happens at that moment. You get fusion, essentially, and you get into a zone where exciting things happen, and there's a quality to it where the film feels immediate, it feels urgent, it feels found. I'd often say on a set, "I don't want a fucking airline meal." I don't want it. You take your plastic top off, and there's the meal. You've got your little bit of ham sandwich there, and your little bit of this there. I want it to be an experience.'

Along with the *LA Times* rave Paul Attanasio sent to Greengrass, he wrote, 'Congratulations on your excellent reviews. In the end your vision of the film carried the day. Now you're hot. Use it wisely.'

7: REVOLUTION

At 8.46 a.m., on 11 September 2001, American Airlines Flight 11 crashed into the northern facade of the World Trade Center's North Tower, at an impact velocity of 200 metres per second. It was followed seventeen minutes later by United Airlines Flight 175, which crashed into the southern facade of the South Tower at an impact velocity of 240 metres per second. Each plane weighed some 127 tons, and before colliding with the towers, they both banked to the left and hit with roll angles of approximately 26 degrees and 35 degrees respectively.

Upon impact, the aluminium fuselages and wings sliced through thirty-three of the North Tower's and twenty-three of the South Tower's exterior columns, each one constructed of welded steel plate. As the floors rippled and were ripped apart, the planes' wing beams were most probably sheared or crushed, but those portions of the wing that fitted in between the floors penetrated all the way to the building's core columns – steel pillars that were continuous for almost the entire height of the towers, from their bedrock anchors in the sub-basements to near the very top. At 500°C, a third of the temperature actually attained in the ensuing inferno, steel loses 90 per cent of its strength. Somewhere between seven and twenty of these core columns were ruptured in the

South Tower, and between four and twelve in the North Tower, suggesting that very little of the planes made it past the buildings' cores, although one engine, a portion of landing gear and a small section of fuselage were found a few blocks away. All the passengers and crew were incinerated in the fireball created after the planes' remaining fuel – around 10,000 gallons each – ignited. That is not what we saw if we were watching the news coverage, though. 'The airplanes collided with the buildings at a cruising speed, cut through the outer shell and *disappeared* inside the towers,' observed Tomasz Wierzbicki, professor of applied mechanics at MIT, in a 2003 paper written with two of his colleagues, Liang Xue Meg and Hendry-Brogan.

On the day, Greengrass was driving to the cutting room to work on *Bloody Sunday*. It was lunchtime. He was coming in late, having worked the night before. A friend, David Leigh, a journalist at the *Observer*, phoned him up.

'Are you watching the television?'

'No, I'm in the car.'

'Two planes just hit the World Trade Center.'

Greengrass turned on the radio in time to hear the second plane strike the South Tower. He turned around, went home and spent the rest of the day watching TV. 'We were quite well advanced on *Bloody Sunday*, whose purpose, at root, from my point of view, was to talk about the Troubles. If you were my age, wherever you were in the islands of Britain and Ireland and whatever tradition you were from, or even no tradition, the Troubles were the dark, endless reality, and they were coming to an end. And then, all of a sudden, it felt like that moment in *Close Encounters*, when you've been dealing with spaceships that are like this size, and then suddenly this enormous fucking thing comes over the horizon, and it's "Oh, my God, we've been dealing with nothing compared to what's coming at us now." It didn't change what I wanted to do on *Bloody Sunday*. But straight away you could feel you were entering a new world.'

From that date on he kept a file of clippings on United 93 – the only flight not to hit its target that day, after it was brought down in a field in Pennsylvania – making note of the dark bravado with which the vice

president and others in the Bush administration recounted their deliberations over the prospect of shooting it down. 'Very, very tough decision, and the president understood the magnitude of that decision,' said Vice President Dick Cheney's chief of staff Scooter Libby of Cheney's reaction when told, sometime between 10.10 and 10.15 a.m., that the aircraft was eighty miles out. The vice president authorised two fighter pilots from the Air National Guard to engage with the plane in 'about the time it takes a batter to decide to swing', Bush's then chief of staff, Andrew Card, told ABC News. In his autobiography, *In My Time*, Cheney reaffirmed this version of the story:

> At about 10:15, a uniformed military aide came into the room to tell me that a plane, believed hijacked, was eighty miles out and headed for D.C. He asked me whether our combat air patrol had authority to engage the aircraft. Did our fighter pilots have authority, in other words, to shoot down an American commercial airliner believed to have been hijacked? 'Yes,' I said without hesitation. A moment later he was back. 'Mr. Vice President, it's sixty miles out. Do they have authorization to engage?' Again, yes.

Cheney was logged calling the president at 10.18 a.m. for a two-minute conversation. The president confirmed the order for the shoot-down of an American passenger jet. 'It's an order that had never been given before,' said Cheney. Comments such as these were repeated by other administration and military figures in the weeks and months following 9/11, forging the notion that only the passengers' counter-attack against their hijackers prevented the inevitable shoot-down of United 93. Notably, Colonel Robert Marr, the Northeast Air Defense Sector (NEADS) battle commander, states in the US Air Force's official history of 9/11, *Air War Over America*: 'As United Airlines Flight 93 was going out [west, towards Chicago], we received the clearance to kill if need be.'

Hearing this during the 9/11 Commission hearings in 2003, the ears of Commission staff member Miles Kara perked up. 'I said to myself, "That's not right."' Kara had seen the radar recreations of the fighter

```
                                        BIN LADIN WAS PLANNING TO EXECUTE
NEW OPERATIONS AGAINST UNITED STATES (U.S.) TARGETS IN THE NEAR
FUTURE. PLANS TO HIJACK A U.S. AIRCRAFT WERE PROCEEDING WELL.  TWO
INDIVIDUALS FROM THE RELEVANT OPERATIONAL TEAM IN THE U.S. HAD
SUCCESSFULLY EVADED SECURITY CHECKS DURING A TRIAL RUN AT "NEW
YORK AIRPORT                          BIN LADIN HOPED THAT THE
OPERATION WOULD BE IMPLEMENTED BEFORE THE START OF RAMADAN.

CIRCA 20 DECEMBER.) THE OBJECTIVE OF THE OPERATION IS TO OBTAIN
THE RELEASE OF BLIND SHAYKH 'UMAR AHMAD 'ABD AL-((RAHMAN)), RAMZI
((YOUSEF)) AND MUHAMMAD SADIQ ((ODEH)), A SUSPECT IN THE BOMBING
OF THE U.S. EMBASSY IN NAIROBI, KENYA.
YOUSEF AND RAHMAN WERE CONVICTED OF THE WORLD TRADE CENTER BOMBING
IN NEW YORK.  MOHAMMAD SADIQ ODEH
WAS ARRESTED
```

'The 1998 Raw Intelligence Report on UBL's Plans to Hijack an Airplane', which became an item in the President's Daily Brief on 4 December 1998. 'Bin Laden and his allies are preparing for attacks in the US, including an aircraft hijacking,' it warned.

planes' routes. 'We knew something was odd, but we didn't have enough specificity to know how odd.' At 9.16 a.m., when the tracking of United 93 had begun, the plane had not yet been hijacked. And while North American Aerospace Defense Command (NORAD) commanders did, indeed, order the fighter jets to scramble, as had been testified, it was not in response to the hijacking of American 77, on its way to the Pentagon, or United 93. Rather, they were chasing a ghost: United 93 had already crashed. Moreover, as Marr later acknowledged to the Commission staff, the shoot-down order was never passed on to the pilots because NEADS commanders thought it irresponsible to do so. There were simply too many planes in the sky.

All this would eventually be confirmed, thanks to the information found in two locations. The first was United 93's crash site near Shanksville, Pennsylvania, where the 128,730-pound Boeing 757, plummeting at more than 500mph, had burrowed a pit deep into the earth. Books, clothing, papers, two Bibles and a red bandana were among the effects recovered, while one of the plane's two black boxes, containing the flight data recording, was discovered two days later, at a depth of 25 feet (the cockpit voice recorder was found at a depth of 15 feet the day after that). The second was tucked among pines in the hills of the

southern Adirondacks, where a twenty-two-year-old aluminium bunker was tricked out with antennae that were tilted skywards: this was NEADS, and the regional headquarters for NORAD, the Cold War-era military organisation charged with protecting American airspace. Four Dictaphone multi-channel, reel-to-reel tape recorders mounted on a rack in a corner of the operations floor contained the sum total of America's military response during those critical hundred-odd minutes of the attack. What the tapes revealed was not the story that was being told to the public by the Bush administration.

In September 2003, Greengrass attended the 30th Deauville Film Festival, where *The Bourne Supremacy* was to receive its French premiere, alongside Jonathan Glazer's *Birth*, Michel Gondry's *Eternal Sunshine of the Spotless Mind*, Steven Spielberg's *The Terminal* and Michael Mann's *Collateral*. Greengrass had arranged to meet Matt Damon, who was also attending, along with his wife Joanna and Damon's fiancée, Lucy, but before they met, Damon said, 'I'm having dinner with Steven [Spielberg], and he'd love to meet you.' Also at the festival were Tom Hanks and his wife, Rita Wilson; maybe they would like to join them? 'Well, that was a very significant moment for both Joanna and me,' recalls Greengrass, who, when he got to the restaurant with Joanna, peeked through the window to see all of them already there. The introductions done, Greengrass and Spielberg exchanged admiration for each other's work: Spielberg for *Bloody Sunday*, Greengrass for *Schindler's List*.

'I have astonishing admiration for Spielberg,' says Greengrass. 'He is the last great classical film-maker that we will ever see. Deep focus, specific kinds of lenses, specific kinds of choices . . . It is a lost art, an art that will die with him.'

At their end of the table, Joanna and Spielberg's wife, Kate Capshaw, talked about families and the difficulties of balancing them with their husbands' directing careers. Capshaw told her it was like going on the road with a circus or a rock 'n' roll band. Everybody travels together;

if they had to take a teacher or friends with them, so be it. That was how Spielberg made *Schindler's List*, accompanied by all seven of their children, a friend of their sixteen-year-old's and a teacher, with some of the film shot during the school holidays. "'We're making a film about Schindler's list. You're going to learn more on this shoot than you will sitting in school,'" Capshaw said she told her kids. 'And they came, and we made it work, and that's how we do it and it's non-negotiable. If you have to spend all your salary, that's what you do.'

Afterwards, Greengrass and his wife made a decision: where possible, he was going to make movies in the UK. That autumn, they moved from Queen's Park to a cottage house near Henley with a barn that Greengrass could use as an office, and space, too, for Joanna to use for her talent agency. It was a bold choice on Greengrass's part as not only did it put him eleven hours away from Los Angeles, but America and its 'forever war' against terror would continue to fill much of his creative airspace for the next decade. The following July, he sat down to lunch with Universal chairwoman Stacey Snider at the studio's in-house restaurant, the Commissary, to discuss possible future projects.

'What do you want to do next?' she asked him.

'9/11 and the invasion of Iraq, because those are the twin drivers of our lives right now and for the foreseeable future,' he said. He started to talk about the underbelly of the so-called War on Terror. 'Okay, here's what's going on right now. There's this Gulfstream aeroplane, Gulfstream number N379P. And what they're doing is, they're grabbing people off the street in places like Stockholm and Rome, blindfolding and hand-cuffing them in broad daylight and bundling them into the back of this Gulfstream and taking them to God knows where . . . It's called "rendition".'

It was summer 2004. Lord Butler's *Review of Intelligence on Weapons of Mass Destruction*, examining the unreliable intelligence used to justify the war, had just been published. There were reports of CIA kidnappings and something called 'extraordinary rendition'. 'I was very interested in what was going on in the War on Terror,' says Greengrass. 'So that was what I was about in those years. I wanted to deal with that; that was what

was going on in the world. You could feel this enormous accumulation of secret history – I mean, what the fuck was being done in our name in the War on Terror?'

Among the projects that presented themselves was an adaptation of Alan Moore's 1986 graphic novel *Watchmen*. Set up initially as a project for Darren Aronofsky to direct at Paramount, in October 2003 producers Lloyd Levin and Larry Gordon sent Greengrass a copy of David Hayter's script, a faithful adaptation of Moore's story about morally ambiguous superheroes struggling against a ban by Congress to right a world being dragged towards a nuclear showdown. 'I would have made that film. And I had a particular view of it. I liked its wild embrace of conspiracies and its melange of all sorts of elements of popular culture. It had a sort of Rauschenberg–Richard Hamilton feel to it. I said, "Let's make this film, not as if all these people were superheroes, but as if they thought they were." Really, they were just real people. That seemed to be much more interesting, so that you had a sense of self-actualisation in these characters, as well as all the dark, conspiratorial things. When I saw *Joker* – which I thought was a magnificent film, by the way – I thought it had gone down that road. It had taken the movie out of the realm of the comic book and put it in the world of behaviours and damage and self-actualisation, and that's what I was interested in.'

Greengrass met with Levin in October 2004, and a month later with Hayter, after he delivered a new draft of his script, with billionaire industrialist Adrian Veidt at the centre of it. 'All the steps to Armageddon that Paul Greengrass was asking for, the murder of The Comedian, all of that was set up by Adrian,' said Hayter, and in mid-December Greengrass signed on officially and began designing and casting the film. Paddy Considine was in talks to play Rorschach, while Jude Law and Tom Cruise were lobbying to play Ozymandias. Greengrass wanted Joaquin Phoenix for Dan Dreiberg and Hilary Swank as Laurie. Graphic artist Tristan Schane drew designs of Dr Manhattan for the film, which depicted him with visible intestines. 'It would've been done a little bit documentary-style, with a little news reporting mixed in,' production designer Dominic Watkins told the website CBR. 'Ours was similar to

[Zack] Snyder's [eventual *Watchmen* film], but much more kind of fucked up . . . We tried to think through every element and go, "If this was a real thing, then where does it come from? How did it get there?"'

In March 2005, however, Paramount's CEO Donald De Line was fired, and Brad Grey took over the studio. Fearing potential budget cuts, Levin and Gordon began to make plans to move the project outside the UK in an effort to save money, but before they could, at the end of May Paramount abruptly cancelled production and placed *Watchmen* in turnaround, just a week away from breaking ground at Pinewood and building a backlot based on Manhattan's West Side.

Greengrass went back to his War on Terror idea, and in May 2005 he pitched to screenwriter Brian Helgeland his idea of 'a tough, gutsy, big contemporary thriller about the War on Terror that takes us inside the secret Pentagon counter-terror task force in Tampa, where they plan and do the really morally questionable stuff – all those things that we know about but don't see'.

Helgeland was interested, but before they could get further down the road of putting flesh on the bones of their thriller, on 7 July three terrorists separately detonated three home-made bombs in quick succession aboard trains on the London Underground, and later a fourth attacker detonated another on a double-decker bus in Tavistock Square. In all, fifty-two people were killed and more than seven hundred injured, making it the UK's deadliest terrorist incident since the 1988 Lockerbie bombing. Greengrass's son Tom was out and about in London on the day. He'd gone to a friend's house, so when the news came in at just after 9 a.m., 'There was this sort of fear, when you can't get hold of your children,' remembers Greengrass. 'Where is he? We can't get hold of him. And he's crossing town. You felt the fear like everybody else, I'm sure, who momentarily couldn't get hold of their kids that day. It turned out he was at the friend's house, and there was no problem. But I remember I walked into the office the next morning and said, "I'm going to do *United 93*."'

He started writing the treatment that day.

The first documentary Greengrass ever worked on was about an air disaster: the Munich air crash, involving a British European Airways flight that, on its third attempt to take off from a slush-covered runway, had crashed and claimed the lives of twenty-three Manchester United players and staff, after the team had just advanced to the semi-finals of the European Cup. Before shooting, Greengrass was sent by Granada's head of sport, Paul Doherty, to meet a man named John Slater, who ran the directors' training scheme down on the first floor. He knocked on the cutting-room door and found Slater hunched over a couple of Steenbecks, one for the editor, one for the assistant, both in white gloves to handle the pieces of film, which were identified with letters and numbers – E745, E746, E747, etc. – and were all coiled above two or three canvas trim bins. Greengrass attempted to tell him why he'd been sent.

'Yes, yes, I know,' interrupted Slater. 'Well, what do you know about film?'

'Well, I mean I've done local stuff. Shot stripe and cut stripe,' he said, referring to the magnetic striped film traditionally used by television broadcasters.

'But have you actually shot 16 mill? Have you done mag and all that?'

'No.'

'Okay. Have you ever touched a piece of film?'

'Yeah. I mean, not really, but yeah. I mean, I've been in cutting rooms, sort of bits of stripe –'

'Yeah, okay. Well, go and pick up some film then.'

'What do you mean?'

'Go pick up some film.'

Greengrass walked to one of the bins and plucked a single, long strip of celluloid.

Slater looked up. 'No, pick it *up*, for God's sake,' and he gathered a massive bundle of film, coil after coil of precious, easily crushable celluloid film – representing many days' or weeks' worth of work by a director, a producer, a cameraman, a crew – and dumped it in Greengrass's arms. 'Hold that.'

Greengrass stood there as the coils of film cascaded in all directions, wondering if the assistant was going to have a heart attack when he saw what he was going to have to sort out and hang again.

'Hold it, hold it, hold it, for fuck's sake, hold it,' said Slater. 'Don't crush it.' Then, at last, he told a bemused Greengrass, 'Okay. You've just had your first lesson in film-making.'

The penny dropped. 'What he meant was that, first of all, you have to get comfortable with the physicality of film, not be frightened of it, not treat it as some rarefied object, but have a physical relationship with it. It's not a job for timidity. It's a contact sport. Film-making is a process of making the film be what you want it to be, but also at the same time, paradoxically, listening to what the film itself wants to be. If you crush that film, you destroy it. The film will want to be spiralling in all these directions, and you must allow it to be, but also you must at the same time shape it. It's the paradox of film-making that you see again and again and again. I think every film-maker operates somewhere in that paradigm, towards more wanting to control it or towards the looser side of it, letting it speak and following its lead. But that's the paradox of it, and I've never forgotten that. It was a wonderful time. That was a simple little film. And it also allowed me to see Matt Busby at close hand, which was an amazing thing. But John Slater, it was like a little masterclass.'

Not long after he started work at *World in Action* as a researcher, Ray Fitzwalter, one of the show's longest-serving editors, gave Greengrass a list of past *World in Action*s and sent him down to Granada's preview theatre to watch them: Leslie Woodhead's 'Stones in the Park'; Mike Ryan's film about Steve Biko's funeral; Leslie Woodhead's 'The Demonstration', as well as his 'The Dumping Grounds', about South Africa; John Shepherd's 'Dust at Acre Mill', about a factory in Derbyshire that had covered up the death of its workers from asbestos poisoning. 'That was classic *World in Action* storytelling,' Greengrass remembers, referring to the latter. 'A factory in the middle of nowhere, ostensibly not very interesting, but just by remorselessly looking at it in detail, you could tell a much bigger story. You stood back on a long lens and you observed. I grew to love, and

still prize, that economy of storytelling. There was something beautiful about it.'

It all went back to Sergei Eisenstein. 'From a tiny cellular organism of the battleship to the organism of the entire battleship, from a tiny organism of the fleet to the organism of the whole fleet – thus flows through the revolutionary feeling of brotherhood,' wrote Eisenstein of *Battleship Potemkin*, his 1925 film showing how a mutiny on a ship over a meal of borscht ends up igniting full-scale revolution and then counter-revolution, after a sailor's dead body is put on display, bearing the sign 'For a plate of borscht'. Like the immolation of Mohamed Bouazizi, the Tunisian fruit-and-vegetable vendor whose death triggered the Arab Spring in 2011, news of the mutiny goes viral.

Greengrass's treatment for *United 93*, written in just a few weeks during the summer of 2004, framed the action tightly within the time span and location of the actual events, with no 'backstory' of the terrorists and their motives and no attempt to sentimentalise by showing anxious relatives on the other end of the telephone calls that the desperate passengers were making from the plane. 'A film about Flight 93 that will look and feel like *Bloody Sunday* – clearly structured, but heavily improvised – with the same raw, unflinching immediacy and truthfulness,' he wrote, ending with his belief that 'sometimes, if you look clearly and unflinchingly at a single event, you can find in its shape something precious, something much larger than the event itself – the DNA of our times'.

From the beginning, he was fascinated by the communications on that day. Having dispatched researcher Kate Solomon to make contact with all the families, he also hired *60 Minutes* producer Michael Bronner, who made contact with the Pentagon, NEADS, the various civilian air traffic controls in New York, Boston and Cleveland, and Ben Sliney, the manager of the Federal Aviation Administration's command centre in Herndon, Virginia, who had ordered all the planes to land that day. 'It was very, very important to me, as we were writing the screenplay, to know exactly what happened in all those air traffic control rooms, in the most extreme detail that I possibly could. It gave us the absolute unvarnished truth of why it was. So they could absolutely tell you, "This

is what we would have done on that day. Why he answered the cockpit door." Ben's situational instinct was part of the toolkit, alongside the journalistic impulse to find out what happened and the good judgement to balance the two. The point was, we wanted to get into granular detail with the actual people.'

The challenge was to take the methodology Greengrass had used for *Bloody Sunday* and scale it up for a big American movie studio. Greengrass sent the treatment to Tim Bevan at Working Title and also to Universal, who were very keen for Greengrass and Matt Damon to reunite for a follow-up to *The Bourne Supremacy* the following year. 'It came together with astonishing speed,' recalls Greengrass. 'It seemed almost to have a charmed life. I made it swiftly but with great deliberation – a calm frenzy. I felt great clarity of purpose. I was sort of made to make that film, it felt at the time. I was ready.'

In September 2005, as Greengrass was preparing to shoot *United 93*, his executive producer, Michael Bronner, requested copies of the four Dictaphone multi-channel, reel-to-reel tapes of NORAD's and NEADS's responses during the hundred-odd minutes of the attack. Subpoenaed by the 9/11 Commission during its investigation, the recordings had never been played publicly, beyond a handful of soundbites presented during the Commission's hearings. He was told his chances of hearing the full recordings were 'non-existent', but he did manage to obtain transcripts through Major Kevin Nasypany, who was the overall commander of NEADS that day. At 08:37:08, there is discussion of ottomans and other home furnishings ('Okay, a couch, an ottoman, a love seat and what else? Was it on sale? Holy smokes! What colour is it?'), while in the background you can make out the sound of Jeremy Powell, a burly, amiable technical sergeant, fielding the phone call that will be the military's first notification that something is wrong. On the line is Boston Center, the civilian air traffic control facility that handles that region's airliners:

Timeline of the United 93 flight, drawn up by first assistant director Chris Carreras.

BOSTON CENTER: Hi. Boston Center TMU [Traffic Management Unit], we have a problem here. We have a hijacked aircraft headed towards New York, and we need you guys to, we need someone to scramble some F-16s or something up there, help us out.

POWELL: Is this real-world or exercise?

BOSTON CENTER: No, this is not an exercise, not a test.

Powell's question – 'Is this real-world or exercise?' – is heard over and over on the tapes and in the finished film, as first he, then others assume the phone call is from the simulations team putting scenarios into play for that day's training exercise. One was a 'traditional' simulated hijack, in which politically motivated perpetrators commandeer an aircraft, land on a Cuba-like island and seek asylum. 'When they told me there was a hijack, my first reaction was "Somebody started the exercise early,"' Nasypany later told Bronner for *Vanity Fair*. 'I actually said out loud, "The hijack's not supposed to be for another hour."' At this point in the morning, more than three thousand planes were already in the air over the continental United States, and the Boston controller's location of the plane – '35 miles north of Kennedy' – doesn't help the NEADS controllers at all. At 08:46:36, you hear:

NASYPANY: Hi, sir. Okay, what – what we're doing, we're tryin' to locate this guy. We can't find him via IFF [the Identification Friend

or Foe system]. What we're gonna do, we're gonna hit up every track within a 25-mile radius of this Z-point [co-ordinate] that we put on the scope. Twenty-nine thousand [feet] heading 1–9–0 [east]. We're just gonna do – we're gonna try to find this guy. They can't find him. There's supposedly been threats to the cockpit. So we're just doing the thing . . . [off-mic conversation]. True. And probably right now, with what's going on in the cockpit, it's probably really crazy. So it probably needs to – that will simmer down and we'll probably get some better information.

Four seconds into this transmission, American Airlines Flight 11 slammed into the North Tower of the World Trade Center. Five minutes later, at 08:51:11, senior airman Stacia Rountree gets the first report of the crash from Boston Center and is overheard by her colleagues, Tech Sergeant Shelley Watson and Master Sergeant Maureen Dooley:

ROUNTREE: A plane just hit the World Trade Center.
WATSON: What?
ROUNTREE: Was it a 737?
UNIDENTIFIED MALE (in the background): Hit what?
WATSON: The World Trade Center –
DOOLEY: Who are you talking to? [Gasps.]
WATSON: Oh!

DOOLEY: Get – pass – pass it to them –

WATSON: Oh, my God. Oh, God. Oh, my God.

ROUNTREE: Saw it on the news. It's – a plane just crashed into the World Trade Center.

As Martin Amis pointed out in an essay originally published by the *Guardian*, it was the second plane 'that was the defining moment. Until then, America thought she was witnessing nothing more serious than the worst aviation disaster in history'; with the second plane, 'she had a sense of the fantastic vehemence ranged against her', wrote Amis, 'the world-flash of a coming future'. If terrorism is political communication by other means, then *United 93* shows in granular detail the moment al-Qaeda's message dawned on us, collectively. That's why Greengrass's decision to play this story through the air traffic controllers was such a crucial one, because the controllers were as close to omniscience as anyone, at work in the place where all the information pooled in real time.

For those non-actors in the cast who actually worked in air traffic control, there was something eerie about seeing the images from that day projected onto the giant screens on set. 'Once you get those images up on screen, the air traffic control or military control people all said you're in effect reliving it,' says Greengrass. 'One of the principal things that I used to say in making the film, all the way through, was, "Don't play the end. You know too much. Be blind, be safe, be hopeful." The central idea of the film was that the people on the aeroplane were the first people who knew. We didn't. We were still staring at our TVs in disbelief. The other aeroplanes had all gone down, and one was left flying, which was 93, which is the one where they fought back. They knew what we did not know. They knew for sure who had done it, why they'd done it, and so they were, in my mind, the first people to inhabit the post-9/11 world, which is the world that we were going to then live in. They were the first. I knew it was about blindness. I knew it was about the latticework of modernity, its outrageousness, but also its vulnerability. Our lives rely on trust and blindness. I remember looking at shots of the air traffic control's map of America and thinking, "It looks just like a Jackson Pollock painting." There it is, it's the

outrageous modernity of all these aeroplanes, criss-crossing the screen. It's our world, distilled. It's high up, hermetically sealed, beautiful – blind and vulnerable. And then, all of a sudden, it stops.'

They started shooting *United 93* on 14 November 2005, just four months after Greengrass has finished his treatment for the film, and almost immediately hit a problem with the actor playing Ben Sliney, the air traffic controller who grounded all the aeroplanes over America on 9/11. Day one was a disaster because the guy was just delivering lines that sounded like they were scripted. At lunchtime, Greengrass had a word with him, and after the afternoon went the same way, had another conversation: 'Listen. This is not what we agreed. This isn't working. If you play it that way, everything falls apart, because you're the main guy. If you're doing this, it kills it for everybody, you know? But, also, you're not being fair. I mean, we discussed all this, you know?'

'Okay. Yeah, yeah, yeah.'

The next day, the actor put loads of Post-it notes all over the set, on telephones and behind computer screens, so he could read his lines off them. Greengrass stewed. 'I mean, this was a crisis. When you've got no money and you've got to be off the set soon, there's no coming back. There's a mountain of work to do, and a guy's out there playing a different movie and it's killing everyone. The film is going to die. We got to the end of that day, and everything we shot was a total write-off. I remember going to see him after the end of the second day and saying, "This isn't working," and he agreed. So he left.'

Suddenly, the film, which had thus far seemed to have led an almost charmed life, was coming to pieces in front of him. They had just two days left on the air traffic control set, so Greengrass, his producer Lloyd Levin, the first assistant director Chris Carreras, Greengrass's wife Joanna, Michael Bronner and Kate Solomon held a crisis meeting at Pinewood. Greengrass called his pal, the actor Jason Isaacs, but he was busy. At eleven at night, he called another actor friend, David Morrissey, from his

car outside the studio in Pinewood. 'Can you please just come in for no money?' he begged. 'Just fucking do this with me.' No luck. They were on at eight the next morning. Then Joanna said, 'Why don't you use Ben?' Earlier on in the process, Greengrass had considered casting Ben Sliney to play himself, but he had felt it tipped the piece over – there wasn't enough acting in it. 'No, it can't be Ben! We've got to find an actor!'

Finally, he relented. It was too late to call Sliney, so he wrote him a note and had it put under the door of his hotel at New Pinewood: 'In the morning, are you all right to come in and . . .'

Greengrass got up the next day, went into work, headed over to make-up and waited for Sliney to arrive. Finally, with just minutes to spare, the air traffic control manager showed up.

'Are you all right to do it?'

'Oh, yeah, fine. It's no problem,' Sliney said, as he sat down in the chair.

'Listen, we'll just take it easy and see how it goes.'

'Don't worry about it, it's going to be absolutely fine,' said Sliney. 'And by the way, I just want to say thanks for making me second choice to play myself.'

Within the first few takes, Greengrass knew he'd made the right choice. Sliney was magnificent. He grasped the film and its methodology, and became its heartbeat every moment he was on screen. What they had scheduled to shoot in four days, they shot in two.

As he had on *Bloody Sunday*, Greengrass divided the action on board the plane into three separate 'plays', twenty- to thirty-minute self-sustained pieces that he could shoot uninterrupted: entering the plane, the hijack and the counter-attack right up to the end. The actors playing the terrorists were segregated from those playing the passengers, staying in different hotels, and the two groups did not meet until the hijack sequence was shot. Working from the script, Chris Carreras constructed a 20-foot-long timeline of events both on and off the plane and put it on the wall of the studio. 'You cannot know what happened on the aeroplane definitively,' says Greengrass, 'but there are lots of tools for unlocking truth in its broadest sense: the cockpit voice recorder; the phone-call records pinpointing where everyone was sitting, where they moved to; the many

phone calls themselves; deductions from what happened on the other planes, because there was clearly a common modus operandi for each of the hijackings; and, finally, being in the actual physical space with a professional air crew. How might this have occurred? What is believable? It led us to all sorts of things that must have been the case: the body of the pilot, the fact that the passengers must have seen it at a certain point; the trickle of information from one phone call to the next. So, piece by piece, you deduce what must have happened on board United 93.'

In April 2006, a military public-affairs officer emailed co-producer Michael Bronner, a full seven months after he had first requested the tapes, saying she'd been cleared, finally, to provide them. 'The signing of the Declaration of Independence took less coordination,' she wrote. They got three CDs containing huge digital .wav file recordings of the various channels in each section of the operations floor – thirty-odd hours of material in full, covering six and a half hours of real time. The first disc, which arrived by mail, was decorated with blue sky and fluffy white clouds and labelled, in the playful Apple Chancery font, 'Northeast Air Defense Sector – DAT Audio Files – 11 Sep 2001'. The recordings were fascinating and also chilling, a mix of staccato bursts of military code, urgent, overlapping voices, the tense crackle of radio traffic from fighter pilots in the air, commanders' orders piercing through a mounting din, and candid moments of emotion as the nature of the attacks became clearer. At 10:10:31, the answer to Nasypany's question about the rules of engagement comes back in no uncertain terms:

NASYPANY (to operations floor): Negative. Negative clearance to shoot . . . Goddammit!
MAJOR JAMES FOX: I'm not really worried about code words at this point.
NASYPANY: Fuck the code words. That's perishable information. Negative clearance to fire.

In the event, the shoot-down authorisation, when it arrived on the floor at NEADS at 10.32 a.m., was not passed to any of the pilots,

because Colonel Marr was concerned how the pilots would, or should, act as a result, with so many other planes in the air. The passengers on board United 93 were Washington's last and only line of defence.

When Greengrass flew to the Philippines in February 1986 to cover Cory Aquino's election campaign against Ferdinand Marcos, he felt revolution was in the air. Marcos had been president of the country since 1965. After declaring martial law in 1972, he suspended and eventually rewrote the Philippine constitution, curtailed civil liberties and had tens of thousands of opponents arrested and thousands more tortured, killed or disappeared, while he and his allies siphoned off funds from the US, the World Bank and the International Monetary Fund. Among the rivals he murdered was Benigno Aquino, who was shot in the head at the airport after returning to the Philippines in 1983. The remainder of the opposition movement eventually coalesced around the widow of Senator Aquino, Corazón 'Cory' Aquino. For a moment, everything seemed possible. Everyone knew the election would be rigged; what she was really doing was fomenting revolution. Greengrass travelled with her around the Philippines, from Manila down to Mindanao. In every barrio they came to, in every town and on every street, Aquino would stand up in the car, daring Marcos to kill her.

'What I noticed was how incredibly well organised Cory's operation was, and that was because the Catholic Church were right behind her. The Church know how to arrange insurgencies – they've been doing it for five hundred years. This was the high-water mark of the liberation theology that was driving insurgencies in South and Central America, as well as in the Philippines. The Church provided the capillaries of communication and organisation that enabled Cory to campaign the way she did. The crowds would always multiply as she went, so the end of the trip through wherever would always be vastly inflated compared with the entry. It had an excitement, a celebratory character, almost a street-party feeling. It just got bigger and bigger, more and more confident.' Much

Greengrass attending a press conference in Manila in 1986.

of the Philippine Left decided to boycott the election, fearful that participation would serve only to further legitimise the regime, and when Marcos predictably declared victory, hundreds of thousands of Filipinos gathered on Epifanio de los Santos Avenue to protest. Cardinal Jaime Sin, the archbishop of Manila, called upon his countrymen to support the peaceful protests. When Marcos ordered the military to arrest his detractors, Sin called upon the people to shield them. The Catholic station Radio Veritas became a major communications hub for the People Power movement.

'You had simply enormous but very quiet, hushed crowds. None of the election razzle-dazzle, just the will of the people, led by the Church, willing and daring the army to either disperse or join them. It was very peaceful, until the end, when there was violence as Marcos holdouts made their move, but Marcos didn't have the bottle to start mowing them down himself. He'd lost the army and was trying to get asylum in America and save his money, but obviously he had goons and thugs who were going to

be toast when he left. There were the odd ones who fought. It was over in two nights or so. I never felt the Philippines was going to be a bloodbath.'

Revolutions had always fascinated him. When he was in school, he saw Alistair Cooke's *America*, which declared that America was a revolutionary society. At sixteen, he saw Pontecorvo's *The Battle of Algiers*, Costa-Gavras's *Z*, about the assassination of an opposition politician, and Eisenstein's *Battleship Potemkin*. 'The fact that *Potemkin* starts with food, and maggots in the food, that was very familiar to me because one of the things my dad read me was the story of Lord Nelson. He also took me to the *Victory*, the actual ship. I would have been very small – six, seven. They had multiple figures with guns and tremendous amounts of banging and flashing and smoke. It was all supposed to make you feel like you were in the middle of the Battle of Trafalgar. Ships had a big effect on me, because my dad was at sea, and I remember drawing the list of the guns – what was the 12-pounder and what was the twenty-fourth gunner, forty-eighth gunner – and also I understood what the phrase "square meal" meant. "Square meal" comes from the navy. You got your food on the square bit of wood. That's a square meal. And scurvy, why they would treat it with lime juice. I had grown up with all that. So I hooked into *Battleship Potemkin* straight away because it was the story of a ship and mutiny, revolution and counter-revolution, and all without a single protagonist.'

During the shooting of *United 93*, Greengrass had a series of long conversations with Khalid Abdalla, the Egyptian actor playing one of the terrorists, Ziad Jarrah. These exchanges covered everything from drama to nation-building. A Cambridge graduate with great intellectual range whose father, Hossam, had been imprisoned five times during President Anwar Sadat's rule before he resettled in Britain in 1979, Abdalla would return to Cairo after production on *United 93* was finished and become one of the founding members of the Mosireen Collective, a group of revolutionary film-makers and activists based around Tahrir Square dedicated to supporting citizen media across Egypt in the wake of President Hosni Mubarak's fall. Theirs was the most-watched non-profit YouTube channel in Egypt of all time, and in the whole world in 2012, during the

Arab Spring. Nobody saw the latter coming, and even after it started, few saw that it would spread. Why? 'Because – and here is the technological fact that underpins the social and political aspects of what's happened – a network can usually defeat a hierarchy,' writes Paul Mason in *Why It's Kicking Off Everywhere*, a book that persuaded Greengrass to hire him as a consultant on *Jason Bourne*. 'As information passes through a network, it is both freer and richer [than in a hierarchy]; new connections, new meanings are generated, debated and evaluated.'

The 1979 Iranian revolution was closely linked to the audio cassette. Tiananmen was called the 'Fax Revolution'. The course of World War I was changed by the field telephone, just as the American revolution was fomented by pamphlets and the printing press. When the British attacked Lexington and Concord, Massachusetts, in April 1775, the early forerunner of the wire services made that news available in Virginia and elsewhere. 'Communications are at the heart of every insurgency,' says Greengrass. 'How did all those minutemen end up on the bridge at Concord? One of the projects I've never been able to move along adequately was about the American revolution, pre-1776. It was exactly the same as Tahir Square. You had many levels of insurrectionist activity, beginning in London, Paris, and in Philadelphia, Virginia, Boston, Massachusetts. Getting the messages in and out effectively was absolutely fundamental to running a pre-revolutionary insurgency, and then when you get down to Concord, how those minutemen were rustled up – the same thing. When you look at the events of Concord or Bunker Hill – messages going out left, right and centre. When you look at what happened on board United 93, it's basically minutemen activity.'

All told, they ran through the hijacking fourteen times, in a salvaged Boeing 757 commercial airliner that had been disassembled and shipped to Pinewood, where set designers and engineers meticulously reconstructed the 140-foot-long fuselage using a 9,600-page manual from Boeing that was specific down to every last nut and bolt. Dominic Watkins divided

the plane into three segments that could be bolted back together again, so they could shoot in the whole plane or in just the cockpit and galley. The sections were on separate computer-controlled gimbals so they could simulate the pitch and roll of the aircraft, with moveable lighting rigs to replicate the sunlight and a small pulley in the ceiling that ran the length of the plane, from end to end, during the long takes – each lasting up to fifty minutes – beginning with the captain, Jason Dahl, the co-pilot, LeRoy Homer Jr, and a first-class passenger, Mark Rothenberg, being brutally stabbed, while a flight attendant, Deborah Welsh, has her throat slit.

'To stop it all was really difficult,' recalls Greengrass. 'They were so intensely on it. "Stop, stop, stop!" You'd be yelling at the top of your voice to make them stop. Oh, my God, it was intense. It was really intense. I wasn't in there with them all of the time. I was right outside the door by the monitors. Sometimes I'd be sitting there, but more often than not on my feet. The energy was very strong, such that you would have to shout, "*Stop!*" You'd have to shout, "*Cut!*"'

Afterwards, the cast would emerge from the shell of the plane, faces solemn, hands shaking, wiping away tears. 'All of the cast and crew were completely drained emotionally and physically,' Chris Carreras told the *Daily Telegraph*. 'People would come out in tears. Paul would give them a bit of down-time to recover themselves, redo the make-up and then start all over again. It was an unbelievably intense experience.' Video diaries of the shoot reveal the director striking a careful balance between comforting his actors and persuading them back into the plane. He praises and cajoles, urges and exhorts, encourages, begs, pleads, hugs and applauds them. At one point, he even plays music and dances – Aretha Franklin's 'Rescue Me', The Crystals' 'Da Doo Ron Ron' – to relieve the tension, as the cast approached what he called 'the summit' of the movie: the passenger rebellion.

'Very, very good, but here's the thing,' he told the cast on day seven, in a large, brightly lit conference room: 'today, we've got to be just as good. That's the note. That is the hardest thing, believe me, when you've given it your all, as you guys did – three times. Keep the discipline. In simple

dramatic terms, what I'm trying to achieve here is that the stewardesses are going to have some knowledge – i.e. that the pilots are almost certainly dead – and as they move out, so they're going to meet the exact reverse situation, which is that the passengers themselves have information that they don't have, about the World Trade Center. And so these two ripples basically move up like that' – his brought his hands together and interlinked his fingers – 'and at that point the power structure in the room . . . is going to change, the moment those two ripples meet.'

He was talking about was the film's pivotal scene: the tipping point when the passengers realise they must take matters into their own hands. It happens in stages. The first thing the passengers see, of course, is the hijacking itself – the stabbing of the passenger, the slitting of the stewardess's throat. The next thing they sense is the plane's manoeuvring. 'I think we're turning,' says Thomas Burnett (Christian Clemenson), the first passenger to make a call home on the airphone – 'Just listen to me, sweetie. I want you to call the authorities . . .' – followed by Mark Bingham (Cheyenne Jackson) and Jeremy Glick (Peter Hermann) – 'Richard, it's

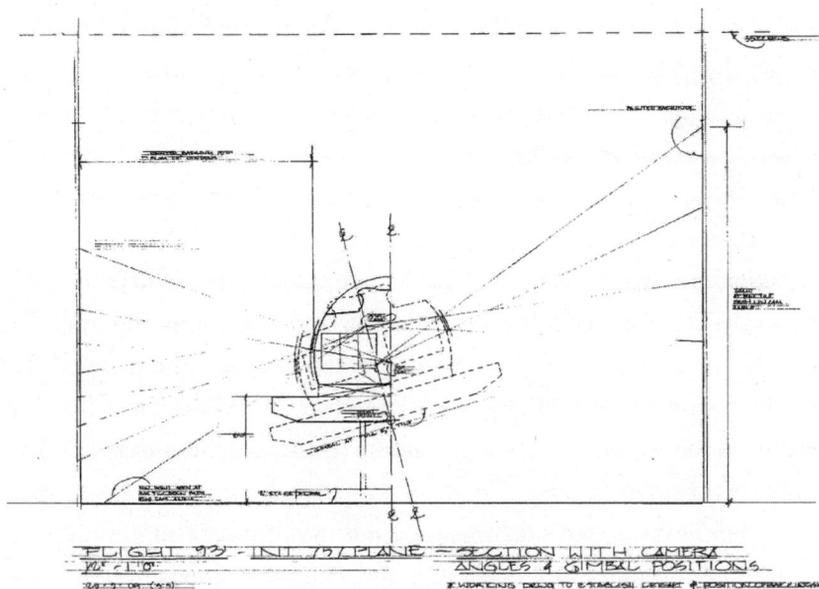

Schematic showing the Boeing 757 airliner in which some of *United 93* was shot at Pinewood.

Greengrass directing the hijacking of United 93. 'Oh, my God, it was intense,' says the director.

Jeremy. I'm on the plane. Let me talk to Lizzie' – all using the words spoken by their real-life counterparts. A first-aid run to the front of the cabin reveals the dead bodies of the pilots, lying on the ground outside the cockpit, behind the first-class curtain. This is no hijacking for ransom. 'Listen, the pilots are on the ground outside the cockpit . . .' whispers one of the stewardesses. She is overheard by one of the passengers, who passes the information on.

At the front of the plane, the hijackers scan the number of talking heads nervously, for they haven't considered the threat posed by their delayed take-off: the attack on the World Trade Center is now common knowledge to anyone on the ground with a TV switched on. 'What?' says Burnett, who is on the phone to his wife. He passes the news on to a woman ('Two planes hit the World Trade Center'), then back over his seat to the man sitting behind him, who then passes it on to the passenger behind *him*. 'Two planes hit the World Trade Center. Tell the stewardess . . .'

It may be the single most beautiful sequence in all of Greengrass's films: we could almost be witnessing the birth of a democracy. You

could show the sequence in civics class to demonstrate the definition and purpose of a free press, the difference between an uninformed and an informed citizenry. 'Two planes hit the World Trade Center,' whispers one passenger to the next, while on the phone picking up two new morsels of information ('There are five jets that have been hijacked . . . There's been an explosion at the Pentagon') along the way. By the time the news reaches the back of the plane, the field has shifted entirely. 'This is a suicide mission. We have to do something,' says Burnett. 'They are not going to land this plane.' In his helpful book, *Guerilla Warfare*, the Argentinian diplomat turned revolutionary Ernesto 'Che' Guevara outlined four basic conditions for an effective insurgent force: a secure base, with access to weapons, medical personnel and an effective communications network. 'Remember that we are in a period of war subject to attack by the military and that often many lives depend upon timely communication,' he wrote. Only when these conditions are met, 'the guerrilla, having taken up inaccessible positions out of reach of the enemy, or having assembled forces that deter the enemy from attacking, ought to proceed to the gradual weakening of the enemy'. When Glick, Bingham and Burnett leave their seats and gather in the plane's rear galley to hone their strategy, they fulfil the first of these conditions: a secure base. When Lauren Grandcolas, an emergency medical technician, tends to a wounded passenger, they have their medic. When Burnett hears about the Twin Towers from his wife and passes it on, they have an effective communications network. And when the flight attendants start to boil water and hand out forks and knives as weapons, they have their weaponry.

Now, the counter-insurgency can begin.

In February 2006, Greengrass flew to Newark with Barry Ackroyd to shoot some exteriors and the hijackers in the Mariott hotel. Upon returning to the editing bay, he found the film in deep trouble. He had been editing it with Clare Douglas, who had worked with him on *The Murder*

of Stephen Lawrence and *Bloody Sunday*, but Douglas was approaching retirement and was beginning to rely heavily on an inexperienced assistant. 'I felt there was something not right when we started. She was giving him way more responsibility than I would ever have wanted her to or could countenance, given that this was a movie for Universal on a deeply sensitive subject matter,' says Greengrass. 'A step up from *Bloody Sunday*, from a technical point of view. And the demands of the film rapidly overwhelmed the cutting room.' Once they started shooting, the cutting quickly lagged alarmingly behind, and by Christmas they were in trouble. 'The film was a mess. Bear in mind we started shooting in October, and it was scheduled to be in the theatres in April. It was unbelievably fast, the whole thing. And we were in disarray.'

He brought in Chris Rouse, his editor on *The Bourne Supremacy*, to help, the editing team working twenty hours a day, from January through April, in two cutting rooms at Goldcrest, on Lexington Street in Soho, with Douglas working on the master and Rouse on individual sequences that they dropped into it. Increasingly, however, it became the other way around: Rouse's cut became the master, and Douglas found herself relegated. 'That must have been incredibly painful for her,' says Greengrass. 'I know that it was for me, but the truth is we had different approaches. She felt that if she cut it with a light touch, the film would come out, and I felt that we weren't imposing ourselves on it strongly enough. We had to let it sprawl in a good way in the shooting, and now it needed to be pushed. You seek to exert extreme control when writing the screenplay – depicting the fundamental architecture and narrative shape of the piece; then, when you shoot, you're seeking to open it all out again; and then, when you cut, you exert order again. To go back to John Slater, you have got to listen to it and impose yourself on it, both at the same time. Chris and I had that ability to impose ourselves on that film, yet also let it speak to us. I mean, the final bit of editing in the cockpit is, I think, fantastic. It's like Eisenstein. That's montage – creating at the angles. You don't even know which way is up. Like the conflict, everything is coming to a head. It's an amazing sequence. What you're trying to find is an interface between order and

Timeline of the last portion of the United 93 flight, drawn up from producer Michael Bronner's research. 'He's down,' reported Washington Centre. 'What – he's down?' asked Tech Sergeant Shelley Watson. 'Yes.' 'When did he land? Because we have confirmation –' 'He did – he did – he did not land.'

chaos, between the forces of control and forces of liberation. There's a rhythm to it.'

The final forty minutes of *United 93*, showing the passenger counter-attack playing out in real time, stand at the summit of Greengrass's docudrama work, a stunning act of granular, imaginative recreation that stands shoulder to shoulder with Pontecorvo's *The Battle of Algiers* and Eisenstein's *Battleship Potemkin* in terms of its depiction of actions and emotions at the furthest reach of human endurance. Every tool in Greengrass's box is put to furious work. The film-makers knew as a matter of fact where everyone on the plane was sitting, because they had the phone records. They knew that the youngest, strongest males – Bingham, Burnett, Glick, Todd Beamer, Louis Nacke and Richard Guadagno – had got themselves to the front, as there were a whole series of calls made from those seats by people saying goodbye. It was widely believed that the passengers had taken a dining cart and charged down the centre of the plane towards the attackers, but when Greengrass's cast, along with professional air crew, tried something similar, it became clear that this couldn't have happened. 'I remember Trish [Gates] saying, "There's no way. Have you ever tried to? It's difficult enough to wheel a trolley down the centre, let alone run with it at speed." We tried it a number of times in rehearsal, and it was impossible.'

From this they deduced the sequence as it appears in the finished film. In a sustained assault, Jeremy Glick, a former national collegiate judo champion, leads the revolt, his running kick levelling a hijacker, who brandishes his bomb as if it were a false idol. '*It's a fake!*' yells Nacke, a toy-company executive with a weightlifter's physique. Up in the cockpit, Jarrah buckles up and starts to roll the aircraft. Luggage and people start to fly, the stewardesses clinging on to seats for support, the passengers crawling up the aisle as if it were a mountain slope. They do battle with the hijackers over a dinner trolley, punches flying, and have mace sprayed in their faces, before stampeding to the front, breaking Ahmed al-Nami's neck and using the dining cart as a battering ram on the cockpit door. Jarrah changes tactics and pitches the nose of the aeroplane up and down. Luggage and passengers go flying, as editor Chris Rouse conjoins images seemingly shot on a gyroscope.

The final images of the film are like something out of a Goya or Picasso's *Guernica* in their depiction of extremity, as bodies mash into the tiny cockpit, hands claw at faces and the plane goes into a dive, rolling onto its back as it descends, everyone held in place by its sheer velocity. It is hard to tell left from right, up from down, the only orientation the unearthly sight of a field through the cockpit window, coming up to meet us at 580 miles per hour. On the soundtrack, the rhythmic pulses and percussion are joined by a swell of horns, coming up fast beneath them, almost like a surge of adrenaline kicking in. Greengrass had told composer John Powell to think of that state when you're only half awake, aware of the fact and trying to rouse yourself. We could almost be listening to the internal sounds of an anaesthetised patient, pulse fluttering, as they swim back into consciousness.

'I was also trying to add in a certain layer of chaos, rhythmically as well,' said Powell. 'I didn't necessarily want people to know exactly where they were going. So even though it's pulsing, sometimes it changes pulse in an odd way, or changes tempo.' A cut from a passenger saying the Lord's Prayer to Jarrah shouting, 'Allah is the greatest!' makes it clear that we are watching more than just a fight for control of a plane's cockpit; we are seeing a death match between civilisations. At the end of the film,

there's what sounds like a young child vocalising a childlike song, which is then picked up and repeated by the violins, then the violas, then the cellos in a kind of canon. It is actually Powell's five-year-old son, whom the composer had observed arguing with a friend over something one day. 'That is the Middle East,' Powell told *Ain't It Cool News.* 'It's all political argument. It just doesn't make any difference if you're an adult or a four-year-old. Somehow or another humanity speaks out in this basic and awful language when it comes to what it wants and why it wants it.' Worried that the song would sound manipulative, he sent it over to Greengrass and said, 'This is either a good idea or the worst idea you've ever heard.'

Greengrass listened to it and said, 'It works.'

On 28 April 2006, *United 93* was released in the US, just nine months after Greengrass had started writing it. There were two screenings for the families, one on the west coast and one on the east. Greengrass recalls the latter vividly. 'I can remember that screening for the [United] 93 families – oh, my Lord. It was pretty shattering to watch it on a big screen, and in New York. I mean, the end to that film, we were in whatever theatre it was in New York, and there was this pause. The plane's gone down, and then there's just that sort of child's voice in the music. So it's not soundless, but it feels like it is. There was just this ghastly hole in the cinema, and then there was enormous distress from the families, all sitting at the back. I thought, "Oh, my Lord, this is just . . ." Because it's important to go and watch these films with people. You've got to do it. That's the contract you make, so if they hate it, they can tell you right there and then . . . There was this terrible pause at the end of the film. I think people were stunned actually, but I felt like I had done a terrible thing. Then I heard sobbing, and then they all stood up, and you could feel that it wasn't that. It was like catharsis, and they were absolutely wonderful about it.'

That screening marked the beginning of a marathon press tour for Greengrass. The film opened the Tribeca Film Festival in April, then

went to Cannes in May, where it received a standing ovation, and finally to Washington in June, where it was screened for staff at the Pentagon, who later sent Greengrass a letter congratulating him on furthering comprehension of what went wrong on 9/11, and for President Bush at the White House, who was joined by the families of some of the forty-four passengers and crew. White House press secretary Tony Snow described the screening as a 'very emotional night' and said that the audience were deeply affected by the movie's final scene. 'It has a very powerful ending,' Snow told reporters. 'It's dead silence as the credits roll and you had sounds of quiet sobbing in the room.' The president spoke briefly with the families of the victims before the screening and stopped to console several of them once the lights had come up. Greengrass was also invited but declined. 'I felt it would be wrong for me to go. I didn't feel it was my place really. I slightly regret it now actually, because I spoke to many people after – how unbelievable Bush was to select that film, A, and watch it with them, B. Afterwards, he went and talked to everybody, and he was unbelievably gracious and thoughtful and compassionate and decent. And that was people who didn't agree with him politically saying it. He clearly had significant human qualities.'

The film took $76 million at the box office – an incredible feat given its subject matter and lack of stars – won the Los Angeles Film Critics Award for Best Director and the New York Film Critics Circle Award for Best Film, and in December received Oscar nominations for Best Editing and Best Director. Greengrass was on set shooting *The Bourne Ultimatum* when producer Frank Marshall came up to him bearing a bottle of champagne. It was the year of *The Departed*, so there wasn't much suspense as to which way the evening was going to go, but Greengrass took a break from work to fly over for the event. 'It was all a bit of a blur, because I was then shooting *Ultimatum*,' he recalls. 'Normally, you have to do this grind of going out and talking to everybody. I didn't do any of that stuff because I was shooting. I'm very glad I got to go to the party once, even though there was absolutely no tension in my nomination. I remember, as we walked out afterwards, Clint Eastwood goosed me from behind. And I turned around, and it was Clint. You go, "Fuck, that's

Clint Eastwood." And he goes, "It's shit when you lose, isn't it?" But with a smile. It was a part of the blur of life at that time. If I have regrets about that period, it's that I wish I'd been able to focus on it and enjoy it more. I was in a zone of working non-stop, so it passed me by a bit. But it was lovely. It was fucking great.'

8: MOTION

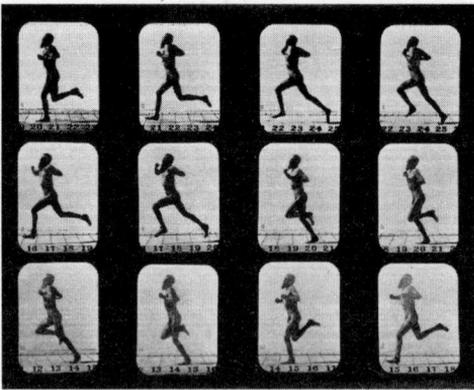

Greengrass was ten pages into Tony Gilroy's screenplay for *The Bourne Ultimatum* when he realised that one of the characters was based on him.

In 2005, Universal had written Gilroy a $3-million cheque to write the screenplay for a third Bourne movie, with the promise that he would not have to speak with Greengrass, but that did not stop him from communicating his feelings about the director more indirectly. Gilroy's script picks up a mere six weeks after the second film ends, with Bourne in Moscow, injured and in hiding after telling Irena Neski he killed her parents. Enter Simon Ross, a journalist in his mid-forties, 'hyper and furtive', who is angling for a book deal with an American editor, Ken Castle, in the back room of a London pub. 'I'm broke, Ken. I'm broke and I'm into the biggest story I've ever had my hands on,' he says, pulling from his beaten-up leather satchel scribbled notes, cigarettes and a series of crumpled 'WANTED' flyers and faxes showing Bourne and Marie's faces, which he's been given by the French and German police. 'By the time I got there, they'd already turned Berlin upside down. Hotels. Railyards. Airports. And guess what? It's déjà vu all over again. He's gone. Or hiding,' he says, after relaying the action of *The Bourne Supremacy*. 'Huge chase. Twenty-five-car pile-up.

Automatic weapons. This is like ten blocks from Red Square.' After working the story for several months, Ross found a bug in his house and went into hiding, using safe houses, phoney IDs, his latest hideout an old, funky attic studio filled with stacks of papers, newspapers, magazines, books, take-out boxes and dirty laundry. A hundred things are pinned up on the wall, covered in his 'manic scrawl'. After exiting the pub via a back door, Ross is hit by a passing truck, in a replay of the random traffic accident that killed Marie, which had been such a sticking point between writer and director on the previous film.

It seemed to be a clear, if unflattering, portrait of Greengrass in his *Spycatcher* days, complete with cluttered attic office and fears of being under surveillance. Among the other innovations of Gilroy's script were the introduction of a new head of Treadstone to replace Ward Abbott, Noah Vosen ('Taut and driven, but far more imaginative than he looks. Good leader. Dangerous enemy'); a younger, smarter, more dangerous generation of assassins – Paz, Desh and Arnaud – all of them hooked on mood-stabilising drugs; some action at the Gare du Nord train station in Paris; a 'bad' Nicky Parsons, who turns out to be an agent, just like Bourne, and is furious with him for turning. 'This is clarity, Jason. This is strength,' she tells him in Tangiers, where she tries to tempt him back onto the meds. 'They made us special. They made us unique and powerful. That you would want to betray all that is something I just can't believe.' We get a videotape that Landy threatens to send to CNN, exposing the whole programme. It shows a teenage Bourne being interviewed, demonstrating his French, Dutch and German, while reciting details about the muzzle velocity of the Ruger P89 and Glock 29. Finally, Bourne meets his maker: Dr Devitt of the Institute for Neurocognition on East 71st Street, who prompts a flashback to Bourne, aged fourteen, in his pyjamas, tears welling, a gun in his hand.

'I hated Gilroy's draft,' says Greengrass, who was in New York, deep into prep on *United 93*, when he received it in October 2005. 'I remember reading it and thinking there are some good things here, but it's the same old-fashioned mess. He turned Jason Bourne into a kid, which I really didn't like, and he wanted him to have been medicated. He was very taken

with that idea, which later turned up at the heart of *The Bourne Legacy*. I hated that idea in particular, because if Jason Bourne was drugged and turned into a killer, it took away his free will. It was always essential to me that Bourne chose to be a killer and was on a quest to deal with the consequences of that choice. Of course, the journalist wasn't a journalist; he's an author, a bit of an ass, paranoid, middle-aged. I read that as Gilroy's attempt to make him a version of me in my *Spycatcher* days, but I could be wrong. If it was, fair play to him. And then, of course, he's knocked over by a truck – hilarious. But it was the same problem as *Supremacy*: lots of action but lots of old-fashioned things and lots of stuff that just didn't tie up.'

Visiting Matt Damon on the set of *Ocean's Thirteen* in New York, he discovered that the actor felt the same way – 'Matt absolutely hated the whole thing' – and in January, having returned to London to finish shooting *United 93*, Greengrass submitted a detailed critique of the script to Universal, outlining where he felt it needed to go. Frank Marshall suggested a rewrite by Tom Stoppard, who had adapted J. G. Ballard's *Empire of the Sun* for Spielberg. Stoppard worked on his draft for four months, before delivering in April 2006, just as *United 93* was being readied for release. His draft glints with interesting ideas – Nicky is rehabilitated as an accomplice for Bourne, and there are hints of a romance, long forgotten by Bourne, as they hurtle around Europe on the Eurostar – but is otherwise sluggish, with flashbacks to the events of the second film, without ever getting up the momentum needed for the third. 'Some of the themes are still mine – but I don't think there's a single word of mine in the film,' complained Stoppard, when he saw the finished film in 2007. 'I remember being assailed by his agent,' says Greengrass. '"I can't believe you had Tom Stoppard's script and didn't use any of it. What were you thinking of?" But when you're making a film, you've got to go, "What works is what works." I've explained to Tom. He understands.'

They were five months from the start of production. Busy dropping in at a series of film festivals – Tribeca, Cannes – to see *United 93* into the world, Greengrass had very little time to attend to the script, but while on the road in the south of France, he asked Chris Forster, the storyboard

artist who had worked with him on *Supremacy*, to start working on out-
lines for some of the action sequences. Right after a brief, post-Cannes
vacation with his family, Greengrass sat down with the various drafts of
Ultimatum to see if he could synthesise something. 'I remember sitting
down and reading Gilroy's draft again, and Tom Stoppard's draft, and
going, "*Fuck me. Oh, here we go again . . .*" There were two questions in
our minds. One, what are we going to use as the basis for the story? And
two, what the fuck are we going to start shooting in October? There was
more anger, weirdly, the second time. Matt was angry that he was being
placed in that position again, and so was I – that we were going to have
to spend another ten months on the edge of the precipice, every day
being a nightmare. It is *un-fucking-real* when you've got big film crews
and money pouring out the door, and you're trying to make it up as you
go along. It's unbelievably stressful, because it feels like every minute of
every day you're fighting disaster.'

In May, at Damon's suggestion, screenwriter Scott Burns was hired
to do a few weeks' work, and at the beginning of June, Frank Marshall,
line producer Pat Crowley and editor Chris Rouse met with Greengrass
in Los Angeles to discuss the production schedule. Marshall began the
meeting by talking up the merits of Gilroy's draft, telling them how he
felt Gilroy had hit it out of the park again, at which point Greengrass's
face hit the floor.

On the sixteenth, they met with Burns to discuss his plot outline, which
had Bourne going back to Nixa, Missouri, where a reporter was interview-
ing his sister, who lived on the outskirts of town. She was told that her
brother had been killed by friendly fire in a training exercise somewhere
in the Balkans. At that meeting, Greengrass presented his own treatment,
a synthesis of Gilroy's draft and some of the ideas he'd been working on
with Forster. It opened with Bourne on the run in Russia, then in Paris
to see Marie's brother, then in London to meet with *Guardian* journalist
Simon Ross, who is close to completing the Treadstone puzzle. Bourne
leads him through the concourse at Waterloo station, where Ross panics,
makes a run for it and is killed by the assassin Paz, setting in motion a
series of chases and confrontations around the world, first in Madrid,

then Tangiers, where Bourne and Nicky start working together to hack into the Treadstone archive, and finally New York, where Bourne, helped by Landy, meets his maker, Dr Albert Hirsch. Reading Greengrass's outline, Burns immediately conceded that it was superior. 'Oh, let's do this,' he said. 'This is much better.'

Later that day, Greengrass flew home to London, and from July through August worked on the Tangiers and Waterloo sequences with Forster and Rouse. He wanted the film to be headquartered in London, as *United 93* had been, so that he could be closer to his family, but also because he wanted to shoot guerrilla-style, on the fly, in locations like Waterloo station, where you couldn't seal off the production into a self-contained world; you had to share the space with the public and operate like a guerrilla unit, seizing shots on the run. 'To me, it's pointless to pretend now that we can make a follow-up to *Bourne Supremacy*, and *Identity* too, and pretend that we're some little indie film masquerading as a studio movie. We're a big studio movie. It's a big, huge, successful franchise – let's not kid ourselves. But how do we keep alive the indie spirit that served it so well? And this was something I was saying from the word go to Frank and the studio: that whatever we do, we have to set the film in places where it's not going to be possible for us to operate like a commercial film. I wanted to film in places where you couldn't have a big unit, because what that will do is it will force us to shoot in a certain way, behave in a certain way, head out into a real world and tell your story within that real world, be fleet of foot and catch stuff on the fly, and it will keep that spirit alive.'

The first big battle was persuading the producers to let him shoot in London. Waterloo station wouldn't shut down just so they could shoot a movie – too many people pass through it each day– so in early October, when *The Bourne Ultimatum* began principal photography, they were restricted to a small, skeleton crew of about fifteen to twenty people, based in the Southbank Centre, just under half a mile away, who would film while the station operated as normal. A second-unit crew headed by Dan Bradley started simultaneously in the medina district in Tangiers, shooting what they could of the chase sequence there. With

production spread between two countries simultaneously, cinematographer Oliver Wood found himself shooting in one country, while gaffer Ronnie Schwarz was prepping a location in another. They used Google Earth to bat ideas back and forth. 'My thinking was that if we started in Tangiers, which was largely one huge action sequence, followed by Waterloo, which was the same, that would buy us time to get a draft in hand and sort the problems of the third act,' says Greengrass. 'So that became the production plan.'

Greengrass wanted the Waterloo sequence to go through several evolutions, utilising different aspects of the physical space that the public doesn't usually see: the little buildings inside the station, the area up behind the signage. What starts as a scoping scene becomes a fight, after Bourne lures the CIA agents onto a staircase behind a shop, which then turns into a flight, as he leads a balls-out chase sequence across bridges and rooftops. Over a couple of early mornings, Greengrass had sat down in Costa Coffee in the middle of the station's concourse, dressed in a North Face jacket, black jeans and plimsolls, to map everything out. 'The thing that I wanted to do was, instead of thinking about it as being five-finger exercises, which is how I sort of thought of *Supremacy* – "Right, we're going to do a fight." Okay, cool. Boom. Fight. "We're going to do a car chase." Right. Boom. Car chase – by *Ultimatum*, I was going for something a bit more symphonic, if I can call it that. Now what I want to do is create and sequence what I would call "movements of action". In other words, I want action sequences that seamlessly move from one thing to another thing to yet another thing. And they have variations of pace and variations of activity, all designed to develop character and narrative, but ultimately, we'd get this sort of liquid movement over long periods of the film. It would just enter a zone of total action. The whole thing will be in motion. That was my conception of the film: to try and put the whole movie into the present tense, if you could.'

They faced one obstacle that they never had to worry about on *Supremacy*: the ubiquity of mobile phones. Damon was usually able to accomplish only a single take before a small crowd of onlookers began to gather and film him and the rest of the crew. 'As soon as we pulled a

camera, everybody started to film *us*,' says Greengrass. 'So I said, "Okay, we will position ourselves at one end of Waterloo concourse." We'd have make-up and costume checks and standby and all the bits and bobs. Then, I think, we had a tiny crowd, like six people or something, just so we could feed it around the camera, if we needed it. Then we would ostentatiously pull all the camera gear out, as if we were setting up for a shot, and a crowd would gather. Then Oliver [Wood] and Klemens [Becker] would surreptitiously take a camera down to Matt and shoot him at the other end of the station, while everyone was distracted by the set-up at the other end. That's basically how we did that whole sequence. It was done on the run, so that people didn't see us. That gave it its tremendous aliveness.'

When it came to the scene in which Bourne tries to shepherd the reporter through Waterloo while avoiding the all-seeing eye of the CIA, who have hijacked the station's CCTV – a virtuoso expression of the need to see without being seen that Greengrass had come up with to confirm our worst fears about Echelon-era government technology – the director paid a visit to the security room at Waterloo to look at their banks of CCTV screens and ask a few questions. 'I remember saying to the guy, who was a railway executive, "I've got this wild idea that the CIA might follow Jason Bourne and use your cameras and 'slave' them to Langley or whatever. I know it's ridiculous . . ." And he said, "Oh yeah. They could do that. Absolutely." And I went, "*Really?* Oh . . . okay . . ."'

The production was turning into a re-enactment of the very themes – privacy, paranoia, Big Brother surveillance tech – that drove the script. The real world was catching up with Jason Bourne. Which meant that in *Ultimatum*, Bourne would have to go one better.

When Greengrass was growing up, at the end of the pier at Gravesend was a busy communications hub controlled by the Port of London Authority. Housed in a big building fronted with classical pillars and Union Jacks,

the Authority trained the merchant navy and co-ordinated all the river traffic heading for the docks. The main communications room was filled with radar screens that tracked the various boats. Greengrass sometimes accompanied his father when he acted as the on-duty pilot. 'It was like a big taxi rank, basically,' he says. 'It was a bit like going into an early air traffic control room, really. I mean, it was smaller, but it was essentially a

'You're seeing the purveying of the image and the world as it's mediated to you.' Greengrass in the CIA 'hub'.

sea-dock approach radar. You'd see the radar screens going around, tracking the ships, with charts everywhere and a big list of the pilots that was constantly being updated.'

It was the closest he ever came to his father's work, and it fascinated him: the tracking of the boats, the radar screens, the sense of orderly hubbub. Later on, he was enthralled by the TV screens in the work of Richard Hamilton, whose *Kent State* prints, spectral and blurry, show the wounded student, Dean Kahler. While at Cambridge, Greengrass designed a production of *Julius Caesar* that relocated the action of Shakespeare's play about political betrayal to a modern Democratic Party convention, complete with security chatter about the grassy knoll and a

series of massive TV screens. He was inspired in part by Robert Frank's photographs of the American political process, which always seemed to include the mediated nature of events. He had seen it first-hand when he visited the Democratic Party convention at Madison Square Garden in 1976, during one of his trips to America. 'Conventions, even in those days, were multimedia events,' says Greengrass. 'You're seeing the purveying of the image and the world as it's mediated to you. He did that a lot with politics, did Frank, and that would have been very much part of what I was doing. That was what excited me about going to the convention in 1976 – the excitement, the cameras and the screens.'

Later still, when he first started working at Granada as a researcher for Paul Doherty, the head of sport, Greengrass had to learn every aspect of broadcasting: editing short films and longer documentaries; live outside broadcasts; studio shows; *Kick Off* on Friday nights, which was live; and the three-minute sports segments for *Granada Reports*, the local six o'clock nightly news show. 'If you were doing the three-minute sports bit, then you'd have to write your script. "*Today Manchester United signing Joe Jordan has a groin strain after a night spent in a nightclub . . .*" Your script would be fed into the script for *Granada Reports*, then you'd go down to the studio and sit at the back of the gallery, where what you're looking at is multiple screens. Up front is the mixing desk, where the vision mixers are fading in and out. And the studio director's going, "*Camera one. Coming to you, Bob.*" "*Good evening, everybody.*" "*Okay, cue VT.*" And then the VT package comes on the second screen. The vision mixer fades from one to the other. "*Coming out of VT package in ten, nine, eight, seven, six . . . Cue Bob.*" "*So that was Livingshire Hospital, and now*

The console used by producers to mix live news feeds at Granada.

Sport. Over to you, Tony . . ." Very exciting, if you're a young kid, as I was, because you're suddenly watching live TV happening.'

Sometimes, on midweek evenings, he had to cut the second half of a football game, while the first half was being broadcast. For that, he had to go up to the VT edit suite, which was filled with monitors, with remote voices crackling in and out of speakers and in the earpieces worn by the director and vision mixer. 'It was very futuristic,' he says. 'You've really got to know your shit to cut live football, when the first half is actually being transmitted to the country, and it's all down to you, because Paul Doherty's in the commentator's box in Liverpool or wherever, it's a European night, it's just you and a couple of engineers. And you've got to have that fucking cut-down ready, because we're going to the commercial break in five minutes. And it takes two minutes to lace it up. I loved all that, because it's pressure, pressure, pressure. Remember, I'd just left university. I was desperate to go to work, and here I was, right where they actually make programmes that people actually see. It had a huge impact on me, of course. Going into a television studio was absolutely intoxicating.'

The imagery of banked screens and communication hubs is a consistent leitmotif of Greengrass's movies – the comms room of the British army in *Bloody Sunday*, the air traffic control rooms in *United 93*, the CIA comms hubs in the Bourne movies – all allowing participant observers to track real-world situations and investing the action with the neurological crackle and excitement of a live broadcast. It's what George Smiley called the oldest question of all – 'Who can spy on the spies?' – given a pristine, hi-tech update. We watch them watching. In the original *Bourne Identity*, Bourne was tracked from a room filled with chunky mainframes, behind which CIA technicians pound away at keyboards, as a grim Chris Cooper barks, 'I want Bourne in a body bag by sundown!' But the surveillance is done with photographs, a bulletin board with drawing pins and that quaintest of technologies, a map. In *The Bourne Supremacy*, the surveillance is higher tech but still largely passive, as agents wait for Bourne to pop up in Naples or Munich, always at a time of his choosing. 'Turn it upside down and see what you can find,' Pam Landy instructs her

Berlin team in an open-windowed office, ten floors up, who use satellite imaging, together with information from the airports, train stations and local police reports to track Bourne.

For *Ultimatum*, production designer Peter Wenham gave a further upgrade to all the film's tech, even though only six weeks are supposed to have elapsed since the action of *Supremacy*. We get alert monitoring, wiretaps, GPS tracking, gunmen with camera phones, giant video screens, real-time geo-tracking, cellphone hacking, a pre-paid mobile phone that grants a limited but crucial privacy smokescreen, a dual-authentication biometric key, a Norton anti-malware program and the first on-screen appearance of the Echelon programme – by which agencies from the Five Eyes countries exchange intercepted transmissions, using supercomputers to flag any messages containing key words – which is used to intercept Simon Ross's phone call to his editor, during which he mentions the word 'Blackbriar', the CIA's rebranded version of the Treadstone assassination programme. 'I want all his phones, Blackberry, apartment, car, bank accounts, credit cards, travel patterns,' says Vosen. 'I want to know what he's going to think before he does. Every dirty little secret he has.'

The CIA hub in *Ultimatum* was filmed in the conference rooms of the BioPark science complex, in Hertfordshire, where Greengrass mixed his actors in with American radio operators from the airbase at Lakenheath. 'I didn't know David Strathairn, though I'd loved him in *Good Night, and Good Luck*. I absolutely adored working with Joan [Allen] again. She is really a fantastic actor, absolutely brilliant, but very frightened of jargon. Rightly so. She used to get brain freeze and get terribly stressed when she had these twenty-five lines of undiluted jargon. But as we got the thing cranking, she loved it, because she understood that it enabled her to sit on top of something rather than play it as written. It really worked perfectly in *Ultimatum* because Corey Johnson, who'd worked with me on *United 93*, and Tom Gallop, who plays Cronin, the two of them were the rhythm section in that room. They had a thing going, Corey and Tom. It enabled David and Joan to sit on top of it and play the drama between the two of them, and come in and out of the scenario that was playing out between all the techs and Tom and Corey. They started it all off. Tom

and Corey were like the Charlie Watts and Bill Wyman of the Bourne movies, they really were. They laid it down. They created a groove, essentially, that drove the whole thing.'

For Greengrass, it all goes back to the situation room in *Dr Strangelove* (1964) and Sydney Pollack's *Three Days of the Condor* (1975), which sees Robert Redford's CIA agent tracking global hotspots by scanning texts into a giant, reel-to-reel Bell computer that is running crypto-analysis software. 'I think *Three Days of the Condor*'s a really important film, because it does two things. First of all, it creates a paradigm of the man on the run in the espionage movie, a man on the run and the faceless forces and technology and all the rest of it. And it's also very important because it helped define the world of the professional assassin. The great scene with Max von Sydow, where he says it's all just a job. He has no morality distinct from his job. No *Three Days of the Condor*, no Bourne. It's as simple as that. The creed and culture of the professional assassin is laid down there. I think the absolute fundamental thing that Bourne brought in or exploited was the growth of CCTV, mobile phones and personal computing. I think what made Jason Bourne seem cool and modern was, he was the first hero in mainstream cinema to swim in that world and be familiar, and understand it, and know it. You couldn't have said "He's come up on the grid" in *Three Days of the Condor*, because the concept of the grid didn't really exist.'

Bourne thus solved a problem that had been brewing in the fictional espionage universe ever since surveillance tech made its first appearance in films like *The Falcon and the Snowman* (1985) and *Patriot Games* (1992), where the ability to track the movements of a man remotely far exceeded in speed and efficacy that man's ability to gather intelligence himself. Signals intelligence – SIGINT – had, by the mid-1990s, begun to outweigh human intelligence – HUMINT – which, on screen, meant the gradual ubiquity of high-tech monitors and the eventual obsolescence of the old-fashioned secret agent. Simply put, computers were outpacing humans. Hence the appeal of a character like Bourne, who, turning against the technological capabilities of his own country, uses only a ballpoint pen (*The Bourne Identity*); a magazine, a power cord and a toaster

(*The Bourne Supremacy*); or a broomstick, a penlight and a rotating fan (*The Bourne Ultimatum*). These weapons could easily have been plucked from the playbook of the CIA's 1953 manual *A Study in Assassination* ('A hammer, axe, wrench, screwdriver, fire poker, kitchen knife, lamp stand, or anything hard, heavy and handy will suffice'), but equally, they aren't too far from the masking tape and box-cutters used by the 9/11 hijackers to hijack and fly two jets into the World Trade Center. A lingering ambiguity around Bourne's allegiances is picked up by the Middle Eastern-sounding oboes of John Powell's score. Simply put, he took a leaf out of the terrorist's book and outwitted the entire security apparatus of America using the stuff it leaves lying about the house.

The plot of *The Bourne Ultimatum* came out of one of Tony Gilroy's better inventions. In George Nolfi's ending for *Supremacy*, written in the final weeks of production, Bourne phones up Landy in New York, is told his date of birth and concludes the conversation with the comment, 'You look tired.' Gilroy had wondered: what if the conversation was something more? What if it contained a covert communication of some sort?

'In other words, what she was actually conveying to him wasn't his birth date at all but a code,' says Greengrass. 'It was a very clever idea. *Supremacy* gave Jason Bourne his identity, and it was very necessary for the film to be satisfying, for the audiences to feel that Jason Bourne had succeeded in his quest. They didn't like it when the film was unresolved. But the problem is that if he's already found his identity, how do you do another film and not face the same problem? It was very, very clever of Gilroy to come up with that idea, because it essentially meant that you hadn't got to the end. The ending actually meant something different and unlocked a whole new third act.'

After finishing shooting in London, Greengrass caught up with his second unit in Tangiers, where second-unit director Dan Bradley, camera operator Klemens Becker and cinematographer Oliver Wood had turned

his detailed pre-production animatics into a live kinetic playground on the rooftops, streets and in the apartments of the medina district. They had built a massive cable rig for the camera that spanned six buildings, which had taken a couple of weeks to construct, to which was attached a two-wheel upright trolley, modified with scaffolding poles, into which a cameraman was strapped, with three grips pulling it backwards while Damon ran forwards for about 50 metres. A jump from a rooftop through wooden shutters into a kitchen 12 feet below was captured, after months of preparation, by Damon's stunt double, who made the jump with an Arriflex 235 strapped to his body. Inside the apartment, the crew built a rig on the ceiling that could guide an operator from room to room, around corners and across to the next building. Fight co-ordinator Jeff Imada built up the ensuing fight move by move, at quarter speed, so that Greengrass and Bradley could block it at walking pace, trying to find its shape, its dramatic contours, its story.

'It's like ballet-dancing,' says Greengrass. 'You try and construct it as a piece. So you start off with an idea. And the idea in that whole sequence, from the beginning, with the running and the rooftop and all of that, was to run through the whole expanse of the city and end up with the tiniest room for the kill. So from the moment he comes through the window, you're trying to trade the specificity of the fight moves with the sort of sprawl and messiness of a pub brawl.' They had used a pen as a lethal weapon in the first film and a rolled-up magazine in the second, so for the third they chose a book. 'It's like a dance. You start slowly and you rehearse moves and you slowly build up the speed. Jeff might work on it for half a day and then say, "Come and have a look at this." I'd go in and have a look and say, "Well, it's great. Can you make it more messy? It feels like it's too stagey now." You've got to have stakes. It's got to feel like he's going to lose. Those are the things you're really worried about. Once you've got the overall shape, once you've got all that straight, then you can start to hone those moves. When it gets very, very fast, and you're doing it for real, it's dangerous.'

As the sequence was shot, Chris Rouse cut it together in the editing suite, where Greengrass would join him in the evenings to see if they were

missing any shots, so he could go back the next day and shoot them. As with *Supremacy*, it was in the editing room that *The Bourne Ultimatum* took shape, with the plot mapped out on large note cards tacked to the wall, giving Rouse the 'big picture' view of how the film was constructed and the ability to quickly rearrange the scene order so he could judge how an alternative flow might affect the story. Sometimes he used several walls in order to compare different versions. 'We were constantly assessing structural issues,' said Rouse. 'We knew that we had to keep certain scenes, as they were anchoring the story. Other scenes were much more in flux – some cuts we had them in, and then they'd be out in the next version – or sometimes in a different configuration. Keeping a scene or losing it can be a hard choice to make, because a scene's presence, or lack thereof, has a domino effect on the entire film.'

In January, Rouse set up shop back in Los Angeles and continued to communicate daily with Greengrass until he returned to California. 'Chris and I were very, very, very tight,' says Greengrass. 'There is no balls-out that is balls-out enough for Chris. And, of course, we would egg each other on, because we were in search of something then. I've always remembered that great quote from Braque, "We were like mountain-climbers roped together," as he discovered abstraction with Picasso. I've never forgotten that. I'm not at all putting myself and Chris Rouse in the Braque/Picasso bracket, but there was an element of that *esprit de corps* when we were doing our thing. We're doing something here, and we're just going to fucking go for it. We were roped together through all of this – *Supremacy* through *United 93* and then on to *Ultimatum* . . . There is a place where a film is moving so fast that if you can harness the detail, if your conception of the character and the action is sufficiently precise and compelling that you hold the whole movie in your hands, you know where it's going and you can then proceed to propel it at enormous speed, but ensuring all the while you're giving the audience all the information – spatially, narratively, character-wise – they need. You could receive the detail at an astonishing pace, so you can maintain pace with detail, precision. Any fool can wave a handheld camera around and go like that. That's easy to do. It's can you do it in the service of character, narrative

and precision and hold all that in your hands and do it? That was what *Ultimatum* was all about.'

No footage exists of Ayrton Senna's qualifying lap at the Monaco Grand Prix in Monte Carlo, on Saturday, 14 May 1988. The on-board cameras that have become commonplace in the coverage of Formula 1 were still at the experimental stage during the 1980s, so his feat that day is instead the stuff of legend. He had already eclipsed Alain Prost in the opening sixty-minute qualifying session on the Thursday, his 1m 26.464s lap 1.9 seconds quicker than the other McLaren's best. Lap after lap, the Brazilian found himself focusing harder and harder, going faster and faster, until he reached a point where he felt he was no longer consciously controlling the car. 'I was at one stage just on pole, then by half a second, and then one second, and I kept going,' he told Canadian journalist Gerald Donaldson in the media centre afterwards. 'Suddenly I realised that I was no longer driving the car consciously. I was driving it by a kind of instinct, only I was in a different

Ayrton Senna at the 1991 United States Grand Prix.

dimension. It was like I was in a tunnel. Not only the tunnel under the hotel but the whole circuit was a tunnel. I was just going and going, more and more and more. I was way over the limit but still able to find even more. Then suddenly something just kicked me. I kind of woke up and realised that I was in a different atmosphere than you normally are. My immediate reaction was back off, slow down. I drove back slowly to the pits and I didn't want to go out any more that day. It frightened me.'

The television cameras didn't pick Senna up again until he entered the pit lane at the end of the session, where he shook hands with his mechanics and chatted to McLaren boss Ron Dennis. He had gone an astonishing 1.427s faster than his teammate Prost, and a whopping 2.687s faster than

the third-placed Gerhard Berger. 'On that day, I said to myself, "That was the maximum for me; no room for anything more,"' he said later. 'I never really reached that feeling again.'

Greengrass first read about Senna's almost mystical moment at the outer limits of human-engineered speed in Richard Williams's 1995 book *The Death of Ayrton Senna*, which he first picked up around the time he made *The Bourne Ultimatum*. 'It had a very big effect on me. It wasn't a very long book, but he talked about Senna, like all great racing drivers, as being essentially an artist, really, an artist with speed who found a zone where the car was racing at such speed that control cedes itself momentarily to the out-of-control. Senna found that zone where the rules of time and space no longer apply and what is incredibly fast feels incredibly slow, and he was able to operate in such a way that he almost danced around the racetrack, he didn't drive around it. It's almost like quantum physics. He doesn't use that analogy, but I certainly came to believe that when I was making *Ultimatum*. I was very interested at that time – from *Bloody Sunday* through to *Bourne Ultimatum* – in what that zone felt like and trying again and again to create physical conditions of filming where, if you can get control and out-of-control in perfect alignment, there's a truth that's only revealed in that place.'

He had long been fascinated by the illusion of movement, going back to his days spent studying the images of Eadweard Muybridge's zoopraxiscope at Sevenoaks. In 1878, to settle a $25,000 bet with racehorse enthusiast Leland Stanford – 'Do all four feet of a horse leave the ground at the same time during the trot and gallop?' – Muybridge placed numerous large, glass-plate cameras in a line along the edge of the track at Stanford's Palo Alto Stock Farm. The shutter of each was triggered by a tripwire as the horse passed, capturing it at different stages of motion. He copied the images onto a disc that was to be viewed in a machine he had invented, which he called a zoopraxiscope. 'It does not lie,' he said. The first film – and the first documentary – was made possible by something called 'apparent movement', or the 'phi phenomenon'. Two lights, side by side, that are switched so that one comes on just as the other goes off are perceived as a single light that shifts position. Within certain limits, the

brain tolerates gaps, and it is this tolerance that allows cinema and tele-vision to be possible. In his silkscreens *Kent State* and *Swingeing London 67*, Richard Hamilton reveals the mediated nature of the image by push-ing the technology to its limits: we're beginning to see the gaps *between* Muybridge's images.

'If you look at the series of prints of Kent State, it was electronic news-reel, blown up and explored, with all the motion blur included,' says Greengrass. 'And the same thing famously with the picture of Jagger with the handcuffs coming out of the courthouse. Hamilton was very interested in rendering motion blur in a painterly fashion to create this softness, so you both fix the image, but you're aware it's an image cap-tured in the moment. You can feel the flashbulbs go off on Jagger's face, but rendered in paint pigment, which always had a huge impression on me. I can remember in the art room, we used to do a lot of what we used to call "dot prints", where you would take a photographic image and basically turn it into pixels and then blow it up, and you get this strange image, a bit like a Bridget Riley. You could see it or experience it as a field of motion when you're looking at it close up. But if you step back, you can see the ghost of an image, because your brain aggregates the pixels into a shape.'

In the Bourne films, Greengrass pushes that system almost to the point of abstraction – a blur of fists and footfalls, moving so fast the film-making achieves neurological lift-off. *The Bourne Identity*, directed by Doug Liman, averaged about 3 seconds per shot. The second film, *The Bourne Supremacy*, came in at 1.9 seconds. *The Bourne Ultimatum* contains about 3,200 shots in 105 minutes, yielding an average of about 2 seconds per shot. For some, it was too much. As a perceptual event, *Ultimatum* left some viewers dizzy or nauseated. Over at RogerEbert.com, a page was devoted to viewers complaining about the fast-cutting, handheld style of the film. 'Frankly, it just gives me a headache,' said Craig Sikurinec of Johnstown, PA. 'I had to sit about 4 rows back from the front of the theatre' said Chris Howard of Fort Collins, CO, while others gathered their pitchforks. 'A major director should not be able to get away with this,' said Zoran Simic of Pleasant Hill, CA. 'A spectre

is haunting contemporary cinema: the shaky shot,' wrote film historian David Bordwell, in a blog post that was the most considered of the critiques.

As we'd expect, in *Supremacy* the bounciest camerawork and choppiest editing are found in the sequences with the most energetic physical action. Most of the surveillance scenes get a little bumpy, while the chases are wilder. The most extreme instance, I think, is the very last pursuit in the tunnel, when Bourne avenges the death of Marie and slams the sniper's vehicle into an abutment. As in *Identity*, *Supremacy* arrays its technique along a continuum, saving the most visceral techniques for the most bruising action sequences. *Ultimatum* raises the stakes by applying the run-and-gun style in a more thoroughgoing way. Everything is dialled up a notch. The flashbacks are more expressionistic than those of *Supremacy*: instead of dark hallucinations we get blinding, bleached-out glimpses of torture and execution, in staggered and smeared stop-frames. The conversation scenes are bumpier and more disjointed; the cat-and-mouse tailings are more disorienting, with jerky zooms and distracted framings; the full-bore action scenes are even more elliptical and defocused. It's as if the visual texture of *Supremacy*'s tunnel chase has become the touchstone for the whole movie.

'My dad used to send [the reviews] to me,' says Greengrass. 'He loved them when they were really rude. Look, I started at Granada. You didn't talk down to your audience and you didn't talk up; you had to be eye level with them. It wouldn't have concerned me because people were going to see the movies. They were hits. Much, much later, really with *Jason Bourne*, I felt I'd got to the end of a certain way of shooting, and I was bored with what I was doing and I wanted to change. But that wasn't to do with people saying, "I don't like that camerawork again." It's the Ayrton Senna thing. There's a zone where speed becomes elastic, you know? Provided you're really adhering to character, detail, physicality, then you can start to push speed. But the minute you lose focus in terms of character or detail, then you're lost. Then it's just cutting. Pace comes from your playing with the audience's ability, which is why it's so pleasurable for them, and why in the end I didn't really care about people who didn't like it, because so

many did. They loved the essential relationship you're in with them, which is: how fast can this go and you still keep up? And the audience are always, "Fucking make it faster. Play it faster. I'm getting it all. I'm getting he's following him and he's running . . ." They're getting it all.'

You only have to look at *Jason Bourne*, in fact, to realise how much the speed and propulsive force of the first three films were generated by Bourne's desperate hunger for information about himself and, conversely, his fear of what he may find. Damon makes the ambivalence dynamic. It was all character-driven. Brooding and dark, his brow knotted, with a streamlined crop and a strong, compact body, he is almost continuously in motion in *Ultimatum*, as if frightened of his own thoughts when still. He runs as if to give himself the slip. In the Tangiers sequence, Greengrass layers three chases on top of one another: Bourne pursues Desh, who is chasing Nicky (Julia Stiles), while simultaneously trying to duck his own police pursuers. One of the best things ever written about a Bourne movie was David Denby's description of *Ultimatum* in *The New Yorker*: 'You come out of the movie both excited and soothed, as if your body had been worked on by felt-covered drumsticks.'

Bourne's moves, in full flow, *are* like a kind of jazz. Detonating a small aerosol can on a street vendor's flames in order to throw the police, like Art Blakey rattling off a snare lick, Bourne jumps from rooftop to rooftop, through washing lines, aerials and satellite dishes, at one point grabbing some laundry to wrap around his knuckles as he vaults over a wall topped with broken glass. He's thinking so fast he's not even conscious of it, the orchestra downsized to just its rhythm section now – bongo drums and tablas – as Bourne jumps from building to building, before finally spying Nicky and Desh a block away and taking the simplest, shortest route imaginable: across the alleyway and through the living-room window.

The soundtrack cuts out entirely for what follows; the cracks, snaps, smashes and whooshes of the fight become their own kind of musical accompaniment. Again, Greengrass follows the same course of simplification, attenuation, purification: a gun, brandished and fired, is quickly tossed to the side. Swung at with a candlestick, Bourne retaliates with a book, jamming it into Desh's windpipe. Desh throws Bourne into the

bathroom, grabbing a razor from the sink, while Bourne defends himself with a towel, eventually getting it around Desh's neck and throttling him. It's dirty and messy and violent and real, Damon grunting with the effort, his face red and bloated. You've been through the whole physical experience with them – through the medina, up onto the roof, down through the apartments, the big jump, the immense, sprawling fight – and it comes down to this: one man choking another in a bathroom the size of a shower cubicle. Bourne lets Desh's dead body slide down to the tiles, then looks up and sees Nicky watching him. She's seen everything, and immediately we feel Bourne's disgust with himself. He's like a man coming out of a dream, looking back at the body, then up at Nicky, then around the room as if looking for an exit. He'd rather be anyone, anywhere, than the person he is in that room.

As production moved to Madrid on 11 November, the all-too-familiar pressure on Greengrass started to ramp up, as they began to run out of agreed material to shoot. Greengrass started pushing to have a writer on set who could help them work from the cards, in the same way that Paul Attanasio had done on *Supremacy*, and solve the problems that were now coming at them fast. His first choice, *Cracker* writer Paul Abbott, lasted only a day: he arrived in Madrid, checked into his hotel, saw the chaos and departed the same afternoon. Finally, he persuaded the studio to hire George Nolfi, who had come up with the ending to *Supremacy*, and on 16 November he started work in Madrid, staying with the production until the end, his sojourns in the local nightclubs notwithstanding, writing up pages from the cards that Rouse and Greengrass had knocked up in the cutting room. Nolfi was particularly good when it came to the comms-hub scenes, writing a knockout scene for Joan Allen, in which Pam Landy walks in and puts the whole room in turnaround.

'He would literally be in his hotel room working on the pages for the next day while we were working on the pages he had given us for this day, and we were making our tweaks in the real location, going, "Okay, well

let's change this to that, because that thing's over there,"' said Damon. 'It's such a fluid process and we'll end up doing scenes and we'll just be sitting there saying, "Well, this will never be in the movie, this doesn't work at all," but a lot of that we don't know until we get them up on their feet . . . You start trying to shoot the stuff you think does work while trying to fix the other stuff. It means a short day of filming is 12 hours. On top of that, you're going out to dinner and writing. We had a conversation, I'll never forget, in Madrid. It was three or four in the morning. We were standing in this street, and we look at each other and go, "We're in the wrong country. There's nothing else we can shoot here."'

The third act remained a massive problem. At the end of November, the production moved briefly to Paris, then back to London for the Christmas break, before resuming in New York in January, where Greengrass had a blow-up row with line producer Pat Crowley while filming on location in uptown Manhattan. 'We really hadn't figured out the third act nearly enough,' he says. 'The reality of those films is you have to shoot things that you know don't work just to keep yourself going until you find what does work, but it was frustrating. We were on very thin ice. We were shooting a scene that clearly didn't work, with Landy. And Pat's job was to keep us going. I think I said, "For fuck's sake, we're shooting this fucking stuff and we don't really know what we're doing here." Pat was patient, to be fair, while I blew my stack. It was nothing to do with him. I was like, "For fuck's sake, this fucking process. This is no way to shoot a movie." Those Bourne movies, you can know a lot, but you can't know it all. And you have to trust that you're going to get there. And sometimes you sit and you go, "Well, I'm fucking stuck now and I'm never going to get out." And you get frustrated. It wasn't like a terminal fall-out or anything, but I vented at him, which was unusual for me.'

As they had on *Supremacy*, Damon and Greengrass released the pressure they were under through pranks and shared jokes. On *Ultimatum*, the idea from Universal that most drew their unending scorn, as the bonfire salute had on *Supremacy*, was the line 'I am the weapon', which Attanasio had contributed to the shooting draft back in September, along with a plot-line in which Bourne puts himself on the black market for $10 million.

Universal loved it. 'The studio wanted desperately for Matt to say, "I am the weapon," which Matt and I hated, because it sort of made him mercenary as a character. Studios often get obsessed with "trailer moments", where they can have their main character do iconic things, say iconic lines, be butch and strong and manly, whatever, often generated in the marketing department, because they're putting up a lot of the money, so they want to have a say in it all. But Matt and I used to howl with laughter about this particular one. It became a regular feature of our communications with the studio. It would come out of left field. "We're very worried about the catering budget, but maybe it would help if Jason Bourne said, 'I am the weapon.'" That kind of thing. We used to howl.'

One time, they were shooting the scene where Bourne scopes out Landy in her office using his rifle sight. They'd mounted the camera on a crane and built a section of windows, 40 or 50 feet up, to match the view Bourne would have looking down. Taking direction via radio, Damon appeared at the window, held his binocular sight up, then ducked out of view and reappeared holding a sign that said: *I am the weapon.* 'I fell about laughing,' recalls Greengrass. 'Entirely unusable but hilarious, and entirely necessary to keep our sanity. That was what we thought about that. We were like naughty schoolboys, we were. We were just pissing ourselves laughing.'

They were not laughing on 13 February, when principal photography ended and Greengrass and Rouse began wrestling with the film's ending in the editing room. The workload and schedule pushed the team to add more edit systems – eight in total – for the various editors, assistants and visual-effects editors who were working on the film round the clock to get it finished in time for its 3 August release date. 'We started shooting last October and originally were supposed to be done with all photography by January, but we actually shot some pick-ups as late as June,' said Rouse. 'The script and the film's structure were evolving all the way to the end.'

The only remaining question was: which end? In Gilroy's draft, the creator of Treadstone was a doctor at the Institute of Neurocognition, Dr Devitt, 'a powerful man wasted by age and entropy. Sick and tired and dreading this conversation.' He and Bourne meet, and Devitt apologises, claiming his hands were tied – an impotent Frankenstein figure. 'I never

liked Gilroy's doctor idea,' says Greengrass, 'because the doctor always led to medicine, and I was actively, profoundly and irrevocably opposed to any drugging of Jason Bourne, anything that would involve compromising his moral culpability. That was an *idée fixe* for me. I wanted Bourne to do it consciously knowing who he was. I wanted a Bourne who had to choose to kill, knowing what the consequences of it were. I wanted him to be parked up against what he did, with no moral get-out.'

The key idea was to show Bourne's initial kill. If *Supremacy* had shown the first mission, *Ultimatum* would show the first time he took a man's life. Inspiration for the scene came from the news story that had made Greengrass sit up and want to become a journalist in the first place, the story that had drawn him all the way to Washington, DC, to meet Bob Woodward in the fluorescent-yellow offices of the *Washington Post* and trawl through the National Security Archive's seven million pages of declassified documents.

The original anonymous source: Deep Throat.

When the ex-deputy director of the FBI, Mark Felt, revealed to *Vanity Fair* in 2005 that he had been the anonymous source immortalised in Woodward and Bernstein's *All the President's Men* as 'Deep Throat', he was ninety-one and his health was failing. A severe stroke in 2001 had robbed him of much of his memory. Woodward stewed and postponed calling him for a few months, unsure of what sort of reception he was going to get – Felt's life had been turned upside down by the prolonged effort required to keep his secret under wraps and he had been hounded for decades by suspicious journalists – but eventually he

Ex-deputy director of the FBI Mark Felt, better known as 'Deep Throat'.

rang him at his house in Santa Rosa, California, and identified himself. Woodward knew from his experience with his own father that there was no way of knowing his precise mental state, but Felt seemed to recognise Woodward's name, if not Woodward himself. They made small talk about the dissatisfactions of old age, before Woodward got to the list of questions he had always wanted to ask Felt, as he later recounted in his 2006 book *The Secret Man*:

'What I wanted to ask you, if you were to look back on Watergate, not the unraveling of Watergate after the burglary, but prior to the June '72 burglary, and ask you "What was Nixon's undoing?"'

'The trouble is I wouldn't really feel capable of addressing your question,' Felt replied. 'I have to do a lot of reading and a lot of research and revise and go back and refresh my recollections on a lot of things . . . It doesn't ring any bell or anything like that.'

'Do you remember when Nixon testified at your trial and [Ed] Miller's trial?' I asked.

'No, I have no recollection of that,' Felt answered.

'And eventually when Reagan pardoned you. Does that ring a bell?'

'Doesn't ring a bell,' Felt said. 'No, I don't remember specifically that he pardoned me. I don't remember anything that happened that I would have to be pardoned for. I wasn't convicted.'

Woodward filled him in as best he could, then asked:

'And the White House.'

'Well, I don't really remember any specific problems in dealing with the White House,' he said. 'I mean I can't recall any specific instances of problem. I think there must be some record of all that somewhere though. But I can't comment on it.'

'Sure,' I said. 'What are you spending your time doing?'

'This afternoon I'm just spending my time waiting until it gets late enough for me to eat my dinner.'

The ironies were legion. That a former government employee well versed in the language of official prevarication – 'I can't remember' or 'I can't comment' – could for once say those things and mean them was bathetic. That he could use them in reference to the biggest political crime of the century even more so, almost seeming to mock the

Greengrass, Albert Finney and Matt Damon consult before shooting the climax of *The Bourne Ultimatum* (2007).

public's desire for closure. This government man, the pre-eminent insider who due to his advanced age or Alzheimer's could no longer remember the events whose moral weight he was being asked to bear – *that* was surely Bourne's creator, thought Greengrass. He wrote to Tom Stoppard before the playwright began his draft: 'Personally, I would rework the end so that Bourne's creator isn't a doctor at all, but a Washington power-broker. I suggest taking a look at Woodward's *The Secret Man*, where he describes his relationship with Mark Felt. How about Bourne tracking down his creator, only to find that the old man has himself lost his memory through Alzheimer's, thus depriving Bourne of the final truth of his identity?'

In Stoppard's draft, Dr Devitt became Joseph Benziger, once at the Pentagon, but now housed in a private home for elderly people. A day nurse leads Bourne to Benziger's small, simply furnished room, where Bourne finds him sitting, looking out of the window.

BOURNE: It's David.

JOSEPH turns and smiles blankly at him.

JOSEPH: Have you brought the letter? I'm expecting . . . What is your name?
BOURNE: David. Do you remember me?
JOSEPH: David?

BOURNE: David Webb. We met when I was in the Army . . . I had
to deliver some documents to some office in the Pentagon . . . They
made me wait . . . in a room. You were there, in this room. We
spoke. You took an interest . . . asked me things, and told me . . .
about the knife edge . . . Do you remember that?
JOSEPH: They hide my letters, you know.

Beat.

BOURNE: I'm glad I saw you again.
JOSEPH: What is my name? Do you know?
BOURNE: Joseph. Your name is Joseph Benziger.

The only problem with the idea was that it too closely replicated Bourne
himself – it was one amnesiac too many – so they ended up splitting the
difference between the two drafts. Bourne's creator would be a medical
specialist employed by the CIA, like the scientists and medical doctors
who helped determine how many times the agency could waterboard
its captives in Guantanamo and various black sites around the world.
Bourne's complicity could still be made clear, although, like almost all of
the key decisions in the scene in which Bourne met his maker, eventually
named Albert Hirsch and played by Albert Finney, the concept of him
having volunteered for Treadstone, rather than being recruited, came in
the editing room, during post-production.

'That scene, for me, is one of the best scenes in the Bourne series,
when Hirsch goes, "You volunteered,"' says Greengrass. 'That was the key
line. It's the twist in this whole story. "You volunteered, Jason. You came
to us." [Albert] Finney knew exactly what it was we wanted to do. He
hands him the gun and he says, "Will you commit to the programme?"
It's fucking awesome. You could *feel* the electricity.' When scoring the
scene, John Powell abandoned his more metallic percussive ideas and
moody, industrial-edged textures and returned to the oboe that he had
used since day one to suggest the haunted, lonely quality of Bourne's
existence. 'What John did that was so brilliant was, he took that tem-
plate of the commercial action thriller and made it much more lyrical

and filled it with space. He inverted the palette, and then everyone copied him because it was still powerful and driving, but it gave you much more space, much more emotion. I think the music when Bourne has to commit is just exquisite. Your heart breaks for Jason at that point. He's being seduced, isn't he, by Finney, and then it breaks into this incredibly lyrical oboe line. You see the moment when Jason Bourne falls morally. He chooses to kill, in the full knowledge of what that means, because that was where we were in our world. In the end, what made Bourne the supreme avatar of those years, and Matt's performance so electrifying, was that he distilled choices that we had made. And we didn't make them in a fog of drugs. We didn't suffer from amnesia. We chose to do it as an active choice. And I wanted that choice to have consequences for him. It's written all the way through that film. They were intense scenes, played with a great force of naturalism. They felt like they belonged in our world somewhere.'

Here are some words that do not appear at all in the Bourne films: 'terrorist', 'terrorism', 'Iraq', 'Afghanistan'. There are no Muslim terrorist cells, no radical mosques, and Morocco is as far as we get to the Middle East. If this comes as something of a surprise, it may be because the Bourne movies seemed to take the temperature of post-9/11 America, with its black sites, rendition and off-the-books torture programmes. All these things are present by their absence. One critic quite accurately called *The Bourne Ultimatum* 'a meditation on the dehumanizing effects of American foreign policy masquerading as a summer blockbuster'. The Bourne movies hold a mirror up to the shadows of post-9/11 America – what Dick Cheney rightly called 'the dark side' – just as surely as Fritz Lang's *The Testament of Dr Mabuse* (1933) did to Weimar Germany and the Maysles' *Gimme Shelter* did to the convulsions of the Vietnam era. Over the course of the films, we see flashbacks of Bourne going through something that looks very like the Pentagon-funded programme known as SERE (Survival, Evasion, Resistance and Escape), which was created by the air force at the

WILL BE DEPLOYED AT THE EARLIEST OPPORTUNITY TO BE PRESENT AND ASSIST IN DESTROYING THE TAPES COMPLETELY:

B. POLICY ON USAGE OF TAPES: STARTING IMMEDIATELY, IT IS NOW HQS POLICY THAT RECORD ONE DAY'S WORTH OF SESSIONS ON ONE VIDEOTAPE FOR OPERATIONAL CONSIDERATIONS, UTILIZE THE TAPE WITHIN THAT SAME DAY FOR PURPOSES OF REVIEW AND NOTE TAKING, AND RECORD THE NEXT DAY'S SESSIONS ON THE SAME TAPE. THUS, IN EFFECT, THE SINGLE TAPE IN USE WILL CONTAIN ONLY ONE DAY'S WORTH OF INTERROGATION SESSIONS. (A SPECIFIC EXCEPTION TIMETABLE MAY BE MADE WHERE REQUIRED IN DAY'S SESSION.)

For disseminated intelligence, see

70879 70870 70866 70868

29768 11246 11243 11258 11284 11322 NOV
11270 11293 11322
11359 NOV 02) DEC 02)

335
336 See, for example, 11263 11294 11352 11344 DEC 02)
NOV 02) DEC 02) NOV 02).
02); 78275 COBALT is not well documented in CIA records. As described
337 Al-Nashiri's time at DETENTION SITE COBALT

To: Dusty Foggo
cc:
Subject: short backgrounder

Dusty - at both the DO update and right after the G-7 the issue of the Abu Zubaydah tapes were discussed. You may recall these concern the tapes which were made during his interrogations at and being held by the of that country. It was recommended to previous DO management that the tapes be destroyed. This was after the had reviewed them and deemed that transcripts were an accurate reflection of what happened and they were no longer needed from their perspective. For whatever reason it seems, previous DO asked (nf) someone (nf) downtown and as a result got cold feet and did not order them destroyed. Current not wanting - smartly - to continue to be custodian of these things was advised to send in a cable asking for guidance." He did so. Guidance just sent - cleared by , DDO and - told him to destroy. He did so. Rizzo found out today this had occurred as was upset - apparently because he had not been consulted - not sure if there was another reason. He raised at DO update but was 'calmed' (only slightly) when told had approved. Jose raised with Porter and myself and after G-7 and explained that he (Jose) felt it was extremely important to destroy the tapes and that if there was any heat he would take it. (PG laughed and said that actually, it would be he, PG, who would take the heat) PG, however, agreed with the decision. As Jose said, the heat from destroying is nothing compared to what it would be if the tapes ever got into public domain - he said that out of context, they would make us look terrible; it would be 'devastating' to us. All in the room agreed but noted that we needed to find out Rizzos concern and whether it was substantive or just being 'left out.' Jose was going to pursue this. Believe this is end of it, but in case it comes up, you need the background.

A selection of declassified CIA reports relating to the torture of Abd al-Rahim al-Nashiri and Abu Zubaydah, whose interrogations were videotaped. By October 2002, the agency had decided that these videotapes posed a security risk that could endanger intelligence personnel and 'all Americans'. They were destroyed on the orders of CIA director Gina Haspel.

end of the Korean War to train recruits to survive torture such as water-boarding. Bourne's signature instrument on the soundtrack is a Middle Eastern-sounding oboe. The assassination programme, Blackbriar, finds its echo in the special forces authorised by George Bush to take 'lethal direct action' in Afghanistan and Iraq after 9/11.

'Bush wanted an Iraqi version of the OSS Jedburghs,' said paramilitary operations officer John Maguire, of the Memorandum of Notification granting 'exceptional authorities' to the CIA six days after 9/11, on 17 September 2001, which provided them with legal cover to carry out direct lethal action anywhere in the world, like the Jedburgh teams, trained in

sabotage and guerrilla warfare, who parachuted into France to assist the Allied invasion during World War II and whose motto was 'Surprise, kill, vanish'. What goes around comes around. The only thing that changes, apparently, are the euphemisms for murder that give plausible deniability to those who commission it. Eisenhower's advisors talked of 'eliminating' foreign leaders, or else 'neutralising' or disabling' them; Kennedy's called it 'executive action'. In Central America, in the 1980s, under Reagan, the US special forces' motto was 'Find, fix, finish'. Bush's Memorandum of Notification remains in effect today. When Navy Seals conducted direct action against Osama Bin Laden in 2011, the team, though technically part of the defence department, was operating under the CIA's authority and given legal cover by Title 50 of the United States Code justifying covert activity overseas.

'The difference after 9/11 was that we were doing it,' says Greengrass. 'We weren't outsourcing assassination to the Mafia or MK-Ultra or Cuban exiles, as it was in the 1960s and '70s. Outsourced again in the 1980s. By the time you get to the Bourne period, *we're* doing the killing. Assassination became, quite quickly, after 9/11, a province of special forces. Assassination and pre-emptive strikes were explicitly articulated as a policy. That obviously developed enormously in Iraq. There was such a large amount of killing that was going to have to be done, it was going to have to be done by us. And, by the way, we did, because we all bought into the idea. It's in *United 93*, where you desperately want those people to survive, you know they're going to smash those hijackers' heads off, if they can. And wouldn't you just, if you were on that plane? We're in a world of "Kill them before they kill us". There's no doubt that one or other of us is going to die.'

One of the key influences on the Bourne films, as well as on *United 93* and *Green Zone*, was a book of photographs, *Fear This*, by the Pulitzer Prize-winning war photographer Anthony Suau, who, when American troops invaded Baghdad in April 2003, surprised his colleagues by staying in the US to report on the war at home. He first flew to San Francisco, just as the city was shut down by anti-war rallies; then, on the red-eye back to New York the night after the war began, awoke to the sight of

all the seat-back TVs of the aeroplane showing a news reporter standing on top of a tank as it rolled across the desert towards Baghdad. Published in June 2005, the book showed a country alternating between war fever and a bad dream: anti-war demonstrations in Chicago; the bombing of Baghdad on live TV; a support-the-troops rally in Richmond, Virginia; a North Carolina church revival meeting for the families of soldiers who were stationed in Iraq. 'The war was being broadcast *everywhere*,' said Suau. 'You'd walk into a Wal-Mart store in North Carolina, and all the televisions mounted on the walls would be showing the bombing of Baghdad. It was *there*. It was so present.'

The power of Suau's book, which Greengrass bought for Bourne production designer Dominic Watkins and Matt Damon, among others, lies

An anti-Iraq War demonstrator, photographed by Anthony Suau for his book *Fear This: A Nation at War* (2004).

in its indirection: we are shown not the fight on the front lines, but the fear and anger roiling the home front, sandwiched between the familiar, bland surfaces of America's consumer reality, its shops and kiosks, demos and rallies, flags and mementoes – the War on Terror as merch haul. 'Because it's like, "This is where we are – we're full-tilt paranoia,"' says Greengrass. '*Fear This* is such a great title. The key thing is that Suau stayed home while all the other photographers went to Iraq and Afghanistan, because he wanted to show what those wars were doing to America. That's why I found it so useful for Bourne – also *United 93* and *Green Zone*, but particularly the Bourne films – because I've always felt those films are like a good popcorn guide to what those years felt like. I used to say that there's a difference between being contemporary and being topical. You want to be contemporary, but you don't want to be topical. Contemporary makes you resonate. Topicality makes you feel like you're yesterday's headlines. Topicality makes you feel like you're following. Contemporary makes you feel like you're leading. That was the dance. I wanted to set it in the post-9/11, post-Iraq landscape of waterboarding, assassinations, and hence, when you finally saw Jason Bourne in the past, he was always in that green military T-shirt. You understood instinctively that this was a special-forces type of a thing and that they were going to experiment on him, not in a medical sense, but morally. He was going to have to undergo all the things that we were going to do to them and were doing in the real world, post-9/11, but he would have to choose to join it. And that was going to be the journey of *Ultimatum*.'

———

They never previewed the film, which was rare for a big studio release, which meant they were flying a little more blind than usual as they neared release date. 'I had a lot of anxieties,' says Greengrass. 'I don't know why, because I look at it and go, "Why was I so anxious about it?" But I really was. Quite late on, I can remember feeling it wasn't going to work. We had one screening – what they call "friends and family" – at the studio lot, because we were literally down to the wire to finish it. I think there

were test cards, but they were an invited audience. It was people at the studio, friends, that sort of thing. And that went fantastically. I think that's when I knew we were going to be fine. I seem to recall being in a minority of one in my anxieties. I think everybody else thought it was going to be great.'

When the first press screening happened, cast and crew all got Blackberried during the movie: 'They're cheering at Waterloo.' 'It feels so good I can't even tell you,' an elated Damon told *Collider*, 'because we didn't know, we came so down to the wire, as we always do on these Bourne movies, that we didn't even get a test in, so we had shown it to – we each had little DVDs, we showed it on television, I showed it to my wife, I showed it to my brother, he was like, "Yeah, cool." And so we'd have these little friends and family screenings. Paul showed it to twenty-five people, you know, people in the business that we know that make movies, "Are we missing anything, guys? Can you help us out?" Collecting notes as quickly as we could and trying to get them into the edit, and then putting it out . . . Last night we were at dinner, and the Blackberries all started going off at the same time, and we heard that it was a crowd pleaser again. It was Paul and George Nolfi, the writer, and me and Joan and David Strathairn and Julia so we just told the publicists to expect a hungover group coming in the next day, because that's when the champagne came out.'

The numbers were giddy. *The Bourne Ultimatum* rocked the North American box office by opening with a $24.5-million Friday and a $25.4-million Saturday for a $70.1-million weekend, more than twice that of the June 2002 original *The Bourne Identity* (which opened with $27 million) and way more than the July 2004 sequel *The Bourne Supremacy* (which debuted with $53 million). The film was eventually to take $442 million, four times its budget, but by the time they stopped counting, Greengrass was already on the runway with *Green Zone*, readying for take-off. The film had gone through many changes since he had first pitched the thriller about rendition to writer Brian Helgeland back in 2002. The project had grown in about five directions at once – they had optioned a book, *Imperial Life in the Emerald City*, read myriad

Senate reports and spoken to countless weapons hunters and CIA officers on the ground in Iraq – while looming over everything was a possible writers' strike, threatening to remove Helgeland from production just when he was needed most. The summer of 2007 was not the best time for Greengrass to receive this apparent confirmation of his invincibility at the box office.

'*Ultimatum* was a pretty giant hit,' says Greengrass. 'You do feel like it's all in front of you. You get lulled into overconfidence, which was not a normal state of mind for me, but I did. I'd had a string of films that worked, one after the other, and that gives you tremendous power, of course, and confidence, and, subtly, everybody watches and defaults to where you want to go. Which is not necessarily the best place for you. I should have taken a short break. I'd done films back-to-back, and they were films of pretty intense pressure in their different ways. We'd done *Bloody Sunday*, *Supremacy*, *United 93*, followed by *Ultimatum* – they were incredibly quick, one after the other. You've only got to be 1 per cent off. That makes a big difference. And, looking back, I needed to be a little bit fresher to think my way through the situation that unfolded in front of me. What happened was *Ultimatum* came out in July, and I was shooting *Green Zone* towards the end of that year, so I was straight into it. So a little bit of overconfidence and a little bit of secretly being a little bit tired mentally and a bit physically too, but mentally I was in the wrong place. It made me reappraise a lot of things afterwards. I would never get myself into such a situation again. It made me ask different questions about the films I make, in terms of the budgeting, and I always have since then. Never again would I let a film bite me like *Green Zone* did.'

9: CHAOS

In November 1999, a forty-one-year-old former Baghdad taxi driver, Rafid Ahmed Alwan al-Janabi, arrived in Munich from North Africa requesting political asylum. Plump, nervous and smelling strongly of cigarettes, he approached German intelligence while living in a refugee camp outside Nuremberg, claiming he had worked as a chemical engineer at a secret Iraqi bioweapons lab. This led to vetting by the German foreign intelligence service, the Bundesnachrichtendienst (BND), who sent their resident expert on weapons of mass destruction, whom al-Janabi addressed as Dr Paul. For the next six months, he sat with Dr Paul and, calling upon his knowledge of chemical engineering from university and his work in Baghdad, concocted a tale of dread designed to strike fear into Western hearts: a birdseed purification plant in Djerf al-Nadaf, ten miles south-east of Baghdad, which he claimed was where Saddam's bioweapons programme was based; a fleet of mobile bioweapons vans, capable of dispensing biotoxins into the winds; and an accident at the site in 1998, which resulted in the death of twelve technicians.

The BND in turn shared its information with the Americans. For years, the CIA had had zero intelligence on Iraq, but that all changed when they received these reports from al-Janabi, who was known to them

as 'Curve Ball'. In autumn 2002, the CIA director, George Tenet, asked the agency's European division chief, Tyler Drumheller, to vet him. A bulky, rumpled man who often seemed oblivious to the tufts of dog hair on his clothes, Drumheller had spent part of his childhood in Germany, and beneath his affable manner lurked a prodigious memory that enabled him to keep track of cryptonyms, children's birthdays and Detroit Tigers statistics. The first thing he did was take his BND source out to lunch in Berlin. According to Drumheller's 2007 book, *On the Brink*, their conversation went as follows:

'You know, Tyler, they're never going to let you talk to him,' the officer told him.

'Why not?'

'First off, the guy hates Americans.'

'We can send someone who speaks native German.'

'He's Iraqi, he won't know the difference.'

'Well, just between us – and I'll deny it if it ever comes out – we have a lot of doubts about this guy. He's a very erratic character. We had to move him a couple of times. And it's a single source whose reporting can't be validated. I personally think he's a fabricator.'

Further investigation revealed that al-Janabi's previous life in Iraq had been chequered with deceit, fraud and fabrication. Drumheller pushed and pushed to get in-person access to al-Janabi, but the German intelligence service refused, denying him even the original transcripts of their conversations with him. The CIA was working strictly from Defense Intelligence Agency (DIA) translations of German texts. Curve Ball had been seen by only one American, a DIA official, who had harboured doubts about the man after it was discovered that he in fact spoke fluent English – contrary to the BND's claims – and because he appeared to be hungover. In an email, the official explained:

I do have a concern with the validity of the information based on 'CURVE BALL' having a terrible hangover the morning

I do have a concern with the validity of the information based on "CURVE BALL" having a terrible hangover the morning ▇▇▇▇. I agree, it was only a one time interaction, however, he knew he was to have a ▇▇▇▇▇▇▇ on that particular morning but tied one on anyway. What underlying issues could this be a problem with and how in depth has he been ▇▇▇▇▇▇▇?

The DOD detailee also expressed concern in his e-mail that,

During the ▇▇▇▇▇▇▇ meeting a couple of months ago when I was allowed to request ▇▇▇▇ that "we/USG" wanted direct access to CURVE BALL, ▇ ▇▇▇▇▇▇▇▇▇▇▇▇▇▇▇▇ replied that in fact that was not possible, ▇▇▇▇▇▇▇ were having major handling issues with him and were attempting to determine, if in fact, CURVE BALL was who he said he was. These issues, in my opinion, warrant further inquiry, before we use the information as the backbone of one of our major findings of the existence of a

An email from the only senior American to have met the Iraqi defector codenamed Curve Ball to his friend and immediate superior, the deputy chief of the CIA's Iraqi WMD task force, telling him that he thought the US's main *casus belli* was based on the testimony of an alcoholic. It was included in the Senate Select Committee on Intelligence report of July 2004.

REDACTED. I agree, it was only a one time interaction, however, he knew he was to have a REDACTED on that particular morning but tied one on anyway. What underlying issues could this be a problem with and how in depth has he been REDACTED.

In the meantime, the DIA had distributed over a hundred intel reports based on this material, which went out to multiple analysts in the American intelligence community. Even as Drumheller was being asked to check on it, WINPAC – the Weapons Intelligence, Nonproliferation, and Arms Control Center – was drafting a National Intelligence Estimate based on Curve Ball's testimony, and by late December 2002, as war approached, the CIA was making official enquiries of the BND as to whether the US – and the White House – could use the material. It was what Drumheller later called 'pit-of-the-stomach time', as he began a race to warn his colleagues within the CIA against the use of Curve Ball, only to find that it was too late. War fever gripped Tenet and his top aides, as well as the CIA's weapons analysts. People were spooked – looking for any evidence whatsoever that Saddam might blow them up in a puff

of smoke – and when the officer from the counter-intelligence centre responsible for verifying speeches brought down the text for Secretary of State Colin Powell's planned speech at the UN, Drumheller went through it, to find his worst suspicions confirmed. It was the Curve Ball material. 'I really am uncomfortable with you using this stuff,' he told deputy CIA director John McLaughlin's chief of staff, according to *On the Brink*. 'If you want to say you're overruling me and you want to use it, that's fine, but I have serious problems with it.'

'Hold on a second. I'll call you back.' He rang back and said, 'Come on up. John wants to talk to you.'

Drumheller went up to McLaughlin's little conference room, outlined the issues and said the source was probably a fabricator.

'Oh, I hope not,' said McLaughlin, 'because this is really all we have.'

'You've got to be kidding. This is all we have?'

Drumheller came up with a plan. They would cross out the section of the speech that they didn't think should be used and send it back up to him. Drumheller told the executive officer, 'Stay in touch with the staff up there and make sure that they get the right copy.'

'They're going to take it out,' he was assured.

The night before the speech, he got a call from Tenet himself. He and Powell were already in New York, engaging in final rehearsals. They were going to deliver it the next day.

'Boss, there's a lot of problems with that German reporting,' said Drumheller. 'You know that?'

Tenet replied, 'Yeah, don't worry about it; we've got it.'

The next day, Drumheller's wife called him to let him know the speech was coming up on CNN. Modelled after Adlai Stevenson's vivid appearance before the same body in 1962, during the Cuban missile crisis, Powell's address was punctuated by a glossy slide presentation and show-and-tell devices, including a vial of powder that he held up before his audience, declaring that if it were a biological weapon, it would be enough to kill thousands of people. 'We have first-hand descriptions of biological weapons factories on wheels,' Powell said. 'The source was an eyewitness – an Iraqi chemical engineer who supervised one of these

facilities. He was present during biological-agent production runs. He was also at the site when an accident occurred in 1998. Twelve technicians died.'

At the UN, and to everyone watching, the effect was dramatic: here, finally, was first-hand testimony that Saddam had defied the UN weapons inspectors, possessed weapons of mass destruction and planned chemical war. But at the CIA's counter-proliferation division, where officers sat rapt before the television, watching Powell speak, there was dismay. Drumheller couldn't believe his ears. He would write a book about the politicising of intelligence in the lead-up to the war, *On the Brink*, and in March 2007, after meeting with co-producer Michael Bronner, he became a consultant on *Green Zone*.

'You've only got to look back to *Our Man in Havana* or *Tinker Tailor* or indeed Kim Philby with the Volkov case, which is really what inspired *Tinker Tailor*, to see how easy it is to create a situation where I say that you, my source, are telling me X, Y and Z, and I tell my superiors you said A, B, C,' says Greengrass. 'It becomes almost impossible for any outsider to verify that actually I've misrepresented what you said. Intelligence reporting does involve these chains, but when you are operating a cautious, proper verification process inside an intelligence service, that chain has to verified. That takes months, if not years, and very careful, cautious judgement. That's the essence of it, sorting the wheat from the chaff. In Iraq, raw intelligence just went up the stovepipe. Basically, this stuff was just chucked unverified up to the policymakers. Did they know it was bullshit? A lot of the time they really did know it was bullshit. They really, really fucking did. I sat and listened to those CIA guys, and there was no doubt about that.'

The director felt personally betrayed by the Bush and Blair administrations in the run-up to the war. He had voted for Blair and saw him as the culmination of a lifetime of effort by the Labour Party to get a centrist candidate into Downing Street. 'It seemed to me an essential part

of getting anything done as a government was that you hung together. And so, when we faced Iraq, the proposition in 2002 was: "I know things that I can't tell you because we're the government. We ask you to support us in this." And I felt that it was very important that we gave them our trust. I can remember going to constituency meetings, where younger people would be bitterly opposed to the war and arguing against the government's case. So when it later transpired there were no WMDs, I felt utterly betrayed. And that's why I wanted to make *Green Zone*. I wanted to make a film about someone going on that journey that I had gone on. And that brought me to WMD hunters, who I thought were really interesting.'

The story had come a long way since Greengrass first pitched screenwriter Brian Helgeland 'a tough, gutsy, big contemporary thriller about the War on Terror' that took the audience to Guantanamo, to Fallujah, to the radical mosques in Hamburg – 'All those things that we know about, but don't see' – in May 2005. A year later, while he was grappling with the screenplay for *The Bourne Ultimatum*, Helgeland pitched Greengrass an idea about an American returning to the US on a plane who finds himself sitting next to a Muslim. 'There's a discomfort, in that way that there was in those days,' says Greengrass. The plane lands. And then all of a sudden, out of nowhere, the plane is stormed by the Feds and the Muslim passenger is dragged away. The hero might have been on vacation or a business trip or government business, Greengrass suggested in response, 'or he might be involved somewhere in the whole build-up to war, selling dodgy intelligence about WMDs, or he might be involved on the peripheries of an unnamed military mission . . .'

Of the WMD idea, Helgeland replied, 'Not to lock down too early, but that feels like it.'

Research by Greengrass's executive producer, Michael Bronner, had turned up two dozen US combat vets who had served in Iraq, including Chief Warrant Officer IV Richard 'Monty' Gonzales, who had led MET-Alpha into southern Iraq after the invasion, where they headed the search for WMD. 'Monty had a natural gift for intelligence gathering,' a colleague said. 'He also had a knack for crossing over the line with Special Ops and

pissing people off.' By the time he reached Karbala, he was 'convinced there was no smoking gun', Gonzales told Bronner. 'Karbala solidified my scepticism. I mean, you can smell a rat. We weren't going to be finding any vast weapons manufacture facilities.' *Green Zone* had its hero.

'That felt to me like, "Great." I understood who that guy was,' says Greengrass. Then he started to bait the mystery more. 'There are no weapons. Why? Who gave us this intelligence, and what's wrong with it?' That led to Curve Ball, whom they had heard about from Drumheller, and the 'idea of a cabal determined to fix the intelligence in order to get us in there, knowing or suspecting that there were no WMDs, being egged on by corrupt elements of the press'. In July 2006, Helgeland suggested the story have a female reporter who was laundering false intelligence the way Judith Miller had inadvertently done at the *New York Times*, but by October, Greengrass was off in another direction, having read and fallen in love with Rajiv Chandrasekaran's book *Imperial Life in the Emerald City*, which meticulously detailed the almost comical levels of incompetence, ignorance and infighting that went on within the Green Zone, the coalition's secure Baghdad enclave. Greengrass was in Tangiers at the time, shooting *Ultimatum*, and raved about the book to Matt Damon, who also read it and told him, 'I'm in.'

Helgeland was less keen – he wanted to write an original screenplay, not adapt a book – and in January 2007, he quit the production. 'It's what happens when you're master of the universe. I needed someone to say to me, "What the fuck are you doing? Making a film about Iraq on that scale? Why are we doing this? And by the way, why do you need to spend money on that book? You don't need it." It was just the title I loved, actually, which in the end I didn't use. But why did I need to option it and pay a lot of money to a terrific journalist? Chandrasekaran was very helpful and enthusiastic and supportive of our project, but the movie really had nothing to do with his book at all.'

Eventually, Helgeland came around, and in February 2007, in between shooting the final scenes of *Ultimatum*, Greengrass had dinner at the Four Seasons in New York with his producers Tim Bevan and Lloyd Levin, co-producers Michael Bronner and Kate Solomon, Chandrasekaran and

Helgeland. They tried to hash out the film's various threads. Should it stick to the Green Zone, the four-square-mile, heavily guarded strip on the banks of the River Tigris known as 'Little America', or should there be a journey? Should it be a spy thriller or a war film? *Our Man in Havana* or *Apocalypse Now*? The tendrils of the story went everywhere. In April, Helgeland and Bronner met with more CIA officers: former Baghdad station chief Whitley Bruner and Charlie Seidel, the senior US intelligence representative during the invasion of Iraq, a fluent Arab speaker who had spent most of his career in the Middle East and who told them about General Sultan Hashim Ahmad, Saddam's minister of defence and the '8 of Hearts' in the 'Iraq's Most Wanted' card deck used by the American military to hunt down prominent Iraqis. A great patriot who was never quite trusted by Saddam and who stood the Iraqi forces down when the invasion began, General Hashim had been identified by Bruner and Seidel as a key figure who could potentially stabilise the country, but any hopes the general had for a role in post-war Iraq were dashed by US viceroy Paul Bremer's catastrophic decision to disband the Iraqi army and outlaw the Ba'ath Party. Seidel described a fierce, almost physical shouting match he had with Bremer over the decision to de-Ba'athify. Seidel was ignored and watched helplessly as the country was kicked over the edge of a cliff.

'That gave us our endpoint,' says Greengrass, who in April suggested setting the climax of the movie on the night they announced de-Ba'athification. 'I was very influenced by those CIA guys that we met, Drumheller, Bruner and Seidel. That all drove us towards more of a conspiracy thriller in form. Out of talking to Charlie, I got the idea of creating some Curve Ball-type legend, a little like *Our Man in Havana* or *Tinker Tailor*, where the source had said, "There are no WMDs," and it had been corrupted to, "There *are* WMDs," and who would ever know? Brian bought into that. We were making the kind of progress that you would ordinarily make in a project like this. It needed to be worked on much more, as any screenplay does, but we were getting there.'

Helgeland's first draft, entitled *Hearts and Minds*, arrived with Greengrass on 13 July and centred on Chief Warrant Officer Miller, 'a

tough mustang of an officer' tasked with leading the men of the 75th Exploitation Task Force in finding WMDs in Iraq during the early days of the American invasion. He and his team investigate a cavernous, rusty warehouse facility in al-Nasiriya, where he finds only disused vacuum cleaners – a droll reference to Graham Greene's cash-strapped vacuum-cleaner salesman in *Our Man in Havana*. 'These are not the droids we're looking for,' says one of Miller's men, before returning to Baghdad, which teems with surreal culture clashes between the invading Americans and the looted Iraqis: a pick-up truck towing a motorboat; forklifts carrying pallets stacked six foot high with $100 bills; the unreal opulence of the Green Zone, where American soldiers chow down on Froot Loops beneath crystal chandeliers, to the sound of Hank Williams Jr's 'All My Rowdy Friends Are Coming Over Tonight' playing over the distant pop of gunfire. The script had the structure of an odyssey.

'It wasn't really a thriller per se,' says Greengrass. 'Where Brian was wanting to go, I felt at the time, was sort of like *Apocalypse Now* territory, the surreal journey through Iraq. He was going on this journey and seeing surreal elements of it all, and the journey was a journey of self-discovery. I didn't really want to do that because I felt that's what *Apocalypse Now* had been. All I knew was that I loved the world of the Green Zone, which I thought was fabulous. If I had my time again, I would have made it a very interior film about mood and the menace inside the Green Zone, moved away from full-on action thriller and into more a kind of conspiracy thriller, a *Parallax View* type of film. That would have been to Brian's taste, I think, because he loves those movies as much as I do. But at some point, I made a very bad decision – and I can't understand why, or at what point I made it, if I ever did – but at some point, I allowed it to become a big film. I should never have done that. The minute you get trapped into a big film, then you're trying to service a big film. "Well, okay, let's see if we can pump up that end and make it really pop, because then it will work as an action thriller." But before you know it, you're no longer its master. You're trying to feed a monster.'

At the very time that they needed to slow down, events were speeding up. Just one month after Helgeland delivered his first draft, Universal

rang Greengrass to let him know that *The Bourne Ultimatum* had taken $70 million over its opening weekend. Ordinarily, the studio might not have been so keen to put an expensive film about the Iraq War into production, but *Black Hawk Down* (2001) had been an encouraging success, the writers' strike was looming, and more importantly, Universal wanted to keep Greengrass and Damon happy for a third Bourne film. 'Studios all over town were desperate to chuck anything into production because of the writers' strike,' remembers Greengrass. 'And I was in a very dangerous situation because I was coming off a run of successful films. I was king of the world in a way – certainly, Matt and I were. So Universal were in a difficult position. "Here we have Matt and Paul, and they've knocked it out of the park twice for us, and actually Greengrass didn't do so bad with *United 93* in the middle." It's like, "So we've got to have them do another Bourne film. So whatever those guys want to do, we've got to just do it to get them to do a Bourne movie." It put them in a situation where they couldn't say "no" to us, really, even though they should never logically have said "yes". It was a fateful moment. It was an unholy, unrepeatable mixture of elements.'

Out of the blue came another serious impediment. The Writers Guild of America voted to authorise a strike just as Helgeland was delivering a second draft. The two men had literally only a few days in which to work on the script before Helgeland was forced to fly back to Los Angeles. He sent one last email before the strike began, attaching a reworking of the first seventy-five pages of the script. 'I had no option left but to try and wrestle those solutions on the fly to a hugely difficult, logistical, complicated film, while accelerating towards production. And instead of postponing, I said, "Let's just fucking go. Get down that tarmac and go." What it felt like is, you're fuelled up at the end of the runway, and you know your plane is not airworthy and you want to go back to the hangar. "We're not ready to fly this thing yet." Instead, you go, "Fuck it. We'll go." That's where the overconfidence comes in. I was overconfident, I think. Actually, I don't think "overconfident" is the right word. I think I had been led by the two Bourne experiences to be blind to the risks. "Fuck it. Just go. Full power. We're going. And we'll sort out the problems along

the way. We'll be fine . . ." It was a pretty brutal experience. You're trying to use every little ounce that you've got to keep the thing from crashing, desperately trying to keep it in the air, and every three seconds an alarm goes off and the wing drops and you go, "I'm fucking struggling here . . ." You're trying to use all your skill to try and get it to where it wanted to be, and we didn't crash, but it wasn't pretty either.'

———————

On paper, what Greengrass found himself having to pull off with *Green Zone* wasn't too dissimilar to what he had done on the Bourne films. He had a script that wasn't quite ready, a $100-million production already up and rolling, an expectation from the studio, Universal, that they would come up with something big and crunchy to rock the summer box office, and a 200-plus-strong cast and crew awaiting instructions on what to do next. But on the Bourne pictures, he generally had a writer on set – a Paul Attanasio, a George Nolfi – solving problems as they came up.

On 12 February 2008, the writers' strike ended, and ten days later, Brian Helgeland submitted a reworked draft of the script's first ninety-six pages, but by that time the film was already in production, and in Helgeland's absence, a number of other voices jockeyed to fill the void. One was co-producer Michael Bronner, a prodigy of research, whose eighteen reports succinctly detailing the US and UK's choreography of the whole Iraq/WMD affair, made up a 9,000-word treatment entitled, rather ominously, 'How Did We Get It So Wrong?', which ran to 156 pages, complete with figures, bullet points and thirty-two footnotes detailing his sources, from newspapers and books to Congressional reports and debates in the House of Lords. Another was Greengrass's editor Chris Rouse, whose rocket-propelled instincts had helped the Bourne movies break the sound barrier. It was an odd pairing, the researcher and the speed freak, but it echoed the split in Greengrass's own nature between the intellectual and the visceral, the historian and the hooligan.

'One of the things that happened in *Green Zone* was that I had actually become too obsessed with the facts and not obsessed enough with the

film,' he says. 'I got that balance wrong, in a way previously I had got it right. We were swimming in an ocean of facts and detail and knowledge, in what was really an alternate-reality film, which itself is a very, very, very difficult space to operate in, because what is it? Is it a true story? No, it's not. Well, it's meant to be true. And that was my mistake. There were too many facts coming at me for me to get a fix on the central drama of it all. What we needed was fictional firepower, for Brian and me to be in the same place, hammering it out up front. But instead of Brian and me wrestling with the core issues, I had Michael giving me high-class facts, and Chris Rouse, who had been such a powerful, shaping creative voice on *Supremacy* and *Ultimatum*, engaging with Brian's work before it was really fully formed. We just didn't have enough structure. We didn't have enough worked out. We had enough to get started, and then there were some interesting sort of avenues that we went down, but they didn't quite all fit together. But the further down the movie we looked, the more unclear it was. And as for the third act, it was almost entirely unformed.'

Greengrass can remember the point when he knew he was in trouble. They were in Morocco, in its capital, Rabat, filming the various highly dynamic chase sequences that took place either in Humvees, minicabs or on foot. The Centre Cinématographique Marocain had granted permission for everything they needed – military personnel, helicopters and military bases – and the flat red-tiled roofs and narrow, shadowy streetscapes, surrounded by wide, flat desert, handily evoked the humming, busy, claustrophobic atmosphere of Baghdad. One day towards the end of the afternoon, when the light was beautiful, Greengrass drove to the set just outside the capital, where they had established a camp. He asked to be dropped off a little way out so he could walk the last fifteen minutes towards the base, to clear his head. He walked down this dusty track, came over a rise and saw the camp, about a mile ahead. It seemed enormous, with lighting and camera trucks, military vehicles, Humvees, trailers and row upon row of catering and equipment tents, with a couple of hundred crew making their way from one to the other.

'It looked like a military camp, basically, sprawling out ahead of me. I can remember standing and looking at this thing and thinking, "This

Greengrass sets up a shot for *Green Zone* (2010).

is just the perfect metaphor for the Iraq War. Because we're in this thing now, and it's too big to be sustainable. Jesus Christ, our day costs must be hundreds of thousands." I mean, we weren't any bigger than Bourne, but we were certainly as big as Bourne. And I remember it crossed my mind: "This is just a movie. Imagine invading Iraq. Imagine the logistical nightmare." Hundreds of thousands of troops have got to be moved and all the associated jets, missiles, ships, the whole panoply, and they've all got to be fed, watered, armed, equipped. I mean, the mind boggles. There's a sensation you have when you're filming – you always have it, whether the film's small or big – of this dial like a fuel dial spiralling, and that's your resources diminishing, hour by hour, during the short period that you're shooting. Because you're haemorrhaging money while you're shooting. And I remember thinking, "This thing is eating us." A horrible

feeling. Once you've put yourself in that position, as I did on *Green Zone*, you learn that lesson and you never want to go back there.'

After making it, he says, 'I never felt as young again.'

'Every C-130 that lands here brings another bunch of goddam crazies from Washington with no understanding of the culture, the history, but determined to unleash the magic of the market, and they are going to fuck things up around here for a long time . . .' growls Martin Brown (Brendan Gleeson), a hulking, grizzled CIA man at odds with his own government's mission in Iraq. 'You cannot just hand this country over to an exile no one's ever heard of and a bunch of interns from Washington.'

Burly, rumpled, wearing a tan suit that looks as if he has slept in it and sporting a day's growth of stubble, Brown is a rolled-up version of all the CIA agents Greengrass met with before making the film – Seidel, Drumheller, Bruner – a bulky Cassandra who pops in and out of the plot to deliver grizzled realpolitik in a whisky-gruff growl, drop a few leads into the lap of Matt Damon's befuddled Sergeant Miller and then disappear again to down gin and tonics as if he's momentarily escaped from a Graham Greene novella.

We first meet him at an intelligence briefing in Baghdad, where Chief Warrant Officer Roy Miller (Matt Damon) complains about the faulty intelligence that has led them to vacant warehouses. 'It just seems like we're chasing our tail here,' Miller tells neocon Clark Poundstone (Greg Kinnear), a newly arrived ideologue from Washington who burns with bright-eyed zeal and brushes off Miller's concerns as if swatting flies. 'It's a shitty game you're getting into, are you sure you want in?' Brown asks Miller, setting him on the trail of an Iraqi exile, Ahmed Zubaidi, leader of the Free Iraqi Resistance, who sips tea in a bombed-out shelter as he feeds pro-West pablum to a *Wall Street Journal* reporter named Lawrie Dayne (Amy Ryan). 'Does it make sense to you that we're still coming up empty?' she asks. 'Someone told us they were there, right?'

So there is our Curve Ball. There is the laundering of intelligence. 'That's how they work it,' says Brown. 'White House gets bogus intel from Zubaidi, they leak her a story, she writes it, *New York Times* prints it. And the next day the vice president is on *Meet the Press* quoting the story she wrote that they leaked to her in the first place.'

Miller puts the pieces of the puzzle together with the help of a Saddam-loathing translator, Freddy (Khalid Abdalla), who expresses all the hope, disappointment and anger of ordinary Iraqis towards their American 'liberators' and puts him on the trail of the highest-ranking Iraqi military general, General Al Rawi (Igal Naor), who has gone into hiding and may know the truth about the weapons programme. Would a warrant officer get so far out of his lane and investigate all this? The line of command is somewhat hazy. Seconded to Brown's security detail, Miller turns freelance investigator to try and track down Al Rawi before a gung-ho special forces operative, Major Briggs (Jason Isaacs), can get to him. As Miller says at one point, 'It's one big ad lib.' Effectively, between them Brown and Miller decide to freelance the foreign policy of the United States of America. They Jason Bourne it.

The film's problem is relatively straightforward: Miller's endgame – to find Al Rawi and make public the information he holds, which is that the Americans knew there were never any WMDs – is not sufficient to power the kinetic, thrill-of-the-chase mechanics to which Greengrass defaults in the film's second hour. As Miller closes in on Al Rawi in the dark labyrinth of Baghdad's streets, with Briggs in hot pursuit of both, FBI agents track them from a makeshift control room, calling up classified information from immense databases and night-vision surveillance displays in the cockpits of helicopters to track their targets in real time. 'If you pull this off, you might just save the country,' Brown tells Miller. But we know how this will end; that 'might' is doing a lot of work. De-Ba'athification was not averted, and Iraq went over a cliff. So *Green Zone* is fated to run out of gas as an action thriller. The one type of film that could have successfully accommodated tragic failure as an endpoint would have been the kind of darker, wryly fatalistic, Graham Greene-style spy thriller, which *Green Zone* only intermittently manages to be. 'The next time I

give you a lead, can you not go straight in and shoot somebody?' says Gleeson's CIA malcontent. The most violent action in *All the President's Men* is, after all, typing.

If the studios tend to over-trumpet their successes, the press like to overplay their failures to the same degree. In his classic book about the making of *Heaven's Gate*, *Final Cut*, Stephen Bach recounts the final unveiling of Michael Cimino's beleaguered epic to the public gaze in 1980:

> No one saw it. They saw, instead of the movie on screen, the movie they had been told about by forests of newsprint, by cascades of critical condemnation . . . that 'unqualified disaster' they tried to discern through the lights and shadows of the truncated one before them . . . they seemed to feel cheated somehow for it was . . . a movie . . . The phenomenon produced was, well, no phenomenon at all. It was just a western.

So too with *Green Zone*, a film which upon its release in March 2010 was neither a box-office smash nor the unqualified disaster trumpeted by the press, taking just short of $100 million. But no other Iraq War film has attempted to mount such a systematic breakdown of the intelligence failures underpinning this tragic piece of American adventurism – from the point of view of soldiers, Ba'athist higher-ups, Iraqi civilians, poolside Western bureaucrats – and for its first hour *Green Zone* positively hums along. It begins, in fact, with one of the best sequences Greengrass has committed to film, in which General Al Rawi makes his escape from a safe house as missiles rack his neighbourhood. Orange flashes of light through net curtains are all we see of the weapons themselves. Instead, we see scared men and women evacuating down dusty corridors illuminated by swinging torchlight, as more bombs continue to rattle the building, shaking plates free from shelves and shaking chandeliers. Finally, as the general exits into a waiting car, we briefly see a snatch of tracer fire reflected in its window, and as the vehicle pulls away the camera cranes up to catch the famous sight of Baghdad's port, lit an infernal orange: Operation Shock and Awe is under way.

'The last time I watched the film, I remember thinking actually that for about an hour it's a pretty good movie – much better than I remembered it,' says Greengrass. 'Its flaws are its flaws, but I'm not ashamed of the film. I think there are lots of things in it that I'm really proud of. It just didn't, in the end, deliver on what it purported to be. It was a mistake to default to that Bourne style of film-making, I think, but I had too much of that inside me. That stadium-rock thing gets in your head – *boom be-ba, boom be-ba, boom* – that sort of driving, mainstream energy that you feel in modern cinema, whether it's Batman or Bourne or Marvel. It's a cinematic palette that is about percussive drive and dark synths and ostinato. Once you've inhabited it, you've got to consciously step away and let it go, and that's quite frightening, because what's going to replace those hard, percussive elements? When you're thrown into production, you default to those things because you think they're going to get you home.'

Universal head Donna Langley – always one of Greengrass's greatest supporters – commiserated with him afterwards: 'Don't worry about it. You can't win everything, but there are some lessons to be learned. It was a horrendous time for the business, what with the strike and all that. But I don't ever want you to feel that we recriminate with you in any way. On the contrary.'

'I really wish,' says Greengrass, 'somebody had said to me, "Hey, loved *Ultimatum*. You want to make a film about Iraq? You've got $33 million. You can do what you fucking like with it. Make any film about Iraq you like, but we'll only give you $33 million." I'd have gone, "Great. Okay." I don't say that to absolve myself of the fact that I was the person who should have said that. I was a bit haunted by it when it was all over. I'm not so much now, or much less. But you can't get every film 100 per cent right. That's the way of it. You have to just take it and move on.'

After the film's release, having beaten himself up for a bit, Greengrass took six months off and conducted an inquest into what had gone wrong on the film, particularly with regard to its ballooning budget. 'I really needed to know what had gone wrong. When you're making a movie,

there are so many moving parts, so many demands on your time. I probably had too many people around me at that moment and not enough strong voices to make me stop, only really Joanna, who warned me of the dangers from the beginning. But in the end, you lose touch with risk, with the meaning of money. I think every film-maker who's worked for a long time has to learn that lesson. And what happens once you learn it is, you get set free. I can remember when I came to make *Captain Phillips* explicitly saying to everybody, "This film we're making for X" – about $50 million, I think it was. "And just so you know where I am at, this film is going to be made for that amount of money. And if, at the end of the day, we get to a place where we're having a conversation along the lines of, 'If we spend X, it'll be that bit better,' I just want you to know that my answer's going to be 'no'. This film is going to come in for its money." And ever since then – *Captain Phillips, Jason Bourne, 22 July, News of the World* – they've been on budget, every single one. And there will never be a film that I'll make that won't be on budget. That's the basis of your freedom and your control.'

He took his time in choosing his next project. He worked for a while on a screenplay about the assassination of Martin Luther King – one of the most vivid memories of Greengrass's childhood – and the FBI manhunt for his killer, led by the young, recently appointed attorney general, Ramsay Clark, against a backdrop of America going up in flames. 'We have to ride this,' says Clark, attempting to prevent the country from slipping into civil war as rioting breaks out in Cleveland, Pittsburgh, Baltimore and Chicago's West Side, the riots following King's footsteps all the way down to the South. 'Wait for it to blow itself out. It's our only chance.'

The second storyline, covering the days leading up to his assassination, presents us with a weary MLK, tired from having been on the road too long. Unnerved by bomb threats and the FBI's surveillance, jostled by a younger generation of black activists espousing Black Power,

Martin Luther King Jr in 1964 (left), and
(above) map from the FBI file on him.

he must run the tightest of gauntlets past press, cops and hostile white onlookers if he is to keep the future of peaceful protest alive. 'We don't need any bricks and bottles. We don't need any Molotov cocktails,' he insists. 'Either we solve our problems and achieve change peacefully – or we will be engulfed.' If all film directors have one great unmade script, *Memphis* is Greengrass's – an impassioned, urgent, beautifully structured bookend to *Bloody Sunday*. If protest is the language of the unheard, *Memphis* is Greengrass's definitive primer on political violence and keeping the peace.

'King wasn't very well when he gave that last "I've been to the mountaintop" speech,' says Greengrass, who in 1982 made a documentary for *World in Action* about the Ku Klux Klan in the South, in the aftermath of a terrible case in which the Klan had attacked some protestors at an anti-Klan rally in Greensboro, North Carolina, and later a short film for the twentieth anniversary of Live Aid in 2005, cutting together some of King's less well known speeches on poverty.

THE GREENGRASS PAPERS

'One of the things about King was he grew in radicalism, particularly in 1967 and '68. He still held to non-violence, of course, but he had a much more urgent critique of the Vietnam War, but also a sense of what role poverty played. It was incredibly well judged, but he lost popularity through it, and he was never able to gain the traction that he had in '63, '64, '65. Radical groups were coming in, and he was seen as out of touch. Non-violence was not seen as the only way forward. And it came to a head in Memphis. That was what I found so interesting, King trying to negotiate with these more radical, younger figures to engineer this march. And the strain had got to him. Very, very similar to what was going on in Derry in '72.'

Greengrass had conversations with MLK's son Dexter King and Dreamworks, who had secured the copyright on King's speeches for their own project (he had a meeting with Spielberg, the studio's boss, and suggested they merge the two), but the book Greengrass had already optioned from one of MLK's mistresses, Georgia Davis Power's *I Shared the Dream*, was a deal-breaker for the King estate. 'They disliked her intensely, of course, because she had broken the code of *omertà* around King, and that put me beyond the pale so far as they were concerned.' Through Scott Rudin, Greengrass secured funding for his film, and even a release date – MLK Day in 2012 – but on the eve of screen-testing Jeffrey Thomas, a real-life Baptist minister from Georgia, for the role of King, Greengrass's assistant producer Amy Lord came with some bad news.

'He was due to fly out whatever that day was to Los Angeles – we'd done all his travel and everything – and Amy came to the mixing stage and said, "You need to come outside." I said, "Why? What's happened?" "Jeffrey has just been found next to his suitcases at home. He's had a heart attack and died." That was such a shock. And then afterwards I started to feel that as a white middle-aged man, I was not the best person to make that film. I couldn't get comfortable with it. I could say to myself, "Martin Luther King belongs to everybody," but I never quite got comfortable with that, not wholly. It's a shame because I was pleased with the screenplay. It's about many things other than King, political unrest, rioting and white nationalism and why these guys think what they think and do what they

do. There's bits of *Hillbilly Elegy* in there. But in the end, I never doubted that I was right not to make it. I never had a regret, looking back. When you look at the culture, it's for other people to tell King's story, not for me.'

Other projects he was looking at around that time included *Rush*, about the rivalry between Formula 1 racers James Hunt and Niki Lauda, and *Captain Phillips*, about the rescue of Richard Phillips, whose cargo ship was hijacked by Somali pirates in 2009. After Phillips published a memoir detailing his exploits, *A Captain's Duty*, the following year, producers Scott Rudin, Michael De Luca and Dana Brunetti, the production team behind 2010's *The Social Network*, optioned the book and commissioned screenwriter Billy Ray to write an adaptation in December 2010. Ray delivered a standard, high-octane portrait of an all-American rescue operation that attracted Tom Hanks to the project. Phillips was portrayed as a square-jawed hero who at one point wishes they all had machine guns and bids his crew to take their Bibles with them when they hide from the pirates in the engine room. There are conventional cutaways to Phillips at home in Vermont, where his wife, besieged by reporters, pines by the nautical bell that hangs from their clothesline and sheds a single tear when a member of his crew tells her, 'We owe your husband our lives, every guy on this ship. So you stay strong, okay? He'll get back home to you.'

Nothing too egregious, just the kind of patriotic pap Hollywood used to put out during the 1980s and '90s without thinking about it. But the world – and the film market – was globalising fast, and to Greengrass the script missed the real story. 'It was very American-centric, if I can put it that way,' he says. 'Billy Ray had done a good script that was as much about what happened to the wife at home as it was about what happened at sea. It was the press besieging her, and how people rallied round her in prayer circles. It would have done extremely well, or as well as our one did. It just wouldn't have been me.' He turned down the opportunity to direct *Captain Phillips* twice before he finally said yes. 'I didn't engage. Didn't engage. Then I was in Los Angeles – I can't remember why – and [Sony co-chairman] Amy Pascal said, "Look, won't you come in and just talk about it properly? Let's have a proper conversation."'

Meeting at Sony with Pascal and the studio's head of production, Doug Belgrad, Greengrass said he thought the 'red, white and blue rah-rah' version of the story had a limited audience beyond America.

'What's a rah-rah film?' asked Pascal.

'You know, where everybody waves a flag and goes, "Rah, rah, rah." They're great, but they're just not me. It's not how I see the world. What's interesting to me is, the world is globalising. The movie business is global-ising. There's a market, of course, for your rah-rah film, but lots of people in the world are turned off by that.' He told them, 'Here's what it could be. It would be the story of two captains. It would be as much in Somali as it would be in English, and it wouldn't be about the wife at home. It would be about this conflict between these two men of the sea on the far edges, on the frontiers of a fast-globalising world. These vast shipping lanes go past the coast of Somalia, and these kids paddle out and take a ship, and what unfolds is an encounter that draws in other forces – the US military.' Very much in his mind was *Dog Day Afternoon*. He added, 'I think that you want to make this film so that people want to see it, wherever they are in the world. *That* would be the film I would make.'

Pascal looked at him. 'Well, great,' she said. 'We'll make that then.'

10: GLOBALISATION

Greengrass had watched the drama play out in real time on cable news, like everyone else. On 8 April 2009, a 17,000-ton, Danish-owned container ship, the *Maersk Alabama*, sailing several hundred miles off the coast of Somalia towards Mombasa, Kenya, was hijacked by a group of four armed Somali pirates travelling on simple skiffs. All aged between fifteen and eighteen, they intended to take everyone on board hostage and demand a ransom of millions of dollars. But something happened that derailed their plans, and they were forced to escape in one of the ship's lifeboats, taking the captain, Richard Phillips, hostage instead. 'The crew's chilling message: the ship is safe, but they have got our captain . . .' reported CNN. As the hijackers fled back to the Somali coast, a warship followed, and the resulting stand-off, shown around the clock on cable news, kept the US riveted: five tense days of candlelit vigils at the home of Phillips's wife, and shots of the American Navy gathering in the Gulf of Aden. But what, exactly, had transpired during those five days, on board both the bridge of the *Maersk Alabama* and that tiny lifeboat, away from the TV cameras?

According to Captain Phillips in his book *A Captain's Duty: Somali Pirates, Navy SEALs, and Dangerous Days at Sea*, the crew had enough time, before they were boarded, to go into a prearranged hiding place below decks. Having disabled the ship's radar, Phillips convinced the

pirates that much of the vessel's equipment was broken and couldn't be fixed. They threatened to kill the four men on the bridge, but after two deadlines had been breached, they became less aggressive. 'I felt my spirits lift,' wrote Phillips. 'These guys were just businessmen, after all. Crooked, violent, thuggish businessmen, but they weren't about to waste precious resources like human beings unless they had to.' The drama that followed was a striking example of one of Greengrass's favourite themes: the asymmetric fight between the powerful and the powerless, and the tipping point where their positions can suddenly reverse. 'It was like a three-dimensional game of chess,' wrote Phillips. 'I move my man here, you counter. I protect one player, you make a move on another. I just had to figure out the pirates' strategy before they figured out mine.' Game on.

'One of the reasons I loved *Phillips* was because it had that "Who are you?" question at the heart of it,' says Greengrass. 'The crackerjack-action aspect of it was always going to be a part of it in my head, but the particulars of how a guy like Richard Phillips starts working out this algorithm in his head the moment he first sees the pirate skiff approaching, that was brand-new territory. *That* was what I wanted to explore. Once they're on the lifeboat, the pirates are prisoners of what they've done. So it's all about being entangled in who you are.' He was very influenced by an article in the *New York Review of Books* by Gary Wills entitled 'Entangled Giant', in which Wills wrote:

> The whole history of America since World War II caused an inertial transfer of power toward the executive branch. The monopoly on use of nuclear weaponry, the cult of the commander in chief, the worldwide network of military bases to maintain nuclear alert and supremacy, the secret intelligence agencies, the entire national security state, the classification and clearance systems, the expansion of state secrets, the withholding of evidence and information, the permanent emergency that has melded World War II with the Cold War and the Cold War with the War on Terror – all these make a vast and intricate structure that may not yield to effort at dismantling it. Sixty-eight

straight years of war emergency powers (1941–2009) have made the abnormal normal, and constitutional diminishment the settled order.

The pirates who found themselves in the crosshairs of this juggernaut, on the other hand, were not ideologues or enemies of the US. They came from a country with one of the lowest per-capita incomes in the world, which had been ravaged by a civil war that had left its waters undefended and patrolled by foreign vessels. They were desperate. They saw their fellow countrymen grow rich through piracy and hoped to become wealthy, too, by using smaller, faster skiffs to board huge cargo ships. First, it was seen as patriotic: people applauded them for taking a position against the foreign invaders. But once they started attacking merchant ships and holding them to ransom, ordinary Somalis turned away from them. Greengrass wanted a moral calculus for the film that included all of this – the violence and ruthlessness, but also the economic desperation and the scrappy national pride. 'Piracy's roots lie in the desperate poverty, violence and deep corruption that mar Somalia, juxtaposed with its proximity to the busiest shipping lanes in the world,' wrote co-producer Michael Bronner in his research document, commissioned by Greengrass in July 2012 as prep for the film.

Determined to avoid the mistakes of *Green Zone*, Greengrass was adamant they would bring the film in for the price the studio wanted – $57 million – and do so with a script he was happy with before they started shooting. Producer Scott Rudin introduced Greengrass to Greg Goodman, who would become his long-time producing partner. 'Greg was the person I needed to meet that I didn't know I needed to meet, the yin for my yang, a genius at running a production, and that is why he and I have made every film since,' says Greengrass. 'The fundamental thing he and Scott taught me is that if you're making films of any scale, there are two things you need to control in order to be free: your script and your budget. Without control of those two things, you're just a shooter, not a film-maker. Do it on the money, and you'll be totally free.'

It wasn't just the ghost of *Green Zone* that Greengrass wished to exorcise. He also hoped to expel the remnants of bad blood between him and

Tony Gilroy with a demonstration of what a functional, working relationship with a writer looked like. 'Billy Ray is an extremely nice man, and I used to have a good laugh with him, because we viewed things very differently,' says Greengrass. 'Billy had written an excellent commercial film, exactly what they wanted. But he and I were looking at that story from diametrically different points of view. Billy's a very different kind of person to Tony Gilroy, but he occupies the same territory. He's a big-movie guy, conversant with big-movie tropes. But he's a civilised human being and also has a very good sense of humour, and I was determined that I was going to work with Billy, not fall out with him, and that push and pull would be good for the film. We set about getting it to where I wanted it to be, written the way I wanted it to run.'

An efficient, jingoistic celebration of American military prowess, Ray's script went into great detail on the Navy Seal rescue team that eventually freed Phillips: sixteen of them, aged twenty-five to fifty-two ('Warriors. Athletes. Patriots'), parachuting from a military transport plane 5,000 feet over the Indian Ocean, before 'splashing in'. With weapons, comms, navigation equipment and scuba gear all strapped in to a rigid-hull inflatable boat, they assemble their sniper positions, belly down on a mat in the fantail of the vessel, using SR-25s with optics devices, each focused on a single target, a clean line of sight. 'Any of our team members could then put three slugs inside the head of a quarter [coin] at 100 metres,' says one. The pirates, on the other hand, are indistinguishable from jihadis, taunting Phillips about his religion, singing off-key war songs and praying to Allah. 'Bow down and face Mecca,' their leader commands Phillips at one point. 'You're not gonna get paradise and seventy-two virgins for doing this,' Phillips retorts to another. 'You're just gonna get your men.' In Ray's telling, it was basically 9/11, the rematch.

Bronner's research, which filled a seventy-page document and was drawn from interviews with all the key players, including Frank Castellano, the skipper of the USS *Bainbridge*, former SEAL Team Six members and individuals from the FBI's Crisis Negotiation Unit, painted a subtly different picture from the one relayed via the US media storm. Back in Washington, DC, policymakers started spinning the classic two-track

approach to a hijack: negotiate, but also expedite Castellano's request for more military firepower. 'From the off there's a tension between the two roads,' reported Bronner. 'They're almost in competition.' There was Gary Wills's unwieldy giant.

On 9 October, Greengrass wrote to Ray, laying out his vision for the film:

> Our theme here is all about being a prisoner. our main story – our a story – hanks' story – is a simple and emotional story of an innocent man taken prisoner, and how he learns through his experience, about what's important in life. and this meshes perfectly with . . . our b story . . . which is about how the military set the prisoner free. and our c story – which is about how a pirate takes an innocent man prisoner, and ends up being captured himself . . . and what's great about this is: it's not simplistic. it's not anti military. we root for the seals to get an innocent man free we can show their skill we also show how the decision to use force is made inevitable by the hopeless failure of the pirates to appreciate the reality of their situation. but by showing the steady unwavering way the military option supercedes the negotiation option, we're getting to something true about our world. and at the end . . . when the goal has been achieved and phillips has been set free . . . and a grateful nation celebrates . . . we are left – after that military action – with a problem still unsolved. dangerous seas and impoverished, desperate young men still willing to ride out into the ocean in search of pirate bounty.

Ray set to work incorporating Greengrass's notes, producing a new draft in mid-October. It was still very far from where Greengrass wanted it to be, but Ray was concerned that taking the focus away from Hanks would rob the story of its moral clarity. He joked that Greengrass wanted to make a 'Marxist' film, but throughout their email exchanges, which accompanied the various drafts of the script as they flew back and forth across the Atlantic, can be heard the sound of a director reasoning, patiently, with his writer, trying slowly to turn the ship through 180

degrees. 'I do hear your worries Billy, I really do,' Greengrass wrote back to him in an email. 'This movie has to have utter moral clarity at the end to be emotionally satisfying. When the Seals shoot, we have to be in no doubt at all but that they are justified in firing.' But, he added, 'I feel we then earn the right to explore underneath, in a lesser register, the complexities that underlie the denouement and without them, it's a less interesting movie . . . I can give us both what you rightly need at the heart of the movie, front and centre. . . but it'll sit best, if we give it the unease, the uncertainty that I'm talking about, that I think is at the heart of where we are in the world right now.'

Their difference of opinion was never wholly resolved throughout the long, sometimes painful back-and-forth that followed between screenwriter and director throughout the autumn and winter of 2012. On 25 October, Ray sent over another draft, which Greengrass still wasn't happy with. 'I need the movie to be substantially different to where we are now,' he wrote, 'with a lot more layers of doubt built in – a movie that is less consoling and more rooted in the challenging complexities of our world.'

They had reached an impasse and decided to turn the script over to the film's producers. 'I'm sceptical about where we currently sit, and he's sceptical about the direction I want to go,' Greengrass wrote, enclosing a sixty-page outline of where he wanted to take the film – to a 'less consoling, more real world (though I would argue just as commercial)'. The producers agreed that the best next step was for Greengrass to write a rough draft of the script himself, so everyone could read and then discuss it. 'Take my draft – literally – and beat the hell out of it,' Ray agreed. 'Move things around, put new scenes in, cut whatever you feel needs cutting. Lay out your movie.'

Greengrass wrote four successive drafts of the screenplay – on 15 November, 18 January, 7 February and 13 March – each with input from Ray and editor Chris Rouse, and on 15 March 2012 the producers put his version of the script into production. 'Before I went to Hollywood, I always wrote my own films, with one exception, and I carried on doing that in Hollywood. I just didn't bother trying to get credit for it,' says Greengrass. 'Sometimes the writer can be quite powerful, more so than

you'd think. The writer might be working very closely with the producer, or sometimes movie stars have their own writers. So you'll have competing writers. That's very common. There's no rules about it. But I got *Captain Phillips* to where I wanted it, and at the end, I resolved that I wasn't going to do that again, wrestle with someone to turn something of theirs into something I wanted to do. After it was all over, I said, "That's the last time I'm going to do this."'

———

Tom Hanks had been keen to work with Greengrass ever since seeing *Bloody Sunday* and subsequently meeting him, with Spielberg, at the 2003 Deauville Film Festival. A few years later, the actor sent Greengrass a book called *They Marched into Sunlight*, which juxtaposed a small but ghastly battle in Vietnam with an anti-war demonstration at the University of Wisconsin–Madison. The director wrote a treatment for it, although he wasn't sure he wanted to make a film about Vietnam, but when *Captain Phillips* came along, the actor was dead set on their collaborating, having heard first-hand from Matt Damon about Greengrass's unusual shooting methods. He was not without trepidation, though. 'I said, "So what's the deal?"' Hanks told the *Hollywood Reporter.* 'He said, "OK, your first rehearsal will be a disaster, and the first time you shoot it will be like everybody's talking over each other and no one can figure out what's going on. But then you end up getting at stuff better than you ever would imagine."'

This prediction turned out to be uncannily accurate. The two met the day after Greengrass's meeting with Amy Pascal at Sony, and again in London, a few months later, for dinner at Cecconi's, in Mayfair, when Hanks arrived for the premiere of his recession-themed romantic comedy with Julia Roberts, *Larry Crowne* (2011). 'I felt comfortable with him the minute I met him,' says Greengrass. 'He and I are almost exactly the same age. We've travelled the miles. We've both lived long lives, and this character had too. Phillips was not a young man; he was getting to the end of his working life and was worried his world was changing

beyond recognition. I thought if we could capture that, it would be really important to the film working. My view was that there was rich territory for Tom to play a mature man, a man feeling his years. He had probably reached the limits of playing younger. I remember saying, "We want Lear here. We want you to play older. Do you want to play your age?" I think I met him at the right time on *Phillips*, because he was ready to do it.'

Months before shooting on *Captain Phillips* began in Malta, casting director Francine Maisler began scouring the US for Somali actors, looking in particular in and around Columbus, Ohio, and Minneapolis, both hubs for East African immigrants. Adverts were placed in the local papers, and seven hundred turned up at a community centre in Minneapolis on the first day of auditions – among them, Barkhad Abdi, who had heard about the try-out while watching the news. 'They came to my neighborhood,' he told *The Source*. 'One day I'm just hanging at my friend's house and it came on TV. It came on the local TV channel that says a Tom Hanks film is casting local Somalians.' Friends warned him, 'Oh, they're going to embarrass Somali people, don't go,' but for Abdi, the promise of working with Hanks was too great, so he went along to the casting call. After answering a few questions, he was given a piece of paper and told, 'You are trying out for the Muse character. You memorise these lines, you come back tomorrow.'

Above: infrared aerial surveillance of the *Maersk Alabama* on 9 April 2009. Right: a computer graphic of the evasive manoeuvres the ship made to evade the pirates.

The next day, he came back and found a smaller crowd of around forty to fifty, and was told to form a group of four to do the audition. Abdi recognised three friends from his neighbourhood, with whom he formed his own little group. After they auditioned a few times, there was silence for two weeks, and then they got called by Maisler, saying that the director wanted to meet them. Abdi went to the airport, saw his friends there and said, 'You guys got called, too? Alright, maybe there's more auditioning going on then.'

The fact that Abdi had formed a tight group with his three friends made them all especially appealing to Greengrass, who met them after they were flown to Los Angeles. 'To be honest, as soon as you saw those four it was like, "It's got to be them, it's just got to be." I did a bit of work with them, and then I met them again and gave them the part. They didn't hear me at first. We were in a hotel in Los Angeles, down on the ocean, and I said, "Well, listen, I'd just like you to know that you've got the part." And they didn't understand. I think they were in shock, to be honest. So we carried on the conversation. I went into my speech about how much hard work it is, and Francine nudged me and said, "I think you're going to have to repeat it. I don't think they understood they got the parts." So I repeated it – "You've got the part" – and it was kind of an *American Idol* moment, where they all jumped up shouting.

'Barkhad was superb. He was very thoughtful and had done music and had never acted, but I could engage with him as an actor. He really understood what I was driving at with Muse. He's dangerous because he's out of his depth. You never know quite what he's going to do. So a lot rested on him. It was a defining moment.'

Greengrass wanted to shoot all the scenes at sea straight through, at speed. 'It would have been very tempting to try and split up the filming and shoot it in little pieces, but very early on we decided that the only way to make the film was to get an actual ship,' he says. 'If we had a ship, we could do everything we wanted. That meant we had to shoot it much

THE GREENGRASS PAPERS

quicker than we ordinarily would because the ship was going to cost us a lot of money. One of the things I talked about in the film was you've got to have an overall sense of rhythm and intensity. You weren't going to drive it like that car in *The Bourne Ultimatum*. This was a different kind of drive because it was a ship, and the point was to start slowly and give ourselves a place from which to build. I was very determined that the film that I made after *Green Zone* was going to be as good as I could make it. Not that I didn't want *Green Zone* to be good, but it was like, "I need to get my A game on." That meant having a clear idea of what the film was going to be, doing the things that had always served me well, having an absolutely clear conception of what the film was and pursuing that at all costs, and not worrying about the politics of it. You get into that place where you're going to do good work. You're really focused on it. I wasn't tired. I was ready.'

Then, on day one of production, on 26 March 2012, in Boston, he choked. It was a simple enough scene: Hanks and his wife, played by Catherine Keener, getting ready to leave the house in the morning, which Greengrass shot in the traditional way, with dollies and tracks and locked-down cameras. At the end of the second day, he saw the rushes and called editor Chris Rouse.

'Have you seen the rushes?' he asked.

'Yeah, yeah, I'm putting them together now.'

'They're fucking terrible, aren't they? They're fucking terrible. What was I thinking of?'

Rouse was diplomatic. 'Well, to be honest, I did wonder what you were doing. I thought it was a choice.'

'A choice. A fucking *choice*? I might as well go and slit my wrists. What the fuck am I doing?'

Rouse rolled with laughter. 'It'll be fine. There's going to be something there.'

'Jesus fucking Christ. There had better be.'

Greengrass went back to his hotel and stewed all night. The next day, he went on set and said to the grip, 'See that dolly? I don't want to see it till the end of the shoot.' They were all looking at him, like, 'What's got

into him?' Then Hanks came onto the set. 'Okay, we're going to do the scene again,' Greengrass told him. 'Okay,' replied Hanks, and off they went. This time, the atmosphere was completely different, and within about an hour the fog had lifted. '"Okay," I thought, "we're rocking now,"' says Greengrass. '"This scene is cooking."' After about two hours, Hanks came and sat down next to him. 'Well, this is much more like it,' he said. 'For a moment, I thought I wasn't going to get the Greengrass experience. I was wondering what all the fuss was about.'

'Oh, mate, you haven't seen the beginning of it yet . . .'

After a few days' shooting in Boston, production moved to Malta, where the producers had secured the sister ship of the *Maersk Alabama*, the *Alexander*, with crew that Greengrass mixed in with his actors, as he had done with the air traffic control in *United 93* and the CIA hub in the Bourne films. 'We had a crew who were actually taking the ship out and bringing it back every day,' says Greengrass. 'So we had a deep reservoir of knowledge on the set every day.' The director rehearsed with each cast member individually so that they understood what they were doing in each scene, but only ran through its entirety minimally, just enough to get into the swing of things, but not so much as to dissipate any of its spontaneity. Then, at a certain point, he would say, 'Let's put the camera up,' Barry Ackroyd would throw it over his shoulder, and they would see what they caught. 'Now Tom had never worked like that,' says Greengrass. 'I have a picture of him standing on that bridge. "Okay, that moment's going to be there." "Right, I see. Yeah, okay." "Then this happens, and then actor X is going to come up. He's going to do that . . ." He was getting himself situated. At one point he turned and said to me, "This is scary shit." But oh, my God, the way he jumped into it. Respect for his courage.'

Hanks told NPR he stopped seeing the camera 'very, very quickly. You're never aware of when it's your shot. I don't recall thinking oh, now it's my close-up and so now I get to unleash all my bags of tricks here

because it's only going to be locked down on me. And this is where I get to throw certain looks or put a very particular spin on something.' Instead, they would do the scenes from beginning to end, however long they lasted. 'Sometimes they're 16 minutes and multiple cameras are used and they reload on the fly or another camera is put on the cameraman's shoulder once one rolls out. And so you ride the entire scene from beginning to end and then you regroup and then you go back and ride the entire scene again from beginning to end.'

A couple of times, after they had shot something on the bridge, Hanks went over to Greengrass and asked, 'Are you going to get that little bit over there by the charts?'

'We've already got it,' replied Greengrass.

'When?'

In the course of shooting the scene, the camera had snuck in for a close-up and then backed out again, without the actor noticing. 'It swivels around so every conceivable type of segment that Paul, I think, needs for whatever his vision is, is obtained without it being the sole focus.'

Always at the back of Hanks's mind was the looming confrontation with the Somalis. The director kept him and the Somalis apart until the day the pirates were filmed storming the bridge. 'We could see them out there in the distance working on their stuff and getting some second-unit stuff,' Hanks told NPR. 'Through binoculars you could see these very skinny people on these rickety boats. You know, "It's pretty calm today, they must be working." "It's pretty rough, are they still working?"' They knew the day was coming as it was on the calendar – they would be shooting the hijacking scene on Tuesday – and as they got closer and closer to it, everyone's heart started beating a little bit faster. 'We were up on the bridge and here they came. And I think there's three of us actually that are in the scene on the bridge, and it was tense. We were scared in the best way possible because we know the guns aren't loaded, but those guys were. They came in, you know, pumped up with all the anxiety of being there in the first place and all the expertise that they had learned, all the work that they had done. So when they came in – I have to say that when they first blew that door open and came in screaming at us, I

saw four of the skinniest, scariest human beings on the planet. And the hair did stand up on the back of our heads and it was chaotic, it seemed like the rules had gone right out the window. When Barkhad says "hey, I'm the Captain now," that wasn't in the screenplay. That just came out because we were riding the ups and downs of the scene that suddenly had no rules.'

Abdi, too, was greatly preoccupied by the scene in advance of shooting it. This was what he had auditioned for, so he knew that he had to make an impression. 'I remember I didn't sleep much that night just thinking about how I'm going to do it, how can I get it right?' the actor told *The Source*. 'Whatever plans I made didn't make sense to me. So I was still nervous when I came to the set that day and Paul told me there that I have to own him. I have to take control. You have taken over now, you are in control, not just play it, be it . . . So I understand, you know, I became the character and I let go. And then the line comes out: "*I'm the captain now.*"'

After the first take, Greengrass called 'cut' and applauded – 'Fucking well done.' After the fourth or fifth, the ice was broken – 'Hey, man, nice to work with you, what a pleasure. Wow, we finally get to meet'; 'I've been watching your movies all my life'; 'Is it cold in Minneapolis?' – and then it was straight back into it.

Sidney Lumet was sceptical when Al Pacino recommended his good friend John Cazale, whom he'd acted opposite in *The Godfather*, to play the part of his bank robber accomplice, Sal Naturale, in *Dog Day Afternoon* (1975). 'Al came to me and said, "Sidney, please, I beg you, read John Cazale for it,"' recalled Lumet in *Making Movies*. 'And when John came in I was so discouraged and thought "Al must be out of his mind." This guy looks thirty, thirty-two, and that's the last thing I want in this part.' Screenwriter Frank Pierson had envisioned the Sal character as a hand-some kid whom Sonny (Al Pacino) had picked up in Greenwich Village, describing him in his script as 'medium height, also good-looking in an

intense boyish way'. But Lumet knew Pacino had great taste in actors and he hadn't yet seen *The Godfather*, so he invited Cazale in to read for the part. 'Cazale came in, and then he read, and my heart broke. One of the things that I love about the casting of John Cazale was that he had a tremendous sadness about him. I don't know where it came from; I don't believe in invading the privacy of the actors that I work with, or getting into their heads. But, my God – it's there – in every shot of him . . . When Al asked him during a scene, "Is there any country you want to go to?" Cazale improvised his answer by saying, after long thought, "Wyoming." To me that was the funniest, saddest line in the movie, and my favorite, because in the script he wasn't supposed to say anything. It was a brilliant, brilliant ad lib.'

Quieter and more sensitive than the bombastic Sonny, Sal can't quite believe that he's a bank robber or that Sonny will kill anybody; he softly explains to one of their hostages that she shouldn't smoke because of the risks of cancer. Abandoned by their third accomplice after he gets 'bad vibes', surrounded by the police and TV cameras, Sal and Sonny never seem remotely in charge of the situation they have created, but their desperate, end-of-tether energy hooks the audience right in. Greengrass wanted a similar air to attend his doomed-to-fail Somali pirates, behind whom stand their local warlords, propelling them forward.

'*Dog Day Afternoon* is a brilliant film, absolutely brilliant film,' he says. 'You look at it in detail, and it becomes about so many more things than just a bank heist. They have such ridiculous ideas about how they're going to pull it off and they're going to get a plane and they're going to go to Cuba. Because obviously they're never going to be allowed to, and the audience knows that, and deep down Sonny probably does too. The way that they're never really in control of the events that they have planned. *Captain Phillips* had something of the same theatricality to it. I definitely pushed it that way. I said, "If you think of this as a bank raid, there's always a driver. He's not necessarily the same as the muscle. So one hijacker is the driver; the other guy with the funny eye, he's the muscle. And then there's the kid, the little boy, and there's the leader." And that was my conception of the four characters. That's what I worked

for on the page. But they were very, very quick on the uptake, those four young men.'

What excites Hollywood, traditionally, are contests of power, resolved with violence, but what stimulates Greengrass, for all his smash cuts, racing cameras and propulsive soundtracks, is the *transfer* of power – the tipping point at which hunter becomes hunted, predator prey. The taking of the bridge in *Captain Phillips* is very like the storming of the aisles by the passengers in *United 93*, or the moment the shooting starts in *Bloody Sunday*: it amounts to a small revolution of sorts. The bridge is *seized*, not given. 'I'm the captain now,' says Muse (Abdi), and the line resonates because it is simple yet expresses a complex set of truths. It is an assertion of power by a single pirate fronting a quartet of armed men against a crew of twenty; it is an assertion of sovereignty by a country, Somalia, whose waters have been overrun by too many interlopers over the years; and finally, it represents an assertion of confidence by an actor, Barkhad Abdi, attempting to quell his fear at confronting a global megastar, Hanks, whom he had long revered from afar. He could almost be the Excluded World standing there, staring accusingly into the eyes of the West.

With his skeletal head, wild eyes and khat-stained teeth, Abdi is unlike any Somali we have previously seen in a mainstream American film – dangerous and streetwise, but also young and childishly curious about the Americans in his charge. He wants Phillips to know who he is; he's not just some punk with a gun, and the humanisation hits you with a jolt. In Billy Ray's original script, he was 'a rail thin killer' who sings off-key war songs and prays to Allah: 'Muse looks up from his prayer, his eyes lifeless.' There is nothing lifeless about Abdi. He exudes menace, but he also looks starved; his tall, spindly frame seems like a frail counterweight to the heavy rifle he carries, and his ruthlessness is born of economic desperation. He is there because his warlord demanded it. He doesn't want anyone to be hurt, and the ransom he puts on Phillips's ship – $10 million – seems touchingly naive.

'The film doesn't soften the fact that the four pirates who attack the *Alabama* are brutal, desperate young men – but, unlike much news coverage, it makes us aware who they are, and what's behind their contempt

Greengrass at work aboard the *Maersk Alabama*'s sister ship.

for the powerful nations that they're nevertheless mesmerized by (the hijackers' leader Muse is convinced he can buy himself a ticket to a new life in the United States),' wrote Jonathan Romney in his review of the movie for *Film Comment*. 'These renegade fishermen are bitter at seeing these monolithic American ships sail along their coast and feel their profession has been destroyed by wealthy countries fishing their waters. This is a story about globalization and its discontents.'

The mid-section of the film is a magisterially tense bout of cat-and-mouse, with Phillips and his men exploiting their knowledge of the ship to keep the pirates from taking full control of it. A waiting game will win this fight, for the Navy has been alerted and help will eventually arrive, unless the Somalis can get the ship moving again. Plying the pirates with sodas and leading them on a wild goose chase as they hunt for his crew, who have hidden themselves below decks, Phillips gives away crucial tactical information to his shipmates – numbers, weapons, positions – while looking Muse straight in the eye. 'Rich had this fabulous lie and truth that he kept telling them at the same time: "I don't know, I'm here with you,"' Hanks told NPR. 'You know, they would ask questions, "where is

your crew?" "I don't know." He did know where they were. That was a lie. But he'd also say, "I'm here with you." "What's wrong with your ship?" "I don't know. I'm here with you." "What's happening?" "I don't know. I'm here with you.'"

During preparation, Greengrass and editor Chris Rouse talked a lot about the geography of the sequence, and as they passed through the ship, they tried to choose shots and moments that told the story and acclimated the audience as best as possible to each environment. As Muse, Phillips and his sidekick Bilal get closer to the engine room, the sound becomes an important dramatic device, as the crew hear them approaching. Finally, the pirates take Phillips hostage, escaping in one of the life rafts, which bobs like a cork upon the waves, pursued by an aircraft carrier, two warships and a contingent of Navy Seals. For the scenes inside the vessel, production moved to Norfolk, Virginia, where a simulacrum of the bullet-scarred, five-ton fibreglass lifeboat was floated in a tank. The intensity of the shoot was unrelenting: guns, hostility, fighting, shouting, all at sea, the horizon heaving, or trapped inside in Norfolk, unable to look through a window. Many of the film crew got seasick, although Hanks and Abdi somehow escaped it. Cinematographer Barry Ackroyd's hands sometimes quivered with the effort of getting the camera into the position he wanted.

'It was an incredibly small space,' recalls Greengrass. 'Barry literally used to get himself into places I never thought we'd get the lens, get the movement and intensity. We shot some of it out on the ocean itself on that lifeboat, and when you go in that lifeboat, oh, my God, because the smell, the movement of that lifeboat, it's turning on its axis and rotating and pitching. Your inner ear goes in about thirty seconds. So the first day we started shooting, we kept having to stop because people got so sick, just profoundly sick. I wasn't on it; we had a little boat that was next to it. So I can hear it, and then Barry's saying, "Oh, Christ. I feel so ill," and then somebody threw up all over Barry's legs. I mean, it was just horrendous, horrendous, the physical challenge of shooting that thing. You could feel it on the set. It had great intensity, that film. To this day I remember the scene between them, where Barkhad goes, "Only in America, Irish. Only in America."'

Rouse's editing in the final act of the film is a masterful display of ticking-clock tension, ratcheted up to heart-stopping levels for a good forty minutes. But even as the movie's rhythms quicken – with smash cuts, racing cameras and a percussive soundtrack – a uniquely Greengrassian ambivalence materialises: we want the forces of the American military to prevail, but equally, we feel a certain dread at how blind the pirates appear to be to their looming fate. 'It was important that the build at the end to Phillips' rescue didn't let the audience off the hook for a moment, so the setup, development, and payoff of that sequence had to be well considered,' said Rouse. 'That sequence begins very procedurally, very deliberately, as the SEAL Commander sets his plan in motion. As the plan unfolds and the lifeboat is drawn closer to the snipers, the tension builds in a fairly methodical way. But once Phillips jumps out of his seat, chaos follows – everything changes and becomes more urgent – the actions of the characters, the nature of the cuts, the intensity of the music . . . It's only afterward that the audience has a chance to reflect on what's occurred.'

At the end, says Greengrass, 'although it's a very satisfying film because Phillips gets away and the bad guys suffer, there's a muted sense that all of this explosion of power hasn't changed anything, because in the end, it's just four kids who paddled out and paid for their crime. But the big ships are going to continue to go past the poor parts of the world. So when you pull out on that big, wide shot at the end, I think you have that sense that you have seen a little encounter that's endlessly to be replicated and illuminates the much larger forces at play in our world.'

Tom Hanks loves procedure. His movies are famously rich in MacGyver-ish feats of *in extremis* ingenuity by which his characters survive the hostile environments in which they find themselves: the mirror fastened by a stick of gum on the end of a knife that allows him to look around a corner while storming the beach at the start of *Saving Private Ryan*; the carbon dioxide filter, fashioned from plastic bags, spacesuit hoses and

grey duct tape, by which the Apollo 13 astronauts make the air on board the Lunar Excursion Module breathable again. More than just digging into the background to flesh out the particular profession he happens to be playing, it is Hanks's immersion in procedure that is the key to his performance in *Captain Phillips*, for it is Phillips's knowledge of his own boat that enables him to turn the tables on the hijackers. Once inside the lifeboat, the actor does an extraordinary job of balancing mortal terror with sympathy for his hijackers, whose looming fate he senses before they do, all the while looking for a chance to escape. But what propels Hanks's performance to the top of the league – making it his best since *Saving Private Ryan*, and according to some, his best ever – are the movie's final scenes, showing Phillips decompressing from the extremity of his ordeal. Most kidnapping movies have a cathartic final scene in which the victim reunites with their family, but with Phillips's wife not a major part of the film, Greengrass and Hanks had to fashion a catharsis from the elements they had. They had limited options. In his book, Phillips described the effects of what was clearly a case of PTSD in the days and weeks following his release. The first two nights after getting off the lifeboat, he found himself waking up at 5 a.m., crying his eyes out, something a New England sea captain doesn't do too much. It was only after one of the Seals insisted he talk to a psychologist, who broke it down for him in terms of chemicals in the brain, that he finally began to understand what had happened to him. 'He said, "Don't fight it. Let it flow. Let it flow as long as it goes,"' wrote Phillips in *A Captain's Duty*. 'And so I followed his advice and I let it flow. I just sat there in my bed and I probably cried, bawled like a little kid for, I'm going to say two minutes. And then it ran its course, I dried up. Then I threw water on my face, I took a shower and started my day with my coffee. And I never had a problem after that.'

Greengrass had a scene in the script that corresponded to that reaction, in which Phillips attempts to ring his wife from the captain's cabin of the USS *Bainbridge*. He's been cleaned up and given a uniform, a beer and a phone, but he is unable to make the call and instead breaks down. Hanks worked from actual photographs and a bit of home video of Phillips on board the *Bainbridge*, in which people are congratulating him and saying,

'Welcome home,' 'and he's in an absolute daze. You can see in his body language and in his eyes he's barely cognizant of the surreal realities that have just happened to him.' They were shooting on a warship off the coast of Virginia, and because it was a working destroyer, they had very little time – just ten days. This particular scene was the last on the schedule and they had only a day in which to get it, but it was an important one. 'We shot that scene up and down,' says Greengrass. 'The captain's cabin was two rooms, a bedroom and a study. Was he in the study standing up next to the television? Was he sitting down at the desk near the television? Was he standing in the corner? Was he lying in the bed? Was he sitting on the bed? Tom is giving his all, trying to give this moment its due, and it's not real. We couldn't put our finger on why it wasn't working. It wasn't anything that he wasn't doing. It's just there was something not right. And it was pointless to talk about it because you start to talk about it, it becomes inhibiting, and that makes the problem worse. But you know, both of you, that it's not working. And the hours tick by, and it's like stones in a bucket. There's nothing in it. And I'm thinking, "This is a disaster." We've come this far, we've got such good material that we have to finish. It has to come good, the film.'

Greengrass ran through the mental checklist he uses when he gets into trouble. Is it how he was shooting it? Is it where they're situated? Are they coming to the moment too early? Too late? Is the moment itself wrong? Would it be better if they didn't have it? 'It's like diagnosing a fault in the car,' he says. 'You just got to run through your checklist and try each of them. Well, we'd done all that, and I was running out of places. And then finally, it's like, okay, last roll of the dice.'

It just so happened that on the set that day watching the scene was the captain of the *Thruxton*, a sister ship of the *Bainbridge*. 'Where would you have taken Phillips when he first came on board?' Greengrass asked him.

'He would have been a mess, so they would have sent him down to the infirmary,' replied the captain.

'Well, let's go see the infirmary. Where's the medical unit?'

'Well, it's at the other end of the ship.'

'Can we film there?'

'Sure. Yeah. If there's no one in it. I mean, I'll check.'

He went off to do so and quickly came back. 'It's fine. There's no one in there. I mean, there's the stand-by crew, the medics.'

It was a big gamble. They didn't have much time left, and moving a crew from one end of a ship to the other, through tiny corridors with bulkheads every 12 feet, designed for one person only, was insanely difficult. 'We could just about do it,' Greengrass calculated. 'If we did our very best, we might get a take or two down there. Who knows what those medics are like? But you're in a corner. You just go, "Fuck it." You know, gamble. "Go. Let's go, let's go. We're going, everybody. We're going to the medical unit. We're going now. Carry whatever you can." Barry's got his camera. I say to Tom, "Okay, this is what I want to do. I want to play a different scene. It's the scene where you come in. It would have been literally contiguous with the shot that we did in the morning of you coming onto the ship. Do you remember that? You remember that."'

After Hanks made a quick costume change back into his yellow T-shirt and underwent a full make-up session to get him all bruised and bashed up again that took forty minutes or so, they all raced down to the infirmary and found the actual medical crew there: a man and a woman, Danielle, who was the chief medical officer. There wasn't much time left, so nobody was able to think too much. 'Do you mind if we do a scene here where Captain Phillips is brought in just after he's arrived onboard?' Greengrass asked them.

'Sure,' they replied. 'What, just us?'

'No, no, no. Tom Hanks will be coming in . . . but don't worry.'

Danielle blanched. 'Tom Hanks?'

'Yeah, it'll be fun. Just look, just be professional. He's just a patient. He's come in; you just respond as if this was a training exercise, except it's got Tom Hanks in it.'

She looked at him as if he were demented. Greengrass asked her, 'Well, what would you do?' recalled Hanks. 'And she just ran through, "Well, I'd try to get his focus. I'd try to talk to him. I'd try to find out how badly he's wounded. I'd try to figure out what blood is his, try to figure out if there's any internal bleeding. I'd take his vital stats." She had a whole

procedure, you know, equal to an emergency medical technician. And so we just cranked it, let fly. It fell apart. The very first take fell apart for technical reasons, and also because it was loaded with moments of great self-consciousness, even from the Navy folks. And so they said, "Sorry, sorry, sorry, sorry." And we said, "Look, do not apologize. There's no such thing as sorry. This happens all the time. We stop scenes. Don't feel like you've committed anything wrong. We'll just get up and do it again and just follow through. And there's nothing you can say that is incorrect, and there's nothing that you can do that is not going to be worthwhile. So just go ahead and do it." And we did a couple of other versions of it over, you know – I don't remember much of it – a dizzying period of time. As far as behavior goes, I did not know specifically what was going to happen, but I felt as though I had a good line on what would come out of my side of that was Richard Phillips having witnessed and experienced some terrible things. And on top of that, it was, you know, a very nice lady and a very crack team being sweet to Rich Phillips. She says something that is just heart-rending, which is that "You're OK . . . you're going to be OK." And those are the greatest words that a human being could hear in that circumstance.'

The medic messed up her first take, but Hanks guided her through it, reassuring her that she knew what she was doing, telling her he was nervous too. This was followed by a take that went off into the stratosphere. Greengrass remembers tearing up. 'You remember the guys who walk around carrying cleft sticks to find the water? Okay. That's what actors do, in my view. They do it not for the water, but for the truth. When they feel that, when they hit the truth of it, it goes *boing*. And they can feel it. And that's what he felt. And that's why when you direct films, you should, in my view, always be asking the actor, "How'd that feel? Right?" Don't tell them what to do; ask them how they feel. The summation of that film really, for me, was that he felt it. And when he felt that the truth was there, the next take, he walked right through that door and explored the fuck out of it for those five minutes, in a way that was so immediate and so truthful and so vulnerable, and it was genius. And afterwards, one of the medics came to me and said, "Do you know his pulse was running

at such-and-such to such-and-such during that?" I mean, it was like he was physically manifesting what his symptoms were. He was very in the moment. He is a supreme actor because of his ability to access truth. The truth of human behaviour is absolutely unparalleled. I caught him at the height of his powers.'

The captain of the *Thruxton* was watching the scene next to the monitor. Greengrass looked over at him at one point and saw he had tears streaming down his face. The captain took off his headphones and said, 'I've seen a lot of trauma in my time, and that's exactly what it looks like.'

One of the first people Greengrass consulted after deciding to make *Captain Phillips* was his father. Phillips reminded him a little of his dad, who, after the London docks closed, gave up working on the Thames and became a marine pilot. 'I think pretty much when I was on the plane coming home after doing it, I remember thinking, "Oh well, of course now this is going to be a film about my dad." One of the reasons I made it was very personal. He's very old now, my dad, but he was at sea all his life. I grew up in that marine life as a kid. I wanted it to be about a man reaching the end of his working days, played with a poignancy, I think, and also a sense of change. My dad had faced that. The merchant navy declined in the 1950s. The docks closed on the Thames, and he had to join the sea pilotage. People are driven forward on the winds of change, like corks on an ocean. Phillips felt that for sure; it's in the book. You can see it. You only have to meet him to know that. So we've got this character who's a cog in a wheel of an enormous global industry, but he's getting to the end of it. And now he's going to face this unprecedented challenge. So we talked about that a lot. Let's not be afraid of our ages, because there's a courage in facing up to that.'

Then in his late eighties, Phillip Greengrass lived alone in a tall house in Felixstowe overlooking the sea, with a small bedroom laid out like a ship's cabin. When his son visited in 2011, Phillip showed him his sextant and his logbooks, filled with all the destinations he had visited – Brazil,

Ghana, Argentina – and letters home to Greengrass's mother, Joyce, while he was at sea. 'They're quite extraordinary, in so many ways. On one level, they're extraordinary because there's pages and pages and pages of things that she would have had absolutely no interest in whatsoever. Just on the level of emotional intelligence, why would he be writing to her about the philosophy of Spinoza on a fucking ship going to Buenos Aires to deliver copper or whatever it was he was delivering? There would be pages of it. The Alsace question in European politics, there'd be six pages on that. At only one point in the letters did I find a reference saying, "I can see I'm talking at you, not to you . . ." I'm thinking, "Well, there you go. That's my dad." He was alone so much. Somewhere, this nonconformist streak and this extraordinary mind, alive to and open for the world, became closed. It's a mystery. I always ask myself, "Was he always like that?"'

Relations had become strained by his father's drift towards the right, politically. On a good day, he might talk about the past, and his mood would be mellow and his conversation reasonable, and Greengrass would find himself admiring his fierce convictions even while disagreeing with them. Occasionally he expressed regret – for a life spent away from his family, for his temper, for things left undone. Greengrass would tell him that he'd done very well, that they all loved him and that he had given him the great and precious gifts of nonconformism and independence of mind. On this occasion, visiting him in 2011, he was struck by how similar their paths had been. 'First of all, I've always travelled a lot and spent a lot of time away from my family, recklessly so in my twenties, to my bitter regret, in terms of the two older children. And then again on *Bloody Sunday* and *The Bourne Supremacy*, I was away too much and I didn't like it. I knew deep down I didn't want that life. I have a tendency to overwork, but thanks to Joanna, I was able to check myself, and we were able to navigate our way through it. Those were discussions I had with my dad. It was a period of time when I did talk to him about the past quite a bit. And he would say, "I was a bloody fool. Why did I spend so much time away?" But then in the next breath he'd say, "But I really had no choice. It was the only job I could do. It's the only thing I knew how to do." So we talked a lot about separation.'

One of the unusual aspects about the life of a merchant mariner is its isolation. Greengrass saw it in his father's logbooks and he saw it in Richard Phillips too. 'The merchant marine is different from the navy or the army in that you don't have a crew or a battalion that's grown to know you over several months or even years,' writes Phillips. While making the movie, Greengrass had many moments in which to ponder the similarity between the essentially solitary life his father had chosen and the one he had. 'Seafaring is very like being a film director. You might have a couple of people you know, but by and large, it's a new crew every time. Some old familiar faces, but by and large, not. He has been on film sets. I remember bringing him down to the Bourne set. I've got a photograph of him sitting with his headphones on, finding it tremendously interesting. He thinks the finest film I ever made was *Green Zone*. He was very, very opposed to the war. He loves the Bourne movies because he totally buys into "They're up to no good." I remember him having long conversations about them. "Oh, that's marvellous. It's Perseus, it's the Greek myth. It's Oedipus, searching for the secret of your birthright . . ."'

When the 2014 Oscar nominations were announced, *Captain Phillips* picked up six: Best Picture, Best Adapted Screenplay, Best Supporting Actor, Best Film Editing, Best Sound Mixing and Best Sound Editing. Incredibly, Hanks missed out, his relationship with the academy a curious mixture of reward and neglect, having won twice in the early nineties but thereafter been kept from the podium by the sense that he's been 'done'. The film took $107 million at the American box office and $111 million internationally. Greengrass's ability to fashion an American film, celebrating an American military success, but without making it obnoxiously America-centric, had paid off. 'I was very pleased with the film,' says Greengrass. 'It laid to rest a lot of the ghosts of *Green Zone*.'

It was a great source of pride to the director that he was able to take his father to the film's premiere in Leicester Square, where it opened the 2013 London Film Festival. 'He wore his medals. By then he wasn't walking very well, but he came and had a lovely time. Tom [Hanks] was absolutely delightful and made a big fuss of him. But I remember I made a speech in which I basically said something to this effect: "Making this

film has made me realise more than I normally do how I am my father's son. Because when you make a film, you have a crew and you have a map – it's called a script – and your job is to get the cargo to your port of destination safely and on time. That's your job. And you have to deal with the weather and all the things that you deal with. That is really what a film director does. It's very analogous to what my dad did. And I just want to pay tribute to that." When it was all over, he said, "What the fuck was all that all about? I did a proper job. It was proper hard work. None of this fannying about on a film set – real work."'

11: TECHNOLOGY

Jason Bourne died in the same place he was born; Nixa, Missouri. It had changed a lot in the twenty years he had been away, with lots of construction and gleaming new buildings, but he had no difficulty finding the old orphanage. A hundred-years-old, half-demolished, broken and abandoned old red-brick building, the orphanage stood in its own grounds, soon be turned into a gated community. Entering the old dormitory, containing nothing but beds, Bourne hears his fellow assassin, Paz, enter behind him and turns.

BOURNE: . . . in St. Louis you switched from the silver Toyota to the black Mustang, bought that stupid cowboy hat at the gas station in Lebanon, took it off at the city limits here, put on a baseball cap when you parked, reversed your windcheater at the last corner, put the hat on.

Paz sighs and reholsters his pistol. Bourne plants his feet, and make his move, his right hand sweeping aside his coat, pulling what seemed to be a gun. Paz shoots Bourne only to realise he had been reaching for a photo of Marie. Bourne is flung on his back. Paz comes to him and takes the photo out of Bourne's hand. He looks down at Bourne, who is a few seconds from death, blood pooling from a shot to the heart.

PAZ: Why d'you do that?

Paz drops the photo onto his body, then walks away. At the door he looks back, still bothered by something. He'll find out one day.

So went the final pages of Tom Stoppard's draft for *The Bourne Ultimatum*, commissioned but not used by the film-makers except for scrap metal. But when Universal producer Frank Marshall and screenwriter George Nolfi met with the director at his home in Henley in summer 2008 to talk with him about a fourth Bourne movie, they quickly arrived at the obvious: *Bourne had to die.* In Stoppard's draft, his death is preceded by that of Nicky Parsons, after a shoot-out in a movie theatre in downtown Washington that is showing *The Magnificent Seven*. Nicky is caught by Noah Vosen's bullet and dies, prompting Bourne to kill Vosen. He then returns to Nixa, Missouri, where he is confronted by Paz.

'The question then was, at the end of *Ultimatum*, you've had your first three films,' says Greengrass. 'We've done it perfectly. We've resolved it. He's remembered everything.' The breakthrough came when they remembered that Bourne was just a nom de plume, an assumed identity, and could therefore survive the death of the person who had taken it on. 'The movie that I wanted to make was the movie where Bourne dies and passes the identity over to a new Jason Bourne. That would have been a really interesting film to have done because he's got his identity back. He knows he's David Webb. So that's the beauty of it, when the audience knows suddenly that he is just a man, which is what he's always been, not a superhero, and he's going to hand the baton over to the next generation. Do you set that film up as those two fighting, and then finally they realise they're on the same side? Or does he come in, in a cameo, at the end? I mean, anywhere between those two poles you could have put that film.'

The problem was the Ludlum estate hated the idea. At the end of January, they sent their notes, specifying that 'Jason Bourne/David Webb dying at the end of the film is not acceptable to us.' Moreover, following the success of *The Bourne Ultimatum* in 2007, Universal had signed a deal with the Ludlum estate, engineered by the author's old accountant, Jeffrey Weiner, who took an office on the Universal lot as part of the deal and hired executives to take an active hand in developing projects based

on all of Ludlum's books. In exchange for exclusive rights to the Jason Bourne character, as well as a first look at any Ludlum book – including such barrel-scrapings as *The Matarese Circle*, *The Chancellor Manuscript* and *The Sigma Protocol* – the Ludlum estate for the first time got contractual approval on screenplays, characters and actors for the new Bourne films and put the studio under enormous pressure to make a movie every couple of years or else lose control of the franchise.

'In my opinion, it was a dumb deal,' says Greengrass. 'To be fair to the studio, Universal had no choice. They were being squeezed by the Ludlum estate, so they responded to pressure by buying all the Ludlum properties and all the crap that the estate had developed off the Ludlum books. Universal bought them all. Years later, there was very little to show for it, and the crown jewel, the Bourne franchise, was all messed up. I blame the estate. They took something that the studio, Doug [Liman], Tony Gilroy, Frank, myself, Chris Rouse and, most of all, Matt [Damon] had built over three fantastic films of increasing urgency and certainly increasing commercial success – a fantastic opportunity to create a franchise – and drove it into the weeds. I used to sit and talk to these idiots at the estate and say, "Unlike James Bond, where you've got to recast the character, you've actually got a story where the identity is separate from the character. All you need to do for your fourth film is create a character who assumes the identity of Jason Bourne, and David Webb dies either in order to stop him gaining that identity – difficult – or, better still, to ensure that he passes the torch on." If we'd done that, I think we could have got a much stronger franchise, because you could have killed him and have him reborn at the same time. That would have been fantastic.'

At a meeting on 12 February 2009, Universal's Donna Langley reiterated to Greengrass that the estate did not want David Webb to die on camera because he was tied to Bourne, and they did not want to preclude the return of Matt Damon to the franchise. What about if he *appeared* to die? Marshall, Greengrass and Nolfi all said they knew Damon didn't want to 'appear to die', as that had happened in the last two films. The argument continued through September and October, with Langley doing her utmost to see if they could find a way through. One day, while

catching the Tube at Oxford Circus, Greengrass saw a poster promoting movie-going that featured Damon's Bourne and underneath him the words: 'I remember everything.' 'I was feeling pretty anguished about it, and I came around the corner and suddenly there was a big Bourne poster. It was sort of surreal. And I'm looking at this thing, going, "He's remembered everything. It's over. What are you going to do with another Bourne film?" That poster made it crystal clear to me. I was like, "This is nuts. If we can't kill him, I'm not doing it."'

In early 2010, Greengrass wrote a memo to Marshall, in which he stated, 'The only one I'm interested in making – and the only one I can guarantee for 2011 – is the storyline I pitched last year.'

The estate still refused to budge, and Greengrass was forced to walk away. 'I don't blame the studio at all,' he says. 'They tried their very best, but the estate had them by the short and curlies. Their leverage always was, if you're not in production with a film after X years, then you lose the rights. They could control the killing of Jason Bourne. That was the one thing they could control. And they wouldn't do it. They got obsessed with this idea of, like the *Star Wars* universe and the Marvel comics, they were going to have other Jason Bourne-type characters. They were obsessed with "the wider Bourne universe": characters in the Bourne world whom they could spin off into other movies, instead of concentrating on what made the Bourne franchise unique, which was that it was an unfolding story. That was 100 per cent wrong for Bourne, just as it would have been for Bond – you don't have Miss Moneypenny movies. And that's what *The Bourne Legacy* became, because suddenly there was this other Jason Bourne who wasn't Jason Bourne, and it all helped to cheapen it all. And the very thing that was cool about the Jason Bourne world was destroyed for ever. They were so fixated on milking the golden cow that they forgot to lay down the plan for tomorrow. It shows you how a great franchise can be fucked.'

With Greengrass gone, top Universal executives Ron Meyer, Adam Fogelson and Donna Langley flew to New York and took Matt Damon

out to dinner. They explained that they still wanted to move ahead and that he could have any director he wanted, but Damon held firm. 'I always said I wouldn't do it without Paul,' the actor told the *New York Times*. 'I would never feel comfortable doing this with anyone but him.' Facing a contractual deadline with the Ludlum estate to produce another film, Universal then turned to Tony Gilroy, who said he had an idea for a spin-off script, this one focusing on another black-ops agent, Aaron Cross, but leaving the door open for Damon's character to return. No one from Universal informed Damon that Greengrass was being replaced by his old adversary. The actor was in Vancouver in July 2011, filming the sci-fi thriller *Elysium* with South African director Neill Blomkamp, when he stumbled upon the production offices of *The Bourne Legacy* and found himself surprisingly hurt. In an infamous article for *GQ* that December, the actor let rip: 'It's really the studio's fault for putting themselves in that position. I don't blame Tony for taking a boatload of money and handing in what he handed in. It's just that it was unreadable. This is a career-ender. I mean, I could put this thing up on eBay and it would be game over for that dude. It's terrible. It's really embarrassing. He was having a go, basically, and he took his money and left.'

It was a rare outburst from a normally well-mannered actor, one that testified to his sense of betrayal, and he quickly apologised for it before the magazine went to press. 'If I didn't respect him and appreciate his talent, then I really wouldn't have cared,' he said. 'My feelings were hurt. That's all. And that's exactly why I shouldn't have said anything. This is between me and him. So saying anything publicly is fucking stupid and unprofessional and just kind of douchey of me.'

Sometime towards the end of 2013, Langley took over as head of Universal and started talking to both Damon and Greengrass almost immediately in an attempt to repair some of the damage. In March 2014, Jeff Shell, in charge of Universal's filmed entertainment, asked to meet with Greengrass, telling him they wanted him back: 'I'm not saying do a Bourne movie,' he told him. 'Do anything you want, just come back.' Shell had a similar meeting with Damon, and later that month, the director and the star had lunch in LA and discussed reviving Bourne.

Greengrass was still opposed, but year after year of people coming up to Damon in the street, in the coffee shop, at the airport, urging him to make another Bourne film, had had an effect on the actor.

'The truth is audiences really want another Bourne movie,' said Damon. 'Why wouldn't we give it to them?'

'Well, they might not if we give it to them and it's bad,' replied Greengrass.

'But that's not the point. They want it, so why wouldn't we spend a year or eighteen months of our lives trying to give them the best one that we can think of?'

Greengrass wasn't persuaded, but Damon's argument stuck with him, and he was struck by the actor's loyalty. 'It had a big effect on me,' he says. 'You feel a bit of a heel. Loyalty goes two ways. He never said that to me, by the way, but that resonated.'

Greengrass approached his long-time creative partner and editor Chris Rouse, who started work on a pitch document that featured a female Russian spy named Olena. Suitably impressed, the studio hired him to write a draft, while in the meantime Greengrass continued to talk to Damon. 'I said, "Look, if we really want a bold new take after a long time away, then don't make it with me." Because you're not going to change Matt and you're not going to change Chris, because those guys had already started. "So what you need is somebody a bit like me when I came on to *Supremacy*, somebody who's not done one before who can reinvent it and do things that you all think are kind of intense and out there. I don't know what they'd be, but he or she will have fresh eyes on it all."'

In early summer 2014, Rouse delivered his draft and began batting ideas back and forth with Damon. 'I began to feel like I was the only one holding out,' says Greengrass. 'It was the summer, and I got a little nostalgic. I remember saying to Joanna, "This is weird. I'm getting nostalgic for a Bourne movie. What's happening to me?" I think it was probably because Matt and Chris were moving ahead, so you think, "Why am I holding out?" It wasn't a very comfortable position, feeling, on the one hand, that you were being unfair for holding out, and on the other, a

little bit of you was going, "I don't want to miss the party." I had FOMO, is the truth of it. Towards the end, I remember it just felt like I was letting the side down at some level. So you think, "Why am I stopping all these people doing this? Maybe it won't be as good, but it's not an ignoble thing to serve your audience, do the best you can." And I agree with that really in the end. Of course, you're always going to be paid handsomely and all that; it's pointless to pretend that's not part of it. But that's the only film where that's been a part of it.'

In the end, it was a quick decision. A few weeks later, while on holiday in France in July, the director woke up one morning and thought, 'Oh, fuck it. Let's just do it. It'll be eighteen months. What's the worst that can happen? It won't be as good as the previous two, but we'll give it our best shot.' He phoned his lawyer, Carlos Goodman, and said, 'This is a phone call you never thought you'd get from me . . . Let's do a Bourne movie.'

There was a long pause, and then Goodman said, 'Okay, let's do it.'

―――――――――

'The main problem we have to solve is: Why are the CIA still chasing JASON BOURNE, nine years after we last saw him, swimming away down the Hudson?' Greengrass wrote to Donna Langley and Frank Marshall in October 2014. From the beginning, it was clear that Bourne had to return to Washington and find the remnants of Treadstone lurking. Money movements or a list of assets would lead Landy to them and within the first fifteen minutes she would be killed. From October through December, Greengrass and Rouse swapped ideas about what could go into a fourth Bourne film: the world in flux, people feeling disenfranchised, the dominance of social media, the rise of the surveillance state and how you balance personal rights against public safety. 'First and foremost a Bourne story has to be about him and therein lies the challenge,' said Rouse. 'You've got a guy, looking in his rear view trying to understand aspects of his past, so he can reconcile his present and figure out how he is going to attend to the future. Before we did anything else, we had to determine what would be the most compelling narrative and

through line for him and then begin to craft everything else, the other characters, the B and C side stories and how they would inform, either directly or metaphorically, a Bourne journey.'

They agreed that Bourne should meet his father, who should be a political powerbroker of some sort, a senator or someone in the political realm, rather than a CIA man. At a certain point, Greengrass read *The Good Spy*, a biography of Robert Ames, the CIA's Middle East expert, who was killed in the bombing of the US embassy in Beirut in 1983. 'Ames was thought to be a kind of [Yitzhak] Rabin figure, someone who could have helped fashion a Middle Eastern peace but who was killed by radical elements – what became Hezbollah. That is what first gave me the notion of Bourne's father being an Ames-type character.' Briefly, Greengrass thought of casting Warren Beatty in the role, thus taking the Bourne series back to the conspiracy thrillers of the 1970s, like Beatty's *The Parallax View*, which had been one of its original sources.

'Beatty opened up space for film-makers like me,' says Greengrass. 'I'm sure he would have been a nightmare to work with, but he opened up space in a profound way for people to do their thing, whether it's Gordon Willis or [Alan] Pakula or any of those other guys. He was a fantastic producer and a bridge from old Hollywood to new, because the thing about Beatty was that he was also a political activist. He was very involved in the [George] McGovern campaign of '72. He was a figure, for me, who knitted together the real world, the movie world and the representations of both, in that way that I've been interested in, and it wasn't by accident. He had a restless desire to make those connections, in a way that they'd never been made before, at a time of convulsive change in American politics and American cinema. He was a brilliant actor and a fantastic producer. Looking back, I regret that I didn't go that way.'

The idea of a collaboration didn't come to anything, but the interface between national security and corporate interests, first explored on film by *The Parallax View*, in which state-sanctioned assassination is outsourced to a private company, seemed newly relevant in the era of WikiLeaks, Julian Assange and Edward Snowden. Greengrass's eye was caught by an article in *The Verge* about a keynote address given in August

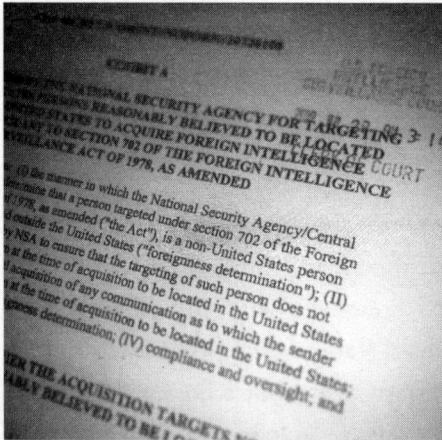

Excerpt from the NSA documents leaked by Edward Snowden.

2012 by General Keith Alexander, the head of the National Security Agency and US Cyber Command, at DEF CON, the world-famous hacker conference in Las Vegas. Dressed down in T-shirt and jeans, and wearing a 'warm, disarming smile', Alexander appeared on stage to address thousands of security professionals, hardware hackers and other computer miscreants during the annual gathering at the Rio hotel. The NSA even had a booth in DEF CON's vendor room and a special recruitment website set up specifically for the conference's attendees. 'Sometimes you guys get a bad rep,' Alexander told the crowd. 'From my perspective, what you guys are doing to figure out vulnerabilities in systems is absolutely needed.'

'Then stop arresting us!' one heckler in the audience replied. Another carried a small cardboard sign that said 'Bullshit', to be used for just such an occasion.

As part of his research, in March 2015, Greengrass visited the offices of AI developer DeepMind in London's King's Cross, at the invitation of its founder and CEO Demis Hassabis, whom he'd met at Queens' College, Cambridge, at a dinner for honorary fellows. A chess grandmaster as a child, Hassabis went to Queens' aged fourteen, made his fortune with his own video-game company by the time he was twenty-one, then decided that he would dedicate his life's work to designing artificial intelligence – a machine that could learn from its mistakes the way a human mind can – and brokered a $720-million deal with Google to set up a group to do just that.

'The whole DeepMind building was staggeringly young,' says Greengrass. 'Everybody was writing equations on the walls.' Leading the director around the open-plan offices, Hassabis showed him deep fakes of Matt Damon that seemed indistinguishable from the real thing,

early artificial intelligence experiments and the recent breakthroughs they had made into managing healthcare diagnostics and the electricity grid that would bring savings of around 20 to 30 per cent every year. 'Hassabis is one of the architects of our future, for sure. It was a bit like talking to Oppenheimer. That's genuinely what it felt like to me – like the Manhattan Project. He is a very friendly, clearly driven, honest guy who is not blind at all to the ethical problems and dangers of artificial intelligence. How do you keep this thing under control? Because you're fusing with machines, at some level. I was already by that stage forming a dark view of [Mark] Zuckerberg and all those people – Snowden had just happened – and the barons of big tech, to my eye, seem like the robber barons of the late nineteenth century. You could see the way AI was going to be at the heart of tomorrow's state control. Governments were very interested in what they could do with it, and Demis was trying to fight them off, because he could see it was a tool that could potentially be highly anti-democratic. And that was really the birth of what I was trying to get to with *Jason Bourne*. I was interested in the next frontier of what Treadstone could do. The relationship between Tommy Lee Jones and Riz Ahmed is absolutely what's going on today, that tension between national security and the global concerns of the tech barons. Because they're in a struggle for this technology. You and I might just live to see the truly transformative effects, but it'll really be our children that will see it. We're all in Jason Bourne's world, aren't we?'

'With the development of television, and the technical advance which made it possible to receive and transmit simultaneously on the same instrument, private life came to an end.' So concludes Winston Smith, the hero of George Orwell's *Nineteen Eighty-Four*, which imagines, among other things, a form of television capable of spying on the families who watch it, even in the privacy of their own homes. To pursue his love affair with Julia, the dark-haired beauty who works in the Ministry of Truth, Smith looks into renting a shabby little room above a shop. 'Privacy was

a very valuable thing,' says the shop's owner, Mr Charrington, staring into the middle distance. 'Everyone wanted a place where they could be alone occasionally. And when they had such a place, it was only common courtesy in anyone else who knew of it to keep his knowledge to himself.' Even tragedy, thinks Winston, belongs to the ancient time when privacy, love and friendship still existed, and when the members of a family stood by one another. 'Such things, he saw, could not happen today. Today there were fear, hatred, and pain, but no dignity of emotion, no deep or complex sorrows.'

In a version of Orwell's novel adapted by playwright James Graham, commissioned by producer Scott Rudin for Greengrass in summer 2015, Big Brother has been replaced by a giant social-media company, Social Seek, whose tentacular reach into the private lives of citizens far outstrips that of government agencies like the UK's GCHQ or the NSA and CIA in the US. 'Your search engines track what questions we ask,' says an investigator, addressing the company's CEO during Congressional hearings. 'Your social networking sites store our likes and dislikes, our music tastes, our politics. Your file-sharing platforms host our videos, our documents. Your Smart Home applications, even say your digital toothbrush software, records on average how long I take to brush my own teeth.' In Graham's adaptation, Winston Smith is an optimisations analyst whose job is to drive traffic ('Rewrite the narrative so it looks like it was always, on reflection, inevitably leading to this one point in time: your story), and Julia is a renegade games designer who wants to blow the whistle on the company's data collection. In the wake of a financial crisis, protestors wearing masks of a monkey emoji with its hands over its eyes ('See no evil') flood Trafalgar Square, while riot police and helicopters circle them. There are glimpses of Edward Snowden's face on placards, and a martyr figure, leading the protest, graffitis the square ('2 + 2 = 5') before setting light to himself, like Tarek el-Tayeb Mohamed Bouazizi in 2010, at the start of the Arab Spring.

'I reread the book sometime after I finished *Captain Phillips*, and I rang up Scott [Rudin] and said, "Fancy doing this?"' says Greengrass. 'And he said, "Great." The interesting thing that I felt when I reread it

was that it had several really well-articulated thriller elements to it, but none of them were really explored. There was the whole business of the missing people, who then subsequently appear. The him and her. Orwell never married them together as one synthesised story, because that wasn't his purpose, but I thought it had lots of promise. It was a fixed idea for me that it be set tomorrow. That was certainly what I felt at the time, like I had to answer the question, "Are we about to live in 1984?" That seemed a very pressing question back then. I think it still is, actually, but was that the problem I've asked myself? Did I start looking for a film that was really a futuristic film, when actually I should have made a period version? I'd still like to feel that I can make that film. I want to set it in the world of tech – Winston Smith would work for an unnamed tech company – but later that became the genesis of what I tried to do with *Jason Bourne*, which was not as successful as the other films, but I think it had some interesting things to say about tech.'

The deal struck with Universal in September 2014 to make *Jason Bourne* was very simple: in exchange for agreeing not to kill Bourne, Greengrass could have final cut, with no requirement to embrace Tony Gilroy's *Bourne Legacy* or the wider universe of Aaron Cross, and no inter-ference by the Ludlum estate. The budget was set at a relatively modest $160 million. 'It was a really simple deal,' says Greengrass. 'Basically, it protected the studio in every way, but it also protected me. What they got was a Bourne movie, the ability to say "yay" or "nay" to what it was and have a discussion with us. But also, from my point of view, it made the process controllable, which is what I wanted – a more coherent process, where we'll have a script, rather than being close to the precipice every single day, from the beginning to the day you wrap. But I have to face the fact that perhaps that was also a contributory factor to it not having that sparkle. The anarchy of birthing the previous two was part of why they had this intensity and immediacy, and so *Jason Bourne* did rather have the feeling of a rock band doing a greatest-hits tour. Now I didn't do it in a cynical way. I know Matt didn't and I know nobody did. We couldn't have worked harder, but somewhere in the back of your mind was this nagging sense that the movie didn't have an urgent reason for being. One

of the things about film-making that's a total nightmare is that feeling you sometimes get after you've finished a movie, where you go, "Well, if I could start all over again, now I know exactly what to do." You can be haunted by it. I felt it after *Green Zone* and I felt it after *Jason Bourne*.'

———

When the Rolling Stones played Altamont in December 1969, they made their escape in an overloaded chopper, like the last soldiers out of Vietnam. 'It was the end of the dream as far as I was concerned,' wrote Keith Richards in *Life,* noting ruefully that the evening marked the first time 'Brown Sugar' had been played in front of a live audience, although, as was usual with the Stones at this point, they hadn't rehearsed beforehand. It was 'a baptism from hell, in a confused rumble in the Californian night . . . Thank god we got out of there, because it was hairy, though we were used to hairy escapes. This one was just on a bigger scale in a place we didn't know.' As was also usual, they lost money on the concert. By contrast, when Richards and Mick Jagger, after several years of estrangement, decided to meet in Barbados to lay the groundwork for a new tour in 1980, they prepared with care. The set, designed by Mark Fisher, featured the biggest stage ever constructed, with spaces for everything from rehearsal rooms to the pool table where Ronnie Wood and Richards warmed up between shows. 'It was a massive new operation,' wrote Richards. 'No longer a pirate nation on the road . . . This time, I realized how big a spectacle I was involved in – huge, cavernous, a new kind of deal.'

Something of the same vibe attends *Jason Bourne*, Greengrass and Damon's third and final Bourne film together. 'The band is back together for a reunion tour, and if some of the original members are missing, the new additions have learned the chords and are even permitted to try out a few fresh riffs,' wrote A. O. Scott in the *New York Times*. Greengrass's 'vigorous, rigorous style of shooting and editing – maximum speed and maximum chaos rendered with elegant, sometimes breathtaking coherence – has kind of an old-school, greatest-hits vibe. The thrill isn't entirely gone. It's just a little more subdued.'

The film opens in the Balkans, where Bourne is found bare-knuckle boxing, like John Rambo competing in *krabi–krabong* matches in Bangkok at the start of *Rambo III*. The guilty knowledge revealed at the end of *Ultimatum* ('you volunteered') has worked its way through his system, thickening his sinews and coarsening his muscle tone, lending him a slight deadness behind the eyes. Through lack of emotional release, he has turned brutish, as if reverting to the animal Treadstone programmed him to be. The action moves swiftly to Iceland, where Nicky Parsons (Julia Stiles) hacks into the CIA's mainframe to download all the files on its black operations, which sit in a Windows folder helpfully named 'Black Operations', including details of CIA malfeasance involving Bourne's father (Gregg Henry). When the hack is discovered, Nicky hightails it to Athens, where she rendezvouses with Bourne during the middle of a riot in Athens's Syntagma Square, rekindling memories of their meeting in Alexanderplatz amid a crowd of anti-capitalist protestors in *The Bourne Supremacy* ('The World Is Not a Commodity'), and also, for that matter, Winston Smith's and Julia's rendezvous in *Nineteen Eighty-Four*, 'with hands locked together, invisible among the press of bodies', at the demonstration in Trafalgar Square. Besides Orwell, only Greengrass could find a riot romantic.

The romance between Nicky and Bourne was always such a sad, abortive thing, blooming somewhere in the gap between Tony Gilroy's and Tom Stoppard's drafts for *The Bourne Ultimatum*, and over before it got a chance to begin. Does a romance with Jason Bourne still take place if he has forgotten about it? But Stiles is a major presence in the Bourne movies, and something of the old magic attends the sight of Bourne snatching a Molotov cocktail from the grasp of a rioter and tossing it with the same casualness with which he switched SIM cards in *The Bourne Supremacy*. 'All that matters is staying alive, off the grid,' says Bourne, played by the newly buff Damon, who nevertheless exudes a weary grace in the role, and the globetrotting begins. This time our hero is pursued by Robert Dewey (Tommy Lee Jones), the director of the CIA, and Heather Lee (Alicia Vikander), the old and the new guard at the agency, who track Bourne in a high-tech surveillance hub ('Alpha team, I need a sitrep, stat!') that

illuminates their faces with a beautiful, cool blue light. Showing a rare painterliness, cinematographer Barry Ackroyd makes *Jason Bourne* the most beautiful of the Bourne films, thus adding to our sense of subtle dislocation, for their beauty was always something grabbed on the fly, a blur of passing street lights haloed on rain-speckled windscreens.

Time has moved on, people have moved up. It's a brave new world out there. Now ex-CIA, Nicky is working on behalf of a Julian Assange-like figure, Christian Dassault (Vinzenz Kiefer), who is bent on exposing CIA ops going back decades. 'Could be worse than Snowden,' someone says of Nicky's hack, the first of several Snowden namedrops, while the plot features an unholy alliance between the CIA and Aaron Kalloor (Riz Ahmed), a Silicon Valley tycoon who has founded a Facebook-like corporation called Deep Dream to assist with national security – a clear reference to the activities of the CIA's actual venture capital arm, In-Q-Tel. The urge to update the series was understandable – Damon was in his mid-forties, Greengrass in his late fifties when they made the film – but Bourne was trying to catch up with himself, a victim of his own success as a Cassandra-like figure. What happens to the prophet when his prophecies come true? Snowden was only ever a carbon copy of Jason Bourne to begin with, an NSA whistleblower turned off-the-grid renegade who found himself on the run from the US government, caught in the windmill of the world's transit lounges and celebrated as a kind of thumb-drive Robin Hood.

Bourne eventually gets Nicky's files on an encrypted USB drive, tracks down Dassault (Vinzenz Kiefer) and opens his laptop. Again, there is an uncanny sense of self-duplication, for what was Assange except a cheap Bourne knock-off, with his strange, twilight existence spent dodging extradition zones and nesting in the Ecuadorian embassy, where he fashioned himself into a kind of post-patriot (also prefigured by the Bourne movies)? The problem facing the makers of *Jason Bourne* was not that Bourne was no longer 'relevant' or that the world had 'moved on'; it was that the most paranoid prophecies of the Bourne series had been largely borne out, that the world had moved on in exactly the way the films predicted it would. Beautifully shot by Ackroyd and moving smoothly from

location to location – Reykjavik, Athens, Rome, London – thanks to editor Chris Rouse's usual synapse-popping skill, the film nevertheless seems to lag behind itself. This time around, Bourne's journey is not towards the memory of dark deeds and the certainty of his own guilt, but towards the memory of his father, a CIA agent whose killing in Beirut in 1983 first propelled young Jason into the agency. 'You've tortured yourself for a long time,' Nicky tells him. 'You need to read those files.'

Are we interested in finding out that Bourne was innocent all along? The first three movies were down 'n' dirty summer thrillers full of riot and ruckus that nevertheless held a cracked mirror up to the shadows of the Bush administration. The Obama era suits Bourne less well. The news that he had a father who was one of the CIA's good guys rather unpicks the sense of moral culpability Greengrass had worked so hard to achieve in *Ultimatum*, and which he rightly holds up as the signature achievement of the films. Without that ambivalence, Bourne is a much more conventional figure, both more straightforwardly virtuous and more straightforwardly violent, the echoes of *Rambo* in the opening scenes setting up his bruising climactic bout with Vincent Cassel's Asset, which, unlike his death matches in the previous films, climaxes not with a scene of horrified self-recognition, but with brutal self-affirmation.

That may be why the film did the best box office of any of the films, taking $415 million, but Bourne, like Stephen Dedalus and Daisy Miller, is fundamentally an exile who can only love his country through the sights of a rifle, the bleak romance of the character coming fully alive only on the streets of Zurich, London and Berlin, where the winter evenings start to close in at 4 p.m. 'I think he's at a tipping point,' says Vikander's Heather Lee. 'I think he wants to come in.' The series rightly ends with him refusing her offer and walking away from the Washington Monument. Some spies never come in from the cold.

'The one thing that I really do kick myself for is the opening scene,' says Greengrass. 'Because we definitely toyed with various openings. In the

early version of it, I was going to put him somewhere like an oil rig or a steelworks or something like that, just living a life of exile, a blue-collar world. And they come in and they're raiding it, but actually they're going for migrants and not him. And actually, it would have been much better if I'd done that. Would have been less dramatic, but clearer. The bare-knuckle scene didn't bring us to him; it pushed audiences away from the character. You didn't root for him, you didn't lock with him. You didn't get to his emotional core, that he was a long way from home and really wanted to be home, so I missed a trick there.

'But I'm at peace with it. I think a balanced view would be that it was not as good as the first three, but it was a perfectly respectable film. For all the problems of it being the last in the series, where you feel it's losing its energy inevitably and becoming predictable, I did like that I identified things that were going on in the world, and remain so today. The only thing was that nagging sense that it didn't have a real reason to be. The real missed opportunity was not being allowed to kill Bourne off. The story of the Bourne franchise is always written up as Tony [Gilroy] and me clashing. That's just a footnote. I don't have any bad feelings towards the guy at all. I don't hold *The Bourne Legacy* against him. I actually rather admire Tony for making *Bourne Legacy* in a way. He wanted to do his Bourne movie and he was prepared to do it, and good for him. My animosity is towards the estate. They totally fucked the franchise. My only regret is that perhaps if we had held their feet to the fire and delayed it longer, had we not made *Jason Bourne* when we did . . . But we are standing here today. Matt is in his fifties now. He couldn't play Jason Bourne, but he could certainly play a Jason Bourne whose mission is to find someone who's a younger man. They could still do that film. But they would need to find a different director.'

In November 2018, after receiving a Gotham Award in New York, Greengrass went for a drink with Frank Marshall, who suggested he write to Gilroy. On 10 December, the director sent Gilroy an email. He wrote:

First off, I have the utmost respect and admiration for you. For what you contributed to the Bourne movies we worked on together but

also for all your huge body of work, as a writer and as a director both before and since. I know we had our differences back in the day, but I want you to know sincerely that they never blinded me to my feelings of respect. Second, I've got a six in front of my age now. And when I look back, I'm actually quite proud that I've never really fallen out with anyone in my life. The odd spat of course . . . but never real breaches. Except with you. What's the point of getting into the whats and whys of the past – and does any of it matter? It's triviality in the face of the passing of the years, right? Hopefully one day we can do it with a laugh over a bottle or two of red, but maybe we can agree on this: that we were both young and hungry back in the day. And more to the point that maybe being a pair of writers/directors was always going to be an impossible ask for both of us at that point in our lives, in the pressured situation of a movie hurtling towards shooting. For my part I just want you to know that I regret that it went the way it did between us, and I'd like to heal it. So here's my hand of friendship, let's shake, put our differences of the past aside once and for all.

He never received a reply. The irony is that both Greengrass's *Jason Bourne* and Gilroy's *The Bourne Legacy* have what the other one needs. Greengrass's film is expertly made but lacks the bullet-like *raison d'être* of Gilroy's Bourne, while *The Bourne Legacy* features a terrific sequence putting Jeremy Renner's asset against a predator drone but leaves a big Bourne-shaped hole where Matt Damon used to be. Bourne was born of the static between them.

In 2015, not long after the release of *Captain Phillips*, Greengrass and his wife were in Washington for the director to receive a lifetime achievement award from a think tank chaired by former US secretary of state Madeleine Albright. Invited to a dinner party in a leafy Washington suburb, Greengrass found himself sitting between George Bush's CIA director, Michael Hayden, and Obama's director of national intelligence,

James Clapper. There were about sixteen or so guests in all, including Saudi diplomat Adel bin Ahmed al-Jubeir and George Bush's deputy national security advisor, Juan C. Zarate – the great and the good of America's intelligence establishment.

As he sat down at the table and saw his dinner partners, Greengrass thought, 'This is going be very uncomfortable.' On his right was Hayden, who in 2007 had made the decision to declassify the 693-page file known as the 'family jewels', which detailed illegal CIA activities dating back to the 1950s. As soon as they were released, Greengrass had printed the documents out and given them to Matt Damon and David Strathairn, by way of research into their roles in Bourne. Introduced to Greengrass, Hayden's eyes widened.

Michael Hayden speaking at the 2015 Conservative Political Action Conference (CPAC) in National Harbor, Maryland.

'A-*ha*,' he went.

'Don't shoot, don't shoot . . .' joked the director. 'It's very nice to meet you. I hope you are okay with *Jason Bourne*, because it's a film about how you're all a bunch of ruthless assassins . . .'

'Are you kidding?' replied Hayden. 'We loved it. We love that that's what you all think of us.'

Then Clapper arrived. He looked very grey, thought the director. 'He'd probably been up at five and had another twenty-hour day.'

Both men turned out to be big movie fans. They had seen *Green Zone* and thought it captured the actual Green Zone in Iraq uncannily well – how had he done that? – and *United 93*, which was screened at the Pentagon to help explain what had gone wrong with the military response that day; and they greatly admired *Captain Phillips*. 'That was one op that went right. They were very proud of that, that it had worked,' says Greengrass. 'The thing about these people is that they don't want to go around killing people. I mean, they loved the Bourne films, of course. "Oh no, we love

that people think we're able to assassinate people at the drop of a hat. If only it was so easy." *If only.* These are tough, tough guys, but they're charming, thoughtful professionals at the sharp end of turbulent times who essentially see themselves as in the freedom business. They are very aware that movies are such a central part of culture in America and an instrument of soft power around the world. It was fascinating to see it up close.'

Jason Bourne may never have come in from the cold, but Greengrass felt, in that moment, that he had. After the dinner was over, he and Joanna said their goodbyes on the doorstep and saw Clapper's vehicle: a hefty black limousine that looked more like a Humvee, with about sixty-four aerials on it – 'It looked like something out of *Three Days of the Condor.*' Afterwards, he stayed in touch with Hayden, inviting him down for the final days of shooting on *Jason Bourne*. Upon being introduced to Damon, Hayden placed his hand on the star's shoulder. 'Got you,' he joked. 'We're bringing you in, Jason. You thought you could stay out, but we've got you now . . .'

Later, at an event for *22 July* in Washington, Hayden again met with the director and said, 'It's so funny, you and I, all our lives will have been on different sides essentially in the issue of intelligence and spies and what we do. And you think we do it this way, but here's the thing: when it comes to Trump and what's going on in our country and the far right, we're on the same side.'

After *Jason Bourne*, Greengrass felt a strong urge to do something new. 'What do you make films for, ultimately? I could've quite easily become a guy who did very big movies for nice big fat cheques and not worry about the quality. I could have done that years ago. It might fairly be said, "What would the difference have been?" I tried not to do that. But it begs the question, what do you then do? How do you renew when you still feel young and vigorous, but you're no longer young in that sense, and you've got to the end of a bunch of films? I mean, I'm not going to go back and make more Bourne movies. It was the end of something, for sure.'

He decided to shake up his team, just as he had done after *Bloody Sunday*, on the eve of his departure for Hollywood. 'It was no reflection on anybody that I worked with, but that was what I decided to do. I had to have some painful conversations, really. They were painful for me, probably not so much for them, but I had to say to Barry [Ackroyd], "Look, I'm going to make some films with other people for a bit." Not that I would never work with Barry, because I absolutely would. Not that I don't love the films that we've made together, because I do. But I needed to have new experiences. It's like music: you play with new musicians, you play differently. And the same with Chris Rouse. It was difficult because you're saying goodbye to a lot of history and a lot of shorthand and a lot of comradeship, and there's a bit of you that feels you're not being fair to them. But it goes to the heart of directing: you can only walk alone. In the final analysis, for all that it's a collective endeavour – and it is, you're the jack of all trades, but the master of none – you also have to be a cat who walks alone. You have ultimately to not be biddable.'

Then he did what he always does when he's trying to work out what his next film should be: 'I just sit and I try and figure out what's important to me that's going on. I try to filter out the noise. That doesn't mean, what's in the headlines today? It's: what's driving things? That's the question I always ask myself.'

What interested him in autumn 2016 was the migration crisis. While he was still cutting *Jason Bourne*, he hired a researcher, Emily Thirlwell, for three months to do some work on the issue. Where were the migrants coming from? What was causing it? Who is trafficking whom? What are the most popular routes? Thirlwell delivered a two-hundred-page document, the size of a small book, which detailed everything from the reasons why refugees flee to favoured routes and smuggler operations to the rise of the far right. He also looked at optioning a book called *The Optician of Lampedusa*, written by a BBC journalist, which is about a middle-aged Italian who is with his wife on a small boat when, in the middle of the night, he wakes up, goes out onto the deck and hears shouting. In the middle of the darkness of the Mediterranean, hundreds and hundreds of people are in the water screaming, but he can save only a few. How do

you choose who's going to live and who's going to die? Greengrass contacted the actor Stanley Tucci about appearing in the potential film, but as the project progressed, 'I had a sense that unless you were dealing with the migrant experience, you were skirting the issues. And I started to feel that I wasn't the right person to tell the story of the migrant experience.'

And yet he felt passionately about the subject matter. In particular, the rise of far-right populist movements in the US and Europe – the Freedom Party of Austria, the Front National in France, Jobbik in Hungary and Golden Dawn in Greece – in response to the immigration crisis had transfixed and horrified him. That June, Labour MP Jo Cox was murdered by one of her constituents, Thomas Mair. 'That had a big impact on me,' says Greengrass. Mair was found to have amassed a small library about the Nazis, German military history and white supremacy, which he kept in a bedroom at his home, on a bookshelf topped by a gold-coloured Third Reich eagle with a swastika. He was particularly fascinated by the Norwegian Anders Breivik, who, in 2011, after detonating a car bomb parked outside the prime minister's office in Oslo, drove to a ferry that was departing for the island of Utøya, where the Worker's Youth League was holding its summer camp – essentially, a training camp for the country's next generation of political leaders. Once the boat landed, Breivik, heavily armed and dressed as a police officer, rounded up the campers and counsellors and opened fire on them for the next hour, hunting down those who ran away and eventually surrendering when confronted by the authorities. Between the two attacks, he would end up killing seventy-seven people.

'I remember early on talking to [Labour politician] Yvette Cooper, and her saying, "You have no idea how strong the Britain First people are" – the sense you had of it just not being properly reported, the depth and scale of this far-right resurgence.'

Not long after, Adam Lanza was reported to have also collected news clippings about Breivik's attack before killing twenty children at the Sandy Hook Elementary School in Newtown, Connecticut. British college student Liam Lyburd was also inspired by Breivik's lethality to carry out a mass shooting, though he was stopped by the police before he could

put his plans into action, while the far right in America also pledged their allegiance. 'We need tens of thousands of Anders Breiviks,' wrote one of the many commentators on alt-right websites after a white supremacist drove his car into a crowd of people peacefully protesting against a Unite the Right rally in Charlottesville, Virginia, killing one person. Greengrass went back to Breivik's court testimony from 2011, with its rhetoric about 'enforced multiculturalism', 'the betrayal of the elites', the 'sham of democracy' and how they had to 'sweep it all away', and was struck by how mainstream that rhetoric had grown in the intervening years. He can remember sitting in his office, thinking, 'Breivik is the patron saint of it all.'

'That's the moment I knew I was going to make *22 July*,' he says. 'You only have to go online to these far-right sites, and you could see that his manifesto was the urtext. The term you heard from the neo-Nazis in Charlottesville – "cultural Marxism" – that was his term. I remember I came in the office and said, "We're in the wrong place. We need to be in Norway." I didn't want to remake *Bloody Sunday* or *United 93*. I wanted to make a film about Norway as the crucible of how we respond to right-wing attack. It could be Trump, it could be Brexit – those are the obvious electoral manifestations. And the argument is not that the people who believe in Brexit are all violent, right-wing psychopaths. The point is that with Brexit come vectors of violent irrationality. You don't get one without the other. They're not the same, and, of course, people, particularly Brexiteers, always deny the link, always, but they're part of this. We're under attack from virulent right-wing ideology, all of us, and still are. And how do we respond to it? What's the response look like? That's what *22 July* was about.'

12: VIOLENCE

Among the people Greengrass met before making *22 July* – the families and survivors, the detectives who arrested Breivik, the lawyer who represented him in court, as well as the lead judge, prosecutors and psychiatrists – was Jens Stoltenberg, Norway's prime minister at the time of the attacks and now secretary general of NATO. A long-time Norwegian Labour Party politician, Stoltenberg himself had attended the retreat on Utøya as a teenager and had returned to the island almost every year since. 'I thought he might be hostile – or at best neutral,' says Greengrass. 'Norway was not a society I knew. There are advantages and disadvantages to this, but underneath it was a core question, which was, "What is the legitimacy for me as a film-maker to go and make a film about Norway's agony?" I felt the ethical basis for the film was strong. Right-wing extremism is transcontinental and transnational and the coming threat to all Western societies, Norway being the Petri dish, the place where what we are going to face was faced by them. Their society had lessons to teach us as to what we were going to face and how best we might face them. I felt strongly then I was absolutely right, and I do now. But I had an underlying anxiety about legitimacy.'

In February 2017, the director flew to Brussels to meet Stoltenberg at his NATO office and take his 'temperature', as he had done with all the key participants in *The Murder of Stephen Lawrence*, *Bloody Sunday* and

United 93. He was met by Stoltenberg's chief of staff, who ushered him into the secretary general's office, where Stoltenberg was waiting for him. 'Because he was a politician, I thought that he would likely be extraordinarily cautious, as politicians are. And I wanted a response as to whether it was a helpful thing to try and make a film, or whether it would be wrong. I thought if I go to him and he says to me, "Do you know what? I think that's a terrible idea. I've dealt with families. I've grieved with them. Please don't try and do that. That would be terrible," you go, "Okay, fair enough." And I haven't upset them. That was my thinking.

'I remember getting shown in, and he had his back to me as I walked in and he turned around and he shook hands and said, "I've got everything ready." And he had a large conference table with all his materials about 22 July. He said, "I just want you to know before we start that I'm really glad you've come to see me. Obviously, the people you must ask are the family support group, but I just want you to know that if they give you their support, you 100 per cent have mine, because people have to understand this is tomorrow's threat. And it's very, very real."'

They had a four-hour meeting, in which Stoltenberg went through everything, including all the mistakes that he'd made. 'He didn't duck any of the things that went wrong. I subsequently came over to see him again, and we had dinner at his residence. I remember he wept at that second meeting. It was just the most appalling trauma. "For us, this was like 9/11," he said. In a way, I see *United 93* and *22 July* as being related films – bookends, if you like. Breivik's purpose, of course, was to give battle also. They all want the liberal centre out of the way so they can get it on in the streets. It's Berlin in 1921. I'll never forget Stoltenberg's words: "This is just the beginning," he said. "People have got to understand what's coming down the road at us. This is going to be a big, big problem."'

22 July wasn't the only film Greengrass was thinking of directing at the time. The other project he was considering – an adaptation of the graphic novel *Torso*, the story of Eliot Ness's investigation of a serial killer in

Cleveland, after his legendary triumph over Al Capone and his associates in Chicago – was similarly themed. In the draft of the screenplay Brian Helgeland was commissioned to write, the killer was targeting the migrants flocking to northern cities such as Cleveland, who were also in the crosshairs of Father Charles Coughlin, the right-wing populist who was whipping up hatred of immigrants. By the time the world slid into depression in 1929, Father Coughlin was a star. His was a powerful voice that, at one point, reached forty million radio listeners. He was an early and enthusiastic supporter of Franklin Roosevelt and the New Deal but would later sour on FDR and start to refer to him as a dictator, pepper his remarks with anti-Semitic slurs about Jewish conspirators and bankers and become one of the country's most prominent apologists for Adolf Hitler. He founded something called the Christian Front, an ostensibly anti-communist activist group that began harassing Jewish shopkeepers in New York and around the country.

Helgeland's script interweaves Ness's attempt to solve the mystery of who is behind the trail of decapitated bodies that turn up in Cleveland's railyards with the anti-immigrant incitements of Coughlin, a Weegee-era Mephistopheles who prods Ness's resentment over the lack of glory that has come his way after the arrest of Capone. 'The American people are guilty of adulation,' he tells Ness over lunch. 'They make heroes out of sinners and saints out of criminals. Any person who gains prominence, ball players, actors, anyone in the public eye, they end up idolized. Charles Lindbergh, yourself.' The script eerily prefigures the celebrity demagogue who would later hypnotise America during another period of economic instability and immigration chaos. 'As you look at American cities in the '30s, they're all reamed with shanty towns because of the movement of population from the south and from Oklahoma. It's *Grapes of Wrath* – they're all arriving in the big cities and they're being chased out, and people are beating them up to stop them getting off the box cars, and it's all the same issues,' says Greengrass. 'Father Coughlin is basically the Trump of the 1930s. It's American fascism.'

A few months into the project, however, he began to get a bad feeling about it. 'I definitely remember feeling this is like my *Jason Bourne*

mistake. Brian did a good draft – it wasn't there yet, but it was really interesting – but I could tell that what Paramount wanted was sort of *Silence of the Lambs* really, which I wasn't interested in at all. You just go, "They're never going to make this." You can just tell. I remember I talked to Matt [Damon] about it, and he was already doing something, so that was it.'

Greengrass had, by this point, already written a draft of his *22 July* screenplay, been to see Stoltenberg and was ready to pivot. He pitched the project to buyers, Netflix jumped in, and by 30 October he was shooting in Oslo. 'It fell into place instantaneously,' he says. 'And I remember thinking, "Oh yeah, this is exactly right." It was a new adventure, new people, which is exactly what I wanted. Suddenly, it was so easy, it was like, "Let's go to Norway." What was important to us was we had to have a partner who could move at lightning speed because of the snow. We needed to be shooting inside for six or seven weeks, and Netflix came back that night and said, "We'll do it. We'll cash-flow you, even though we haven't done the deal." They were uniquely the company that really had the will and the infrastructure to go from 0 to 100 miles an hour in a day. That's when you felt the power of the new realities in Hollywood.'

Greengrass had read Åsne Seierstad's book *One of Us*, an unflinching account of the atrocity, when it was first published in 2015. The biggest question that had to be answered by the film was about Breivik's motivation: was he mad or a political actor, or somewhere in between? Some of the more chilling incidents in Seierstad's book involve the interactions between Oslo's health board and Breivik's mother, Wenche, after she moved into a housing co-operative in the capital (his father had left when Anders was a baby). Breivik found it difficult to make friends and would often run away. He was 'clingy and difficult', Wenche told the officer dealing with her case. 'Aggressive and nasty with it,' said the case notes. The neighbours used to call him 'Meccano boy' for his lack of affect and often complained that he and his siblings were often left alone while Wenche went out with

boyfriends. Two weeks before Anders's fourth birthday, he was referred to the Centre for Child and Adolescent Psychiatry for an evaluation. 'Marked inability to enter into the spirit of games,' the specialists noted. 'Anders lacks spontaneity, appetite for activity, imagination or ability to empathise.' Even more troubling were the notes made about his mother, who was heard yelling, 'I wish you were dead!' at her son. Observing Wenche's disordered mental state, an officer recommended he be taken away from her and fostered: 'The profoundly pathological relationship between Anders and his mother means early intervention is vital to prevent serious abnormality in the boy's development.' Breivik's father interceded from Paris and the attempt to have him fostered was thwarted, but the case reports make for unsettling reading. Breivik's issues were detectable from infancy.

The perfect example of what German author Hans Magnus Enzensberger once called 'the radical loser', Breivik was rejected from just about every peer group that he tried to join: first from a gang of graffiti 'taggers', then his classmates, then the right-wing Progress Party, then the Freemasons. Breivik finally moved back in with his mother, discovered the *World of Warcraft* gaming network, alienating even that community with his grandiosity, before immersing himself in far-right websites like Robert Spencer's Jihad Watch or the neo-Nazi Stormfront. He began to buy weapons on maxed-out credit cards and wrote a long manifesto, full of bellicose talk and cobbled together from his favourite websites, entitled '2083: A European Declaration of Independence', which was about the need to save Western civilisation from Islam and multiculturalism. The court psychiatrists in Oslo differed on whether Breivik was technically mad. Greengrass had seen tapes of him being interrogated and observed all the classic symptoms of a psychopathic personality on display – the inability to empathise, the lack of affect, the glassy-eyed dissociation – but was less interested in the psychological roots of his pathology than in the political expression it took. On being told that he had disrupted the sense of security that blanketed the quiet nation, Breivik smiled and said, 'That's what they call terror, isn't it?'

'My strong feeling, having read all those psychiatric reports and everything that I could lay my hands on and his manifesto, was that he was a

political actor,' says Greengrass. 'As Åsne says, he's one of us. He was not presentably mentally ill. What he wanted to achieve was to decapitate the state and decapitate the next generation. The destination is political. We would say Hitler, in today's terms, had an abusive childhood. He was beaten savagely, neglected and horribly treated, then went through the trench experience and so on. But he found a sense of a comradeship and belonging in the far right. And that's what Breivik did. Doesn't mean that he doesn't have profound issues, but it's not the same as saying he's mad. He is sociopathic and violently enraged, and the violent cocktail of rejection and anger that he felt found its expression in the extreme right-wing online diaspora. That was where he finally felt at home. He saw himself as John the Baptist, doing what nobody else would dare to do.'

Greengrass wanted the film to follow a number of characters: Viljar Hanssen, one of the victims, and his family; Breivik's court-appointed lawyer, Geir Lippestad; and Stoltenberg himself. 'Viljar Hanssen is not a particularly important character in the book,' he says. 'It's actually much more about the other boys. There were various reasons why I thought Viljar was better. First of all, he was the one they all talked about as being sort of the star – if you like, the proto-politician, the next generation, the one who was going to go far. A lot of people remembered his testimony in court. It was a moment of defiance. My idea was that you had to show how the police responded and how the judicial system responded and how a family responded. Those were intersecting circles of the component parts of a democracy, I suppose. They're common to all of us – rule of law, a democratic system, family life. But it seemed to me that those were the three concentric rings, and at the heart of it you'd have this character, Breivik, who stood in absolute opposition to all of them.'

To play Breivik he chose Norwegian actor Anders Danielsen Lie, best known for his films with Joachim Trier, notably *Reprise* (2006) and *Oslo, August 31st* (2011). 'I had my doubts, to be honest,' Danielsen Lie told *Rolling Stone*. 'I told him from the outset, "It's an honor to be asked, thank you, but I didn't really see myself as a potential candidate for this."' Still, he began to look deeper into the case, going through the court transcripts and psychiatric reports and watching the Oslo police department's

footage of Breivik being interrogated. There were over 200 hours' worth. 'I was watching someone eat pizza and drink a Coke – and it was making me nauseous,' recalled Danielsen Lie. 'I felt sick seeing a person do what is, by any standards, something completely normal. He was showing no empathy or sense of remorse about what he'd done. But it reminded me that Breivik and I come from similar backgrounds. He's from the west side of Oslo, just like I am. We were born one month apart. We have acquaintances in common; we might have been at the same parties in our adolescence.' When it was time to film the massacre – a sequence that takes up roughly twenty minutes of screen time but took ten days to shoot – Danielsen Lie went into what he described as a dissociative state. 'Survivors kept describing Breivik as "calm" when it was happening,' the actor said, 'so I thought to myself, I can't play the psychology, but I can play the behavior. That helped me get through it.'

On 5 November 2017, just after shooting started, Greengrass convened a large meeting of family members at Oslo's main football stadium and made clear, as he had throughout all his conversations with them, that portrayal of Breivik was unavoidable. A few weeks later, he sent a long, detailed letter to all the families, explaining his reasons for doing the film and the storylines. 'To me, the story of how Norway reacted to the attacks on 22 July, how she faced the crisis and preserved her democracy, is an inspiration to the world,' he wrote. 'And this – rather than the attacks themselves – will be the subject of my film.' Nevertheless, it was necessary to depict what happened on 22 July, 'so that it conveys the terrible nature of what was done that day'. In a follow-up letter, he spelled things out in more detail:

> We will see his victims prior to the shooting. But we do not intend to depict the killings themselves . . . we will see Breivik enter the canteen. We will see his victims prior to the shooting. But we do not intend to depict the killings themselves. The shooting of Viljar will be the most graphic violence in the film. We have discussed this with Viljar and his family. They are supportive. We will also see Simon Saebo's murder at the same time. We have approached Simon's family. Other victims

will be non-identifiable . . . Per the screenplay, this will feature Breivik, rather than his victims. In so far as we see other victims, they will be non-identifiable . . . These scenes will be graphic, but handled with discretion (fleeting glimpses etc). No victims will be identifiable.

He recalls one meeting with the families in particular. 'A gentleman stood up. He said, "I strongly support you making this film. But you'll be doing a disservice to me – and, more importantly, to my daughter, who's no longer with us – if you sanitise the violence. On the other hand, you'll be disrespecting us if you exploit the violence or are gratuitous with it. So you're going to have make sense of that. These are our stipulations as parents." That stuck with me.'

There is a remarkable scene of carnage at the beginning of Philippe Lançon's memoir, *Disturbance: Surviving Charlie Hebdo*, if only because for much of it you're not quite sure that what is being described *is* a scene of carnage. It seems more like an ordinary day at the offices of the satirical newspaper *Charlie Hebdo*, on rue Nicolas-Appert, in Paris, which is interrupted on 7 January 2015, at about 11.30 a.m., when Lançon, sitting at his desk, glances at the security guard, Franck, stationed in the corridor, and sees him stand up abruptly and draw his gun. Why Franck has stood up and drawn his gun, Lançon does not yet know, but he remembers a feeling of hope and panic, together with the thought, 'You have to draw faster. *Faster.*' The next thing he becomes aware of is the sensation of time slowing down and the sound of the sharp retort of bullets. Slowly, Lançon drops to the floor, being careful not to hurt himself as he goes down. He notices a pair of feet walking into the room and hears a cry of '*Allah Akbar! Allah Akbar!*' He decides to play dead in a pool of blood – where has *that* come from? – and becomes aware of other bodies on the ground. He doesn't feel the blood, although he is lying in it. A silence settles over everything. 'Everything was still reduced to the appearance of a pair of black legs and the wait for their return.'

THE GREENGRASS PAPERS

Greengrass talks with Norwegian actor Anders Danielsen Lie while on location for *22 July* (2018).

Lying on his stomach, his head turned to the left, Lançon's left eye opens first and he sees a bloody left hand sticking out of the sleeve of his pea jacket. It takes him a while to realise that the hand is his. His forearm has been slit from elbow to wrist; it looks like calf's liver. He glances across the floor and sees the body of a man lying on his stomach, brain matter sticking out of his skull, and thinks, 'Bernard is dead.' At that moment, he finally understands that 'something irreversible had taken place'. Running his tongue around his mouth, he suddenly becomes aware of fragments of tooth and immediately worries that his dentist has done all that work for nothing. Then he rolls over onto his side and sits up against the wall, facing one of the entrances. Silhouettes approach. A colleague, Sigolène, tries to draw close but cannot, for some reason that he doesn't understand. Another colleague, Coco, moves towards him, weeping like Sigolène. Lançon gets his cellphone out of the pocket of his coat to access his contacts, and as he hands it to Coco, he sees reflected in it his hair, his eyes, his upper lip, but where his chin and the

right half of his lower lip should have been there was 'not exactly a hole, but a crater of torn, hanging flesh that seemed to have been put there by the hand of a childish painter, like a blob of gouache on a picture. What remained of my teeth and gums was laid bare and the whole – that combination of a face that was three-quarters intact and one part destroyed – had turned me into a monster.' The whole incident lasted no more than two minutes.

'Do you remember the Henry Reed poem "Naming of Parts"?' says Greengrass. 'Lançon's book has that quality to it.' It was recommended to him by his brother, a retired professor of French history at Sheffield University who now lives in Paris. 'We were talking about family history, hidden family history, because I was then looking into the secrets in our own family, trying to fill in the gaps, and I was saying that the truth is, you can make an account of it, but you can never really know, because it's other people's lives and it's all in the past. He said, "I've just read this amazing book that really is an exploration of the unknowability of the past, how memory is only ever fragments that we try to put into an order – never very successfully really." Lançon gets very frustrated with himself when he's trying to remember the exact facts about the attack, whether somebody said this or that. Amid the great, violent blur, he really needs to nail down this or that fact. The act of violence is always so quick. When we look at depictions of political violence, it's always the aftermath, the journey towards understanding, the intent to make sense of it that fascinates me.

'These journeys are so rich and diverse. Some people remain trapped in grief and some remain angry. Some people go on mystical or spiritual journeys to come to terms with what's happened to them. *The Murder of Stephen Lawrence* was the story of the parents' journey – a love story, or rather, a falling-out-of-love story. The closer they got to justice, the further apart Doreen and Neville became. *22 July* was more explicitly about those journeys than any of the films I've made. For me, it was about putting one family in the middle of it and seeing what happened to them. I wanted to explore an act of utter barbarism and negation of democracy in a dispassionate but also compassionate way, also with a view to what is there in this, if anything, that can give us light at the end of a dark place.

THE GREENGRASS PAPERS

I did not want to do a portrait of the attacks. I wanted to do a portrait of how Norway responded to them.'

———

Far less graphic than Seierstad's book, which details the sound emitted when people were shot in the skull by Breivik ('It was a sort of *ah*, an exhalation, a breath. How interesting, he thought. I had no idea'), Greengrass's film is nevertheless an assault, recreating with visceral intensity the damage done to the Norwegian polity by Breivik's attack and the patient, painstaking steps it takes towards recovery. 'It's intelligently stern, storm-gray filmmaking, as we've come to expect from Greengrass,' wrote Guy Lodge in *Variety*. 'If it feels a bit mechanical as well, perhaps this is a near-impossible story to film with both tact and soul.'

A return to the painstaking, procedural recreations of atrocity in *Bloody Sunday* and *United 93*, the film differs from its predecessors in one important regard. Greengrass had grown up with the Troubles, was drawn into a personal relationship with hunger striker Raymond McCartney and the people of Derry, and had worked in Ireland and America before he made films about their respective national tragedies. In *July 22*, his primary point of entry to the society he portrayed was almost exclusively political. On Utøya, a large banner at the camp states, 'For the many, not the few' – the slogan of Britain's Labour Party in the country's 2017 elections. The teenagers all speak passionately about how they would run their country, and in Viljar, we are given to understand, we could be looking at one of its next leaders. In Breivik, on the other hand, we see all that is implacably opposed to the liberal order, in whose hateful rhetoric can be heard echoes of the Trump and Brexit campaigns, although it remains an uneasy irony that the film's view of Breivik as primarily a political actor chimes perfectly with his own inflated self-estimate. 'This case is about political extremism and not psychiatry,' insisted the killer, fearing the testimony of the court psychiatrists most of all because they might rob him of the opportunity to be seen as a soldier in a larger war.

Uncomfortably, then, the film grants him that wish – a danger with any portrayal of a monster such as Breivik, of course. 'Look away from him!' a police officer barks at his men as they arrest Breivik in Greengrass's movie, as if he might hypnotise them, but the film does not avert its gaze from this smirking narcissist, who relaxes horribly in police custody, snacking on pizza, grandly holding forth on his grandiose fantasies about inspiring a new 'Templar' uprising and pausing to proffer his index finger, which has a small cut caused by a skull fragment of one of his victims. He requests medical attention lest it become infected. The killings themselves are mercifully brief, playing to Greengrass's strengths as a stager of movement and mass panic, with children and counsellors scattering through the woods to find cover. 'You will die today,' shouts the implacable Breivik as he picks them off. 'Marxists, liberals, members of the elite!' Clinging to the side of a cliff with his little brother Torje (Isak Bakli Aglen), Viljar (Jonas Strand Gravli) manages to tell his parents one awful thing – 'He's shooting at us!' – before the call ends.

Brief in its depiction of atrocity, *22 July*, much more than *Bloody Sunday* and *United 93*, concerns itself with the lingering after-effects of national trauma. Shot in the leg, hand, shoulder and head and left for dead on the grey stony beach, Viljar awakens in an ICU, where he undergoes emergency surgery, from which he awakes blind in one eye, bullet fragments still lodged in his brain. He then begins the long, slow path to rehabilitation, which is as much mental as physical. We realise how much his idea of Breivik was formed in those few moments of mortal terror. Breivik is an angel of death to him, which makes it all the more remarkable when Viljar musters all his courage and makes his way to the witness stand. Unable to look up, he recounts the attack in faltering tones – his flight, their hiding place below the cliff edge, his attempts to protect his little brother and then being shot five times. 'I'm blind in one eye, but that's a relief,' says Viljar. 'At least now I don't have to look at him.' The court laughs gently at this rare moment of humour. Breivik looks baffled.

Finally, his voice breaking, chin wobbling, Viljar looks at Breivik, whom we see only as a blur in the foreground, and memorialises his friends and what they stood for. Greengrass doesn't go for any big triumphalist

gestures, just quiet moments of difficulty and necessity and dignity and muted eloquence. 'I have a choice, and I chose to live,' says Viljar.

In a letter to Viljar before filming began, Greengrass summarised the scene as follows:

> You know that you have to do it, but you wonder if you can. Are you strong enough yet? You watch the first day in court on the TV. You see the terrorist arrive and deliver the Nazi salute. Seeing this only motivates you further. You begin to write your speech. You ask your parents for help, telling them that you used to write your speeches with Anders and Simon. You worry that telling the truth of what happened, how it felt, will make you feel weak . . . You walk into the courtroom and confront the terrorist. You describe what happened that day. How you ran, hid, tried to protect Torje. How the terrorist found you and shot you. You describe how you managed to stay awake, by thinking of all of those things that made you want to live. Your family, friends, politics, sport, girls . . . How you sang a song that your mother used to sing. How you have had to relearn to use your body. How your recovery has been difficult. But then you make a joke. Yes, your injuries are severe, but at least the blindness in your eye means you can't see 'him'. The courtroom laughs. Most importantly, you get a reaction from the terrorist. You are in control of the room now. Not him. Having gained the upper hand, you describe how your life is different now. How he took away your best friends. This will be the most emotional moment in the speech. But in this moment of pain, will also come resolution. You tell the court – tell him – that you have a life ahead of you. You choose life. Whereas he will die, alone in a cell. And with that, you are free. You have beaten him.

When Greengrass was a child, he had a recurring nightmare that used to torment him. He'd be playing with some kind of sand tray, smoothing the surface, utterly absorbed, patiently working to make the perfect

surface. And then, suddenly, for no discernible reason, the tray would be disrupted, as if an invisible hand or force has put it into utter disarray. The dream used to make him wake in fear, sweating, utterly undone. 'Dread has never been that far from my surface,' he says. 'I think I have a lot of latent anxiety. I think my resting state always feels a little like that feeling you have, when you think you might have lost your wallet or left the door unlocked . . . That's where the Philippe Lançon book comes in, why it had a big effect on me, because as he shows masterfully, I think, you can't recover the past, make it all fit neatly together. It's a fruitless task, as fruitless as smoothing the sand tray. Best to let the past be, go and make a film instead, expose yourself to the most intense disorder and chaos imaginable, and try and render out something that makes sense, because that's what making a film is.'

Greengrass's sister was an artist who taught painting at the Chelsea School of Art. 'A good painter, very monastic, very ascetic, my sister,' he says. 'Wouldn't sell any of her work.' One day, she phoned him up and said, 'I'm stopping painting.' He was amazed. She'd worked assiduously, seven days a week, all her life. He went round to see her. 'I said, "Why? Why are you stopping?" She said, "What little I had to say, I've said, and I'm bored of copying myself, so I'm stopping." It was like somebody giving up drink or something – shocking. I was really disturbed, and then about a year later she phoned me up and said, "I've got a very bad headache. I'm going to the hospital."'

Two days later, they diagnosed her with cancer of the brain, and she was dead within a year. It was like watching someone settle up, getting everything in order before they left: *What little I had to say, I've said.* By the time he had finished *July 22*, he felt the same about the four docudramas he had made over the course of his career, *The Murder of Stephen Lawrence*, *Bloody Sunday*, *United 93* and *July 22*, each an attempt to metabolise chaos on a national and personal level. 'That was really my adult life, making those movies,' he says. 'I thought, "I've depicted the big events of my life. I've done my bit." It wasn't *July 22* in particular. It was really about the weight of those films together, the emotional weight of those encounters, the responsibility I felt so intensely in each of those

films to do it in the right way, to make a film that they would not reject out of hand. It takes its toll on you, as a film-maker and as a person. When all's said and done, you always feel like at some level you've waded into people's appalling tragedy, and you come to a point where you go, "I just don't want to do any more of those films, and I don't know if I should either."'

Principal photography on *22 July* ended on 14 January 2018, and in September, the film premiered at the Venice Film Festival. Some Norwegian critics objected to what they saw as an over-admiring portrayal of Norway's response to the attacks, when in fact there had been clear failures of communication among the police and security services that allowed Breivik to get to the island unopposed, even after his initial attack. 'The NRK, the Norwegian equivalent to the BBC, who were doing their own drama about it, went very big on all the failings,' says Greengrass. 'That said, I don't think any fair person could watch that film and not be very clear about what had gone wrong: helicopters not being there; police not letting people onto the island while the shooting went on; the people going to the wrong place to get the boats. The whole thing was a failure. What was important to me was that when Stoltenberg realised what had gone wrong, the true extent to which things had gone wrong on the day, he went and apologised to those families. Tremendous scene, I think, where he goes to see them. He did do that. He was with them every step of the way.'

From the beginning, Netflix knew the film had the potential to capture a large, young audience. In October, the film was released by Netflix on its platform, where more than twelve million accounts watched the film in its first twelve days, which was estimated to be equivalent to twenty million viewers. Most of that audience were aged between eighteen and twenty-five. In the end, seventy-four million watched the film. 'It was served up to kids as true crime. But also, it's a landscape that young people recognise they are at the sharp end of. They all know what Breivik is. I think violent extremism, weirdly, seems much more of a direct threat to them than it does to us. Kids get on trains and buses and Tubes all the time. And so when people attack in that way, it's much more of a direct

threat to them. Also, this is a liberalism that's taken for granted among younger people, I think, and the counter-revolution against it, whether from ISIS, al-Qaeda, whether from that intolerance, illiberalism or from the far right, it infringes on them. It's closer to them in a weird way. When Viljar says, "We will beat you. Our children will beat you," when I wrote that, I believed it, because I believe it to be true. I believe our kids, your kids, my kids, we will beat these fuckers. I'm perfectly certain.'

After *22 July*, Greengrass wanted to make a film that ended on a brighter note. 'I have never set out to make a film that had a happy ending,' says the director. 'Neither have I tried to make a film that was bleak, but after *22 July*, I said I want to tell a story that's got a happy ending.' He had been toying with writing a film for actor Mark Rylance, based on Paul Kingsnorth's novel *The Wake*, about the guerrilla fighting against the French conquerors in the aftermath of the Norman invasion of 1066, when on 15 January 2019, Creative Artists sent him the draft of a script by Luke Davies. It was an adaptation of Paulette Jiles's novel *News of the World*, about a former Confederate captain who is offered a $50 gold piece to deliver a young orphan to her relatives in San Antonio. Captain Jefferson Kyle Kidd is a lonely man with unspoken regrets, eking out a living, travelling from one small, poor Texas town or muddy settlement to another, reading aloud the news from newspapers around the country as a form of information and entertainment to gatherings of people, charging 10 cents a person.

'The book's flawed, but it's got two great characters and a lovely, slightly elegiac mood, with some menace, but never really gets into it. I read it sitting in that chair over there, and I thought – it's the Eureka thing – "I know what to do." Of course, the ending's very different in the book, but essentially it's a happy ending. I love these two characters. It made me think. The newsreader, I thought, "I love that." That's me, in a way. Of course, I don't know what that world's like, but we're all just storytellers, aren't we, one way or another.'

On 22 January, Greengrass and his producer, Greg Goodman, spoke to Elizabeth Gabler at Fox 2000 and received an email from Tom Hanks, who was already attached to the project and excited at the prospect of working with Greengrass again. The director met Hanks for breakfast in March, and after Disney bought Fox, Gabler helped move the project to Universal, where Donna Langley was keen to hear what Greengrass wanted to do with the script. When he read the novel, there was something about Texas in 1870, in the shadow of the Civil War, that caught his imagination. Kidd's journey takes him across the state's southern fringes, a divided, lawless and violent world, but the ravages of the recent Civil War were rarely referenced in Jiles's novel or Davies's script, likewise the momentous and often violent struggle to decide the state of Texas's future in respect of the Union. Even more importantly, neither slavery nor the desperate plight of African Americans was ever mentioned, nor the bloody war of dispossession that engulfed the Kiowa. For Greengrass, these were untaken dramatic opportunities, potentially exposing the film to serious criticism for avoiding or whitewashing difficult history.

'There were two versions of that film that were possible to make,' he says. 'One was the version that Luke did. I felt when I read Luke's draft that he had written a very faithful adaptation of the novel. It just didn't feel to me like that was the right way to go with this film. You needed to believe in the world, not skirt it. So when they asked me, I said, "I'll do my own draft." It was nothing personal towards Luke. He is an excellent writer. I just had a different view of the material than he did. You get a Eureka moment, when you go, "I know what this needs to be." I loved westerns when I was a kid. I would never, ever in my entire film-making life have sat and thought, "Oh, I'd like to make a western." That thought never went across my mind. When you're presented with one, and they say, "Would you like to do it?", you go, "Well, for fuck's sake, a western – fantastic. What's not to like? It'll be brilliant." Then, a bit later, you go, "Isn't that weird?" I did a John Ford documentary a year or two back, and this is a John Ford movie. It's *The Searchers* in reverse. I mean, it's perfect. You find out that later there are reasons why you have to do a film.'

13: FACT

On the morning of the Japanese attack on the American base at Midway on 4 June 1942, Captain Cyril Simard, commanding officer of the Midway air station, suggested to director John Ford that he position himself on the roof of the main island's power station. The Americans had been tipped off by their cryptanalysts about the planned Japanese attack a month earlier, and the director, who had been sent there by the US navy to film a documentary, agreed. 'It's a good place to take pictures,' he said. At about 6.30 a.m. on 4 June, Ford and his crew hunkered down on the concrete roof, equipped with Bell & Howell Eyemo 16mm cameras and hundreds of feet of Kodachrome colour film. Twenty-four-year-old Jack Mackenzie, an apprentice cameraman who was about the same age as Ford's son, climbed a ladder to the top of the power station and started shooting as a fleet of more than a hundred Japanese Zeroes approached. Unbeknownst to the Japanese, US carrier forces were just to the east of the island and ready for battle.

Ford wasn't at the centre of the action, but he was in the right place at the right time. 'The planes started falling, some of ours, a lot of Jap planes,' he said, after seeing one dive, try to pull away and crash into the ground. Another dropped a bomb on a hangar, causing it to burst into flames. 'The whole thing went up,' Ford said, 'I think we counted 18 bombs.' Finally, a Japanese plane dropped a bomb from about 50 feet

that tore a corner off the power-station roof and blew Ford off his feet. 'I was knocked unconscious, just knocked me goofy for a bit.' When he came to, a couple of enlistees told him he had a shrapnel wound in his arm and should get off the roof and move to somewhere less exposed. After three days of battle, the Japanese had lost 3,057 men, four carriers, one cruiser and hundreds of aircraft, while the US lost 362 men, one carrier, one destroyer and 144 aircraft. 'All I know is that I'm not courageous,' said Ford later. 'Oh, you go ahead and do a thing, but after it's over, your knees start shaking.'

His knees were not the only things shaking. Even with overdubbed sound, Ford's film of the battle provided American audiences with the rawest battle scenes they had seen to date – buildings set aflame, smoke turning day into night, planes spiralling into the sea – all caught in footage whose 'mistakes' had been deliberately left in. At one point, the camera was rocked so hard by an explosion that the film was jolted loose from its sprockets. Nothing could better certify that, as the narration intoned over shots of American flags being raised, 'Yes, this really happened.'

An early instance of the 'unknowing camera', Ford's film drew praise from Greengrass when he, along with Steven Spielberg, Francis Ford Coppola, Guillermo del Toro and Lawrence Kasdan, was asked to contribute to a Netflix documentary based on Mark Harris's book *Five Came Back*, the story of how five film directors – Ford, William Wyler, John Huston, Frank Capra and George Stevens – covered World War II. Having grown up watching *Stagecoach*, *The Searchers*, *My Darling Clementine* and *The Man Who Shot Liberty Valance*, Greengrass got the Ford chapter.

'Ford knew where to put the camera,' he says, referring to the Midway footage. 'You've either got to commit to being in it or you've got to commit to being able to observe it – it's one or the other. Making those decisions in the moment is fundamental. He was not fucking around when he made that movie. You're in it, so profoundly that you see the sprockets. No one else had ever made a film like that. It changed him too, and it changed films. The first time I remember understanding who John Ford was, was at Cambridge. I was obsessed with watching movies at

that point in time. Literally obsessed. I would regularly go and see two or three movies a day, because each college had a film club, and they were so cheap. I was going to America a lot as a student and exploring America, feeling the power of the landscape. John Ford always seemed to be remote to me, in a way that, say, [Jackson] Pollock was not. A conservative figure, both artistically and politically. I understood and experienced Ford as an old master of great power and weight, but he was remote from me – a figure from a different generation.'

When Scott Rudin rang Greengrass up to ask him if he'd like to cover Ford for the Harris documentary, he didn't hesitate. 'He put together the connection between Ford's Irishness and my interest in Ireland. It was really interesting, because I suddenly went, "Yeah, I want to address John Ford." I needed to understand how such a conservative man could also be such a compelling rebel figure in so many ways – a deep, deep rebel. A little bit of my father in there, I think. Talk about anti-authority . . . Peter Bogdanovich once asked to go on set with John Ford towards the very end of his career. He turns up as a young student, incredibly nervous, and it's the great John Ford there, setting up a shot, and he doesn't dare to speak to him because he feels like he's completely out of place. All these people are going around doing adult business on a movie set, and he's just a young kid. The shot's finished, and suddenly this loud voice booms out, "Hey, Bogdanovich, what do you think of that shot?" He literally wanted to die, a hole to open up, because everybody swivels around and looks at him. He goes, "It's pretty good, Mr Ford, it's pretty good." Ford goes, "Pretty fucking good? I'm fucking John Ford!" Apparently, for the rest of the day, every time he finished a shot he'd turn around and say, "Is that pretty good, Bogdanovich?"'

Unwilling to repeat the uncredited screenwriting work he had done on *Captain Phillips*, Greengrass this time decided to take more direct control of the script. He found it difficult to believe that Kidd would immediately set aside his itinerant life and accept responsibility for taking such a small

girl as Johanna on such a long and dangerous journey, and so crafted a new opening that dramatised Kidd's reluctance to take that responsibility and the steps that compel him to change his mind. At Wichita Falls, he performs a reading and witnesses an altercation between an African-American freighter and some locals. The following day, he comes upon the body of the freighter in the woods. He has been lynched. He sees Johanna hiding, chases her, and they meet for the first time. After realising the army will not take responsibility for her, Kidd asks an old army friend, Mr Boudlin, and his wife to watch the girl while he reads in the local church. Mrs Boudlin offers to take the girl in and raise her as her own, but her husband is utterly opposed. Years of marital resentment burst out into the open, and Kidd is caught in an impossible situation. Realising the girl is as lost as he himself is, he finally makes his fateful choice and decides to take the girl home himself.

Greengrass also gave Kidd a new backstory connected to his wife Maria, who, we eventually learn, died of cholera five years before, after he returned from the Civil War. Grief-stricken and believing himself to be cursed for what he had seen and done during the war, Kidd abandoned his wife unburied and has wandered guilt-ridden ever since. Johanna's character, too, felt under-dramatised. In Greengrass's draft, through Mrs Gannett, who speaks Kiowa, Kidd learns about the death of Johanna's Kiowa family and that she is an orphan twice over. Later, as he and Johanna enter hill country, Johanna recognises her surroundings and leads Kidd to the cabin where her parents and sister were murdered by the Kiowa. Where Davies's draft had been picaresque, with an overall sweetness as they travel along, in Greengrass's screenplay Kidd and Johanna's journey takes on crucial elements of danger. There is a new set piece in Durand, where the two witness the horror of the buffalo slaughter at first hand and survive a shoot-out.

Finally, Greengrass devised an almost entirely new third act, which operates as a drama of survival. There's a sequence in which Kidd and Johanna lose the wagon in a crash and are forced to continue their odyssey on foot; another in which they walk through the parched landscape until they face death from lack of water; and one where they are engulfed

in a dust storm and separated, before finally encountering the Kiowa. He assumes they will kill him and take her, but instead they give Johanna a horse and Kidd the means of salvation. The scene ends with Kidd dropping his gun and wordlessly confronting the Kiowa chief in a gesture of mutual respect. 'They're not warriors,' the script reads. 'They're refugees. Looking for survival.'

In the end, Greengrass added 136 new scenes, 84 per cent of the total number in the screenplay. On 14 July 2020, the Writers Guild of America adjudicated that he and Davies should receive a joint screenwriting credit.

News of the World represented Greengrass's closest brush with a classical film-making style – a Western, filmed under the big sky – so he thought the material called for a departure from his normal shooting methods. He decided to work for the first time with cinematographer Dariusz Wolski, who had shot Ridley Scott's *The Martian* and *The Counselor*. 'I've known Dariusz's work from way back. I thought to myself, "I'm going to be in John Ford territory here. I'm in *Searchers* territory. I need someone whose first instinct is to shoot a big, wide movie." Dariusz definitely does that. Think of *The Martian*, a very different film, but it's got a big, wide scale. He was quite interested in me, I think, as this strange sort of beast. We got on great from day one because we would make fun of our different backgrounds. He'd watched *Five Came Back* and obviously knew my own films. I said, "I want to make this look different, but it's got to be authentically mine. How do we square that? How do we find a language together? You know, your cranes and big developing shots and beautiful, big vistas and a big-movie type of movie, it's your language." He does it brilliantly, and it's a brilliant language too. It's just not mine. So I'm going to want to do it the way I want to do it, but I told him, "Don't let me." He went, "Oh, thanks a fucking bunch." But he laughed and knew what I meant. It is musical in essence. If you want to play differently, play with different musicians.'

With a modest budget and shooting locations throughout New Mexico, the challenge was to evolve a shooting style that honoured the

landscape, the scale and the sky, but moved through it with a certain muscularity, rather than passively tagging along behind the two characters. Wolski suggested they try a combination of handheld, for conversations and non-action sequences, and Steadicam, for the big tracking shots and wagon scenes. The movie featured a lot more Steadicam than Greengrass was used to, as well as some helicopter aerial work that he was originally opposed to but came around on. When it came to a crane-mounted camera, however, Greengrass's foot stayed down. 'There was a really interesting discussion about a visual language through the film between the four of us: Dariusz and I principally, but James Goldman and Martin Schaer, his camera operators, were also part of it. I said, "I want to slow down. I don't want the tempo of this film to be fast." And Dariusz said, "Well, that's great, but if you're slowing down, we need to fill the frame differently because you will see and experience different things if you slow your pace down." And what Dariusz was talking about was that it'll have its own accumulative power, a painterly quality. And I loved that. It liberated my inner Papa Ford.'

The film featured a classic shoot-out, beginning with the two protagonists fleeing into the mountains in a rickety wagon, pursued by three ex-Confederates who want to steal Johanna and traffic her. The wagon crashes spectacularly, and a cat-and-mouse shoot-out ensues in and around the rocks and crevasses of the landscape. Kidd and Johanna are driven ever higher by the Confederates, until they are trapped against the mountain. Shot at an elevation of 7,200 feet in the mountains of New Mexico, the idea was to construct a long, flowing action sequence, not unlike the constantly evolving chases of the Bourne pictures. It starts as one thing, a wagon pursuit, and then becomes a foot chase, and then becomes a gunfight, and then we go to the resolution. Kidd and Johanna use a boulder to drive one of the criminal Almay's (Michael Angelo Covino) men from cover, then Kidd creates a 'draw' with Almay's second man, during which both Kidd and Almay seek to double-cross each other. Finally, there is a sustained *mano a mano* confrontation in the rocks between Kidd and Almay.

Wolski and Greengrass were both struck by the textures of the mountain location – the dust, sand and stone. For the shoot-out, they chose

a location accessible only by foot. Wolski relied on natural light whenever he could. For a few weeks, crew members made an early-morning ascent into the rocks to set up on the side of a steep hill. 'It's got a bigger movie sense about it, yet it feels like mine,' says Greengrass. 'I loved how Dariusz made it look. If you look at the very first scene, where they meet in the woods, the chase, and then the scene where the cavalry come up, if you look at that whole sequence, there's bits of me in it, but there's bits that are not what you'd expect that open out the landscape and allow time into the film. Dariusz was incredibly skilful. It was beautiful. He's just got wonderful eyes. A wonderful cinematographer.'

Proving that a period film can also feel ripped from the front pages, *News of the World* opens in the Texas of 1870. It is five years since the end of the Civil War, but the embers of the Confederacy are refusing to die out. Racist assaults are a daily scourge. There are frequent reports of violence against Indians and Mexicans. The first things we see of Captain Jefferson Kidd (Tom Hanks) are the battle scars on his torso inflicted during the war. He now travels around from one Texas town to the next, telling yarns with a grizzled wit that will distract his audiences from their own troubles: a meningitis outbreak, a coal-mine fire, a ferry accident. 'I am an aggregator of knowledge and happenings from distant places,' he proclaims. 'I bring news from the entire world. Not just this corner of it.' Some locals scowl in disbelief, clinging stubbornly to their certainty that the future is theirs and theirs alone. 'We're all hurting,' says Kidd. 'These are difficult times.' Greengrass zeroed in on a point in American history where distrust of the government, opposition to progress and suspicion of the news media first coalesced. We could be watching the birth of our wariness over 'fake news'.

The wider world simply isn't welcome in Texas. The wider world, nonetheless, is what the movie seeks out, in Wolski's sun-beaten, wind-chapped cinematography, after Kidd comes upon an upturned wagon and discovers a young, frightened girl of perhaps eleven or twelve

named Johanna (Helena Zengel), who is babbling in an unfamiliar tongue. Federal documents reveal that she is the child of German farmers and had been kidnapped by the Kiowa tribe and raised as one of them, before being liberated during a violent army ambush. Orphaned twice, she speaks no English and has no relatives except for an aunt and uncle who live far away in the Hill Country. After attempting to find a home for her, Kidd takes it upon himself to deliver the girl to her aunt and uncle.

This was the second time that Greengrass had cast Hanks opposite a non-English speaker, after Barkhad Abdi in *Captain Phillips*, and the results are marvellously touching. Showing the girl her first newspaper, Kidd says, 'See all those lines printed one after the other? Put them together and you have a story.' Lines matter to him. They provide the template for American life, wherein you travel from A to B, find some soil and plough it in a straight line. Upon learning of the tribal belief in the cycle of life, Kidd thinks for a second and then cuts a straight path with his hand: 'We're more like this . . . We're all journeying across the prairie and looking for that place to be. And then when we find it, we go straight out and we plough it and we plant it, all in a straight line.'

The movie is all straight lines too: horizons, skylines, plains and slopes, all shot by Wolski in a spare, wheat-toned style you can feel as much as see – leather, wood, sun, dust. Slower than Greengrass's usually fast pacing, a lot of the movie is just walking and talking, riding and talking, or just sitting and talking. Johanna demonstrates the Kiowa approach to the landscape by embracing the air, clutching to her breast the enormity of the land and sky, the past and present. With her platinum blonde hair, blue eyes and an opaque gaze that speaks eloquently of horrors past, she is almost feral at first, eating with her fingers while singing Kiowa songs that draw stares from her fellow diners. Unpredictable, defiant and largely mute, Zengel delivers the kind of performance that would have tripped up many other co-stars, but Hanks listens and watches her intently, his curiosity centring him and drawing her out of her shell. He knows himself what it is to be scarred by battle and stared at. After the shoot-out with the child traffickers, Johanna sings a song about their victory, and

Kidd lays his jacket on her to keep her warm. The shortest straight line in the movie is the one between its two leads.

'I knew I was looking for a German girl, because the character in the novel is German,' says Greengrass. 'There were a lot of Germans who came to Texas after the Civil War, attracted by the cheap land. When you start a film, you always have a sense of what your big problem is going to be, and if you'd asked me at the start of this film, I would have said, "Well, our big challenge is going to be to find an eleven-year-old girl who can play that part opposite Tom Hanks." It's a big part. She's got to be able to act and hold the screen and all the rest of it. I thought it would take months, I thought we'd end up seeing hundreds of girls. It actually turned out to be the easiest decision in the film. Gail Mutrux, who is one of the producers, phoned me up and said, "Have you seen *System Crasher* [starring Zengel] yet?" And I said, "No." She said, "Okay, I've got a copy. I'll send it to you." I watched it that night and I thought, "What are the chances of finding another eleven-year-old German girl that good?" Helena and her mum came over to see me in London, and we spent the day together, and she did some screen tests. And it was obviously going to be her. She was absolutely outstanding.'

Before the first scene they shot, in which Johanna and Kidd are in the woods and meet for the first time, Greengrass was nervous. 'She worked ferociously hard to prepare for the thing, and we talked and got her ready, but in the end, for all her maturity, she's still just eleven years old. It's a heck of a challenge to be thousands of miles from home, opposite Tom Hanks on a big film set. The first thing they shot together was obviously a big scene, and I was nervous for her. But, I mean, she was so good. After a couple of takes, Tom came and sat down next to me. "Oh my word," he said, "she's absolutely brilliant." From then on, I never had any nerves about her. I think she's fantastic in it.'

There was some debate with Hanks over how best to do his news-reading scenes. How entertaining should they be? 'The first day that Paul

shot with Tom for the first reading, he did about six or seven takes,' said the film's editor, William Goldenberg. The opening sequence that introduces Kidd at one of his readings was the most difficult because it had to establish the tone. Was he a salesman? Was he a preacher? 'We were halfway through the shooting day, and we ended up sitting on the wooden sidewalk of one of our Western towns,' Hanks told *Cinemablend*. 'And we went at it, he and I, about what these performances of readings of the news meant. And I was hell bent on authenticity and the real news and the real stories, and almost of a dry perspective and presentation of them. And he was bent on the connecting of the audience, of the inspiring of the audience, of the reading of the audience and of the enthrallment of the audience with what this news was. We actually went like this for a bit because he was saying, "You must understand, you are putting on a show to bring people together." And I was saying, "Paul, you've got to understand: I am reading the news to bring people together." And we had to find this thing that was in there.'

'It wasn't straightforward,' remembers Greengrass. 'Who was this man? Was he a sort of entertainer? The truth is, you had to believe that the character could entertain as well as preach. It wasn't a dispute between us, but we were both looking at those readings trying to find our way. Director and actor are literally yoked together at the outset. You're basically in a forest at night, and you know that up ahead is a mountain and you've got to get to the top of it. You've got a map called a script, and there's a fog. You've got a tiny little flashlight that you share between you. Basically, you're going to go on a journey to try and get to the top of the hill. You might know there's a river down there somewhere. You might know that there's a big rock that you've got to traverse, but the fundamentals of the journey are all utterly unclear. The ten thousand conversations that you have as you shoot every scene, scene upon scene, day upon day for the three or four months that you make the film . . . One or other of you is pulling out the torch, going, "Is it that way?" "Maybe it's a bit more that way." "Are you sure?" "Okay. Maybe let's go." "Oh, I don't think this is right. Maybe it's a bit over here . . ." That's what you're doing. You're essentially groping in the dark, using your experience, your sense

of the map, your understanding of the terrain and your instincts in the moment, in the hope that together you're going to get there. It's an uncertain process, and that's why it's ultimately so incredibly rewarding.'

The other section of the film that underwent major revision was the ending. In the novel, Kidd goes back for the little girl, who has been abused by her aunt or uncle – she's got scars from having been beaten – and Kidd more or less kidnaps her, bringing her up as his own child. Greengrass did not believe a modern audience would easily accept a late-middle-aged man removing a child from her family without permission and without consequences, even if she had been mistreated. Kidnap was kidnap in 1870, as it is today. It also profoundly undercut Johanna as a character by diminishing her own agency. 'I felt that that ending was profoundly wrong in a film,' says Greengrass. 'I thought that there was no way that you could have him kidnap the girl against her will, because when all's said and done, he's not family. I also felt that any conception of the aunt and uncle as wicked was uninteresting. They were not wicked people. They were joyless, perhaps, but they were honest people who were trying desperately to eke out a living in a hostile world. They were making America what America became, and there wasn't time for books. That's how I wanted them to be.'

After some trial and error, Greengrass wound up with a version of the ending that went like this. Kidd goes to see a lawyer and asks if he can adopt the child. He decides to come back for the girl, but when he arrives, she's gone. Somebody outside the farm says, 'She's gone. She left four days ago. She ran away.' There then followed five quick scenes in which Kidd looks for her. He looks for her in sunshine. He looks for her in rain. He looks for her in spring. He looks for her in winter. Cut, and he's giving a reading. You know he's been putting posters up looking for her, but you feel he's given up. During the reading, he says, 'What I've learned is that life doesn't always work out as you want, and you can try and fashion it, but in the end, it fashions you. Stories read you as much as

you read them. I've lost everything, but all I can do is tell stories, because in the end, that's all we can do in hard times, is tell stories.' Then he comes out, and it's raining and he's picking up his nickels, and suddenly there she is, just sitting there. They don't speak; they just walk off.

They began shooting this scene, but Greengrass felt something wasn't right. In a flash, he rewrote the ending, in which Kidd finds Johanna at her aunt and uncle's and *asks her* if she wants to come with him. It was about consent. 'That is when it all made sense, because I suddenly went, "Of course he's got to come back, she's got to be there, and it's all about her. She's got to make the choice, not him."'

He found the shooting of the scene brought up a lot of emotions about his own children from his first marriage. 'When a marriage fails, the biggest burden is borne, of course, by the children of a marriage that fails, but the mother and the father also pay a price. The father's price is absence. This story of the little girl who is lost and found played very strongly to that idea for me. I can remember with Tom, when we did the scene at the end, when he comes to her, we had a conversation. It was the end of the shoot pretty much. Not quite the final day, but almost; certainly, the last big thing to do. I remember saying to him that what had been in my mind was that feeling that my parental life with my eldest children didn't go as I would have wanted it to have gone. You can never make whole what was not made whole with your children from the first marriage, even though you do your best. I remember talking to him about that. He said, "I know what that feels like." I said, "Well, look, my only note is, let's play the scene about that, because it really is the only reason to make movies. You get to make things that are broken whole again." He understood what its significance was, that it was about a father and a daughter.'

It meant they had to come up with a new reading for the very end of the film, so they used a resurrection story that had in fact been written for the first scene but was never used. As written, it had a sombre tone, but Greengrass rewrote it to give it a restorative comic flourish. Freed from guilt and reunited with Johanna, Kidd becomes the man he reads about ('A man . . . dead and buried . . . has risen from the grave!'). He and Johanna are a father and daughter, free to make a life together. 'Once Paul

came up with it, we were all in,' Goldenberg told *Indiewire*. 'Here a man has risen from the dead and is whole again. And that's Kidd with Johanna by his side. We thought this was like a mirror image of what we're going through in the world right now. It's a beautiful love story set against the backdrop of a very difficult world.'

The world waiting for *News of the World* was itself about to get ten times more difficult. They were six weeks into post-production in London when the first wave of the coronavirus pandemic shut them down. Goldenberg had to return to Los Angeles; James Newton Howard wrote the music in a different part of LA; the visual-effects team were in Bournemouth; and the sound team worked from London. 'It was going to be this atomised experience, cutting remotely on a version of Zoom called Evercast, where you can see everything,' says Greengrass. 'But after about a week, I completely forgot that we didn't always cut like that. Where I found it hard was when I started to get a bit inhibited about cutting length. I'm usually pretty unsentimental about length, but I never saw that film in front of an audience or even in a screening room.'

Universal decided to hold on to the planned Christmas release date, and on 2 September 2020, they held their first preview of the film, followed by another in October. 'I sent it to Tom a couple of times, and he was definitely like, "Jesus, it's too long. Take ten, twelve minutes out." He was definitely right, but I didn't see it and was resisting him. One day, Billy [Goldenberg] said, "Listen, let me just show you some cuts, see what you think." And I said, "I know, I've seen them and I don't like them." But Tom and he were persistent, thank God. Because when I finally took the time out, it was just so much better. It's important that you have different points of view. I've never had an argument with Tom, but he did push me on the length, for sure. That's the most he's ever pushed me in our two movies together, and he was right. What was throwing me was, I was anxious because I hadn't seen the film in a screening room. Okay, I've got a big screen in my office, but it's not eight foot wide – it's not

the same. And you know, what happens is that you can get lost. You suddenly go, "I'm not sure. Is this better? This may be worse. I think this is probably worse. I don't think I should do that . . ." What's clear looking backwards does not seem at all clear going forwards.'

The coronavirus did more than shut down productions and delay release dates; it accelerated all the forces for change that were, by 2020, beginning to assail Hollywood. Over a couple of years, streaming services fast became the only way most people got their films and TV shows, and when the cinemas finally reopened, it was to an entertainment landscape that was even more globalised, even more sharply divided between big franchise movies and smaller, mid-range ones. Release windows grew even shorter before films moved online, and directors increasingly found the budgets they needed at streaming services like Netflix and Apple, with the best able to negotiate an accompanying theatrical release. *News of the World* was something of a harbinger of the new paradigm, opening on 25 December 2020 in cinemas in North America, on video-on-demand just three weeks later, and receiving its international release through Netflix a few weeks after that, in February 2021. But it would be a year before Hollywood resumed movie production and the cinemas attempted to reopen, and another twelve months before audiences returned in anything like the numbers required to make a film a hit.

The one thing Greengrass could do was write. Hunkered down at his home in Henley, he tried out story ideas that continued in the historical vein of *News of the World*, but set in England: a film about the agricultural riots of the 1880s; that adaptation about resistance to the Norman invasion in 1066; a third about the Peasants' Revolt of 1381 that augured the rise of Robin Hood. For a while he worked with *Bodyguard* writer Jed Mercurio on an adaptation of Fletcher Knebel's 1965 pulp thriller about a president gone mad, *Night of Camp David*, before adapting Stephen King's 2022 Brothers Grimm remix, *Fairytale*, at the behest of the author himself, until Greengrass decided the project was best suited for television. Finally, a script found its way to him from the newly formed Apple Films. Entitled *The Lost Bus* and penned by *Mare of Easttown* writer Brad Ingelsby, it was about the wildfire that razed the Californian

city of Paradise to the ground in 2018, America's worst wildfire in a hundred years. Ingelsby's script centred on the true story of forty-one-year-old bus driver Kevin McKay, who had been on the job for only a few months when he found himself ferrying twenty-two kids from Paradise Elementary School to safety. Their perilous journey lasted five hours, taking them through gridlocked traffic and tight, serpentine mountain roads hemmed in by dense, blistering forest, ferocious 30ft flames and choking smoke that turned the midday sky as dark as midnight. At one point, as the children began to complain of tiredness, McKay ripped off his shirt, tore it up and soaked it in their last reserves of water in order to fashion makeshift air filters for the kids before they passed out.

The script had a way to go before it was ready, but Greengrass, who had spent the summer of 2022 transfixed by the imagery of wildfires circling the globe, immediately saw the potential for an immersive, adrenalised procedural that would sound the alarm over climate change. 'By and large, with projects it's sort of instinctive,' he says. 'I don't very often dwell. The yesses tend to be pretty quick. It's the maybes that generally end up dragging out. The idea – forest fire, school-bus driver, twenty-two kids – piqued me immediately. I read the script and remember being struck by the authenticity of the blue-collar world depicted, which is Brad's forte. It makes him unusual as a writer, but it wasn't the screenplay for me. The question you have to ask is, "What's the film *you* want to make?" I didn't feel like it moved like a movie could, or like one of *my* movies could move. I felt like I wanted to make it much more direct, much more compressed and much more driving – much more of an experience. More of a *Captain Phillips* type of movie.'

The start of John Carpenter's *Assault on Precinct 13* came to mind, with its long, eerily static opening shots of the police headquarters – the site of the coming mayhem – and Greengrass imagined something similar for this film: an opening shot of the natural world, the sun, the parched trees, the pine needles on the forest floor, just waiting to burn. Then the rickety hundred-year-old power lines snaking towards a town in the distance: the community of Paradise, sitting in the middle of a tinderbox. 'Which is the opening I eventually created,' he says. 'When you read something,

you either don't see something or you immediately see a film. It's quite uncanny. You see an idea in your mind, and it germinates straight away, almost despite yourself – "That would make a great start to a film." That's generally when you go, "Oh, I'm probably going to make this."'

14: CONFLAGRATION

At 6.15 a.m. on Thursday, 8 November 2018, hot winds in excess of 100mph shook an electricity tower in Northern California's Butte County, bringing down a section of 143-pound, 115-kilovolt braided aluminium cable. A massive bolt of electricity was generated that charred the tower black and sprayed droplets of molten metal onto the dry grass. A fire ignited, fed by the wind and tearing through tangled brush, pine saplings and dry grass before pushing south-west, where National Forest land abutted private logging fields, eating up a swathe of land the size of Central Park – or downtown Chicago or the country of Monaco – every eight minutes. In places, temperatures exceeded 3,000 degrees Fahrenheit, while the smoke column was visible to satellites floating 22,000 miles above Earth. 'The flames stretched higher, grasping for oxygen, then hunched and bent horizontally with the wind, pushing southwest,' wrote Lizzie Johnson in *Paradise: One Town's Struggle to Survive an American Wildfire.* 'As the hot air rose, cooler air rushed in to take its place, pushing the flames up the slope. The canyon lay in the distance – a ready racetrack. There was nothing, and nobody, ahead to halt the fire's advance.'

Developed carelessly on fire-prone terrain, the town of Paradise, situated at the base of the Sierra Nevada mountains, was, wrote Johnson, 'a tinderbox nestled between two geological chimneys'. Canyons and ridges

made access a problem for firefighters. 'The greatest fear is fire on the ridge,' one of Paradise's citizens told a reporter. 'There's no way out. You're trapped.' From 2013 to 2018, fires scorched some 12.7 million acres in California. Paradise and 189 other communities across the state were listed as 'very high fire hazard severity zones', but Paradise's town council had not a designed a system for evacuating the entire ridge at once. As residents of nearby Concow, still in their pyjamas, scrambled to flee, a partial evacuation order went out to fewer than half of Paradise's fourteen districts, so as to minimise congestion on the roads of those areas in the most immediate danger. Conga lines of traffic had already snarled up the routes out of town. Despite the danger, people were still waiting at red lights and stop signs, as embers descended on the north-eastern tip of the town, setting alight gutters and roadside ditches clogged with debris, and igniting the engines of cars as they fled.

Most wildfires spread at between 1.4 and 1.9mph, but this one, aided by 90mph winds and low humidity, was moving at about 8mph, creating its own fast-moving weather system, similar to the one created by the conflagration that annihilated Hamburg, Germany, after the infamous Allied aerial attack of 1943. Thick black smoke turned morning to midnight, forcing drivers to open their doors a crack to check they were still on the road. Propane tanks ruptured and ricocheted into the air. Ammunition supplies discharged as they caught fire. One ambulance rolled to a stop and simply burst into flames. There was nothing that the fire engines that raced down the roads could do. By the time a full evacuation notice had been typed into Paradise's CodeRed emergency alert system, the town's Internet connection had cut out as the infrastructure melted, followed shortly afterwards by the landlines.

'I don't want to see anybody laying hose or going after a spot fire,' California Department of Forestry and Fire Protection (CAL FIRE) division chief John Messina told his firefighters. 'There will be zero firefighting. Your only mission is to protect evacuation routes and the lives of civilians. Get people moving, *now*!'

Why were the town's defences so quickly overwhelmed? Fire obeys the laws of physics. Researchers have isolated three elements, known as the 'ignition triangle', which when combined result in a blaze: heat, oxygen and fuel. That trifecta was easily met by Paradise's combination of high winds, record-breaking temperatures and dry brush. Embers the size of dinner plates soared atop 90mph gales that carried them far ahead of the actual wall of flame itself, to descend on the north-eastern tip of the town, where they found ideal kindling in the tight rows of houses, with their clogged gutters, attic vents, open windows and thin roofing. The firefighters who headed for the fire-front itself were essentially in the wrong place – or rather, fighting a war that was already over. The blaze had already flown over their heads. 'This was how the fire spread so quickly,' writes Johnson:

> It wasn't a single unbroken front but a hail of embers. Alone, the sparks were too weak to do much damage. A single one could smolder for hours, and they were miles ahead of the mother conflagration. But if two dozen embers accumulated in a crevice or piled up on a clump of pine needles, the potential for fire skyrocketed. A small pile of firebrands could generate forty times more heat than a languid August afternoon of relentless sun. The superheated air started a chain reaction, broiling so hot that sheer curtains behind a single-pane window in a nearby home could catch fire and ignite the building from within.

So a lethal combination of elements – record-breaking heat, high winds to carry the embers, the town's creaking communications infrastructure and the negligence of the Pacific Gas & Electric Company, whose cables started the fire – combined in exactly the wrong way, causing a tragedy to unfold with shocking speed, yet which in hindsight seems grimly inevitable. Events quickly reached the tipping point essayed in every single one of Greengrass's films. In fact, in the fire that consumed Paradise, two tipping points seemed to converge: the moment the firefighters were overwhelmed, and the much larger point of no return we seem to be fast approaching in terms of global warming and our ability to reverse it.

'The first thing that became clear to me was that the film had to revolve around the question, dramatically, of: did we still have time, or was it too late?' says the director. 'What I wanted was to create a core drama where all the characters were faced with the question of whether or not it was too late for them, or whether there was still time for change, because it struck me that was exactly where we were with climate change. That's the issue: is it too late or do we still have time? I started to see very clearly that these characters – the fire chief and everyone involved in fighting the fire – were all experiencing that sense of being overwhelmed by the reality – all of a sudden, out of a clear blue sky – that it was too late. That fire literally overwhelmed them. There was nothing they could do except evacuate. Once I'd got that in my mind, I just had to create central characters who clearly had run out of road, who come to realise to their surprise that they have a second chance, and then to grasp it. If you can create that through this quite simple device of saving the kids, that's a pretty cool, exciting movie – and simple too. That was the core of it.'

After reading Brad Ingelsby's script, Greengrass spoke to Jason Blum, the producer who had brought it to him, and Jamie Lee Curtis, who had originally optioned the extract from Lizzie Johnson's book that had appeared in the *Washington Post*. Then he read the book himself and watched the many documentaries about the fire, including PBS's *Fire in Paradise* and Ron Howard's *Rebuilding Paradise*. Next he spoke to Apple's Matt Dentler, Jamie Lieberman and Zac Donohoe about the film he could make for them. It turned out that Ingelsby was deep into writing *Task*, his follow-up to *Mare of Easttown*, for HBO, which was about a murder and kidnapping investigation, also set in Philly. Cameras were due to roll in March, which meant Ingelsby would have no time to work on his script, so Greengrass set about writing a new draft himself. 'It fell into place almost immediately,' he says.

There was, however, an actors' and writers' strike looming in Hollywood, and as *The Lost Bus* began to gather momentum towards the end of May, production after production ground to a halt in Hollywood. It became clear to Greengrass that the end of the strike would bring with it a terrific

rush that would squeeze their prep time, and so he decided to press ahead with a production plan, guided by a fairly clear idea of where the script was headed. With his long-time producing partner Greg Goodman now on board, and Cliff Lanning as first assistant director, they began searching for a location that could serve as a reasonable facsimile of Paradise, and where they could safely create a real fire. After looking at California, Georgia and New Mexico, they settled on a small resort town three hours south of Santa Fe called Ruidoso, which was an uncanny match for the Californian town as it was before the fire: identical trees and climate, with a sprawl of unplanned houses and structures tucked in among the forest and canyons. All this was done remotely because Greengrass's wife Joanna was not well at the time.

'Writing that film was difficult,' he says. 'You sort of retreat from the world in many ways. Life becomes about dealing with the day to day, but at a certain point, I started writing very intensely, all the while looking after Joanna while she recuperated. Looking back, I was in quite a dark hole in that moment. That may also have affected how I saw it. I liked the idea that the story was going to end with an act of redemption. It felt quite real to me. You're working towards that little patch of daylight. Writing was a salvation for me, because otherwise, those hours you spend where your mind is racing . . . There's nothing you can do. In a way, doing what I do is like going for a run. It keeps you on the train tracks of reason, it keeps you in touch with "We're going to get through this." This film is about getting through it. "We're going to get fucking through it."'

Greengrass's draft of *The Lost Bus*, like Ingelsby's, centres on Kevin McKay, a forty-one-year-old Paradise resident who is not where he thought he'd be at that age. His father is one of the men who helped build the town, quite literally constructing his own cabin in the woods, but when the action of the film opens, Kevin is considering selling the house to pay for his father's funeral expenses, as well as the vet's bill for putting down the family dog. He has only recently left his job at Walgreens pharmacy in order to take

a part-time job driving buses for his local school district, and would take more shifts if he could get them, but his ex-wife is out of town and it is his turn to take care of their listless teenage son, Shaun, whom he suspects of faking illness so as to miss school. Juggling calls from his immediate boss, Ruby, who reminds him to take his bus in for maintenance, his mother informing him that Shaun really *is* sick and his ex-wife berating him for his unreliability ('Start taking responsibility . . . before it's too late'), McKay is up against it, even before he sees the smoke on the horizon and receives the call to evacuate twenty-two children from a school across town to Paradise Elementary, where their parents are waiting to pick them up.

Greengrass's draft of the screenplay pays characteristically close attention to the panic as it ripples through the town and spreads inside the bus 'like a contagion' – yet one more tipping point, like the fire itself. The script describes how 'dense black smoke and ash choke the air. The wind outside buffeting the bus. Branches sweep across the roof and against the windows . . . The bus lights illuminate the darkness on Roe Road. Inside it's eerily quiet. Like a submarine trapped at the bottom of the ocean.' In his rear-view mirror, McKay can see 'red cheeks and scared eyes staring back at him from the darkness'. One girl fans her friend; another chews nervously on her hair; others hold hands. One boy, 'sitting alone, vigilant', appears for the first time in Greengrass's draft, but not in Ingelsby's. It could be the director himself as a young boy, eyes peeled, antennae twitching with dread.

'You always find the character where you look back and go, "Oh yeah, that's sort of like how I feel,"' says Greengrass. 'When I think of Bourne, I relate it to that sense of "They're lying" and "You're never going to fucking catch me." That spoke to me very, very much. It's never, "It's all over, there's nothing to be done." It's always, "There's always something to be done, you can always get out of trouble." Which is why, to me, *The Lost Bus* revolves around the issue of "Is it too late, or is there still a chance?" That's where we are now, isn't it? We are at the tipping point . . . The last film I'd made had been, in my mind, about fathers and daughters – Captain Kidd and the little girl. I loved the idea that *News of the World* had a happy ending. The restitution of the child, that ending spoke to me a lot. With *The Lost Bus*,

I thought, "I can do a father-and-son story." That spoke to me. You've got to write and make a film that means something to you. This is essentially a prodigal-son story. In the Bible story, the father is there to meet him and says, "Rejoice, my son who was lost has come home." In my telling of it, the prodigal son comes home, but he's just too late – it's all over. And he's either going to go down that abyss or find some new way out. It's either going to be too late or he's going to get a second chance.'

A story about fathers and sons, *The Lost Bus* is also, like many Green-grass films, a story about communications. Unlike Ingelsby's version, Greengrass's dramatises the efforts by CAL FIRE to combat the blaze. Hindered by bad access and low visibility, the fire trucks sent to the first reported bushfire, at Jarbo Gap, prove useless, and the news passes up the chain to battalion chief Martinez, a dedicated firefighter in his forties who has spent much of his twenty-year career dreading a blaze this big. 'That's a hell of a distance for a spread,' says his deputy, as news of a second spot fire south of Concow reaches them in their command post, with its maps and array of high-tech comms equipment, much like the comms hub in the Bourne movies or air traffic control in *United 93*, where it pro-vides, as it does here, an overview and a procedural tick-tock of steadily mounting dread to ratchet up the tension. 'We need comms open as long as possible,' says Martinez, as he sends out a limited evacuation order for Concow and sends Grumman S-2 planes to dump fire retardant on the burn sites to keep the blaze at the far side of the canyon and protect the comms towers at all costs. Spreading over 2,000 acres in under ninety minutes, the fire quickly outflanks their efforts. High winds keep the planes at bay, and the canyon is overrun by flames by the time a partial evacuation order for east Paradise goes out. 'Twenty years I've been train-ing for this,' says Martinez, 'warning anyone who'd listen there's a big one coming. Then one day out of a clear blue sky, there it is. And it turns out there's nothing you can do. Nothing at all.'

By the time an evacuation order for the whole town goes out, the comms towers are down. As Kevin, with the help of one of the teachers, Mary Ludwig, loads his bus with frightened, wide-eyed children, traffic is almost at a standstill, the sky is darkening, there's a terrifying orange glow

The 'campfire' viewed by NASA's Landsat 8 satellite (2018).

on the horizon and embers are falling on cars and buildings. By the time they get to the school that has been designated as an evacuation centre, its roof is on fire. With ash collecting on his windscreen and the faces of twenty-two frightened schoolchildren peering over the tops of their seats in his rear-view mirror, McKay must decide on a route out of town: a narrow winding lane covered in trees and brush just waiting to ignite? Or a gridlocked highway packed with gas stations and falling powerlines?

'I didn't want to make it the same way I had *22 July* or *United 93*,' says Greengrass. 'I didn't want it to be a verifiable docudrama, more a movie at the interface where documentary cinema meets film-making, where fact meets fiction. I think a lot of my films are at that junction point, that porous frontier in both directions. It's a place where all sorts of interesting things can happen. I've done some that are very austerely factual. I didn't want to make another one of those. I remember realising straight away

CONFLAGRATION 365

that I wanted to make more of a fictional film, if I can call it that, even though obviously based on real events. Also, I'd just done two films that were quite slow, intimate – *July 22* is really quiet, except for the attack itself, and *News of the World* is a lot slower than my films usually are – but I think, with a forest fire, it's got to have some punch to it. It's got to have some attack. I wanted to push down the *Captain Phillips* road.'

He had thought of again using Darius Wolski, whom he'd worked with on *News of the World*, as cinematographer, but he turned out to be busy with James Vanderbilt's *Nuremberg*, about the Nazi war crimes trials, so Greengrass turned to Pål Ulvik Rokseth, the young Norwegian he'd used on *22 July*. 'Pål's got a great eye,' says Greengrass. 'He's a very inventive guy.' But the largest dividend of pitching the film more towards the fictive end of his cinematic universe was that it opened up *The Lost Bus* as a potential star vehicle, as *Captain Phillips* had been for Tom Hanks. Various names had been floated before the project reached the director, among them Tom Hardy and Chris Hemsworth, but as soon as production was up and running, Greengrass gravitated towards Matthew McConaughey, whom he'd greatly admired in his Oscar-winning turn in *Dallas Buyer's Club*, among others. 'I've never met him, but I love his work, I love his intensity,' he says. 'I thought that he's a bit older than the real guy. But the more I sat with it, the more I thought where I was putting this film on the fact–fiction spectrum – making it work by compressing it, sort of going through all the gears, from a normal day to the middle of hell, and crafting this intense ride that would be a story of redemption for him – the more I could see Matthew in the role.'

He had three long Zoom meetings with the actor, through late November and December of 2023, in which the two men began to feel each other out, see if they were on the same page, see where each wanted to take it – 'How are we going to do this dance together? Are we going to be in sync?' – during which Greengrass found the actor to be 'a very good-humoured bloke, really intelligent. He fizzes with ideas. He was definitely right that the Kevin that I had in the first forty, fifty pages was too much of a downtrodden victim. We had some very good conversations around that. The interesting thing about Matthew as an actor

is that he's not a liberal New Yorker or a Bostonian or a Los Angelino, he's a proud Texan. He comes from a fairly blue-collar family himself. He understands that world, because part of what's interesting about Paradise is it's not some liberal Californian enclave, it's the world of the left-behinds. I knew he could make that real, understand it much better than I could.'

They also talked about how they liked to work. McConaughey was friends with Hanks and knew from *Captain Phillips* what working with the director might be like. 'I said, "I like to be loose when I work." And he said, "I know that, and I do too,"' says Greengrass. 'So, methodologically, I knew we were going to get on great.' They also talked a lot about music, discovering a shared love of country singer Rodney Crowell and singer–songwriter Steve Earle, whose song 'Goodbye', along with Crowell's 'Forty Miles from Nowhere', McConaughey sent to the director when he found that their musical tastes intersected. Then, in early January, the actor called Greengrass while he was watching a football match.

'He said, "I'm in," remembers the director. 'Actually, the words he used were: "Let's make music . . ."'

More so than any film of his since *United 93*, *The Lost Bus* presented Greengrass with a methodological puzzle: how to recreate in the audience the feeling of being engulfed by fire without putting his cast and 480-strong crew in danger? 'It was like a jigsaw puzzle, a more intricate puzzle of greater technical complexity than most films,' says the director. At the production office in Santa Fe, visual-effects supervisor Charlie Noble put together a digital map that tracked McKay's route through Paradise that day, marked in orange, with numbers and letters – 1, 2A, 2B – corresponding to each of the scenes in the screenplay, all with a visual reference, gleaned from social-media posts captured on the day, of the conditions in each place – the density of the smoke, the intensity of the glow on the horizon, the number of spot fires as cars, buildings and trees burst into flames simply from the heat. A team from Lucasfilm

Greengrass and *Lost Bus* cinematographer Pål Ulvik Rokseth
(March 2024).

equipped a stage in Santa Fe with LED screens, onto which was projected fire footage, thus giving the actors, inside a bus mounted on gimbals, something to look at and bathing their faces in the light of flames.

The challenge was how to create an immersive experience – to put twenty-two children in the middle of a raging forest fire and not have it be a visual-effects experience. At first, he thought the amount of effects work would be extensive, particularly after a trip to see U2 perform at the Sphere in Las Vegas convinced him of the efficacy of digital wrap-around screens. Once production had started, however, Greengrass grew much more bullish about the possibilities of shooting 'in camera', with his actors responding to live events on the ground. They'd already bought the wraparound-screen technology, but the bulk of the rest of the

budget had yet to be committed. Greengrass remembers a conversation between himself, producer Greg Goodman and first assistant director Cliff Lanning, in which they decided, 'We don't need to fake this. We're better gambling on a reality that will be very intense to create because we'll have only forty-five, fifty minutes at the end of the day, and then we've got a bedrock of reality,' recalls Greengrass. 'We'll have had a real experience as a cast and as a crew. We'll have reality on screen that we can augment, as opposed to going the other way. The actors loved it because it became super-, super-intense and real. "Get this thing now" – bang! It's like jumping into cold water. It takes a certain sort of actor. It takes courage and trust. They've got to love to work that way because it's mad. It's not mad, it's actually very purposeful, but it feels intensely in-the-moment. It was very difficult with the children, because you're only allowed to expose them to these sorts of conditions for very short periods of time. All roads led to shooting this unbelievably quickly.'

Convinced from the earliest rehearsals that Matthew McConaughey and his co-star America Ferrera, who was playing schoolteacher Mary Ludwig, were more than up to the challenge, and that the children he had cast were strong enough to support the production, Greengrass shot for six weeks in Ruidoso, before moving to Sante Fe, where they had taken a lease on part of the former 64-acre campus of the College of Santa Fe, whose buildings had stood largely empty since 2009, giving it the appearance of a ghost town. About the size of Pinewood Studios, the campus not only housed the film's production office but also provided them with a network of roads, on which they could run ten fire engines and dozens of cars at speed and thus create the film's biggest set pieces, including the long middle section, when the fire's choking, thick black smoke effectively turns day into night. 'I was very struck by the burnover as a dramatic concept,' says Greengrass. 'It's when a fire goes right over the top of you. You're in middle of a fire, and it looks like it's the middle of the night. You start in the day – a lovely summer's day – and then literally it becomes this dark, post-apocalyptic universe. Then, when it's over, and assuming you survive, you emerge into day again. Many people talked about that surreal experience.'

CONFLAGRATION

He decided early on that he needed to personify the fire. 'Fire needed to be a character; it needed to have its own signature, as it were,' he says. 'I remember I phoned up Billy Goldenberg and said, "You know what this film needs? It's like *Jaws*. Imagine *Jaws* without the POV of the shark. That's what we need." We needed a slightly different camera to reflect, not a shark's motion, but essentially that of a fiery dragon as it jumps and spits and metastasises. When the electrical cable drops and the fire starts, it's like the birth of a monster. The wind takes it, and it's off and running, driving the whole story.'

They ended up using drone technology to fly specially fitted cameras through the various locations and recreate the fire's devouring speed. After rehearsing all the mechanical and physical aspects of a sequence – traffic flow, camera movement, the intensity and timing of the flames produced by the dozens of gas burners – during the day, Greengrass would then bring in his actors and work with them for a few hours, mixing real firefighters in with his extras, just as he had done with the air traffic controllers and actual crew on *United 93* and *Captain Phillips*. Then the children were brought on set. Finally, at dusk, they would shoot the sequence live for slightly less than an hour, using this 'sort of strange, eclipse-type, magic-hour light, which for fifty minutes gives you the closest approximation for what Paradise looked like under the fire. Every day became an adrenaline charge, because you knew that at a certain hour you had to shoot the whole thing. Everything went blindingly fast, realising that this is the only time we were going to do it. And if we didn't get it, we'd have to come back the next night and do it again.'

Without realising it, he had evolved a method of shooting that replicated almost exactly the mixture of pressurised improvisation and bonding-under-pressure that sat at the heart of the story he was telling. 'What I love about this story is that it's such an intense journey, because Matthew and America's characters have never met and end up facing the greatest of crises together. It's like *United 93* and *Captain Phillips* – it comes out of nowhere. They're in a situation of unimaginable crisis and end up forming a bond, but it's never romantic, it's not schmaltzy. I love those stories.'

Cast as McConaughey's mother and son in the film were the actor's own mother and son, Levi. 'When I saw the reading, I didn't even know it was his son,' says Greengrass. 'I just thought, "He's got to do it."' Every Saturday the McConaugheys, the Ferreras and the Greengrasses would have dinner together, and something of the bond that was formed found its way onto the screen, particularly in the scene where McConaughey's character tells Ferrera's about his last conversation with his father – 'a terrible row' about nothing. The scripted monologue is as follows:

He laid into me like usual and I just snapped. Went at it, roaring and shouting. And in the end I slammed the door and drove away. Said I was never going to see him again. At first it was pride. I wasn't going to back down and neither was he. But as the years passed and my life went to shit, it was shame. I just couldn't face coming home and seeing him disappointed with me all over again. Then one night I was working late. Walgreens. Trying to figure out where I'd gone wrong, why my life was so messed up. And that's when I decided. To go and see him that weekend. To make it up with him. To ask for help. All those years, he'd been trying to tell me things. Things I didn't want to hear. Maybe I was finally ready to listen, you know? And that's when I got the call. I drove through the night but it was too late. He died that morning.

A lot of this material had originally been revealed in the form of flashbacks, but seeing McConaughey's performance, Greengrass realised that while he'd needed the flashbacks to write the scene, McConaughey didn't need them to act it. 'He played it absolutely brilliantly – heartbreakingly, actually. He really is a fantastic actor, real and committed. He just *was* that guy. You don't need to explain things. You get that his character is in a dead-end job, frustrated by the poor choices he's made in his life. That's the story of his life. He's always been late for the things that are most important to him. It's very, very, very moving. And, of course, it intersects with the larger theme of, are we too late?'

In 1931, *The Times* ran an advert that read: 'Wanted, Young Man over 22 who has studied films, for editing and production: University man with writing experience preferred.'

Among the applicants who turned up for an interview in Merrick Square, Southwark, was a young civil servant by the name of Edgar Anstey, who had trained as a scientist but wanted to move into a more creative field. He was met by an energetic, bespectacled Scot with a thick moustache: the documentary film-maker John Grierson, whose first film, *Drifters* (1929), about herring fishermen in the North Sea, made in his one-bedroom apartment, Anstey had seen when it stole the thunder of Eisenstein's *Battleship Potemkin* at a London Film Society premiere a few years before. Anstey had been among an audience that included H. G. Wells and George Bernard Shaw, all of whom had sat electrified by the film's portrayal of working people.

'So you want to work in documentary, eh?' were the first words that Grierson addressed to the young man, who talked nervously about his presence at the premiere, his views on mass communication and his interest in the Russian film-makers Dziga Vertov and Sergei Eisenstein. He talked for so long that Grierson did not have time to interview anyone else that afternoon. The post was his – if only due to his 'obstinacy', Grierson said later – and Anstey was immediately put to work helping to edit Robert Flaherty's *Industrial Britain* (1931) in the basement of Grierson's Merrick Square house, working long hours and sometimes sleeping in one of a pair of spare bunks, while Grierson did the rounds at lights out 'to see that all was well with his ship's company'. Grierson had served as a telegraphist on a minesweeper during World War I and brought something of the same boots-on-the-ground energy to his film-making, snapping his fingers as he asked for a specific shot, while Anstey rummaged in the cutting-room bins, not sure it even existed. 'I knew I was attempting the impossible and that Flaherty had never even shot it,' he later told an interviewer, but 'I had begun to learn that miracles must be man-made. "Tell a lie today and make it come true tomorrow" was a precept I was offered very early in our association.'

The film was one of several that Grierson produced in his capacity as assistant films officer of the Empire Marketing Board, where he helped usher a generation of documentary film-makers – Flaherty, Humphrey Jennings, Anstey himself – 'from studio interiors . . . into the open air'. The first to coin the term 'documentary', Grierson was not a purist about the form, which he called 'a creative treatment of actuality'. It was about giving creative shape to reality, not reproducing it. 'Art is not a mirror,' he used to say, 'but a hammer. It is a weapon in our hands to see and say what is good and right and beautiful.' He admired only one politician, Leon Trotsky, 'because Trotsky understood art as well as politics'. In 1938, the Canadian government invited Grierson to Canada to help create the National Board of Film, and he acted as its first commissioner, importing film-makers such as Norman McLaren to make films in the series *Canada Carries On* and *The World in Action*, which reached an audience of millions in Canadian and American cinemas. Years later, in 1954, he sold the latter title to the newly appointed chairman of Granada TV, Denis Forman, who was looking for a name for the company's proposed new flagship current-affairs programme.

'Forman wanted *World in Action* to have a film identity,' says Greengrass. 'That's why it didn't have reporters. That's why it was shot on film. When I got to *World in Action*, I was ready to try and find my own synthesis of all of those elements. It had the strong, observational documentary film-making heritage, going back to Grierson. You can see it in many *World in Action*s: the straight observational film, the lack of the mediated reporter, the world in action. It also had the tradition, which was a bit later but came to be part of its DNA, which was the sort of investigative thing on film. And then it had the agitprop political thing, which wasn't just left-wing, it was also anti-metropolitan – "Fuck London." The north-west had tremendous confidence, born of it being the heartland of industrial Britain going back two hundred years, to having been at the heart of war efforts in two world wars, to having been at the heart of the great cultural explosion of the sixties with the Beatles and all the rest of it. Attitude, basically . . . Television was a window on the world in an important way in the sixties. I can remember that very vividly.'

The medium of cinema began on two parallel tracks. On one were the films of the Lumière brothers, who pointed their cameras at reality – a train coming right at the camera, a family feeding a child – and delivered it right into their audience's laps. 'It's life itself!' they said of their short film *Workers Leaving the Factory* (1895). On the other was Marie-Georges-Jean Méliès, who exploited the camera's potential for magic, fiction and *trompe l'oeil* trickery in such films as *A Trip to the Moon* (1902), *Kingdom of the Faeries* (1903) and *20,000 Leagues Under the Sea* (1907). But, in truth, the two tracks are not parallel, but convergent. No documentary, whatever its claims to objective reportage, is ever devoid of manipulation, since a controlling hand is evident in even the most routine matters of camera placement and shot selection. And the opposite is also true. 'Every film is a documentary of its actors,' said Jean-Luc Godard, an aphorism finessed by Jacques Rivette to include not just actors, but everything that is in front of the camera at the moment the film is running. 'I don't make the distinction between my documentaries and my dramatic films,' Martin Scorsese has said. 'How can I distinguish between them?'

So, too, with the films of Paul Greengrass. What is most interesting about his career is that even though his documentary work precedes his feature film-making career chronologically, it is not subservient to it. The two tracks of his career carry equal weight, both with him and on the screen. From the beginning his journalism seeded his features: his encounter with Falklands War deserter Philip Williams evolved into his first dramatic feature, *Resurrected*; his meeting with hunger striker Raymond McCartney fed into *Bloody Sunday*; his partnership with retired spy Peter Wright and immersion in the 'secret world' spawned two of the greatest spy action thrillers of the modern era, *The Bourne Supremacy* and *The Bourne Ultimatum*. He is not a documentary film-maker who made it in Hollywood and never looked back. He has brought to his feature films a methodology forged on the streets of Belfast and Beirut to capture difficult, elusive subjects in the heat of the moment, and lent his features the urgency and scalding immediacy of actual events, happening *now*. In doing so, he has reinvigorated the grammar of Hollywood action movies.

And for every Hollywood feature he has made – first the Bourne films, later *Green Zone* and *Captain Phillips* – he has returned to the docudrama form with which he first made his name, making factual procedurals like *United 93* and *22 July* that feel every bit as urgent as his thrillers. At his best, his fictions hit as hard as his facts, and his factual films have the dramatic shape of good fiction.

'I think I have operated on a spectrum on that porous frontier between fact and fiction,' he says. 'I've explored various positions in it, but that's been my territory. And each project has ended up sitting in a different place in that territory. I'm much more struck at my age now at the continuities than the disjunctions. *World in Action*, as we know, was that strange, wonderful, riotous amalgamation of journalism and film-making and agitprop. It was those three things. And all the years since have been my working-out of that triangulation. Take out any one of those, and I don't think you'd end up with a film by me. When I think of the Bourne films, they were that same triangulation of attitude, fact and film-making. Okay, it was a big, commercial, popcorn movie, but I felt I could root it more strongly in the real world, even though it was a preposterous fiction. I gave it a bit more attitude, a bit more rooting, a bit more expansive film-making pizzazz. *Supremacy* had a flow, I suppose, that all of them had. I can remember sitting in the theatre at Babelsberg, where my first rushes were screened, and feeling like I had come home. There's a reason why my style is sort of as it is, because it's how I express myself with a camera, and I've come full circle to embrace it now.'

His run-and-gun technique was never quite as newfangled as critics thought. It has a long history, going back to the 1960s – *Medium Cool*, *Seven Days in May*, *Dr Strangelove* and the dramas of John Cassavetes – but it had never felt as fluid and expressive as it did in Greengrass's hands, because it came rooted in his own experience. It was how he saw the world, and it only came after many years of hard battle with himself, trying to be something he was not, before realising what he was. 'It was imperative, essential that I learned the classical grammar of film-making – which took me quite a long time, because it takes you time to learn it and know it and shoot a schedule and not get into trouble – but the greater

challenge for me was having learned all that stuff, then to marry it with my past. That was what I was struggling to do, and finally did with *The Murder of Stephen Lawrence* and *Bloody Sunday.* Then what I did was to take that marriage into the Hollywood mainstream, which I think is what the Bourne films achieved. Now, for me, it's all about, "Well, what do you do once you've done all that? What's next?" Those are the questions that I ask myself. And I think the answer is, "You please yourself."'

That doesn't mean a push towards the woolly shores of esoterica, but urgent, well-told stories that speak to our contemporary reality, with something of the excitement he first felt when watching David Lean's *Doctor Zhivago*, aged ten, with his father, at the old Empire, in Leicester Square. 'My engagement with that movie, the images and sound of it, was transformative,' he says. 'I think it's foundational for many film-makers, in my limited knowledge of talking to other film-makers. There's something about getting that mainline thing, if you're a bit of a lonely, insecure kid, because it goes *bang!* And everything else, you're trying to replicate that. It's that ability to make a film that moves, and I don't just mean moves you emotionally, but also which *moves.*

'I don't think of myself as a commercial film-maker, in the sense that I do it for money or in order for my films to make money, because those things never cross my mind. But I think my storytelling instincts are direct and clear and economical, and about being eye level with a big audience. I've never been interested in cinema standing next to the National Theatre and the Royal Opera House. I always want it to be out in the streets. I remember having one conversation with Spielberg after *Lincoln* came out. He said, "That's my theme. My theme is America, and that's how it is." You can see that. He's got a very clear sense of what his theme is, and he expresses it through so many genres and styles. It's remarkable. He is the absolute last of the great, great classical movie-makers, making films in all genres, in all ways – science fiction, history, dramas, adventures . . . I mean, everything. I'm not made like that. You have to just be who you are, because you can't be everything. My theme is, "What's going on?" That's always my theme. "The world in action" is my theme. I worked on the programme, and now I make films about it.

When I'm starting out on the journey to make a film, it's always, "What's going on?" If you look at that phrase, by the way – "the world in action" – the world is what you'd call the journalist, and action is what my films are like, aren't they? They're all the world in action.'

ACKNOWLEDGEMENTS

My thanks go first and foremost to Paul Greengrass, for his time, generosity, patience and collaborative spirit in the writing and production of this book; his wife Joanna, for her kindness and hospitality; Amy Lord, for her enormous help with research; my wife Kate and daughter Juliet, for their patience and contributions; my agent Emma Parry, for her wise counsel and hard work; author James Fox, for his insights into the Rolling Stones; Anthony Suau, for permission to use one of his photographs; Glen Roberts at the US Defense Department's public affairs office, for his assistance with fact-checking; Ian Bahrami, for his eagle-eyed copy-editing; Paige Woodward, for her invaluable help with some of the images; and my editor Walter Donohue, for his editorial wisdom, deep knowledge and appreciation of all aspects of movie-making that have made Faber's film list the world standard.

FILMOGRAPHY

DOCUMENTARIES

'Munich Twenty Years On', *World in Action* (1978)
'Ally's a Lancashire Lad', *World in Action* (1978)
'The Huyton Boys', *World in Action* (1978)
'Mr Kane's Campaign', *World in Action* (1980)
'The Road to Brighton Pier', *World in Action* (1980)
'The "H" Block Fuse', *World in Action* (1980)
'The Man Who Bought United', *World in Action* (1980)
'Russian Games', *World in Action* (1980)
'The White House General', *World in Action* (1981)
'The Curse of the Klan', *World in Action* (1981)
'The Discarded People', *World in Action* (1981)
'Britain's Other Islanders', *World in Action* (1982)
'Private Darkin's Army', *World in Action* (1982)
'Britain on the Brink', *World in Action* (1982)
'The Reluctant Ally', *World in Action* (1982)
'The Spoils of Peace', *World in Action* (1982)
'Operation Peace for Galilee', *World in Action* (1982)
'The System Builder', *World in Action* (1983)
'Your Home in Their Hands', *World in Action* (1983)
'A Farewell to Arms Control', *World in Action* (1983)
'The Spy Who Never Was', *World in Action* (1984)
'New Plans for Coal', *World in Action* (1984)
'Your Starter for Life', *World in Action* (1984)
'A Song for Africa', *World in Action* (1985)
'Civil Unrest', *World in Action* (1985)
'The Knock on the Door', *World in Action* (1985)
'The Swan and the Plough', *World in Action* (1985)

'A Song for Africa', *World in Action* (1985)
'The Widow's Crusade', *World in Action* (1986)
'The Untouchable', *World in Action* (1986)
Food and Trucks and Rock 'n' Roll: The Official Band Aid Documentary,
 Granada TV (1986)
'Bradwell Says No', *World in Action* (1986)
'The Road to Mexico 86', *World in Action* (1986)
'U2: Anthem for the Eighties', *World in Action* (1987)
'Coppers', *Cutting Edge* (1992)
'Remember Kathleen', *The Late Show* (1992)
'Inside the Lubianka', *The Late Show* (1992) ·
'Looking for Irena', *The Late Show* (1992)
'Pibe de Oro – Diego Maradona', *The Late Show* (1992)
'Whatever Happened to Woodward and Bernstein', *The Late Show* (1992)
'Zagorsk', *The Late Show* (1993)
Cutting Edge (1992)
Crime Story (1993)

TELEVISION DRAMAS

When the Lies Ran Out: The Ian Spiro Story (1993; awards: Chicago Film
 Festival 1994, Silver Medal; International Monitor Awards 1994, Best
 Director for Original TV Drama)
Open Fire (1994)
'The Sweetest Thing', *Kavanagh QC* (1995)
Sophie's World (1995)
The One That Got Away (1996)
The Fix (1997)
The Murder of Stephen Lawrence (1999; awards: BAFTA, Best Single
 Drama, 2000; BANFF TV Festival, Special Jury Prize, 2002; Race in the
 Media Awards, Best Drama, 2002)
Omagh (2004; awards: BAFTA TV Award, Best Single Drama; Royal
 Television Society, Best Actor, 2005; Film Fleadh, New York, Best
 Feature Film, 2005; Discovery Critics Award, Toronto Film Festival,
 2004; San Sebastián Film Festival, Best Screenplay, Jury Award for
 Best Screenplay, CICAE Award for Best European Film, 2004; Royal
 Television Society Craft and Design Awards, Visual FX Award, 2004;
 Irish Film and Television Awards, Best Irish Film, 2004; CICAE
 Arthouse Cinema Award, Best European Film; nominated, Irish Film
 and Television Awards, Best Script; nominated, RTS Television Award,
 Best Writer)

Resurrected (1989), directed by Paul Greengrass, written by Martin Allen, cinematography by Ivan Strasburg, starring David Thewlis, Rudi Davies, Tom Bell, Rita Tushingham, produced by Adrian Hughes and Tara Prem, distributed by Castle Pictures. Awards: OCIC Winner, Berlin Film Festival, 1989; Interfilm Awards, Berlin Film Festival, 1989; nominated, Golden Bear, Berlin Film Festival, 1989.

The Theory of Flight (1998), directed by Paul Greengrass, written by Richard Hawkins, cinematography by Ivan Strasburg, starring Kenneth Branagh, Helena Bonham Carter, Anant Singh, produced by Ruth Caleb, Anant Singh and Helena Spring, distributed by Miramax. Awards: Brussels Film Festival, Gold Medal and Best Foreign Film, 1999.

Bloody Sunday (2002), directed by Paul Greengrass, written by Paul Greengrass, cinematography by Ivan Strasburg, starring James Nesbitt, Timothy Pigott-Smith, Nicholas Farrell, Gerard McSorley, Kathy Kiera Clarke, produced by Mark Redhead, distributed by Paramount Classics. Awards: Berlin Film Festival, Golden Bear, 2002; Sundance Film Festival, World Cinema Audience Award, 2002; Selected, New York Film Festival, 2002; Sydney Film Festival, Audience Award, 2002; Jerusalem Film Festival, Spirit of Freedom Award, 2002; Oporto Film Festival, Portugal, Best Film and Audience Award, 2002; Motovun Film Festival, Croatia, Best Film, 2002; Dinard Film Festival, France Hitchcock D'Or Best Film Award, 2002; Cinnessone Film Festival, France, Best Film, 2002; Nordvyck Film Festival, Best Film, 2002; Best Director, British Independent Film Awards, 2002; Dinard British Film Festival, Golden Hitchcock; Fantasporto Directors Week Award, Best Film; Fantasporto, Audience Jury Award; Irish Film and Television Awards, Best Director of a Feature Film; Irish Film and Television Awards, Best Script; Freedom of Expression Award; Rio de Janeiro International Film Festival, Best European Film, FIPRESCI prize, UIP Prize; Sundance Film Festival Audience Award, World Cinema; nominated, BAFTA TV award, Best Single Drama; nominated, Best Film and Best Screenplay, European Film Awards, 2002; nominated, Critics Choice Award, Best Director; nominated, Critics Choice Award, Best Picture; nominated, Best Non-American Film, Robert Festival; nominated, RTS Television Award, Best Writer; nominated, Golden Satellite Awards, Best Motion Picture, Foreign Language Film.

The Bourne Supremacy (2004), directed by Paul Greengrass, written by Tony Gilroy, cinematography by Oliver Wood, starring Matt Damon, Brian

Cox, Joan Allen, Karl Urban, Julia Stiles, Franka Potente, Gabriel Mann, produced by Frank Marshall, Patrick Crowley and Paul L. Sandberg, distributed by Universal Pictures. Awards: Best Film, *Empire* Awards, 2005; nominated, *Empire* Awards, Best British Director, Scene of the Year, 2005; nominated, Academy of Science Fiction, Fantasy and Horror – Saturn Awards, Best Action/Adventure/Thriller Film; nominated, Cinema Audio Society, Best Motion Picture; nominated, Critics Choice Awards, Best Popular Movie; nominated, Moviefone Moviegoer Awards, The Greatest Moment; nominated, People's Choice Awards, Top 3 Nominees for Favorite Movie Drama; nominated, USC Scripter Award, Top 5 Finalists; nominated, London Film Critics' Circle Awards, British Director of the Year.

United 93 (2006), directed by Paul Greengrass, written by Paul Greengrass, cinematography by Barry Ackroyd, starring Christian Clemenson, Cheyenne Jackson, David Alan Basche, Peter Hermann, Khalid Abdalla, produced by Paul Greengrass, Tim Bevan, Eric Fellner and Lloyd Levin, distributed by Universal Pictures. Awards: BAFTA, Best Direction, David Lean Award, 2007; Dallas–Fort Worth Film Critics Association, Best Picture Award; London Film Critics' Circle Awards, Best Director, Producer and Film of the Year; New York Film Critics' Circle Awards, Best Film; Los Angeles Film Critics Association, Best Director; The *South Bank Show* Awards, Best Film; London *Evening Standard* Awards, Best Film; Boston Society of Film Critics, Best Ensemble Cast, Film and Director; Washington Film Critics Association, Best Film; Austin Film Critics Association Award, Best Film; AA San Francisco Critics' Circle, Best Film and Best Director; Kansas City Film Critics' Circle, Best Film; Utah Film Critics Association, Best Film; American Film Institute Award, Movie of the Year, 2007; *Total Film* Readers Award, Best Director; *Empire* Awards, Best British Film, 2007; London Film Critics' Circle Awards, Director of the Year, British Producer of the Year, Film of the Year; New York Film Critics' Circle Awards, Best Film; Online Film Critics Society Award, Best Picture; Washington DC Area Film Critics Association Awards, Best Director, Best Film; Boston Society of Film Critics Awards, 2nd Place, Best Director; Ivea Clarion Award, 2006; nominated Academy Awards, 2007, Best Director; nominated Writers Guild of America, Best Original Screenplay; nominated, Alexander Korda Award for Best British Film; nominated, BAFTA, Best Screenplay; nominated Irish Film and Television Awards, Best International Film; nominated, Columbus Film Critics Association Award, Best Picture; nominated, Chicago Film Critics Association Awards, Best Picture,

Best Director, Best Screenplay; nominated, Bodil, Best American Film; nominated, *Empire* Awards, Best Film; nominated, Online Film Critics Society Awards, Best Screenplay, Best Director; nominated, Toronto Film Critics Association Awards, Best Director, Best Picture.

The Bourne Ultimatum (2007), directed by Paul Greengrass, written by Tony Gilroy, Scott Z. Burns and George Nolfi, cinematography by Oliver Wood, starring Matt Damon, Joan Allen, David Strathairn, Julia Stiles, Scott Glenn, Albert Finney, Paddy Considine, Edgar Ramirez, produced by Frank Marshall, Patrick Crowley and Paul L. Sandberg, distributed by Universal Pictures. Awards: *Empire* Awards, Best Film; London Film Critics' Circle Awards, Best Director; Richard Attenborough Public Vote Award 2007; Jupiter Awards, Best Director; London Critics' Circle Film Awards, British Director of the Year; National Board of Review Awards, Top Ten Films; nominated, BAFTA, Best Director; nominated, BAFTA for Outstanding British Film; nominated, Academy of Science Fiction, Fantasy and Horror – Saturn Awards, Best Director; nominated, David Lean Award for Direction; nominated, Alexander Korda Award for Best British Film; nominated, *Empire* Awards, Best Director, Best Thriller; nominated, Irish Film and Television Academy Awards, Best International Film; nominated, London Critics' Circle Film Awards, Best Film of the Year.

Green Zone (2010), directed by Paul Greengrass, written by Brian Helgeland, cinematography by Barry Ackroyd, starring Matt Damon, Greg Kinnear, Brendan Gleeson, Amy Ryan, Khalid Abdalla, Jason Isaacs, produced by Paul Greengrass, Tim Bevan, Eric Fellner and Lloyd Levin, distributed by Universal Pictures. Awards: nominated, AARP Movies for Grownups Awards, Best Director.

Captain Phillips (2013), directed by Paul Greengrass, written by Billy Ray, cinematography by Barry Ackroyd, starring Tom Hanks, Barkhad Abdi, produced by Scott Rudin, Dana Brunetti, Gregory Goodman and Michael De Luca, distributed by Sony Pictures. Awards: American Film Institute Awards, Movie of the Year; nominated, Academy Awards 2014, Best Picture; nominated, BAFTA Awards, Best Direction, 2014; nominated, Directors Guild of America, Outstanding Directing; nominated, Golden Globe Awards, Best Director; nominated, Australian Academy of Cinema and Television Arts Awards, International Award for Best Direction; nominated, Broadcast Film Critics Association Awards, Best Director; nominated, AARP Movies for Grownups Awards, Best Director; nominated, Danish Film Awards, Best American

Film; nominated, Awards Circuit Community Awards, Best Director; nominated, Denver Film Critics Society Awards, Best Director; nominated, Detroit Film Society Awards, Best Director; nominated, Houston Film Critics Society Awards, Best Director; nominated, IGN Summer Movie Awards, Best Director; nominated, Jupiter Awards, Best Director; nominated, London Film Critics' Circle Awards, Best Director; nominated, New York Film Festival, Grand Marnier Fellowship Award, Best Film; nominated, Phoenix Film Critics Society Awards, Best Director; nominated, *Empire* Awards, Best Director; nominated, Satellite Awards, Best Director.

Jason Bourne (2016), directed by Paul Greengrass, written by Paul Greengrass and Christopher Rouse, cinematography by Barry Ackroyd, starring Matt Damon, Alicia Vikander, Tommy Lee Jones, Julia Stiles, Riz Ahmed, produced by Frank Marshall, Jeffrey M. Weiner, Ben Smith, Matt Damon, Paul Greengrass and Gregory Goodman, distributed by Universal Pictures. Awards: *Empire* Awards, Best Thriller; nominated, Academy of Science Fiction, Fantasy and Horror – Saturn Awards, Best Thriller; nominated, Broadcast Film Critics Association, Best Action Movie; nominated, Locarno International Film Festival, Variety Piazza Grande Award.

22 July (2018), directed by Paul Greengrass, written by Paul Greengrass, cinematography by Pål Ulvik Rokseth, starring Anders Danielson Lie, Thorbjørn Harr, Jon Øigarden, produced by Scott Rudin, Eli Bush, Gregory Goodman and Paul Greengrass, distributed by Netflix. Awards: National Board of Review, Freedom of Expression Award; Cinema for Peace Award, Most Valuable Film of the Year 2019; Venice Film Festival, SIGNIS Awards – Honourable Mention, Paul Greengrass; Mill Valley Film Festival Award; nominated, Venice Film Festival, Golden Lion, Best Film.

News of the World (2019), directed by Paul Greengrass, written by Paul Greengrass and Luke Davies, cinematography by Dariusz Wolski, starring Tom Hanks, Helena Zengel, produced by Gary Goetzman, Gregory Goodman and Gail Mutrux, distributed by Netflix/Universal. Awards: National Board of Review, Best Adapted Screenplay, Top Ten Films; Phoenix Film Critics Society Awards, Top Ten Films; Movieguide Award 2020; nominated, WGA Awards, Best Adapted Screenplay; nominated, Satellite Awards, Best Adapted Screenplay; nominated, Broadcast Film Critics Association Awards, Best Picture; nominated, Broadcast Film Critics Association Awards, Best Adapted Screenplay;

nominated, Houston Film Critics Society, Best Film, Best Adapted
Screenplay.

The Lost Bus (2024), directed by Paul Greengrass, written by Paul
Greengrass and Brad Ingelsby, cinematography by Pål Ulvik Rokseth,
starring Matthew McConaughey, America Ferrera, produced by Jason
Blum, Jamie Lee Curtis and Gregory Goodman, distributed by Apple
Films.

OTHER AWARDS
Alan Clarke Award for Outstanding Creative Contribution to Television,
BAFTA Awards, 2005
Variety UK Achievement in Film Award, 2007
Ghent International Film Festival, Joseph Plateau Honorary Award, 2010
American Cinema Editors, Golden Eddie Award, 2014
British Film Institute, Fellowship, 2017
Gotham Awards, Tribute Award, 2018
Chicago Film Festival, Career Achievement Award, 2018
America Abroad Media, Power of Film Award, 2018

BIBLIOGRAPHY

Works cited in this book include:

Beattie, Keith (ed.), *Albert and David Maysles Interviews*, University Press of Mississippi, 2010

Beaumont, Peter, 'The Truth About Twitter, Facebook and the Uprisings in the Arab World', *Guardian*, February 2011

Blum, Howard, *In the Enemy's House: The Secret Saga of the FBI Agent and the Code Breaker Who Caught the Russian Spies*, Harper, 2018

Bordwell, David, 'Unsteadicam Chronicles', Davidbordwell.com, August 2007

—— '[insert your favorite Bourne pun here]', Davidbordwell.com, August 2007

'*The Bourne Supremacy*: An Interview with Matt Damon', *Blackfilm*, July 2004

Bronner, Michael, '9/11 Live: The NORAD Tapes', *Vanity Fair*, August 2006

Brown, Mick, 'Straight Shooting', *Daily Telegraph*, August 2007

Campbell, Duncan, 'Somebody's Listening', *New Statesman*, August 1988

Cathcart, Brian, *The Case of Stephen Lawrence*, Penguin, 2000

Cox, Brian, *Putting the Rabbit in the Hat*, Grand Central Publishing, 2022

Darghis, Manohla, 'Just Try to Stop Bourne', *Los Angeles Times*, July 2004

De Lillo, Don, *Libra*, Penguin Books, 1991

—— *Underworld*, Scribner, 2003

Deignan, Tom, 'The Making of *Bloody Sunday*', *Irish America*, December/January 2003

Denby, David, 'Dazzled', *The New Yorker*, July 2000

—— 'War Wounds', *The New Yorker*, August 2007

Desowitz, Bill, '"News of the World": How the Editor of Tom Hanks' Western Helped Shape an Emotional Story', *Indiewire*, February 2021

Drumheller, Tyler, and Elaine Monaghan, *On the Brink: A Former CIA Chief Exposes How Intelligence Was Distorted in the Build-Up to the War in Iraq*, PublicAffairs, 2008

Ebert, Roger, 'The Shaky–Queasy Ultimatum', Rogerebert.com, August 2007

Eisenberg, Eric, 'Tom Hanks and Paul Greengrass Fundamentally Disagreed about One Very Important Aspect of *News of the World*', *Cinemablend*, December 2020

'Exclusive Interview with *Captain Phillips* Star Barkhad Abdi', *The Source*, October 2013

Fear, David, 'Paul Greengrass: Why I Needed to Make *22 July*', *Rolling Stone*, October 2018

Fishman, Steve, 'The Liman Identity', *New York Magazine*, January 2008

Galloway, Stephen, 'Inside the Intense "Captain Phillips" Shoot: Tom Hanks' "Mental Stress," His Co-Star's Horrific Backstory and a "Scary" First Day on Set', *Hollywood Reporter*, September 2013

Giardina, Carolyn, '*Captain Phillips*' Editor Chris Rouse on Creating Chaos', *Hollywood Reporter*, October 2013

Goldstein, Gregg, 'What It's Really Like to Work for Kathleen Kennedy and Frank Marshall', *Variety*, November 2018

Gordon, Giles, *Aren't We Due a Royalty Statement?*, Chatto & Windus, 1993

Greengrass, Paul, 'The Old Spy Kept His Cloak On to the Last', *Financial Times*, January 1995

Greengrass, Paul, and Peter Wright, *Spycatcher*, Bantam Doubleday, 1987

Gross, Terry, 'Tom Hanks Is Captain Phillips in High-Seas Hostage Drama', NPR, October 2013

Helgeland, Brian, 'Screenwriters' Lecture', bafta.org, October 2012

Hirshberg, Jack, *A Portrait of* All the President's Men*: The Story Behind the Filming of the Most Devastating Detective Story of the Century*, Warner Books, 1976

Hullfish, Steve, 'Art of the Cut with Oscar-Winning Editor, William Goldenberg', *Pro Video Coalition*, January 2021

Jones, Judith, and Stephen Kelly, 'Leslie Woodhead Interviewed', Granadaland.com, March 2015

Kelly, Stephen, 'Paul Greengrass Transcript', Granadaland.com, May 2020

Lambie, Ryan, 'Barry Ackroyd: The Cinematography of *Captain Phillips* and More', *Den of Geek*, February 2014

Lane, Anthony, 'Dangerous Waters', *The New Yorker*, October 2013

Lazar, Zohar, and Amy Wallace, 'Wicked Smart', *GQ*, January 2011

Lim, Dennis, 'Matt Damon: You Could Call Him Down to Earth', *New York Times*, October 2009

Lumet, Sidney, *Making Movies*, Vintage Books, 1996

Macintyre, Ben, *A Spy Among Friends*, Bloomsbury, 2014

Manly, Lorne, 'Why Matt Damon and Paul Greengrass Couldn't Quit Jason Bourne', *New York Times*, July 2016

Max, D. T., 'Twister', *The New Yorker*, March 2009

Mitchell, Elvis, 'Bloody Sunday in Londonderry', *New York Times*, October 2002

Mullan, Don, *Eyewitness Bloody Sunday: The Truth*, Merlin Publishing, 2002

Nesbitt, James, 'Growing Up, I Knew What Bloody Sunday Meant', *Independent*, June 2010

Otto, Jeff, 'Interview: Matt Damon', ign.com, May 2012

Perez, Rodrigo, 'Interview: Tom Hanks & Paul Greengrass Talk *Captain Phillips* & the Raw Acting Ability of Barkhad Abdi', *Indiewire*, January 2014

Peters, Oliver, 'Interview with Christopher Rouse, *The Bourne Ultimatum*', digitalfilms, August 2007

Phegley, Kiel, 'Inside the Other "Watchmen" Movie', *Comic Book Resources*, September 2010

Phillips, Richard, *A Captain's Duty: Somali Pirates, Navy SEALS and Dangerous Days at Sea*, Hyperion, 2010

Radish, Christina, 'Tom Hanks Talks *Captain Phillips*', *Collider*, October 2013

Richards, Keith, *Life*, Back Bay Books, 2011

Romney, Jonathan, 'Film of the Week: *Captain Phillips*', *Film Comment*, October 2013

'ScoreKeeper Talks to Composer John Powell about *Bourne, X3, United 93, Happy Feet*, and . . . *Mad Max: Fury Road*!?!?', *Ain't It Cool News*, December 2006

Sexton, Jamie, 'Televérité Hits Britain: Documentary Drama and the Growth of 16mm Filmmaking in British Television', *Screen*, winter 2003

Sharf, Zack, '"Watchmen", Screenwriter Sheds Light on Darren Aronofsky, Paul Greengrass' Movie Plans', *Indiewire*, July 2020

Weintraub, Steven, 'Matt Damon Interview – *The Bourne Ultimatum*', *Collider*, July 2007

Wills, Garry, 'Entangled Giant', *New York Review of Books*, October 2009

Woodward, Bob, *The Secret Man: The Story of Watergate's Deep Throat*, Simon & Schuster, 2006

Zaretsky, Robert, 'Donald Trump and the Myth of Mobocracy', *The Atlantic*, July 2016

Books I found useful while writing this one include:

Allen, Richard, *Skinhead*, Dean Street, 2015

Anderson, Jon Lee, *Che: A Revolutionary Life*, Grove, 2010

Bernstein, Carl, and Bob Woodward, *All the President's Men*, Simon & Schuster, 2014

Biskind, Peter, *Star: How Warren Beatty Seduced America*, Simon & Schuster, 2010

Bloom, Clive, *Riot City: Protest and Rebellion in the Capital*, Palgrave Macmillan, 2012

Booth, Stanley, *The True Adventures of the Rolling Stones*, Chicago Review Press, 2000

Brinkley, Douglas, and Luke A. Nichter, *The Nixon Tapes*, Harper, 2016

Brody, Richard, *Everything Is Cinema: The Working Life of Jean-Luc Godard*, Picador, 2009

Brown, Jared, *Alan Pakula: His Films and His Life*, Back Stage Books, 2005

Brownlow, Kevin, *David Lean: A Biography*, St Martin's Press, 1996

Buford, Bill, *Among the Thugs*, Vintage, 1993

Bulgakowa, Oksana, *Sergei Eisenstein: A Biography*, PotemkinPress, 2002

Buskin, Richard, *Inside Tracks*, PerfectBound, 1999

Callan, Michael Feeney, *Robert Redford: The Biography*, Knopf Doubleday, 2012

Capa, Robert, *Slightly Out of Focus*, Modern Library, 2001

Chandrasekaran, Rajiv, *Imperial Life in the Emerald City*, Vintage, 2007

Cheney, Dick, *In My Time: A Personal and Political Memoir*, Threshold Editions, 2012

Greenfield, Robert, *Exile on Main Street: A Season in Hell with the Rolling Stones*, Da Capo Press, 2008

Gregory, Richard L., *Eye and Brain: The Psychology of Seeing*, Princeton University Press, 1997

Grierson, John, *Grierson on Documentary*, Praeger, 1971

Guevara, Ernesto 'Che', *Guerrilla Warfare*, CreateSpace Independent Publishing Platform, 2013

Harris, Mark, *Five Came Back: A Story of Hollywood and the Second World War*, Penguin Press, 2014

Hayden, Michael, *Playing to the Edge: American Intelligence in the Age of Terror*, Penguin Books, 2017

Hull, Christopher, *Our Man Down in Havana: The Story Behind Graham Greene's Cold War Spy Novel*, Pegasus Books, 2019

Jacobsen, Annie, *Surprise, Kill, Vanish: The Secret History of CIA*

Paramilitary Armies, Operators and Assassins, Little, Brown and Company, 2019

Johnson, Lizzie, *Paradise: One Town's Struggle to Survive an American Wildfire*, Crown, 2021

Kaplan, Fred, *Dark Territory: The Secret History of Cyber War*, Simon & Schuster, 2017

Kaye, Harvey J., *Thomas Paine and the Promise of America*, Hill and Wang, 2006

Keller, Helen, *The Story of My Life*, CreateSpace Independent Publishing Platform, 2018

Khoury, George et al., *The Extraordinary Worlds of Alan Moore*, TwoMorrows Publishing, 2003

Lançon, Philippe, *Disturbance: Surviving Charlie Hebdo*, Europa Editions, 2019

Lane, Mark, *Rush to Judgment: A Critique of the Warren Commission Inquiry into the Murders of President John F. Kennedy, Officer J. D. Tippit and Lee Harvey Oswald*, Holt Rinehart Winston, 1966

Le Bon, Gustave, *The Crowd: A Study of the Popular Mind*, Loki's Publishing, 2016

Le Carré, John, *Tinker Tailor Soldier Spy*, Penguin Books, 2011

Levin, Mark R., *Unfreedom of the Press*, Threshold Editions, 2019

Ludlum, Robert, *The Bourne Identity*, Bantam, 2010

—— *The Bourne Supremacy*, Bantam, 2012

McCann, Eamonn, *War and an Irish Town*, Pluto Press, 1993

Mackay, Charles, *Extraordinary Popular Delusions and the Madness of Crowds*, CreateSpace Independent Publishing Platform, 2011

McLane, Betsy A., *A New History of Documentary Film*, Continuum, 2012

McMullen, Don, *Unreasonable Behaviour*, Grove Press, 2017

Martin, David C., *Wilderness of Mirrors: Intrigue, Deception, and the Secrets that Destroyed Two of the Cold War's Most Important Agents*, Lyons Press, 2003

Mason, Paul, *It's Kicking Off Everywhere: The New Global Revolutions*, Verso, 2012

Moore, Charles, *Margaret Thatcher: Herself Alone*, Knopf, 2019

Mueller, Robert S., *The Mueller Report: The Final Report of the Special Counsel Investigation of Donald J. Trump*, Skyhorse, 2019

The 9/11 Commission Report: Final Report of the National Commission on Terrorist Attacks Upon the United States, W. W. Norton & Company, 2004

Orwell, George, *Nineteen Eighty-Four*, Signet Classic, 1961

Philby, Kim, *My Silent War: The Autobiography of a Spy*, Random House, 2002

Pincher, Chapman, *Their Trade Is Treachery*, Dialogue, 2015

Pontecorvo, Gillo, *Pontecorvo's* The Battle of Algiers: *The Complete Scenario*, Scribner, 1973

Sandbrook, Dominic, *Seasons in the Sun: Britain 1974–1979*, Penguin UK, 2013

Seierstad, Åsne, *One of Us: The Story of Anders Breivik and the Massacre in Norway*, Farrar, Straus and Giroux, 2015

Selvin, Joel, *Altamont: The Rolling Stones, the Hells Angels, and the Inside Story of Rock's Darkest Day*, HarperEnt, 2017

Sharps, Matthew J., *Processing Under Pressure*, Looseleaf Law Publications, 2009

Shone, Tom, *Martin Scorsese: A Retrospective*, Abrams, 2014

Smith, R. J., *American Witness: The Art and Life of Robert Frank*, Da Capo Press, 2017

Snowden, Edward, *Permanent Record*, Metropolitan Books, 2019

Surowiecki, James, *The Wisdom of Crowds*, Anchor, 2005

Suskind, Ron, *The Way of the World: A Story of Truth and Hope in an Age of Extremism*, Harper, 2008

Trento, Joseph J., *The Secret History of the CIA*, Basic Books, 2005

Turnbull, Malcolm, *The Spycatcher Trial*, Salem House, 1989

Wilkman, Jon, *Screening Reality: How Documentary Filmmakers Reimagined America*, Bloomsbury Publishing, 2020

Williams, Richard, *The Death of Ayrton Senna*, Viking, 2010

Woodward, Bob, *Veil: The Secret Wars of the CIA, 1981–1987*, Simon & Schuster, 2005

Yapp, Nick, *Camera in Conflict*, Konemann, 1996

Zapruder, Alexandra, *Twenty-Six Seconds: A Personal History of the Zapruder Film*, Twelve, 2016

PICTURE CREDITS

INTRODUCTION

p. 1: Secret Eyes Only, National Security Archive; photo Tom Shone; p. 8: Press passes montage, courtesy of Paul Greengrass.

1: CONFLICT

p. 17: B-52 bomber, Geoff McKay, Flickr Commons; p. 21: PG in South Africa in 1981, courtesy of Paul Greengrass; p. 24: still from 'Discarded People', courtesy of Granada TV; p. 28: Joyce Greengrass, courtesy of Paul Greengrass; p. 29: Phillip Greengrass, courtesy of Paul Greengrass; p. 39: Gillo Pontecorvo's *The Battle of Algiers*, Wikimedia Commons; p. 42: Mick Jagger performing, courtesy of the Library of Congress.

2: CONSPIRACY

p. 46: Watergate Hotel, David Wilson, Creative Commons; p. 49: PG in Washington, DC, courtesy of Paul Greengrass; pp. 54–5: 'Table of Contents', Rockefeller Commission, Investigation of CIA, 1975; pages from CIA 'family jewels' file, National Security Archive; p. 58: PG working for Granada TV's sports department, courtesy of Paul Greengrass; p. 59: Hunger striker Raymond McCartney, courtesy of Granada TV.

3: SECRECY

p. 65: Venona document, courtesy of NSA.gov; p. 70: PG, Peter Wright and his wife, courtesy of Paul Greengrass; p. 74: MI5 files on the *Spycatcher* affair, courtesy of the National Archives; p. 80: PG and Malcolm Turnbull outside court, courtesy of Paul Greengrass; p. 82: Note from Mrs Thatcher, National Archives.

4: SURVIVAL

p. 88: Eye in camera lens, 1929, public domain; p. 92: PG and David Thewlis on the set of *Resurrected* (1989), courtesy of Paul Greengrass; p. 98: 'Looking for Irena' still, courtesy of BBC; p. 103: Stephen Lawrence in *The Murder of Stephen Lawrence*, courtesy of Granada Television; p. 110: Chief Superintendent Isley

in *The Murder of Stephen Lawrence*, courtesy of Granada Television; p. 111: Neil Acourt goads protestors, courtesy of Granada Television; p. 113: Doreen Lawrence, courtesy of Granada Television.

5: RIOT

p. 116: Gas mask mural, Wikimedia Commons; p. 119: Ministry of Defence report on Bloody Sunday, courtesy of the National Archives; p. 121: the Maze Prison, courtesy of Granada Television; p. 124: Jimmy Nesbitt in *Bloody Sunday*, photo Bernard Walsh, courtesy of ITV; p. 131: Derry residents run from paras, photo Bernard Walsh, courtesy of ITV.

6: ASSASSINATION

p. 145: Oswald pin badge, courtesy of myramager2403, Etsy; p. 149: Pages from CIA manual *A Study of Assassination*, National Security Archive; p. 152: PG and Matt Damon in Moscow © 2004 Universal Studios; p. 162: JFK motorcade, Getty Images; p. 178: Moscow car chase storyboards, courtesy of Chris Forster; p. 179: Schematic for Moscow car chase, *The Bourne Supremacy*, courtesy of Paul Greengrass; p. 183: PG and Matt Damon in India © 2004 Universal Studios.

7: REVOLUTION

p. 188: *Battleship Potemkin*, Wikimedia Commons; p. 191: Bin Laden document, National Security Archive; pp. 200–1: Timeline of the United 93 flight, courtesy of Paul Greengrass; p. 207: PG in the Philippines, courtesy of Paul Greengrass; p. 211: Boeing 757 schematic, courtesy of Paul Greengrass; p. 212: PG directing *United 93*, courtesy of Paul Greengrass; p. 215: Last portion of United 93 flight timeline, courtesy of Paul Greengrass.

8: MOTION

p. 220: Muybridge stills, man running, Wikimedia Commons; p. 227: PG in the CIA 'hub', courtesy of Paul Greengrass; p. 228: Producer's console at Granada, courtesy of Paul Greengrass; p. 235: Ayrton Senna racing, Wikimedia Commons; p. 243: Mark Felt, public domain; p. 245: PG, Albert Finney and Matt Damon, courtesy of Paul Greengrass; p. 248: selection of declassified CIA reports, National Security Archive; p. 250: Anti-Iraq War demonstration in San Francisco, 15 March 2003, copyright © Anthony Suau, reproduced with permission.

9: CHAOS

p. 254: 'Iraq's Most Wanted' deck of cards, photo by Tom Shone; p. 256: Curve Ball email, National Security Archive; p. 266: PG sets up a shot © 2010 Universal Pictures; p. 272: Martin Luther King Jr, Wikimedia Commons; p. 272: FBI file map, National Security Archive.

10: GLOBALISATION

p. 276: Kangaroos, Wikimedia Commons; p. 283: Infrared aerial surveillance of the *Maersk Alabama*, Wikimedia Commons; p. 283: Diagram of ship's evasive manoeuvres, Wikimedia Commons; p. 291: PG at work aboard the *Maersk Alabama*'s sister ship, courtesy of Sony.

11: TECHNOLOGY

p. 302: Paperclip, public domain; p. 310: An excerpt from the files Snowden leaked, WikiLeaks, photo by Tom Shone; p. 320: Michael Hayden, Creative Commons.

12: VIOLENCE

p. 325: 'Je suis Charlie', Annecy, 2015, courtesy of Wikimedia Commons, copyright © Ithmus; p. 333: PG talks with Anders Danielsen Lie, courtesy of Netflix.

13: FACT

p. 342: Reel-to-reel tape, credit Richard Clyborne, Flickr Commons.

14: CONFLAGRATION

p. 358: Fire, Wikimedia Commons; p. 365: The 'campfire' viewed by satellite, courtesy of NASA, Joshua Stevens; p. 368: PG on bus with Pål Ulvik Rokseth, photo by Joanna Kaye.

PLATE SECTION

p. 1: (top and bottom) © Granada Television.
p. 2: (top) © 2004 Universal Studios; (bottom) © 2006 Universal Studios.
p. 3: © 2007 Universal Pictures.
p. 4: (top) Courtesy Paul Greengrass; (bottom) © 2007 Universal Pictures.
p. 5: (top and bottom) © 2013 Columbia Pictures Industries, Inc. All Rights Reserved. Courtesy of Columbia Pictures.
p. 6: (top) © Netflix; (bottom) © 2020 Universal Studios.
p. 7: (top and bottom) © Joanna Kaye.
p. 8: © Joanna Kaye.

INDEX

Page numbers in *italics* refer to photographs.
PG = Paul Greengrass.

movies, 239, 313–14; filming, 321; James Clapper 'arrests' Matt Damon during filming, 321; Matt Damon comes on board, 306–7; opening scene, 315, 317–18; Paul Mason as consultant on, 209; PG agrees to make, 306–8, 313; PG's later reflections on, 238, 318; research and ideas for, 308–11; reviews, 314; storyline and characters, 308–9, 315–18

Bradley, Dan, 224, 233

Branagh, Kenneth, 101

Brecker, Ally, 143, 150–1, 153, 166

Breivik, Anders: court testimony, 324; early life, 328–9; influences other terrorists, 323–4; manifesto, 329–30; Norway's response to attacks, 339; police interrogation, 330–1; terrorist attacks by, 323–4; *see also 22 July* (film); *One of Us* (Åsne Seierstad)

Bronner, Michael: 'How Did We Get It So Wrong?', 264; research for *Green Zone*, 259–60, 260–1, 265; research for *United 93*, 198, 199, 215

Brooks, Duwayne, 103

Brown, Marvin, 93

Bruner, Whitley, 261

Burgess, Guy, 67

Burnett, Thomas, 211, 212, 213, 215

Burns, Scott, 223–4

Busby, Matt, 197

Bush, George W., 190, 192, 218, 249, 258–9

Butler, Lord: *Review of Intelligence on Weapons of Mass Destruction*, 193

Caleb, Ruth, 102

California, wildfire (2018), 358–60, 365; book and documentaries about, 358, 360, 361; *see also The Lost Bus* (film)

'Cambridge Five', 67–8, 69–71; *see also Spycatcher*

Cambridge University, 52, 227–8, 343–4

cameras: Aaton, 25; Arriflex, 17, 24–5, 233; Auricon, 18, 24; Bell & Howell, 108, 159, 342; Bolex, 39; Éclair, 18–19, 25; Leica, 50

Cannes Film Festival, 218, 222

Cannon, Pete, 38–9

Capalbo, Carmen, 46–8

Capshaw, Kate, 192–3

Captain Phillips (film): appeal of story to PG, 277; awards, 300; Billy Ray's original script, 274–5, 279, 290; box office success, 300; budgetary control, 271, 278; camerawork, 25, 286–7, 292; casting, 282–4, 296; Derry screening, 4; editing, 293; ending, 294–8; filming, 284–8, 291, 292; Michael Hayden and James Clapper are impressed by, 320; PG agrees to make (his way), 274–5; PG temporarily chokes during filming, 284–5;

premiere, 300–1; reviews, 291; script rewrites, 280–2; storyline and characters, 289–92, 293

Card, Andrew, 190

Carlos the Jackal (terrorist), 145, 146

Carpenter, John, 356

Carreras, Chris, 200–1, 203, 204, 210

Cassavetes, John, 375

Cathcart, Brian: *The Case of Stephen Lawrence*, 103–4

Cazale, John, 288–9

Chandrasekaran, Rajiv: *Imperial Life in the Emerald City*, 252, 260; supports *Green Zone*, 260–1

Charlie Hebdo attacks, 332–4

Chawdhary, Shaun, 111

Cheney, Dick, 146, 190, 247; *In My Time*, 190

CIA (Central Intelligence Agency): assassins, 147, 249; Church Committee report, 146–7; Curve Ball's intelligence on WMD, 254–8, 256, 260; declassified *Spycatcher* files, 84; exceptional authorities to carry out lethal action, 248–9; 'extraordinary rendition', 193; 'Family Jewels' file, 54–5, 55, 146, 320; *The Good Spy* (Robert Ames), 309; interrogations using torture methods, 248; molehunts, 70–1, 73, 84; positive response to Bourne movies, 320–1; provides material for thriller novels and films, 146–7; In-Q-Tel (venture capital arm), 316; *A Study of Assassination* (manual), 147, 149, 232

The Citizen/The Subject/The State triptych (Richard Hamilton paintings), 59

Clapper, James, 320–1

Clarke, Alan, 35–6

Clemenson, Christian, 211

Coogan, Steve, 99

Cooper, Ivan, 122–3, 129–30, 137; *see also Bloody Sunday* (film)

Cooper, Yvette, 323

coronavirus pandemic, 13, 354–5

Costa-Gavras, 117, 128, 208

Coughlin, Charles, 327

Courage Under Fire (film), 168

Covino, Michael Angelo, 347

COVID-19 pandemic, 13, 354–5

Cox, Brian, 55, 165–6, 168, 182; *Putting the Rabbit in the Hat*, 182

Cox, Jo, 323

Cram, Cleveland, 73–4, 83

Crisis: Behind a Presidential Commitment (documentary), 118

crowd psychology: Gustav Le Bon on, 128; PG's understanding of, 125, 128–9

crowds, styles of filming, 126–9

Crowell, Rodney, 367

Crowley, Pat, 143, 153, 155, 166, 181, 223, 241

Croydon Airport, 125–6